ISAMU NOGUCHI
A Study of Space

Ana Maria Torres

Foreword by Shoji Sadao

THE MONACELLI PRESS

First published in the
United States of America in 2000 by
The Monacelli Press, Inc.
10 East 92nd Street
New York, New York 10128.

Library of Congress Cataloging-in-Publication Data
Torres, Ana Maria, date.
Isamu Noguchi : a study of space / Ana Maria Torres ; foreword by Shoji Sadao.
p. cm.
Includes bibliographical references and index.
ISBN 1-58093-047-6
1. Noguchi, Isamu, 1904– —Criticism and interpretation. 2. Public sculpture.
3. Outdoor sculpture. I. Title.
NB237.N6T66 2000
709'.2—dc21 00-020490

Printed and bound in Italy
Production assistance: Paola Gribaudo

Designed by Esther Bridavsky and
Michael Bierut/Pentagram

CONTENTS

ACKNOWLEDGMENTS

This book, its process, and my personal life have been intrinsically linked for nearly a decade. In its earliest stages, my study of Isamu Noguchi's work was simply a matter of bringing a new theme and new perspective to my doctoral thesis in architecture. As work progressed, it became a personal challenge, rooted in my own fascination with Noguchi's work and life—the freedom and the adventurous, irrepressible spirit of both.

After having gone through this process, I came to realize that there were significant personal circumstances that ultimately gave the book life, although it is not possible to mention them all in these brief acknowledgments. The most important is the working relationship I had with the architect Juan Daniel Fullaondo, professor at the School of Architecture in Madrid, Spain, who first challenged my intellect with his unique vision of Noguchi and architecture and to whom I want to express my deep gratitude.

I extend my special appreciation to the Isamu Noguchi Foundation, Inc., and the Isamu Noguchi Museum staff. Shoji Sadao, the director of the Noguchi Foundation, who has followed the evolution of this book from its earliest days as a doctoral dissertation, has my sincere thanks for his tireless interest and support from the time of my first visit to the foundation. I thank Bruce Altshuler, Amy Hau for her continuous help in finding new material to make this book unique, and George Juergens. I am grateful to Bonnie Rychlak, Erick Johnson, Lawre Stone, and Horacio Castaño.

This book was supported by a grant from the Graham Foundation for Advanced Studies in the Fine Arts. I also want to thank the Comite Conjunto Hispano-Americano for a fellowship that brought me to New York to initiate this project; the director, Thomas Middleton, and his successor, Maria Jesus de Pablos, were exceptionally kind. I want to thank the Malka Lubelski Cultural Foundation for its support of this book.

I thank The Monacelli Press, particularly Gianfranco Monacelli for his enthusiasm for the project, as well as editor Andrea Monfried for her patient effort, Sasha Cutter Nye, and Steve Sears. Thanks to Stephanie Salomon for her editing and to the graphic designers Michael Bierut and Esther Bridavsky of Pentagram for the beautiful design.

I am grateful to my many European colleagues for their invaluable opinions: Paloma Fullaondo, Ana Buenaventura, and the architects Maria Teresa Muñoz and Javier Seguí.

In Japan I owe a special debt to Masahiro Soma, who, with great enthusiasm, sponsored this book and translated it into Japanese—thus making it possible for this book to be published in Japan. I am grateful to the translator Michiko Yamada, the architect Takahiro Sato of Cesar Pelli & Associates, the landscape architects Yuichi Sakuma and Miho Saito from Soma Landscape planning, and Takashi Marumo from Marumo Publishing. Thanks to Mika Kazawa, Masae Obana, and Motoaki Fujino, who helped with the computer work at Soma Landscape; to Kazue Soma from *NY Arts;* and to Yoshiko Masuda from 450 Broadway Gallery, New York. I am grateful to the photographer Michio Noguchi, who welcomed me to Japan. I would also like to thank the artists Yoko Yoshida and Makoto Yoshida, who helped me in finding information, and the photographer Shigeo Anzai.

In the United States, many colleagues and friends shared their support and enthusiasm. Roberto de Alba offered excellent advice from the beginning of this long process. As always, Diana Balmori, landscape designer, provided invaluable support in sharing her insights. I thank Jane Roche and Kevin Roche for their indispensable kindness and exceptional advice; the writer Marisa Bartolucci, whose enthusiasm supported this book; and Denis Pelli, professor of psychology at NYU, whose honesty helped improve the project. I wish to thank Elisabeth Cuspinera, the cultural attaché of the Spanish Consulate. I want to thank Thalassa Curtis for editing, and Sally Atkins, Erik Bakke, Paul S. Butkus, James Clark, Eileen Garred, and Jackie McAllister for helping me to correct the manuscript. I thank Hulya Genc and Javier Gonzalez-Campana for indispensable help with redrawing some of the gardens. I thank Jennifer Domask, Nathalie James, Sonali Nagle, and Robert Trostle for helping me with the research grants and photographs. My special thanks goes to Ana Maria de Torre Velasco-Rueda and Jose Maria Torres Hernandez. Finally, I want to thank Abraham Lubelski, who generously shared his invaluable opinions.

It is a special pleasure for me to write this foreword to Ana Maria Torres's study of the landscape designs of Isamu Noguchi. For many years I have lamented the fact that no book existed on Noguchi's landscape work. With this book, a lacuna has been filled.

Noguchi is known for his sculptures and for his collaboration with Martha Graham on set designs for her dances based on the Greek tragedies that inspired her. Less is known of his early fascination with working the earth itself into projects of immense size that prefigured the conceptual art of the 1960s and 1970s. In look-ing at the influences on Noguchi's development as an artist in the 1930s and 1940s, the period when these earthworks were conceived, one can find the inspiration for the project but the creative act itself remains a mystery. *Monument to the Plow* was the result of Dr. Edward Rumely (Noguchi's "guardian") relating to Noguchi the significance of the steel-tipped plow in breaking the soil of the prairie and opening up the vast and fertile midwestern plains to agricultural production. But the leap of imagination from the abstract concept of a monu-ment to a low-lying pyramid 1,200 feet long on each edge, a huge stainless-steel plow at its apex, and with each of its three faces representing an aspect of the transformation of the prairie, is the product of pure genius.

Approaching the design of landscapes from an artist's per-spective rather than a botanist's, and using forms and spaces derived from his earlier work with the stage, Noguchi was able to create works that transcended the academic discipline of landscape architecture. His most successful work, *California Scenario,* is a mas-terful demonstration of his use of abstract forms in a surreal stage

setting. The integration of space, sculpture, plant materials, and architecture creates a whole that is greater than the sum of its parts. It is truly a work of art.

Noguchi's working method for designing any space was through models. He was a sculptor, and modeling came to him naturally as the most appropriate method for visualizing forms and relationships. Drawings were another tool, but he did not trust the two-dimensional representation of a three-dimensional relationship. Plaster, balsa wood, and plasticine were all used to varying degrees. When Louis I. Kahn worked with Noguchi on the Riverside Park Project in New York, the architect was fascinated with the sculptor's use of plasticine in constructing site models. The ease with which it could be worked to accurately represent land forms and masses captivated Kahn to the point that many of his subsequent site models were made with plasticine. I can recall going to Kahn's office with Noguchi and seeing the plasticine site model for the capital of Bangladesh, which Kahn was designing. The relationship between Kahn and Noguchi, I might add, was one of artist to artist, each recognizing the creative gift that the other brought to a project. It is indeed a great pity that they were not able to build Riverside Park. It would have been one of the true collaborations between an architect and an artist.

Isamu Noguchi: A Study of Space will introduce the reader to the realm of Noguchi's landscapes, his metaphor for the world. His landscapes are not just arbitrary shapes and forms placed randomly in space. They are steeped in myth, with allusions to prehistoric sites. They distill and reinterpret for our time the ceremonial spaces of past cultures, be they astronomical observatories, dry rock gardens, or serpentine mounds. Ana Maria Torres has developed a comprehensive study that reveals Noguchi's understanding of art and architecture and allows the reader to see and experience the marvelous spaces that Noguchi created around the world.

SHOJI SADAO
Executive Director
The Isamu Noguchi Foundation, Inc.

INTRODUCTION

WITH MY DUAL NATIONALITY AND DOUBLE UPBRINGING, WHERE WAS MY HOME? WHERE MY AFFECTIONS? WHERE MY IDENTITY? JAPAN OR AMERICA, EITHER, BOTH—OR THE WORLD?[1]

In the summer of 1988 I discovered New York City and Isamu Noguchi's work; both were fascinating and life-altering discoveries. Back home in Madrid, I focused my intellectual curiosity on Noguchi but soon learned that it was difficult to find documentation on him, particularly in Spain. I began traveling to New York several times a year, and as the city became more familiar and accessible, looking for information about Noguchi became an obsession. I was intrigued by his work and life, his eclecticism, and his continuous search for new experiences throughout the world.

Like Ulysses, Noguchi traveled constantly and never seemed to come to rest anywhere for too long. Buckminster Fuller, in his foreword to Noguchi's autobiography, *A Sculptor's World,* suggested a parallel between Noguchi and the airplane: both were born in the United States, and both supported a new era that integrated separate civilizations' experiences into a shared human history and geography. "I work everywhere," Noguchi once said of himself. "I feel myself equally settled wherever I am; people all over welcome me as their country fellow and that is both pleasant and sad for me; since I have not got a home."[2]

ISAMU NOGUCHI
in a Paris studio, 1928

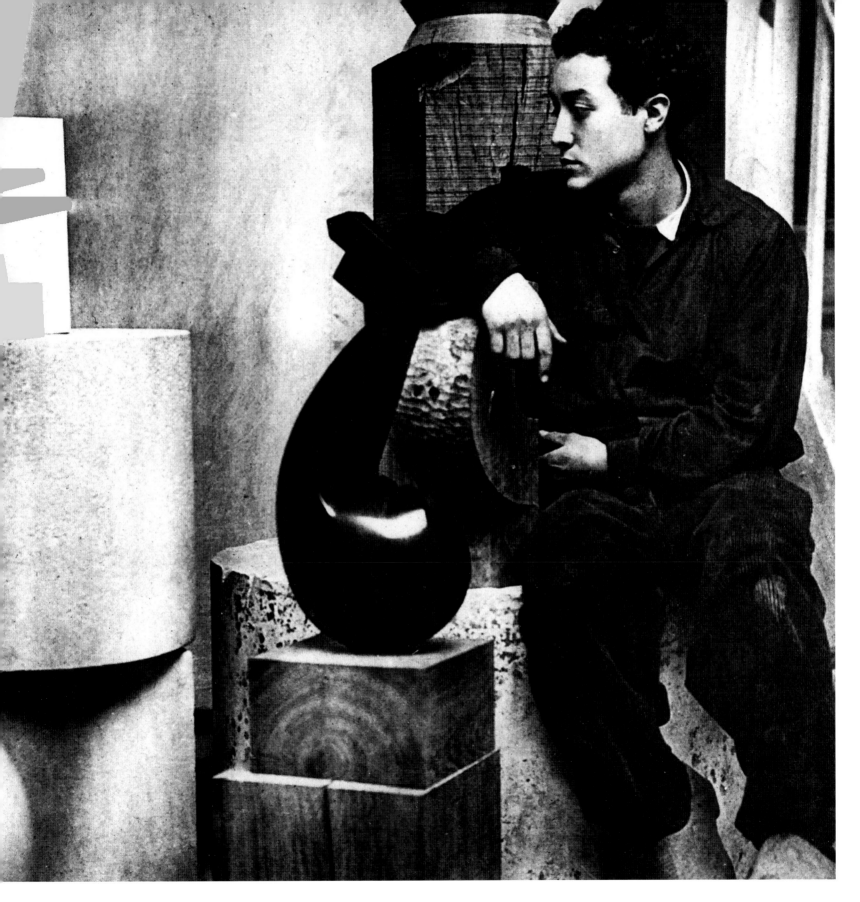

ISAMU NOGUCHI
working in Kita Kamakura studio,
c. 1951

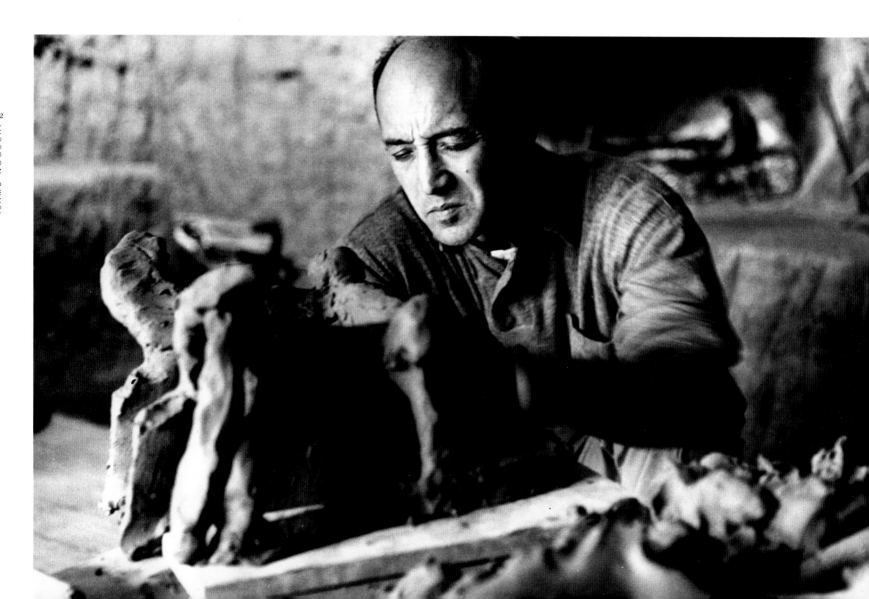

Noguchi extracted particular, evocative images from his odyssey, using them throughout his life as reference points for bringing, most consistently, the ancient environment of leisure and ritual into his work. In much of his work he reinterpreted the geometric forms of the eighteenth-century Samrat Yantra Observatory in Jaipur, India (a creation of the Maharajah Sawai Jai Singh II). He produced mesmerizing abstractions of Ohio's Great Serpent Mound and transformed architectural space with references to stroll gardens (a sequential garden that revealed its succession of views through movement),[3] Zen meditation gardens, Egyptian pyramids, and the ancient Chinese traditions of the Altar of Heaven and the Altar of Earth. Noguchi's deep knowledge of traditions of symbolism provided him with many directions to pursue in the development of his designs. He referred to forms from other cultures and sometimes from other artists—the most important being Constantin Brancusi. As an apprentice of Brancusi's in 1927, Noguchi began to study his work, and later reinterpreted it throughout his own career.

From childhood onward, Noguchi was surrounded by stories about Apollo, the Olympian gods, Eastern gardens and temples, nature, and prehistoric monuments. He inherited a devotion to literature and mythology from his mother. These unique and varied associations affected Noguchi and his art profoundly. As Richard Ellmann suggested in his biography of James Joyce, "The life of an artist . . . differs from the lives of other persons in that its events are becoming artistic sources even as they command his present attention."[4]

Noguchi's life poses a peculiar riddle—a series of questions arises as one studies him developing professionally and coming into contact with others. How did he investigate his identity? What factors informed his decision to transform himself from an individual first named Isamu Gilmour into an artist who became known as Isamu Noguchi?

Isamu Noguchi (1904–88) was born in Los Angeles to a Japanese father, the novelist and poet Yonejirō (Yone) Noguchi, and an American mother of mixed Anglo-Saxon and Native American blood, Leonie Gilmour. Leonie had met Yonejirō in 1901 through an advertisement he placed for an English tutor. Isamu's father returned to live in Tokyo in 1904, abandoning Leonie before Isamu was born. In 1906 Leonie Gilmour moved to Tokyo with Isamu; in 1910 they moved to Chigasaki where she supported herself and Isamu by teaching English. Isamu grew up with a good knowledge of the natural world. He attended an experimental kindergarten that had its own zoo; children there were taught through hands-on learning. Yonejirō married a Japanese woman in 1913.

When Isamu was thirteen, his mother decided to send him to the Interlaken School, situated in Rolling Prairie, Indiana, and he returned to America alone. In his autobiography Noguchi states that he had felt deserted, abandoned first by his father and then by his mother. These experiences provoked his restlessness and constant search for identity. Although the separation was painful for his mother, Leonie felt that if Isamu could attend school in America, the experience might allow him to work out difficulties surrounding his mixed parentage. Looking out for her child, she had selected a school where the boys "learned to know by doing."[5] In the fall of 1918, shortly before World War I ended, the school was closed and transformed into a military training camp. Noguchi found himself alone and supported emotionally and intellectually by parental surrogates, since his mother did not have the financial means to bring him back to Japan. Dr. Edward Rumely, founder of the Interlaken School, heard that Noguchi had been left alone there and brought him to his home in La Porte, Indiana. At Dr. Rumely's suggestion, Noguchi moved in with Dr. Samuel Mack, a Swedenborgian minister, and his family. For the next three years Noguchi attended a new high school in La Porte. Rumely encouraged Noguchi to study medicine, but because the young man had expressed a wish to become an artist, Rumely arranged for Noguchi, who was then eighteen, to begin an apprenticeship with his friend Gutzon Borglum, sculptor of the Mount Rushmore National Monument. This was Noguchi's first attempt at being a sculptor. Borglum discouraged Noguchi from pursuing art as a career because he felt that the teenager was not talented enough.

In January 1923 Noguchi entered Columbia University as a premedical student. While there, he met Dr. Hideyo Noguchi, who had known his father. Hideyo, uncertain about Noguchi's commitment to medicine

(and convinced that only those with a gift for medicine should practice), urged the young man to become an artist. During this time, Noguchi's mother returned to live in New York. In his autobiography, Noguchi wrote that his childhood attachment to her would never return because Leonie's decision to send him to America alone at thirteen had left him feeling deserted: "The more motherly she became, the more I resented her."[6]

When Noguchi committed himself to being an artist in the early 1920s, he decided to change his surname from Gilmour to Noguchi. He saw this identification with his father's name as essential to his development as an artist. This change denied Leonie a role in his artistic identity. Noguchi felt he had, as he later described, adopted a name "that perhaps I had no right to."[7] Leonie's consternation over this name change, however, did not prevent her from encouraging her son to pursue his desire to make art. At her suggestion, Noguchi enrolled at the Leonardo da Vinci Art School where the director, Onorio Ruotolo, introduced him to academic sculpture.

A 1926 exhibition of Brancusi's sculptures in New York served as a turning point in Noguchi's artistic development. After seeing the Brancusi show, he applied for a Guggenheim Fellowship to study in Paris. His Guggenheim application described two important goals he wanted to achieve: "to view nature through nature's eyes"[8] and, more important, to use his sculpture to interpret the East for the West—a role his father's poetry played. In April 1927 Noguchi arrived in Paris on his fellowship, and with the help of the American writer Robert McAlmon, he met Brancusi and soon became his assistant. During the following two years there, Noguchi produced a series of stone, wood, and sheet-metal abstractions influenced by Brancusi, Pablo Picasso, and the constructivists. When his fellowship was not renewed, he returned to New York in 1929.

After his return, two important figures entered Noguchi's life who became great influences on his career: the choreographer Martha Graham and the visionary Buckminster Fuller. At that time Noguchi's powerful sculptural portraits sustained the artist when larger commissions and fellowships were not forthcoming. "There was nothing to do but make heads . . . It was a matter of eating, and this was the only way I knew of making money," he wrote in his autobiography.[9]

ISAMU NOGUCHI
during construction of the
Chase Manhattan Bank plaza,
New York, 1963

How did figures like Brancusi, Fuller, and Graham affect and even direct Noguchi's career? From Brancusi, Noguchi learned to use tools and materials; he was introduced to the language of abstraction and the avant-garde and was initiated into his teacher's universal view of art. Brancusi also introduced Noguchi to the concepts of architectonic and environmental space through his own work at Tîrgu Jiu, Romania. Fuller nourished Noguchi with his deep interest in science, cellular structures, modern technology, and a visionary understanding of the future. Working on Graham's set designs, Noguchi enhanced his sense of illusion, scale, and the way a person moves through space. Through his work with Graham he became reengaged with mythology.

From 1929 on Noguchi became an incessant traveler, searching for ways to define both his identity and his art. It might be said that Noguchi viewed art as his sole god, his sole religion. The next year, he returned to the Far East for the first time in his adult life. Shortly before leaving for Japan he received a letter from his father, forbidding him to enter Japan using his surname. Disturbed by the letter, Noguchi decided to spend several months in China learning traditional brush painting with Ch'i Pai-shih and studying pottery. Ignoring his father's threats Noguchi arrived in Kyoto in 1931 and was welcomed warmly by his uncle, Totaro Takagi, a Buddhist priest. There he learned about prehistoric Japanese art and traditional Zen gardens, and spent five months working with the potter Unō Jinmatsu, becoming more skilled in pottery.

After returning to New York in 1933, Noguchi began developing playgrounds and earthworks, which became the core of his late environmental designs. During this period he also began to forge a collaborative relationship with Graham. *Frontier* (1934) was the first of some twenty sets he would design with Graham over the next thirty-three years. It was designed for a dance that honored the settlers of the American West. *Cortege of Eagles* (1966) was the last set design he completed for her. Between 1935 and 1950 Noguchi would use his theater designs as a way to test sculptural and spatial ideas that he would later apply in the garden design on which the remainder of his career would focus.

One of Noguchi's most prolific periods occurred between 1949 and

1951, after receiving a Bollingen Foundation Fellowship to research leisure environments and ritual around the world. He explored prehistoric caves, menhirs, and dolmens in England and France, Gaudí's architecture in Barcelona, the art of Michelangelo as well as piazzas and gardens in Italy, the Parthenon in Greece, the Samrat Yantra Observatory in India, and finally, the gardens in Kyoto. He returned to postwar Japan, this time without the specter of rejection, since Yonejirō had died three years earlier. In the early 1950s Noguchi received his first environmental commissions: the Reader's Digest garden (1951), the bridge railings in Hiroshima (1951–52), and a memorial to his father in Keiō (1951–52).

Noguchi's maturation as an artist began in Japan, where he was linked to the culture by blood as well as by his own spiritual sensibility. From that point until his death in 1988, Noguchi searched equally for his identity in Japan and in America. His work and life developed at the margins of two cultures, where he carefully situated himself as artist and observer. He always acted and lived as if he were in exile, a foreigner, an outsider. In *A Sculptor's World*, he stated, "I find myself a wanderer in a world rapidly growing smaller. Artist, American citizen, world citizen, belonging anywhere but nowhere."[10]

Noguchi regarded his mixed East-West heritage as a potentially renewable inner source of inspiration, one rich in material. His work represented an important bridge between the Orient and the Occident; he liberally borrowed diverse elements from both cultures.

Noguchi's work in the 1950s marked his evolution as an environmental designer as he developed sculpture in relation to architectonic space. Over the course of the next ten years, Noguchi combined his knowledge of the traditional Japanese garden with elements of the Western avant-garde. He also maintained a successful collaboration with the architect Gordon Bunshaft of Skidmore, Owings & Merrill, designing some of his most important environmental proposals within Bunshaft's buildings: interior courtyards and garden for the Connecticut General Life Insurance Company in Bloomfield Hills (1956–57), and sunken gardens for both the Beinecke Rare Book and Manuscript Library at Yale University (1960–64) and the Chase Manhattan Bank in New York (1961–64).

ISAMU NOGUCHI

working at the Ozeki Factory,
Gifu, Japan, on construction of Akari,
January 1978

Throughout his career, Noguchi stubbornly insisted that the architecture of the modern movement, typically identified with International Style buildings, must be alert to symbolic expression, sensitive to materials, and aware of the spirit in which modern architecture was founded. He believed that a world could be created in which living and working spaces would enrich the sense of self and community. His career consisted of fresh starts and leaps as he immersed himself in the process of creating a personal formal vocabulary that he masterfully retooled in the realm of public sculpture.

Noguchi's experimentation, his eclecticism, and his multidisciplinary character helped him create spaces in which the private sculptural object was integrated with architectonic, theatrical, and environmental spaces. As a result, his projects were endowed with special harmony.

There are many ways to approach Noguchi's work, all of them complex and not completely satisfactory. Each of his works is related; in some cases the relations are obvious but in others almost indiscernible. One difficulty in approaching Noguchi's work is the impossibility of labeling him. In many instances Noguchi's work precedes artistic movements such as land art and environmental design. It is not possible to explain or interpret Noguchi's art from a single perspective, whether it be the artist's background or the purely aesthetic aspects of his work. How can he be placed within sculptural and architectural traditions? Is he an expressionist? A formalist? A minimalist? A conceptualist? One might say that his is the continual adventure that is not yet finished, the *non-finito*. As an artist he attempted to create a new view of nature in an effort to reach the primitive, and so be reborn. But in the end one is left with a riddle. In the middle of Noguchi's thousand faces appears a single face. It is a face in constant search of dualities, always examining one aspect of reality and then another.

This book approaches Noguchi's landscape designs through a description of the forms and spaces he created and through a comparative analysis of processes and references. The spatial relationships in his gardens and plazas, and their architectural surroundings, are important conditions to consider. The relationships among scale, texture, materials, and symbolism are part of the dualities characteristic of the artist's sculptural spaces. Primarily, the book focuses on his public sculptures and environmental works. It begins with playgrounds and earthworks, followed by more detailed commentaries on his gardens, plazas, and environmental proposals.

Fascinated by the world of children, Noguchi expended much of his energy in the development of innovative playgrounds. Because he understood that children view the world differently than adults, he imagined that their awareness of its possibilities would be attuned to their full and real capabilities. For Noguchi, playgrounds were akin to primers on shapes and simple functions. They were simple in design, mysterious in their possibilities, evocative and educational. Noguchi thought of playgrounds as places for investigation and exploration, where a child could go from one experience of play to another, learning along the way. They were to be places for uninhibited play, in which the spaces to be discovered must never resemble naturalistic shapes.

Noguchi's gardens and playgrounds are replete with symbolic references to concepts of place, space, and time. He brings to the gardens the mystery of the relationship between the whole and its parts, associated with a visual balance between symmetry and asymmetry in nature's order. Time can exist on two levels: the geological time implicit in the ancient stones and the time engraved in the history of humanity. Noguchi had the sensitivity to absorb the meaning of a site, its history and its scale. In his work the original reference vanishes, a metaphor takes its place, and then this too disappears.

Noguchi's sculptural and environmental works possess metamorphosing characteristics; within them appears his ever-present sense of light as a function of the time of day and the seasons. Mass, shape, and volume, in addition to a unique feeling for the spectator's sensibility and participation, are also considered. In every piece Noguchi focused on how the spectator would receive a wide range of symbols; he always took care to excite the imagination.

His approach to sculpture was based on the understanding that space was paramount. People may enter the space and then discover they are in

scale with it, and it is, therefore, real. "Empty space," he declared, "has no visual dimension or significance. Scale and meaning appear, instead, only when an object or a line is introduced . . . The size and shape of each element is entirely relative to all other elements and the given space."[11] When a viewer enters, all points assume a central location within the space.

Noguchi blazed many distinct aesthetic trails that have not been investigated adequately. He conceived sculpture as a spatial whole rather than as an object; he manipulated concepts tied to environments of ancient ritual and included them in the sculptural spaces. Noguchi also brought technology and new materials into the sculptural aesthetic of daily life.

Through Shoji Sadao, the director of the Isamu Noguchi Foundation, I arranged a meeting with Noguchi at the Isamu Noguchi Museum in Long Island City on the afternoon of December 2, 1988. I had traveled from Spain to interview him and present to him a Spanish project on which Juan Daniel Fullaondo, other architects, and I wanted Noguchi to collaborate. After the usual introductions and explanations, I posed my first, and last, question. In asking about Noguchi's stage sets, I used the word "decoration." Noguchi gave a brief and upset answer—he never made decorations—and then stood up to answer a telephone call. The magic was broken, the opportunity lost. Noguchi left for Italy the next

day to visit a quarry. He returned to New York a few weeks later and died of pneumonia on December 30, 1988.

The original concept of this book emerged from a strong fascination with Noguchi's work and the conviction that more information about Noguchi's urban designs was needed. During the book's development, I traveled farther west and began to absorb a new culture. I too became an outsider. Finally I settled in New York, an experience that evoked childhood memories, since I was born in the Canary Islands but grew up in the Spanish colonies of Africa and, therefore, understood the nature of Noguchi's cultural rootlessness.

Noguchi's multiple identities and his freedom from the constraints of "nationhood" define his work. The artist discovered that his mixed loyalties and his dual cultural background were outside of traditional black-and-white terms, just as his work was outside of any formal label. It is the opposite: the link between both is perpetual; one affects the other. Noguchi is a splendid representation of a twentieth-century human being. The frequency of cross-cultural peoples migrating around the world is increasing, and these migrants do not belong anywhere, but they would like to find a home everywhere. They, like Noguchi the traveler, establish biographical connections across geography, time, and cultural lineage.

ISAMU NOGUCHI, *1987*

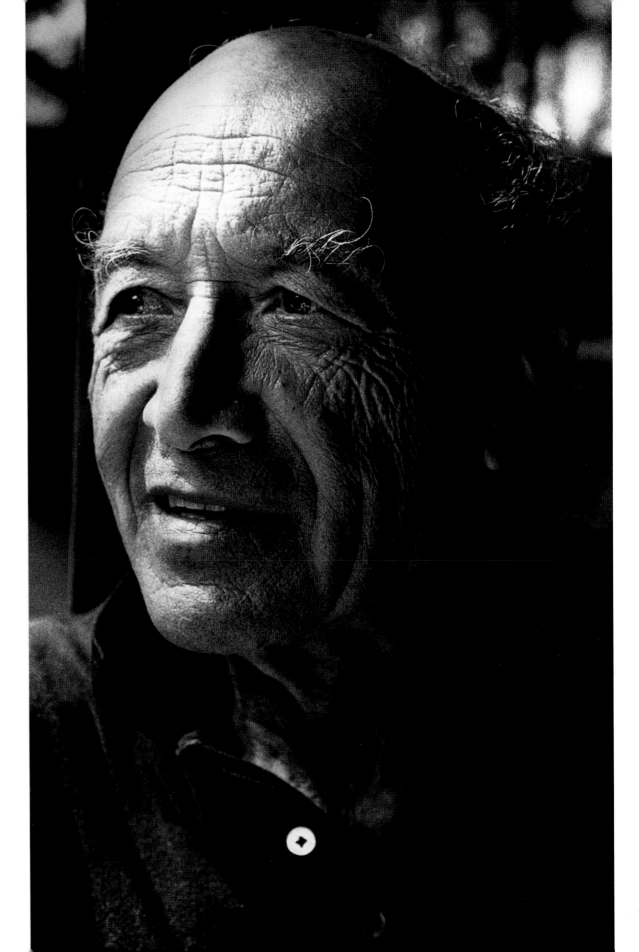

Chapter 1
PLAYGROUNDS

PLAY MOUNTAIN,
1933 (unrealized)
FIGURE 1
Plaster model,
29 1/4 by 25 3/4 by 4 1/2 inches
Play Mountain, shaped as a pyramid,
brought to the children's world
myths of the ancient world. Noguchi
also linked his sculptural experience
to ancient architecture through
the pyramid, a meeting place between
two worlds.

ASTRONOMICAL INSTRUMENTS
BUILT BY THE MAHARAJAH
SAWAI JAI SINGH II IN JAIPUR,
INDIA, *c. 1734*
FIGURE 2
View of the site
Noguchi's visit to the astronomical
observatory proved to be very
influential in his development of a
formal vocabulary.

PLAYGROUND EQUIPMENT
FOR ALA MOANA PARK,
HONOLULU, HAWAII,
1940 (unrealized)
FIGURE 3
Metal model
The space, color, and shapes in
Noguchi's playgrounds also have an
educational function. Elements
from environments of leisure, such as
the Samrat Yantra Observatory,
Jaipur, India, designed by Maharajah
Sawai Jai Singh II, c. 1734, were
also incorporated.

BUT I'M NOT INTERESTED [IN THAT SORT OF PLAYGROUND]. IF THEY WANT US TO OPERATE IT, IT'S GOT TO BE ON OUR PLANS. WE KNOW WHAT WORKS.[1]

With this statement, his mind closed to innovation, Robert Moses, New York City's commissioner of parks and recreation, rejected Noguchi's design for a playground to be located at the United Nations headquarters in New York City in 1952.

Some of Noguchi's early and most important contributions to the design world were his playgrounds for children. In the 1950s (and it remains true), recreational design was in need of critical attention, less formality, and more imagination. Noguchi shaped the land, creating a soft, friendly, colorful, and unexpected environment. His playgrounds were designed to stimulate a child's sense of color, space, and form. Noguchi's early designs for playgrounds and earth sculptures established the foundations for his explorations in parks and gardens.

Play Mountain (1933) was Noguchi's first playground design and also the first in a series of proposals presented to Robert Moses, who did not receive them enthusiastically. Noguchi had a strong urban approach based on the idea of maximizing the playable space of any given city lot by tilting the surface into various dimensional steps to form a pyramid whose interior could also be occupied. On one side of Play Mountain

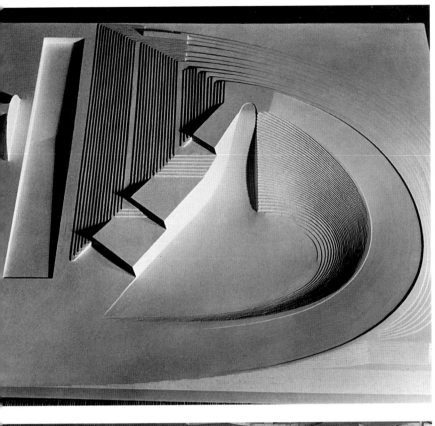

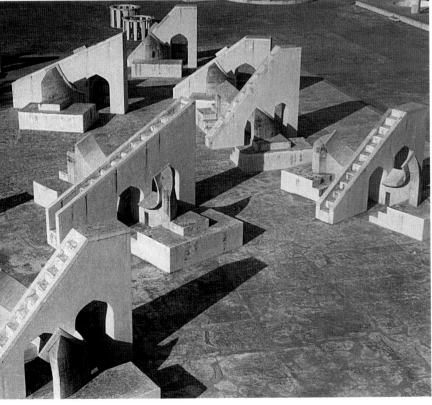

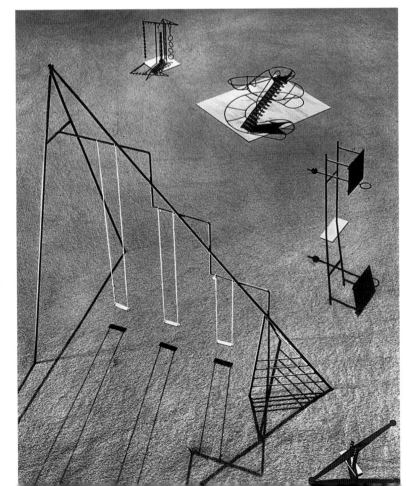

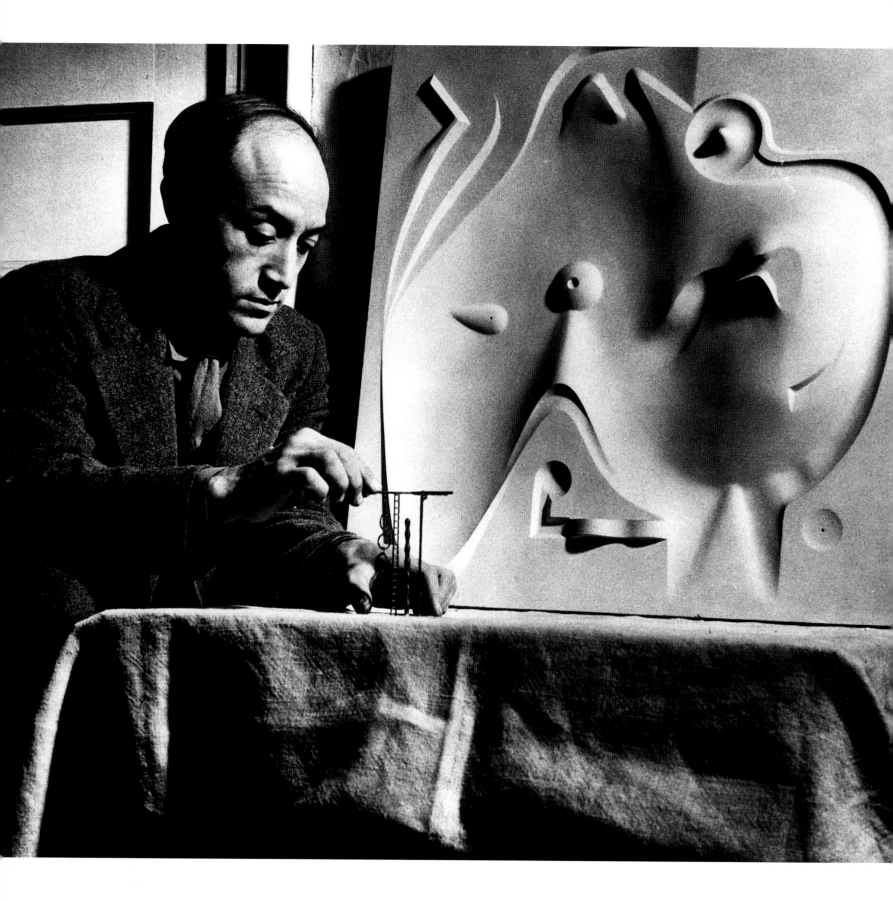

Contoured Playground reflected
Noguchi's desire to put children in
contact with nature using shapes from
the earth. In this way, he created a
unique experience for children who
lived in urban environments. The artist
understood the importance of
discovering nature in one's early
years. The tentative location
was somewhere in Central Park, but
the war put an end to the project.

was a swimming pool and waterfall and on the other a bandstand (fig. 1). Water appeared for the first time in Play Mountain and thereafter became a constant, though variously used, feature in his work.

In 1940 Noguchi was commissioned by architect Lester McCoy, the chairman of the Honolulu Parks Board of the city and county of Honolulu and the builder of the Ala Moana Park System, to design playground equipment for Ala Moana Park in Honolulu, Hawaii (figs. 2 and 3). Noguchi explored the concept of creating and using educational pieces as prototypes for playground typologies. He designed a multiple-length swing with different rates of movement, a climbing apparatus, a seesaw, and other play equipment. Unfortunately, McCoy's death brought an abrupt end to this commission. Noguchi then decided to present the prototypes to the New York City Parks Department, but they were rejected because the equipment was deemed too dangerous for children to climb.[2] In 1941, on his own initiative, Noguchi, frustrated with claims that his designs were dangerous, developed Contoured Playground (fig. 4). This was an earth sculpture consisting of gently mounded earth forms, shallow depressions, and crawl spaces. It was a playground without equipment; the slides and climbing elements were part of the earth forms, and in the summer water flowed through them.

With the outbreak of World War II, Noguchi's ideas for play equipment using earth forms were abandoned and thereafter never realized. He spent months (voluntarily) in a Japanese-American relocation center in Poston, Arizona. During that time, he applied his energies to designing playgrounds and swimming pools for Poston that, like previous proposals, were never realized.

One of the more controversial situations of Noguchi's career arose from a proposal for a United Nations playground to be placed in front of the U.N. Building in New York City. In early 1951 Audrey Hess, the late wife of the art critic and editor of *Artnews* Thomas B. Hess, suggested that Noguchi design a playground for that site. The original concept was to create a place in which a spirit of idealism and goodwill would be represented in a playground (figs. 5 and 6). Money was raised through private subscription and the idea enjoyed widespread support. Noguchi

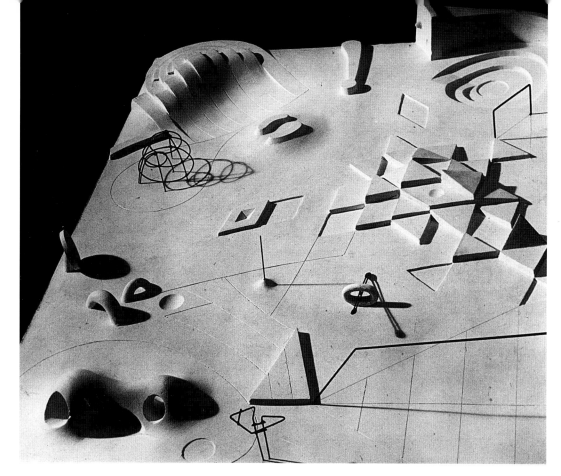

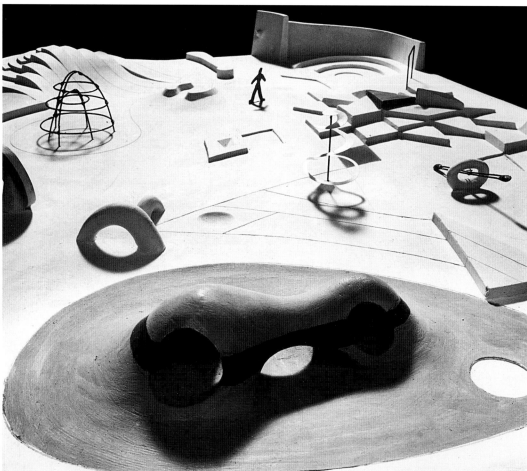

PLAYGROUND FOR UNITED
NATIONS HEADQUARTERS,
NEW YORK, *1952 (unrealized)*
FIGURE 5
Plaster model, 3 by 28 by 19 inches
A laboratory of experiences, the United
Nations playground reflected Noguchi's
conviction that timeless designs allow
children to develop an appreciation for
the ancient world, the art world, and
architecture. He hoped that images
would be imprinted on the children's
minds as a reference for the future.

FIGURE 6
Detail of plaster model
Noguchi defined different activity
areas in the playground by using
two layers. In the first layer, he shaped
the earth. The second layer was
an arrangement of sculptural objects
superimposed on the first.

PLAY SCULPTURES
FIGURE 7
Drawing 1, c. 1970
The shapes of Noguchi's play
sculptures were derived from the
abstraction of forms found in
nature and in ancient cultures.

FIGURE 8
Drawing 2, c. 1970
Noguchi conceived the play
sculptures as elements that brought
art into daily use.

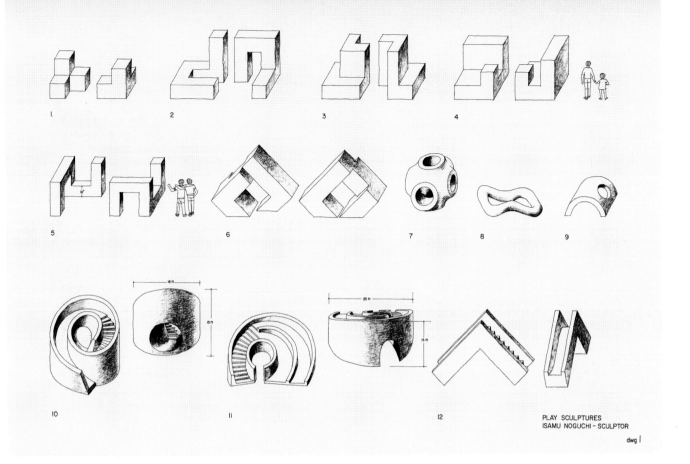

PLAY SCULPTURES
ISAMU NOGUCHI – SCULPTOR

dwg 1

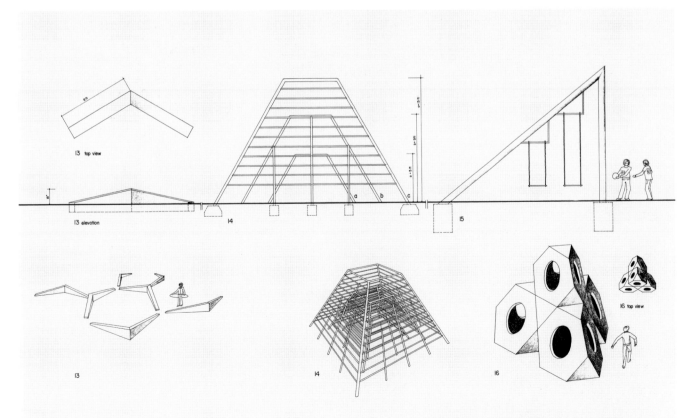

13 top view

13 elevation

14

a b c

15

13

14

16

16 top view

PLAY SCULPTURES
ISAMU NOGUCHI – SCULPTOR

dwg 2

KODOMO NO KUNI
PLAYGROUND, TOKYO, JAPAN,
1965–66
Architect: Sachio Otani
FIGURE 9
Children's Day Celebration
Kodomo No Kuni was created as a
temporary installation under the
patronage of the crown prince and
princess in commemoration of the
Japanese Children's Year.

developed the project with architect Julian Whittlesey, who, in conjunction with Hess, promoted the design during Noguchi's travels to Japan. Despite local neighborhood, civic leaders', and the United Nations' support for the project, Moses made it impossible for Noguchi to realize his dream in New York City. In protest, the Museum of Modern Art displayed the model, drawing a favorable response from the press—but this did not influence Moses's opinion. The negative effect on the artist's career of Moses's aversion to Noguchi's innovative playground designs cannot be underestimated. Had Noguchi, perhaps, been accepted as an artist in the United States by persons such as Moses, his ideas and work might have been more readily embraced. It was not until 1976 that Noguchi would see one of his complete playground designs built in the United States. Between 1940 and 1976, Noguchi developed a complete vocabulary of playground equipment—"playscapes." These were conceived as sculptures and used in his playgrounds in Atlanta, Georgia, and in both Kodomo No Kuni and Moere Numa parks, in Japan (figs. 7 and 8).

In August 1965 Noguchi returned to Japan to design a large play area in Kodomo No Kuni as one part of a larger children's park built near Tokyo. Designed in collaboration with the architect Sachio Otani, the park commemorated Children's Year in Japan. Because the park would function only for one year, Noguchi created it as a metaphor for the inherently ephemeral nature of happiness (figs. 9 and 10). Only Noguchi's concrete trellises, which could not be removed, remain at the site today. The playground was located in a narrow valley surrounded by low-lying hills (figs. 11–13). Noguchi wanted the playground to express the character and history of its place (figs. 14–16). He also wanted to create a model children's world that could be built anywhere.

In 1968 Noguchi was asked by the United States Information Agency in Washington, D.C., to prepare a design proposal for the U.S. Pavilion at Expo '70 in Osaka, Japan. Though the artist's proposed high-tech design was rejected, he was asked to create twelve stainless-steel fountains for Expo '70. His collaborator was the architect Kenzo Tange. The model for the U.S. Pavilion proposal was called *Abstract Moonscape*, a fictional human-made environment in which an exhibition building

ISAMU NOGUCHI

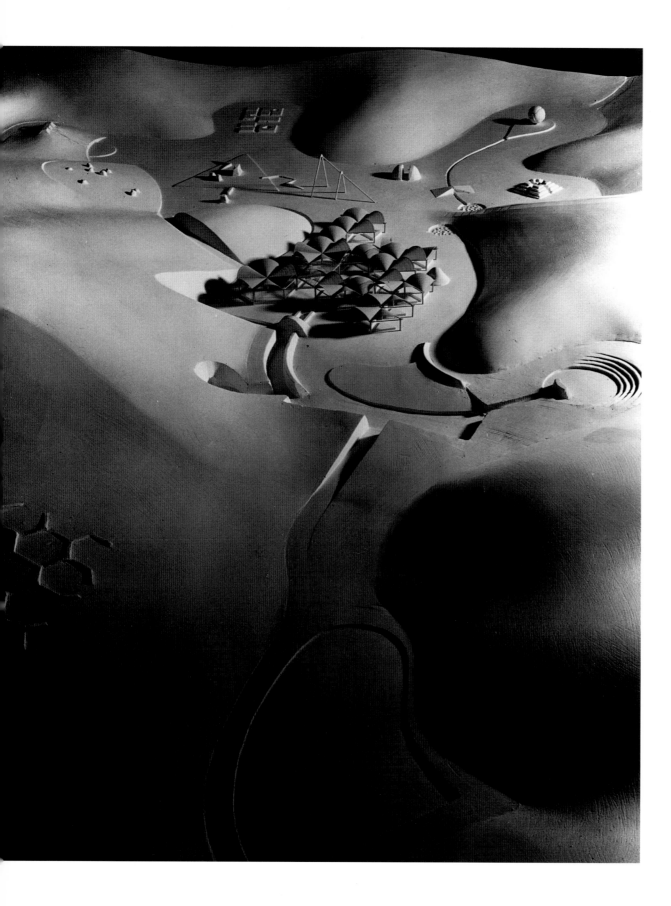

KODOMO NO KUNI
PLAYGROUND

FIGURE 11

Plaster model

Noguchi's sense of place was expressed
through several elements that
emphasize the character of the play-
ground within its particular surround-
ings; here he emphasizes the low-lying
hills so characteristic of Japan.

FIGURE 12

View

The trellis and play elements that
Noguchi designed, like the rocks in
a traditional Japanese garden,
suggest "a protuberance from the
primordial mass below."

FIGURE 13

Detail of concrete trellis

Science was evoked by clustering
concrete trellises as if they were cellular
structures grouped together. They
provided protection and shade in the
exposed area of the valley.

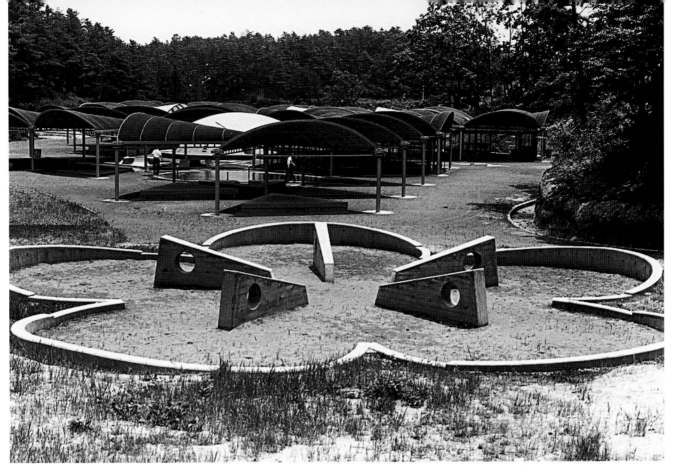

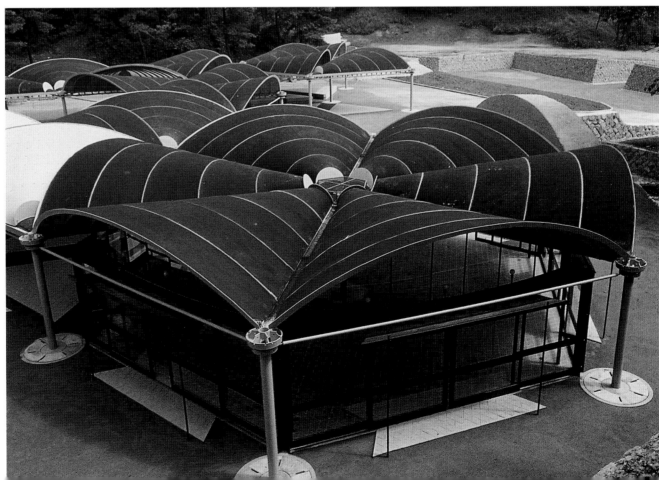

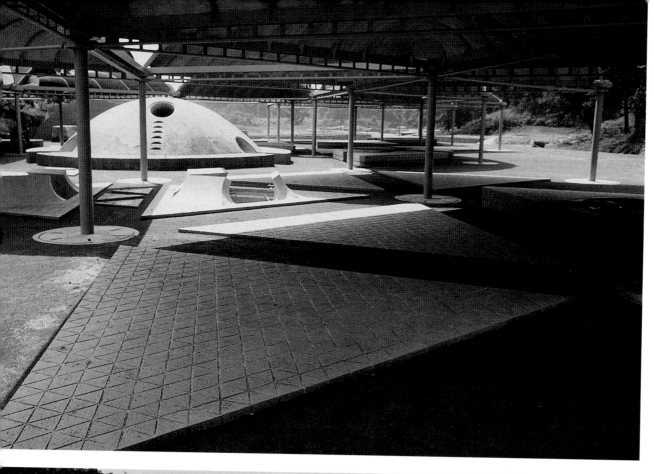

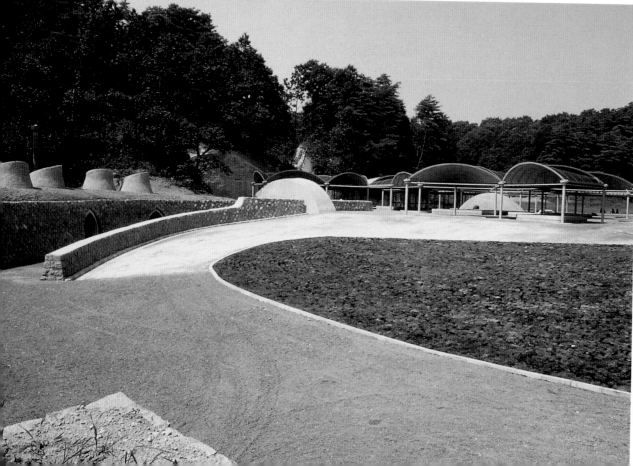

KODOMO NO KUNI
PLAYGROUND

FIGURE 14

Pavement detail

The "floating world" of the
trellises is balanced by the gravity of
the pavement below. Isolated
triangular forms with benches and
tables merge with the trellises
as sculptural elements.

FIGURE 15

Detail of path

A system of meandering paths that
followed the natural shape of the
valley reinforced the children's sense
of discovery.

FIGURE 16

Stair detail

Noguchi emphasized the duality
between the human-made world
and nature through the use of stone
and concrete.

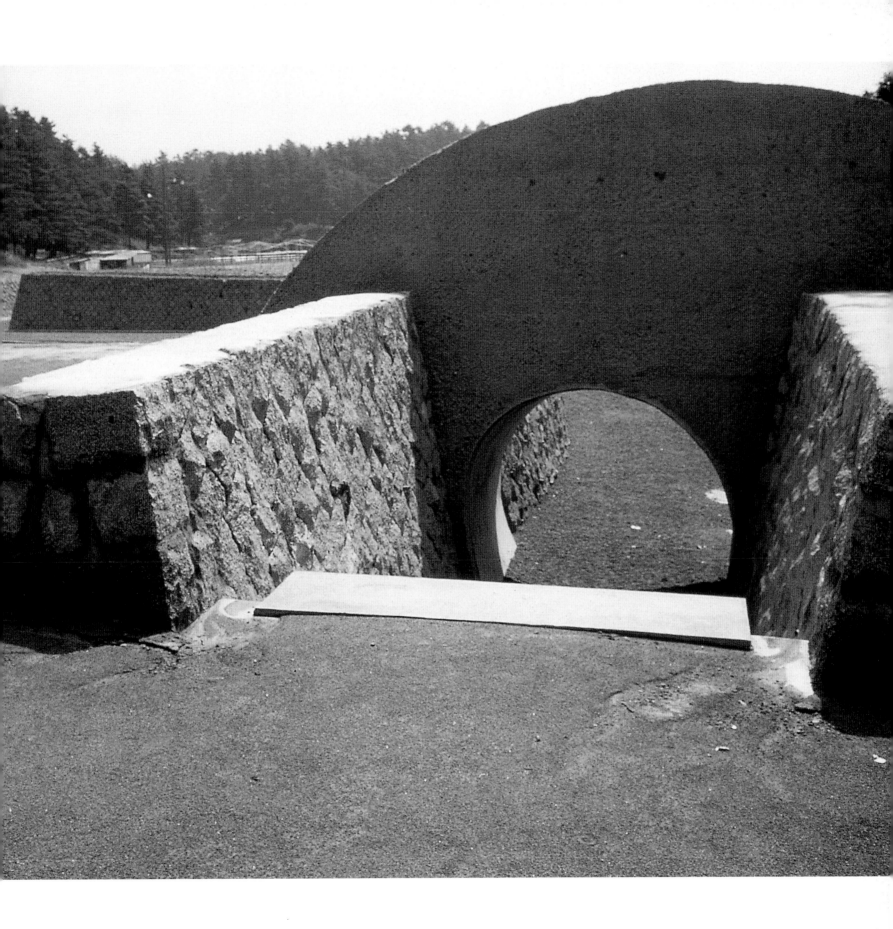

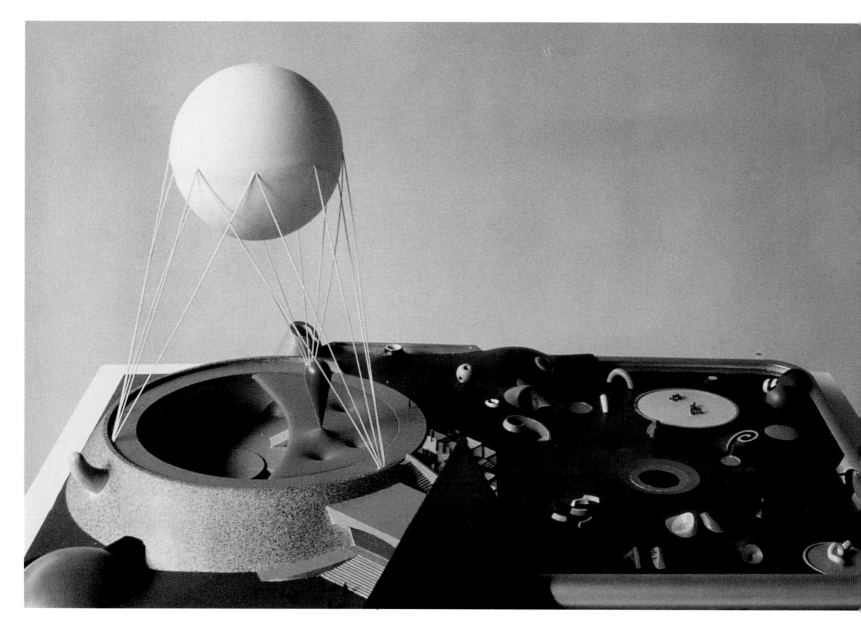

ABSTRACT MOONSCAPE,
U.S. PAVILION FOR EXPO '70,
OSAKA, JAPAN, *1968 (unrealized)*
FIGURE 17
Painted plaster model,
15 by 22 by 33 inches
The artificial moonscape proposed
by Noguchi echoed the contoured
landscape. The circular opening,
the abyss, designated the underground
amphitheater.

FIGURE 18
Detail of painted plaster model
The moonscape was filled with an
explosion of boldly colored play
objects as a metaphor for the universe.

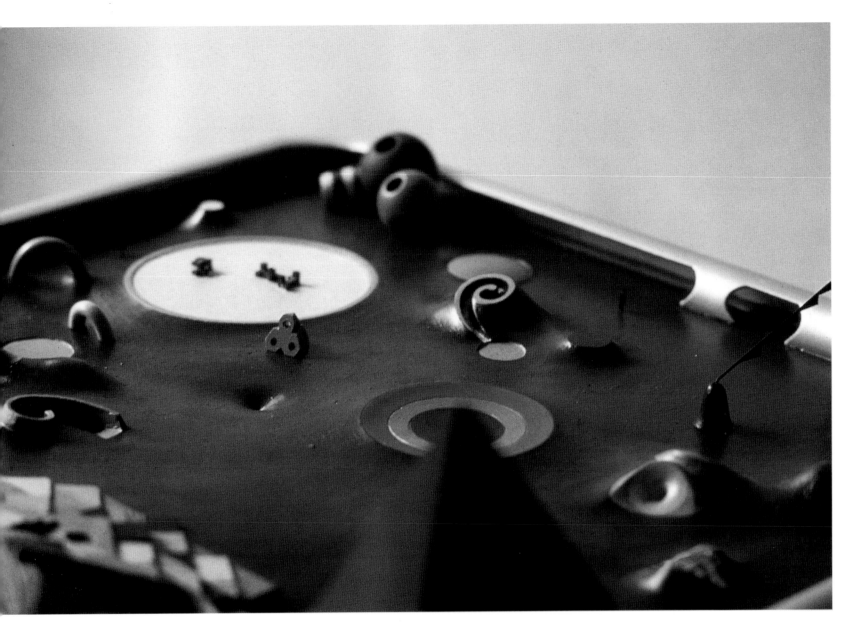

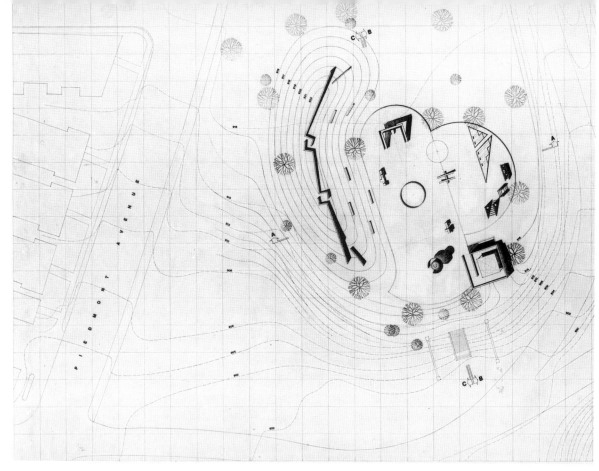

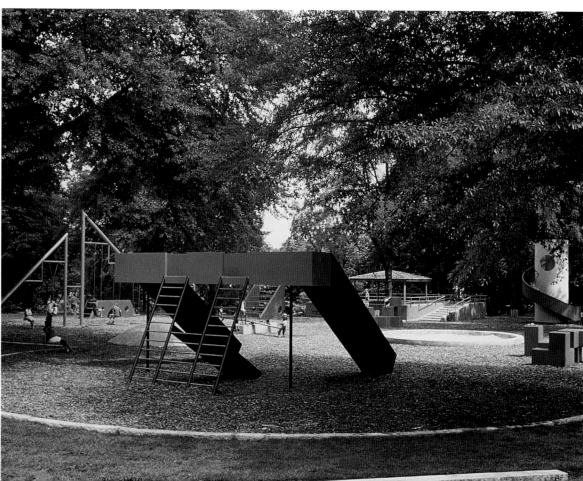

would be sunk and covered over with a contoured landscape filled with play objects (figs. 17 and 18). The intention was to make all components from artificial materials and paint them in primary colors. Many of the objects were derived from Noguchi's playground vocabulary; others, such as *Octetra* (1968), appeared for the first time. *Octetra* later became a play piece for a piazza in Spoleto and was realized as a pyramid of tetrahedrons with circular holes in each side. Children could climb over, under, around, and through the work. Noguchi later proposed a play piece of tetrahedrons for the Moere Numa Park master plan (1988). The entrance to *Abstract Moonscape* was marked by a large tetrahedron that symbolized the future and a space balloon that floated 240 feet above the exhibition building. This project might be understood as evidence of Noguchi's continued intention to bring utilitarian and social aspects into sculpture.

In 1976 Noguchi completed Playscapes in Atlanta's Piedmont Park (figs. 19 and 20). The project was sponsored by the city's High Museum of Art as an American bicentennial project. At last Noguchi had the opportunity to build the playground equipment he had designed earlier, such as the multiple-length swing for the unrealized Ala Moana Park in Hawaii. All of the elements were oversized and painted in bright colors to emphasize their sculptural presence. Noguchi wanted these pieces to be perceived as sculptures (figs. 21–24).

This project marks a turn in the evolution of Noguchi's design concepts for playgrounds. The change in attitude was also reflected in most of his work from this period. The land forms no longer were the basis for his design concepts. Instead, Noguchi used the idea of playground as sculpture, and the playground became the place where sculptures (play equipment) were located (fig. 25). Unfortunately, not everyone shared Noguchi's enthusiasm for or confidence in his designs for playground equipment. After years of use without any reports of accidents, but concerned with issues of insurance, the Parks Department in Atlanta recently proposed altering Noguchi's pieces by removing parts of them. Whether or not the work is inherently dangerous, it may be that the disapproving hand of Robert Moses still overshadows Noguchi's work.

PLAYSCAPES, PIEDMONT PARK, ATLANTA, GEORGIA, *1976*

FIGURE 19

Overall site drawing

Playscapes was the first playground Noguchi saw realized in the United States. It was located in a busy urban area in Atlanta.

FIGURE 20

View

Noguchi situated the play sculptures on a platform and surrounded them with a concrete wall that protected the recreation area from street traffic.

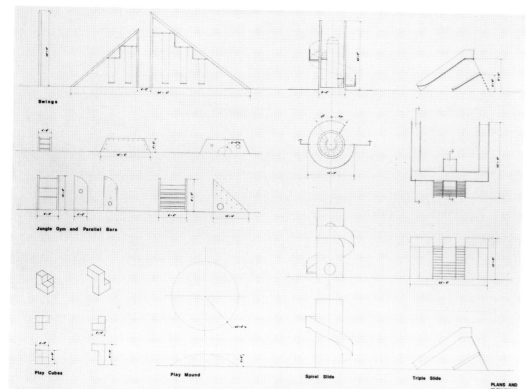

Swings

Jungle Gym and Parallel Bars

Play Cubes Play Mound Spiral Slide Triple Slide

PLANS AND ELEVATIONS

A CHILDREN'S PLAY ENVIRONMENT – PIEDMONT PARK "ART IN THE PARK" PROJECT OF THE CITY OF ATLANTA AND THE HIGH MUSEUM OF ART

ISAMU NOGUCHI – SCULPTOR NOGUCHI FOUNTAIN AND PLAZA INC. – ARCHITECTS

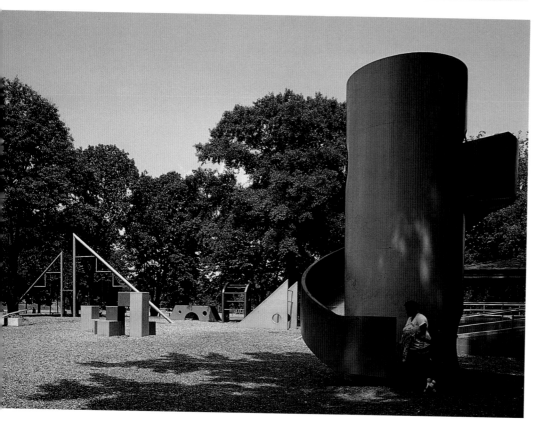

PLAYSCAPES, PIEDMONT PARK

FIGURE 21
Plan and elevation
Playscapes retained the basic language of geometry and color that Noguchi had developed almost thirty years earlier.

FIGURE 22
View
The relationships among the different elements in Playscapes refer to relationships among elements in ancient environments of leisure.

FIGURE 23
View
The multiple-length swing built in Atlanta, with each seat swinging at a different rate, was originally part of Noguchi's unrealized play equipment models for Ala Moana Park in Honolulu.

FIGURE 24
View
The play area that Noguchi designed invited play—climbing, sitting, crawling in and out— with definite but not limited forms.

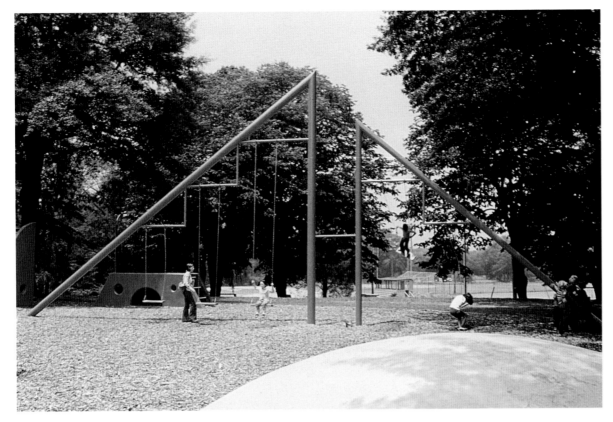

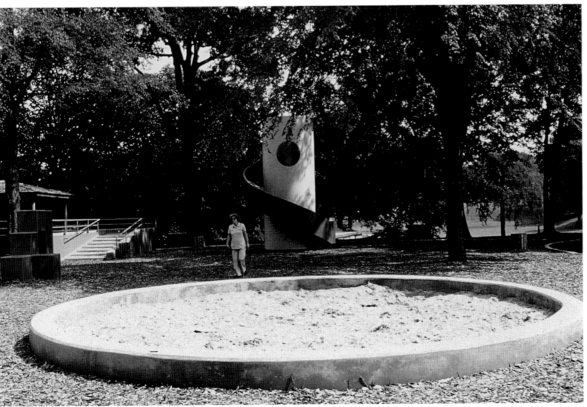

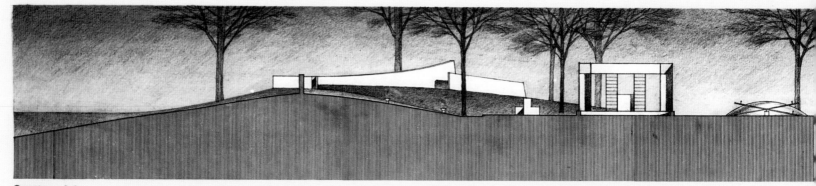

Section A A

42

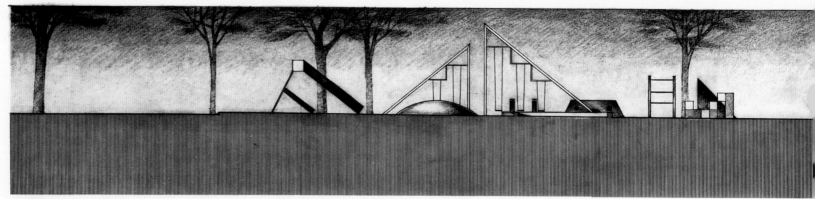

Section B B

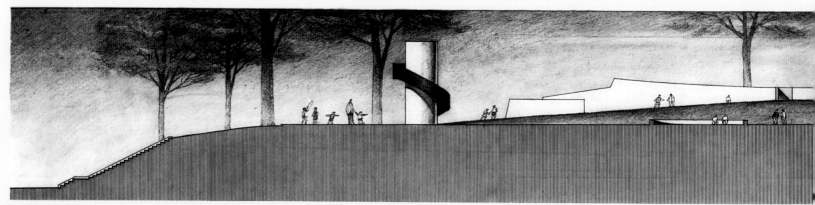

Section C C

FIGURE 25

Section-elevations

The detailed drawings show the evolution of Noguchi's design concepts for playgrounds. In his later projects, the playground became a platform for sculptural play equipment.

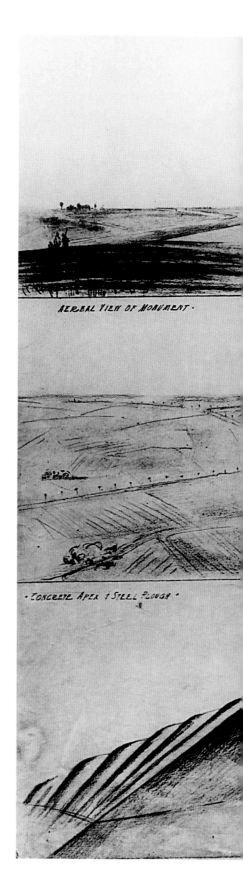

AERIAL VIEW OF MONUMENT.

CONCRETE APEX & STEEL PLOUGH.

WE WERE AT WAR THEN, YOU KNOW. THE EARTH WAS BEING BOMBARDED AND TORN UP BY BOMBING, JUST LIKE VIETNAM. IN THIS PIECE I CONCEIVE OF THE EARTH AS TORTURED BY THESE BOMBARDMENTS . . . IF YOU WANT TO CALL THE EARTH A PLAYGROUND, WELL, WE ARE MAKING A KIND OF PLAYGROUND.[1]

In this commentary on one of his earth sculptures, *This Tortured Earth*, Noguchi expressed his social involvement through art, as well as the relationship he perceived between the earth and his environmental artworks. Noguchi began making proposals for environmental works as early as 1933. These conceptual earth sculptures were inspired by many different sources: prehistoric sites such as the Great Serpent Mound in Ohio, traditional Japanese gardens, Eastern and Western mythology, the social conditions of his time, and most important, his vision of the future and his pursuit of timeless forms. Such inspirations can be found throughout his work, but they are most evident in his environmental pieces.

Noguchi conceived his earth sculptures as hybrid topographies combining geometric and natural forms. Through the manipulation of the land's surface and the use of a distinctive volumetric vocabulary he created a succession of spatial relationships. This particular line of thought and practice distinguished Noguchi as a pioneer in "land art" (even though Noguchi himself would not have used this label). In the 1960s and 1970s, as more artists turned their attention to the environment and natural systems, artists and curators sought to categorize this practice as

MONUMENT TO THE PLOW, *1933*
FIGURE 26
Drawing
The earthen pyramid is an homage to the human efforts that opened new horizons. The monumentality of the triangular pyramid recalls the iconography of Egyptian tombs, symbols of massive human endeavors.

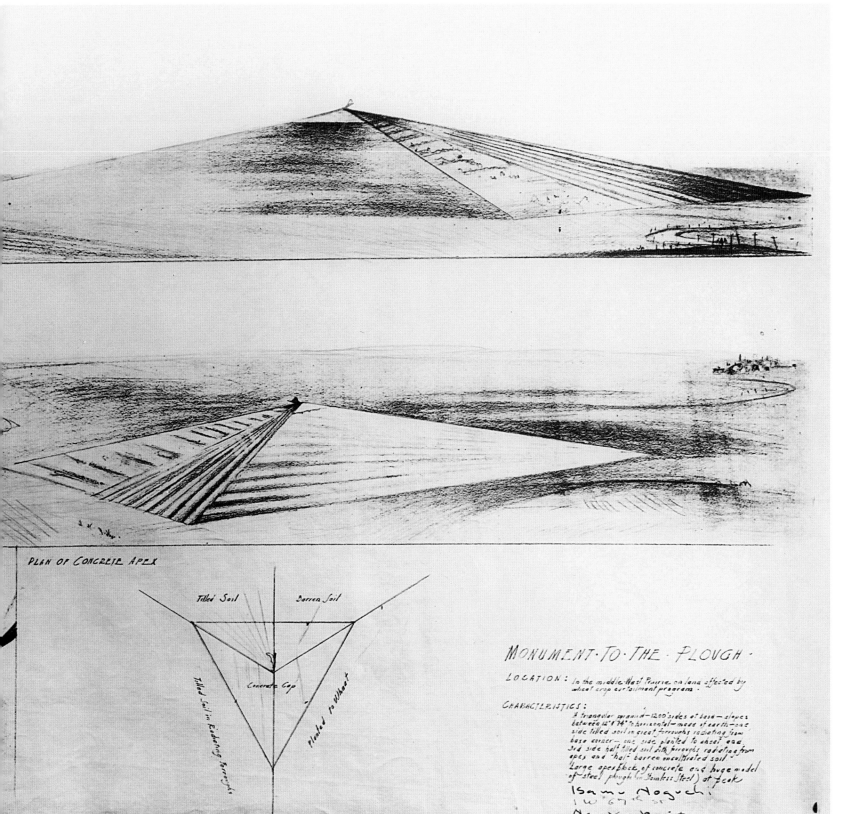

PLAN OF CONCRETE APEX

Tilled Soil Barren Soil

Tilled Soil in Radiating Furrows

Concrete Cap

Planted to Wheat

MONUMENT·TO·THE·PLOUGH·

LOCATION: In the middle West Prairie on land affected by wheat crop curtailment program.

CHARACTERISTICS:

A triangular pyramid—1200' sides of base—slopes between 12° & 74° to horizontal—made of earth—one side tilled soil in great furrows radiating from base corner—one side planted to wheat and 3rd side half tilled soil with furrows radiating from apex and 'half barren uncultivated soil'. Large open block of concrete and huge model of steel plough (in stainless steel) at peak.

Isamu Noguchi
I W 67th St
New York city

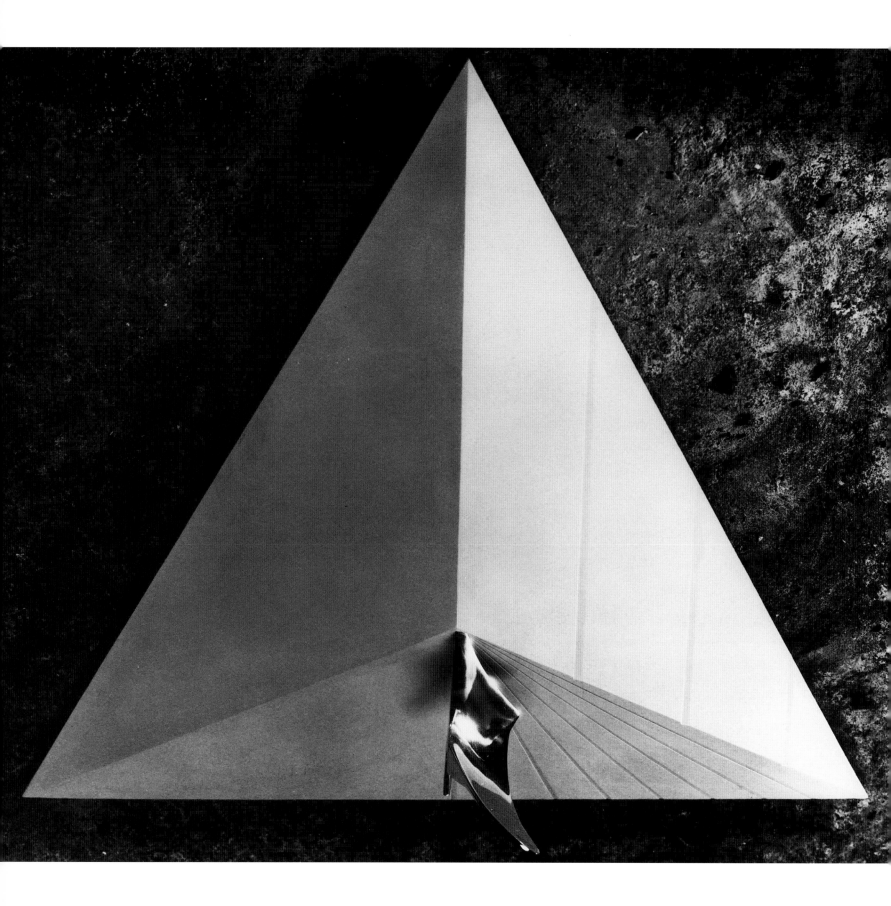

environmental art, ecology art, or land art. In discussing Noguchi's earth sculpture proposals the term "earthworks," borrowed from the artist Robert Smithson, is most appropriate.[2]

In 1933 Noguchi proposed one of his major utopian earthworks, *Monument to the Plow* (figs. 26 and 27). The project was designed for "the Middle West Prairie," in particular the geographical center of the United States. It was a triangular pyramid measuring 1,200 feet along each side and between twelve and seventy-four feet in height, and it was made of earth—one side was tilled in furrows radiating from a corner of the base, the second was planted with wheat, and the third was half tilled and half uncultivated. A huge concrete block and a large stainless-steel plow crowned the top of the pyramid.[3] While *Monument to the Plow* was reminiscent of Native American burial mounds, the work symbolized the changing seasons and commemorated agrarian time. For Noguchi, this monument was an homage to Dr. Edward Rumely, who had shown him how correspondence between Benjamin Franklin and Thomas Jefferson made possible the opening up of the western plains.[4] He submitted this proposal and his *Bolt of Lightning . . . Memorial to Ben Franklin* to the Civil Works Administration's Public Works of Art Project, but neither was accepted. Apparently Noguchi's avant-garde approach did not sit well with the program's administrators. This short-lived federal initiative (a precursor to the better-known Works Progress Administration's Fine Arts Project) paid artists a daily wage to create works of art, and Noguchi's participation in the program depended on his adopting a more conventional approach to public sculpture. Noguchi consequently dropped out of the program.

Unlike *Monument to the Plow*, *This Tortured Earth*, proposed in 1943, was not site-specific (fig. 28). Until that time, Noguchi's innovative idea of sculpting the earth had been used as a metaphor for creating playgrounds. In this case it expressed the horror of war and the self-destructive character of human beings. The swelling forms and mounded orifices represented war's ravaging effects on the earth.

Noguchi's largest earthwork was a memorial, *Sculpture to Be Seen from Mars* (1947), originally titled *Memorial to Man* (fig. 29). In it he

MONUMENT TO THE PLOW
FIGURE 27
Plaster and metal model
From the mid-1930s on Noguchi used tetrahedrons and mounds to shape the earth; Buckminster Fuller maintained that the four-sided pyramid is a basic unit of matter. Noguchi's tetrahedrons, like *Monument to the Plow*, reflect the concept of maximum stability with minimum form.

anticipated humankind's inevitable self-destruction. Humanity is commemorated as a victim of devastating force through the representation of a human face made of huge conical and ovoid mounds and a one-mile-long tetrahedral nose.[5] Noguchi envisioned this earthwork situated "in some desert, some unwanted area."[6] In contrast to Play Mountain and other early designs, the earthworks were intended to be contemplated from a distance; to be viewed, not occupied. This introduction of a Japanese way of contemplation into a Western environment was to be an important characteristic of many of Noguchi's later designs for plazas and gardens, including those for the Chase Manhattan Bank and the Beinecke Library.

Noguchi's earthworks, though never realized, always alluded to great prehistoric artworks. He was more interested in the social connotations that these works implied than in their aesthetic innovation. In them, he resurrected a tradition of redesigning the earth's surface—a tradition that was intrinsic to the survival of the earliest civilizations. Using the basic materials—earth and stone—he created "tells," earthen ramps, mountain cavities, and monuments that reflected a cosmological view of human civilization.

THIS TORTURED EARTH, *1943*
FIGURE 28
Bronze model, 4 by 28 by 28 inches
A symbol of war's effect on the
earth, *This Tortured Earth* may be
considered a playground for the
dead, not one of joy and discovery.

MEMORIAL TO MAN,
later called SCULPTURE TO
BE SEEN FROM MARS, *1947*
FIGURE 29
*Sand model (destroyed),
12 by 12 inches*
Noguchi understood sculpture as
a reminder of "the memories
of expressive humanity," in this
case the reminder of humankind's
self-destructive nature.

PARK AND RECREATION AREAS
FOR COLORADO RELOCATION
CENTER, POSTON, ARIZONA,
1942 (unrealized)
FIGURE 30
Plan, 1942
Noguchi's approach to creating a
livable urban structure here brought
him closer to the architectural
history of urban planning—from the
earliest Roman civic plans to
Le Corbusier's concepts for ideal
cities—and increased the scope of his
work to include more than sculpture.

Chapter 3

GARDENS, PLAZAS, AND PARKS

WITH A FLASH I REALIZED I WAS NO LONGER A SCULPTOR ALONE. I WAS NOT JUST AMERICAN BUT NISEI. A JAPANESE AMERICAN . . . I FELT I MUST DO SOMETHING.[1]

Noguchi was visiting California at the outbreak of World War II. His experience during the war changed his life forever. Soon after the United States joined the war, more than 112,000 Japanese and Japanese-Americans on the West Coast were transferred to ten relocation centers, pursuant to Executive Order 9066. The fate that faced many people of Japanese ancestry made Noguchi acutely aware of his mixed heritage.

As a New Yorker, Noguchi was able to escape the indignity of relocation. He did, however, feel the need to do something for his fellow Nisei. He organized a group called Nisei Writers and Artists for Democracy in an attempt to counteract the public hysteria, but its efforts failed. Noguchi traveled from California to Washington, D.C., with the intention of finding a way to aid incarcerated Japanese-Americans. In Washington, he met John Collier, the Commissioner for the Bureau of Indian Affairs. Collier would soon have jurisdiction over the relocation center in Poston, Arizona, situated on Indian territory. In May 1942, at Collier's suggestion, Noguchi volunteered to move to the Colorado Relocation Center and help in the planning of parks and recreational areas—meaning that he voluntarily accepted the

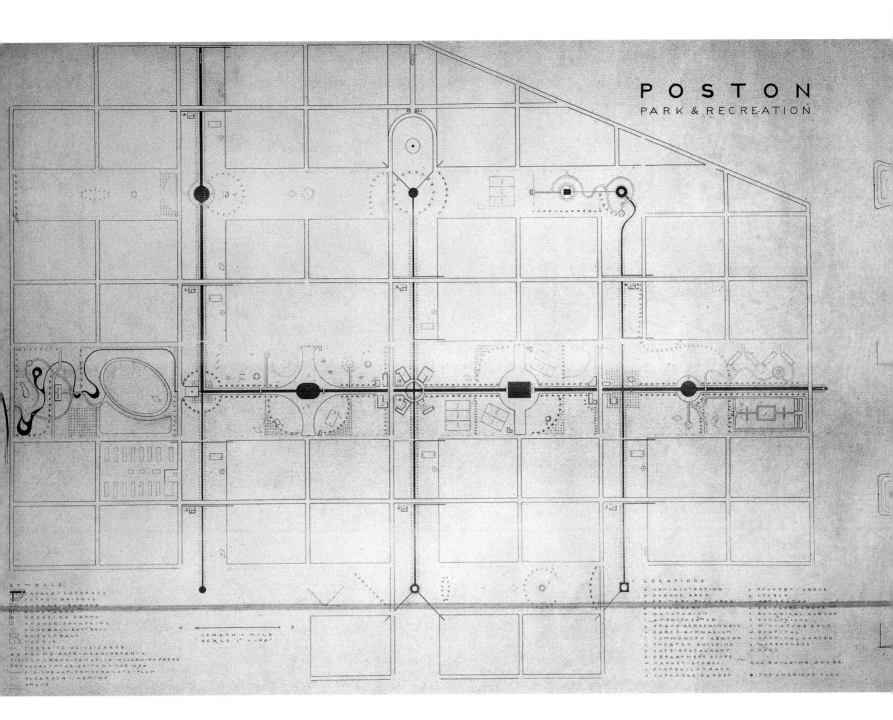

POSTON
PARK & RECREATION

N ← LENGTH 1 MILE
SCALE 1" = 100'
→ S

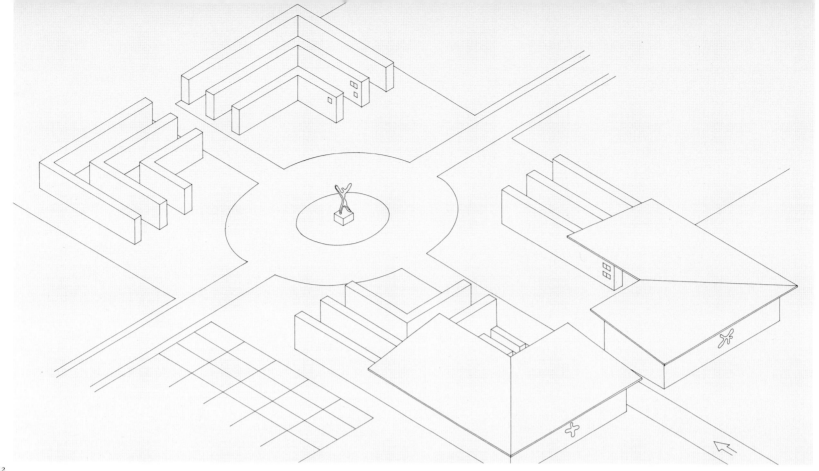

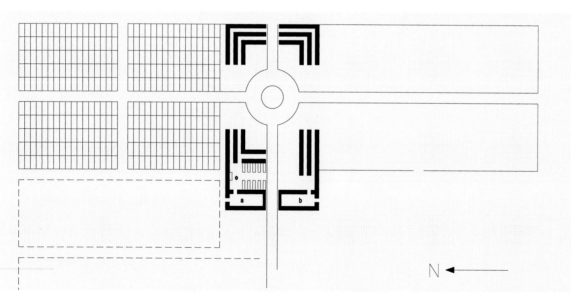

PARK AND RECREATION
AREAS FOR COLORADO
RELOCATION CENTER

FIGURE 31

Axonometric

The orthogonal character of the
cemetery building contrasts with the
rich architectonic spaces evident
in Noguchi's more mature projects.

FIGURE 32

Plan

Noguchi developed a plan that
addressed the primary concepts and
large-scale organization of the camp,
but he also determined how small
elements, such as the cemetery, should
function within the larger plan.

N ←

detainment that was the result of obvious governmental prejudice.

During the next six months, Noguchi planned an organizational model for all relocation centers and designed playgrounds, swimming pools, and a cemetery. The designs he proposed for recreational areas and the cemetery were based on his appropriation of the classical Roman grid [2] in which the central east-west street, the *decumanus*, meets the north-south street, the *cardo*. In the Roman tradition the axes intersect at the forum. In Noguchi's design the *decumanus* was positioned where the main activities would take place—a central spine articulated by a series of small plazas (fig. 30).

The cemetery retained the symmetrical, orthogonal structure of a Roman grid (figs. 31 and 32). At its center Noguchi designed a plaza with a freestanding sculpture. Around the plaza he placed a columbarium (a vault with niches for the dead) forming a series of walls. The graves were laid out in rectangular grids on both sides of the center.

In his early projects Noguchi presents himself as more than a sculptor. He is an artist in the most humanistic sense. In the Poston project he is also an urban planner and architect. Here all the disciplines that have been separated since the Renaissance are brought together.

Noguchi's use of classical geometry and his reintegration of the arts are parallel to Giuseppe Terragni's Danteum,[3] which, in addition to its allusion to Dante Alighieri's *Divine Comedy*, incorporates classical geome-

try and mathematical structure based on the equilibrium of numerical rhythms and harmonic relationships. As Terragni wrote in 1931, "from literature to architecture, from cross-vault to dome, geometry and mathematics have offered architecture the means to build temples, basilicas, bridges, aqueducts and cathedrals from the tracings of a plan. But no geometric formula, no law of physics, could have determined the harmony of the masses or the play of the volumes in the light."[4] Similarly, Noguchi, in his Poston projects, combined sculpture, architecture, and art.

The Poston relocation center was in the desert, an environment that Noguchi found magnificent—the desert heat, the cool nights, the moment before dawn. The absolute solitude honed his senses. Still, nature's awesome power was not enough to banish the negative feelings generated by the incarceration experience that Noguchi shared with other Japanese-Americans.

Because none of the designs were realized, Noguchi felt his presence in Poston was pointless and he decided to leave. Adding insult to injury, it took several months to gain release from the Poston center. This episode left Noguchi disillusioned and with a deep mistrust of the United States government: "Freedom earned has a quality of assurance. The deep depression that comes with living under a cloud of suspicion, which we as Nisei experience, lifted, and was followed by tranquillity. I was free finally of causes and disillusioned with mutuality. I resolved henceforth to be an artist only."[5]

IS THE SOLUTION OF COLLABORATIVE PROBLEMS BENEATH THE DIGNITY OF AN ARTIST?
I HAVE TREATED IT AS A TEST OF MY COMPETENCE TO BE ABLE TO CONTRIBUTE SOMETHING
IN SPITE OF SO-CALLED COLLABORATION, WHICH IS SO ONE-SIDED. IT IS SAID THAT
TRUE COLLABORATION CAN ONLY OCCUR WHEN THE SCULPTOR AND THE ARCHITECT ARE
THE SAME PERSON, BUT THERE MUST BE EXCEPTIONS.[6]

Convinced that sculpture was a creation of space and a counterpoint to
architecture, Noguchi sought commissions and collaborations that
might integrate sculpture with architecture. This was his effort to break
away from the normal situation in which sculpture was an afterthought,
added to a building. As Noguchi stated in 1948 in an article in
Architectural Forum: "At some point architecture becomes sculpture, and
sculpture becomes architecture; at some point they meet. We have to
discover what that point is. For instance a wall is an element of architec-
ture. The dimension of that wall is also an element of sculpture."[7] He
became aware of his need to collaborate with architects in order to assist
his pursuits in sculpture.

In 1945, driven by his own interest in the concept of collaboration
between architect and artist, Noguchi teamed up with the architect
Edward Durell Stone to create a proposal for the Jefferson Memorial
Park competition in Saint Louis, Missouri.[8] Inspired by prehistoric
Native American mounds, Noguchi envisioned this design as an abstrac-
tion of the Great Serpent Mound in Ohio (fig. 33). As earth sculptures,
such Indian mounds continued to be the main reference in his environ-
mental designs, just as they were in his early playground designs. As the
art critic Dore Ashton observed in a review of Noguchi's marble sculp-

JEFFERSON MEMORIAL
PARK, SAINT LOUIS, MISSOURI,
1945 (unrealized)
Architect: Edward Durell Stone
FIGURE 33
*Great Serpent Mound near
Marietta, Ohio*
The prehistoric Great Serpent Mound
and the astronomical instruments
built by the Maharajah Sawai Jai Singh II
in Jaipur, India, were Noguchi's
great points of reference for introducing
history and ritual into modern society.

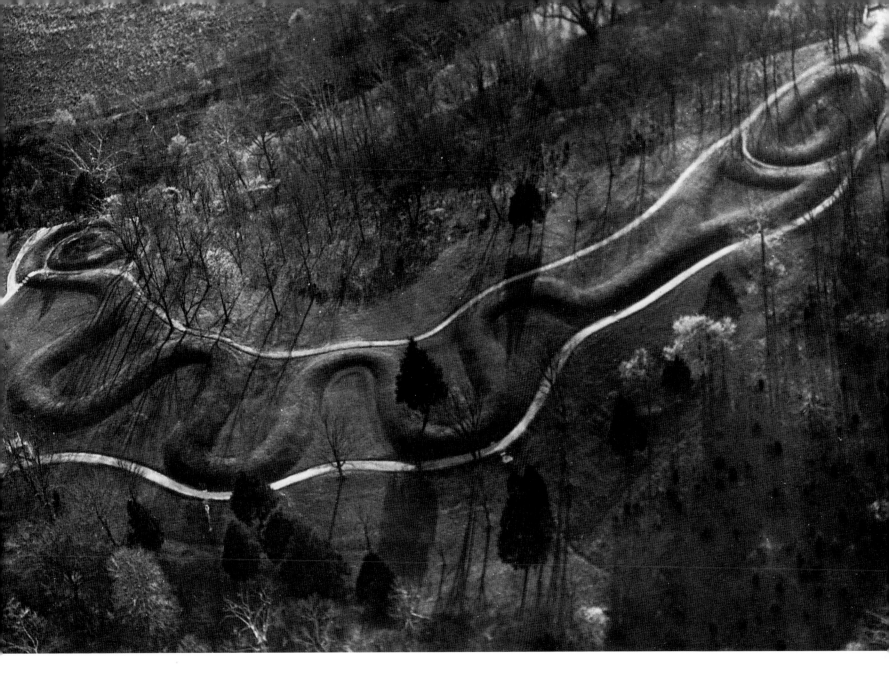

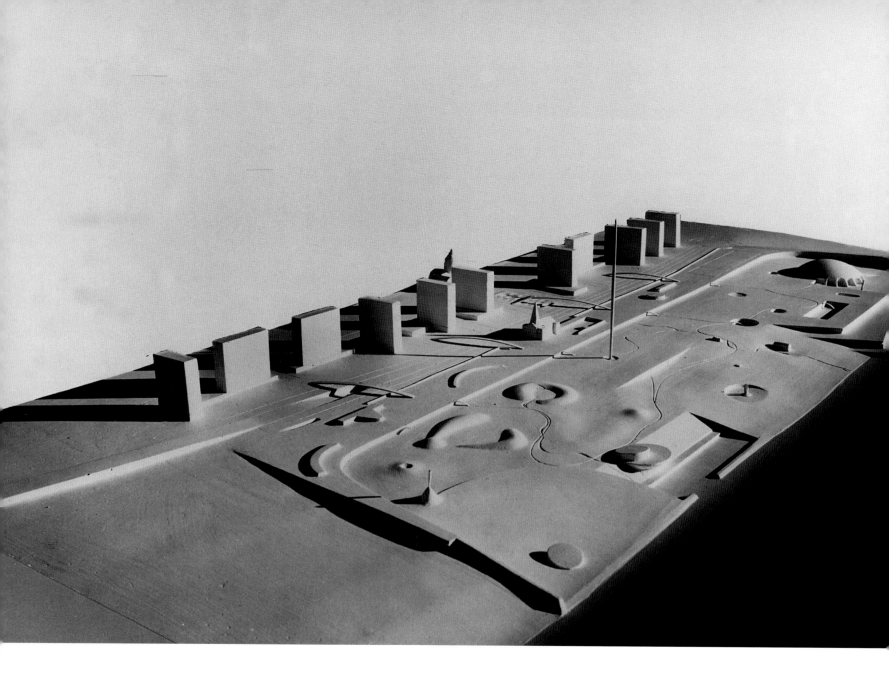

tures, his projects often reflect the strong influence of particular sites such as the Great Serpent Mound, the Zen meditation gardens in Japan, and the Samrat Yantra Observatory created by Maharajah Sawai Jai Singh II in Jaipur, India, around 1734.[9]

The proposed memorial's design reflected a notion of architecture that, like the ancient mound, led to a monumental form created for ceremonial events and rituals[10] (fig. 34). The architecture was not necessarily intended to enclose rooms; rather, it was conceived as a way to delineate a space of solid masses, or to inscribe the space with a system of lines and shapes. Noguchi's invisible architecture enhanced the park, and his reference to architecture was through his experience with the mounds. The traditional architecture, as a container of spaces, was located below the earth's surface. The park's design, like that of Noguchi's gardens and plazas, echoed the modern biomorphic and surreal visual vocabularies with which he was very familiar.

The competition for Jefferson Memorial Park, in combination with the earthworks and the playgrounds, provided the earliest experiments for later realized and unrealized projects such as the Billy Rose Sculpture Garden in Jerusalem (1960–65), Riverside Drive Playground in New York (1961–66), and the Sacred Rocks of Kukaniloko in Hawaii (1977).

This particular project represented the artist's conviction that each culture, as a product of both conscious and unconscious acts, produces certain forms and images that are unique to its place and that have contextual meaning. Through Noguchi's intervention, the work gives voice to a site. The manner in which the artist treated place brings to mind the Inca city name Cuzco—which, for some, signifies an occupation of space (place) in a magical way. Such meanings seem particularly appropriate to Noguchi's work.[11]

JEFFERSON MEMORIAL PARK

FIGURE 34

Plaster model, 1945
This project, like the Contoured Playground, is a prelude to Noguchi's large earthwork projects, such as the Billy Rose Sculpture Garden of 1960–65, in which the character of the place is incorporated into the design.

> BECAUSE OF MY ATTACHMENT TO THE ORIENT AND TO WHAT GANDHI'S WORK STOOD FOR, HIS
> DEATH TOUCHED ME DEEPLY. AS A TRIBUTE I HAD MADE A SMALL MODEL OF THE OUTSTRETCHED
> HAND OF HUMANITY. I THOUGHT IT MIGHT BE BUILT AS A MEMORIAL AND SO SENT IT TO NEHRU.[12]

FIGURE 35
Bronze model of Outstretched Hand
(proposed height 50 feet)
The memorial's Giacometti-like gesture
raises an interesting question about
Noguchi's intentions in this direct
aesthetic reference—whether it is an
homage to the particular artist or a
more complex play with identity, both
as an artist and as an individual.

These words exemplify Noguchi's attitude toward both work and life. With a rich imagination, strong impulses, and the compulsion to address a specific issue or event, Noguchi did not wait for a client's commission—he simply initiated the project himself. He created a need for the existence of his design. In a sense, he carried the studio mentality into his environmental work whereby he conceived a structure and then sought a buyer. This was a tricky proposition, however, when the prospective client was the Indian government.

The memorial sculpture proposed by Noguchi for Gandhi's burial site is not only connected with Alberto Giacometti's sculptural vocabulary but also, as author Albert E. Elsen has commented, refers to modern sculpture and the use of partial figures as a part of Western tradition.[13] Consistently, as he first expressed in his Guggenheim Fellowship proposal, Noguchi revealed his desire to bridge the East and the West.

Noguchi's completed sculpture, called *The Outstretched Hand*, is a thin, fifty-foot-high arm with an outstretched hand representing humanity (fig. 35). Noguchi was not interested in sculpture as a medium for the idealized human figure. As he stated in 1927, "It is my desire to view nature through nature's eyes, and to ignore man as an object for special veneration."[14] Unlike Noguchi's other memorials, this one focused on the gesture of a single body part, the disembodied hand. The isolated representation of the human figure may have been a symbolic expression of Noguchi's appreciation for Gandhi and his deep devotion to humanity.

After Noguchi had sent the memorial to Prime Minister Jawaharlal Nehru, he traveled to India in 1948 and made Nehru's portrait. Noguchi was known for his sculptural portraits, which were, for a period of time, a way for him to make a living. On that visit, Nehru asked Noguchi to improve the design for Gandhi's burial place at Raj-gat.

Noguchi presented two ideas. The first was to remodel the park to be like Stonehenge—an idea immediately dismissed by Krishna Menon, an official and close friend of Nehru. The second concept, which was

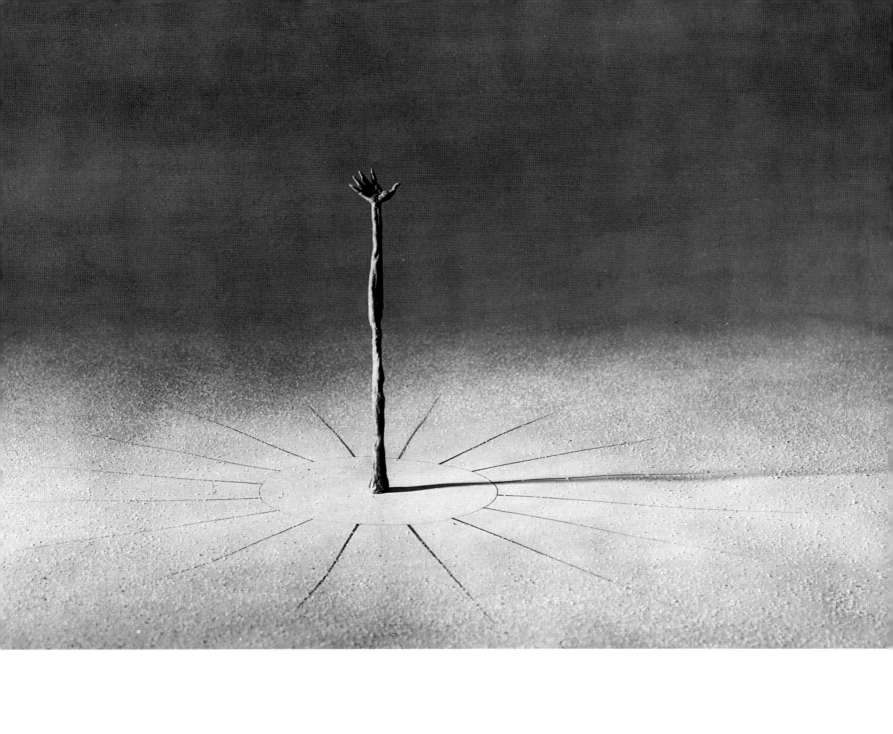

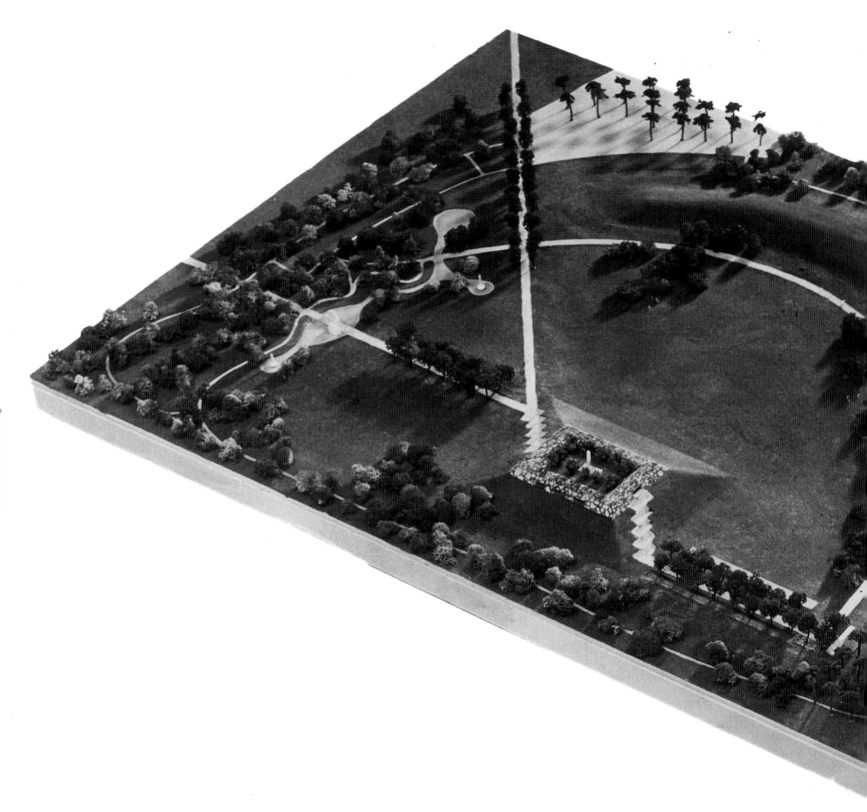

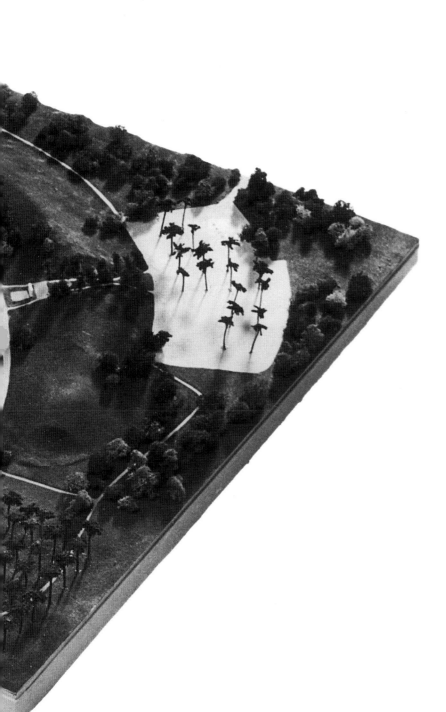

MEMORIAL AND PARK FOR
GANDHI'S BURIAL PLACE
FIGURE 36
Model of park
The use of tumulus, a symbol from the
pre-Columbian world, brought foreign
myth and ritual to Gandhi's burial
place and also united East and West.
With this gesture, Noguchi emphasized
Gandhi's humanitarian character.

approved, was a semicircular plan articulated by a series of paths and
ponds, with an earthwork at its center—a grass-covered, truncated pyra-
mid (fig. 36). In collaboration with the architect Albert Mayer of New
York, Noguchi developed a model in which *Outstretched Hand* was situat-
ed at the pyramid's top.

The pyramid reappeared as a central motif from earlier works such
as *Monument to the Plow* and Play Mountain. For Noguchi the pyramid
represented the myth of the mountain. It is the most evocative of the
three-dimensional symbols because it represents the world axis, the apex
symbolizing the highest point of spiritual attainment. In Egypt pyramids
were funeral monuments, but in America they are often associated with
cosmological symbolism, especially in relation to the sun and the moon.
Similarly, the symbolism of the pyramid in Noguchi's work was varied.
The pyramid was used as part of the artist's basic vocabulary of forms, all
of which were related to returning myth and ritual to modern life.

Noguchi was feeling restless, depressed, and uncertain about the future. In 1948 he applied to the Bollingen Foundation for a travel fellowship to prepare material for a book titled *The Environment of Leisure*.[16] The fellowship was granted and gave him the opportunity to travel to England, France, Spain, Greece, Egypt, Bali, and Japan in the spring of 1950.

The Japan of 1950 was very different from the Japan Noguchi had visited twenty years earlier. He found the country less cold and more open. This was a time of reconciliation for the country: "My own explanation of this is that the war had leveled the barriers and hope was now everybody's property. The disillusionment in war and the loss of one's own particular rights brings with it a recognition of the humanity of all, including Americans."[17]

In Tokyo, Noguchi felt welcomed and needed. Perhaps overwhelmed by the attention paid by Japanese artists seeking his participation and comments, he escaped to Kyoto to continue his studies of Zen gardens, part of his research for the Bollingen Foundation (fig. 37). He returned to New York after four months but it seemed "unreal." Blown by the winds of imagination from the East and perhaps even yearning for his Japanese roots, Noguchi wanted to return to Japan. It was, however, necessary for him to find an excuse to return. Eventually, he pursued the suggestion of building a garden for the Reader's Digest Building in Tokyo (located across from the Imperial Palace) with the architect Antonin Raymond (fig. 38).

The Reader's Digest Garden presented Noguchi with the opportunity to further develop his concept of sculpture as an integrated spatial realm. Disillusioned with the human race after World War II and by the death of his friend Arshile Gorky, Noguchi saw the garden as a place for re-creating ancestral rituals, a place of symbols and mythology.

GARDEN FOR READER'S DIGEST BUILDING, TOKYO, JAPAN, *1951*
Architect: Antonin Raymond
FIGURE 37
Japanese courtyard garden in Kyoto, Japan, c. 1950
Noguchi learned from his study of traditional Japanese gardens how to create illusion and changes in scale, how to manipulate space, and how to use stones as the "bones" of the garden.

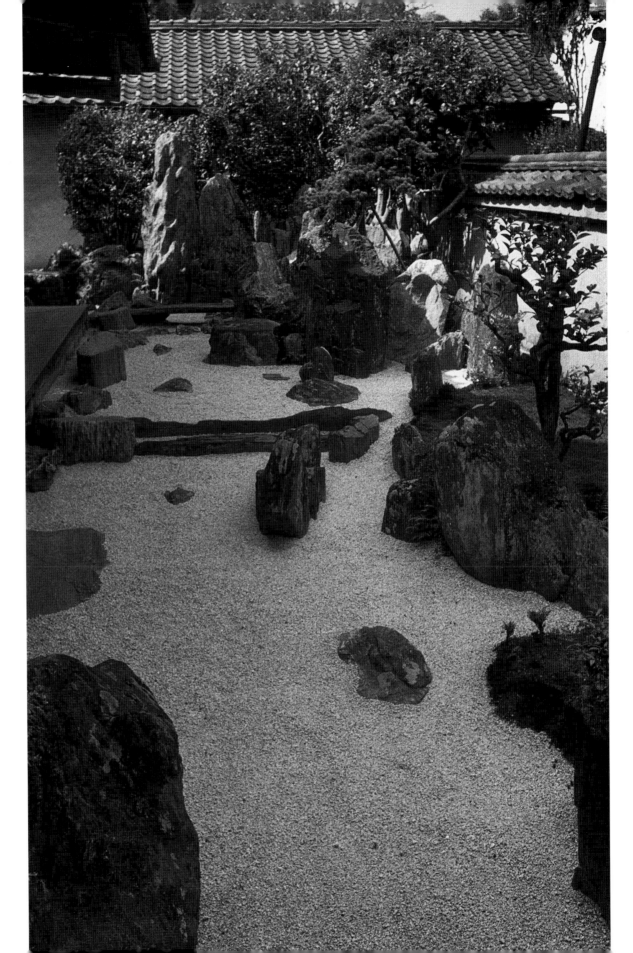

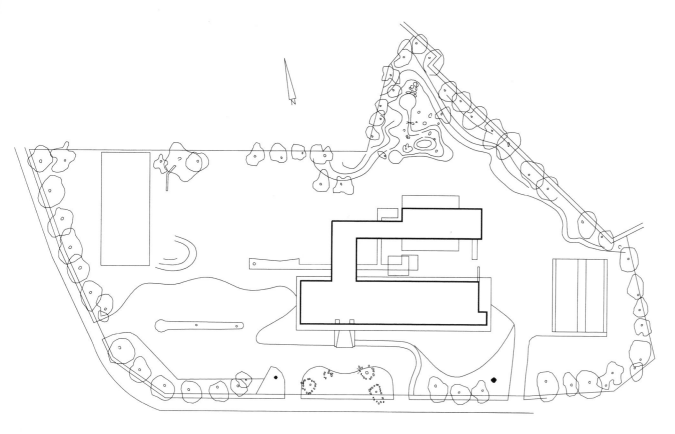

GARDEN FOR READER'S DIGEST BUILDING

FIGURE 38

Site plan

The Reader's Digest Building was located across from the Japanese Imperial Palace. Noguchi limited the garden design to minimal mounds of grass and piled stones to evoke a spiritual quality.

FIGURE 39

Model

Noguchi's first chance to work with Japanese gardeners provided him with the opportunity to realize particular ideas about space and scale.

FIGURE 40

View of garden

Noguchi understood gardens as spatial environments. He worked with the site and sculptural elements as if they were parts of a single sculpted space that ultimately became the garden.

FIGURE 41

Water feature

In his first garden, Noguchi used water to represent the river of life; it seems to appear and disappear in the building. Water became one of the elements the artist would use in almost all of his environmental proposals, introducing into each project different interpretations of water's symbolic meaning.

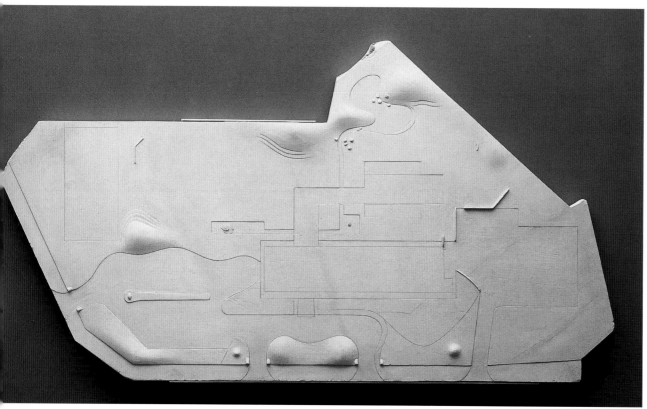

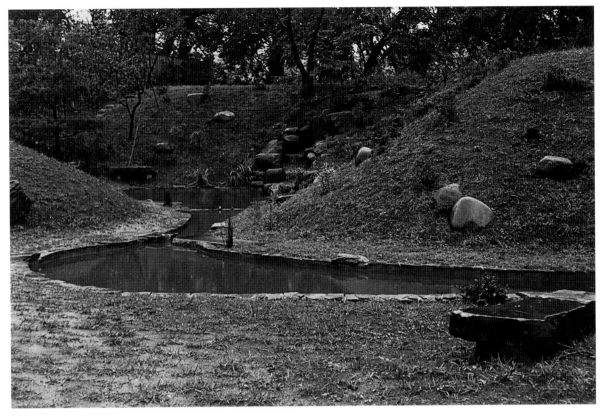

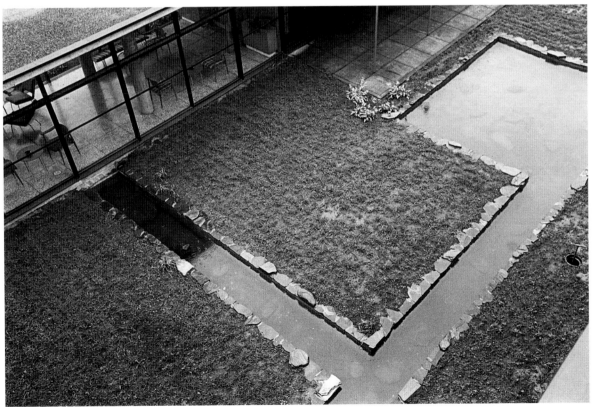

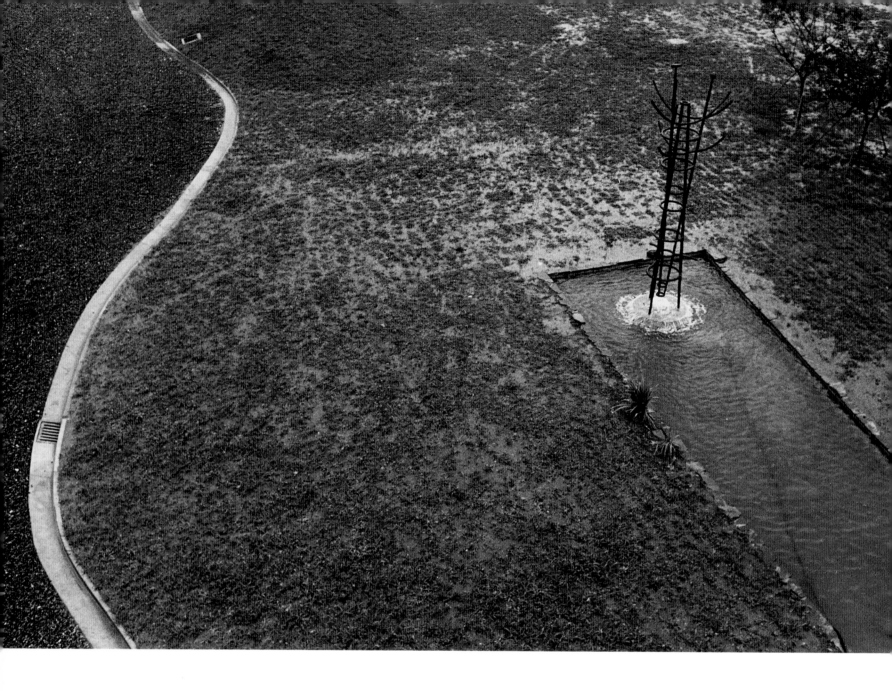

FIGURE 42

Iron fountain, 186 by 58 inches
A tall, welded-iron sculpture/fountain is
located at one end of a rectangular
pool. The West is introduced through
Noguchi's abstraction of forms,
similar to those in the iron sculptures
of Julio Gonzalez or Pablo Picasso,
which derive their formal vocabulary
from surrealism and constructivism
and from organic and fluid shapes.

The project enabled Noguchi to work with Japan's most skilled gar-
deners (*uekiya*) and to learn from them more about the meaning of
Japanese gardens (figs. 39 and 40). As an adult Noguchi understood the
significance of place, the role of myth. He was also reminded of some-
thing he had long since forgotten, that the stones had their own lives. As
a child, "I had built a garden, to which I was devoted . . . The overflow
from the pump I had formed into a brook . . . I stole a rock from a
neighbor's wood to place there. Each time Haruhiko San came to call, I
expected him to recognize his rock."[18] Noguchi would put this knowl-
edge to use in later projects like the UNESCO gardens (1956–58) and
the Chase Manhattan Bank plaza (1961–64).

Noguchi incorporated his vocabulary of earth mounds and main-
tained simplicity in his design through the use of organic and minimal
forms drawn from modernist art (fig. 41). A large iron fountain was
made for the garden (fig. 42), as was a sculpture group that represented
the artist's interpretation of traditional Japanese dolls called *kokeshi*.
Kokeshi are used as toys, or as ornaments, and each is individual and
unique. The welded iron fountain, reminiscent of Picasso's iron sculp-
tures, was installed at the end of a pool. The sculptures were not part of
Noguchi's original commission and the client declined to pay for them,
but Noguchi installed them anyway. The sculptures were later moved
to the Kamakura Museum of Modern Art, where they remain on view.

Noguchi's environmental work was recognized by Aline B. Louchheim,
who wrote about the artist's sculpture gardens in a September 1951
article for the *New York Times:* "But now they were ordered into an entity
which, like modern architecture and like Noguchi's sculpture, has no
single, static axis-oriented point of view, but is composed in a *succession
of changing spatial relations.*"[19]

DURING A BREAK IN THIS ACTIVITY I FOUND TIME TO TAKE A TRIP TO HIROSHIMA, TO WHICH I WAS DRAWN, AS MANY AMERICANS ARE, BY A SENSE OF GUILT. I WISHED SOMEHOW TO ADD MY OWN GESTURE OF EXPIATION.[20]

The years 1950 to 1952 constituted a successful period for Noguchi that included three important projects in Japan—the garden for the Reader's Digest Building, the railings for two bridges in Hiroshima, and a memorial to his father at Keiō University. During a visit to Hiroshima Noguchi met the architect Kenzo Tange. Tange had won a competition for the design of Hiroshima's Peace Park, located on an island in the Ota River. In 1951 Noguchi was invited by Mayor Shinzo Hanai to design the railings for two bridges at the park's entrance. An inveterate world traveler, Noguchi ended up designing this commission in Hollywood, California, on a dresser that was part of a stage set where his girlfriend (and future wife), Yoshiko Yamaguchi (known in the United States as Shirley Yamaguchi), was making a film.

Noguchi interpreted the bridges at the park's entrance as processional pathways that prepared the visitor in both mind and spirit. He wanted each bridge to have its own identity, like the stones in Japanese gardens. Noguchi created a metaphor through his railing designs: *ikuru*, symbol of life, faces the rising sun (figs. 43 and 45); and *shinu*, symbol of death, faces the setting sun (figs. 44 and 46). Designed in concrete, the bridge railings were intended to evoke the character of Egyptian funerary boats. At one point, Noguchi renamed the peace bridges. *Ikuru* became *tsukuru* ("to build") and *shinu* became *yuku* ("to depart").

Today, these bridges, like Peace Park itself, do not carry the same symbolic meaning for the younger Japanese generations who feel distant from the desire for reconciliation that inspired the memorials to the atomic bomb dropped on Hiroshima during World War II. Noguchi tried to bring symbols of the past into the present and the future, in order to keep them alive in human memory.

IKURU AND SHINU, BRIDGE RAILINGS FOR PEACE PARK, HIROSHIMA, JAPAN, *1951–52*
Architect: Kenzo Tange

FIGURE 43

Plan and elevations of tsukuru (ikuru) *railing, 1951*
The Peace Park railings incorporated the same symbols that sixth-dynasty Egyptians used for funerary boats. Two different models of funerary boats were always included with the burial goods.

FIGURE 44

Plan and elevations of yuku (shinu) *railing, 1951*
Like Egyptian funerary boats correctly oriented in relation to the burials, each of Noguchi's railings had a specific name and function: one rigged with a sail for voyaging upstream, another with its sails stowed for rowing downstream.

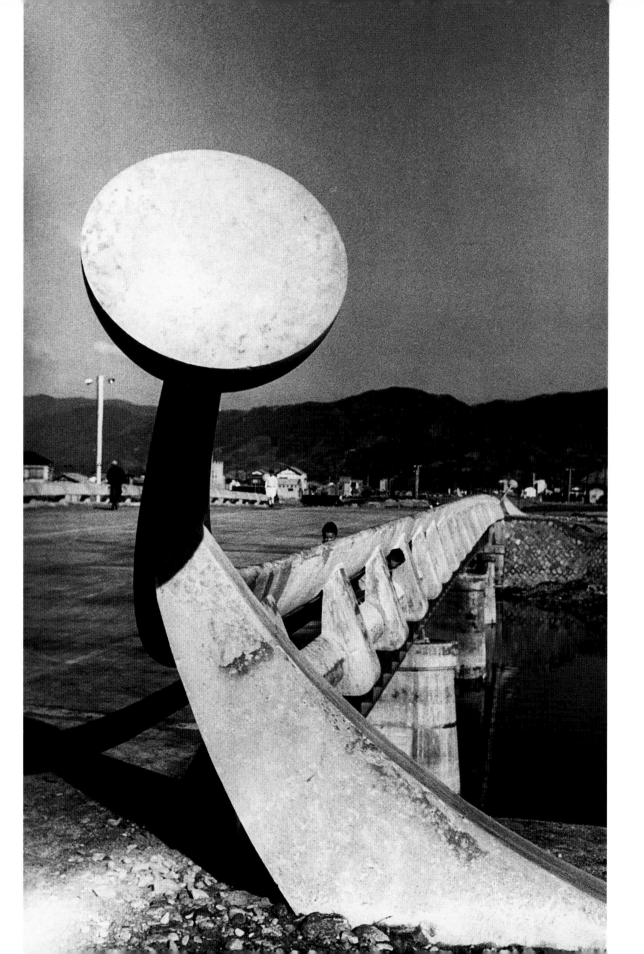

IKURU AND SHINU, BRIDGE
RAILINGS FOR PEACE PARK

FIGURE 45

Tsukuru *railing*

Tsukuru is oriented toward the sunrise
and represents life. Noguchi reinter-
preted the celestial pharaoh's boat,
whose sole purpose was to provide the
deceased with a means of transport
in the afterlife that was similar to what
he or she had enjoyed on earth.

FIGURE 46

Yuku *railing*

Yuku is oriented toward the setting sun
and represents the dead. It is also
the symbol for the papyriform boat that
transported the mummy and funeral
cortege across the Nile River for cere-
monial and religious purposes.

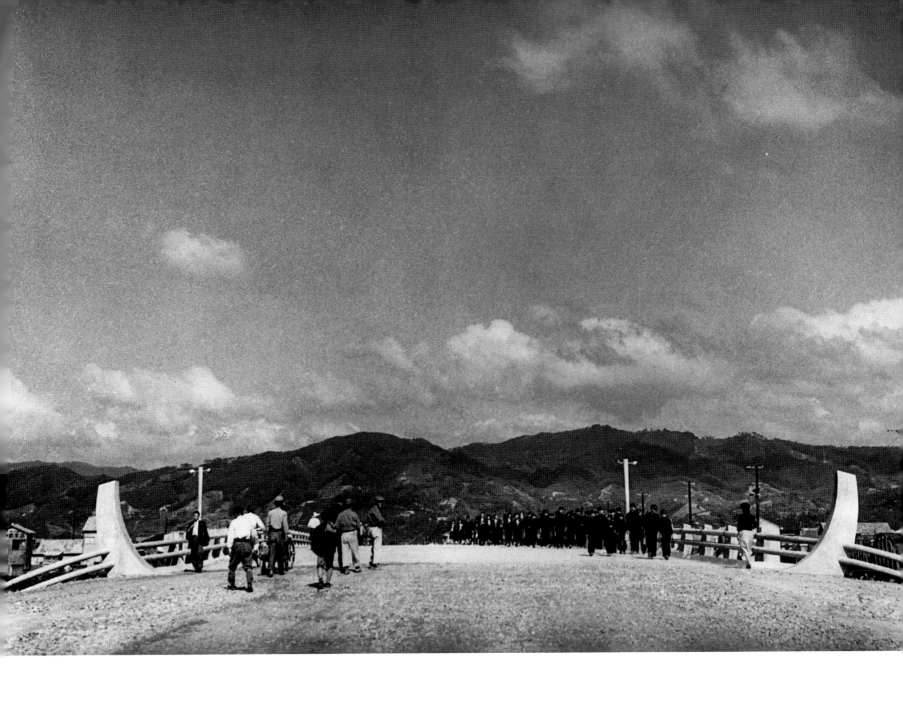

In the winter of 1951, Noguchi was recommended by the architect Yoshirō Taniguchi to receive a commission to design a memorial dedicated to Noguchi's father, Yonejirō (Yone) Noguchi, who had died four years earlier, and who had been a professor of English literature at Keiō University. This project, together with the others he was working on in Japan, represented a personal act of reconciliation with the country: as an American, through the Hiroshima project; and as a son of Yone Noguchi, through the Keiō University project (fig. 47). The memorial took a year to complete, during which time Noguchi commuted between Japan and New York, two distinct places to which the artist ascribed different symbolic meanings. Japan represented nature, stones, rocks; New York represented a machine-made industrial aesthetic.

Noguchi returned to Japan in the spring of 1952 with the intention of focusing on the Keiō memorial, which consisted of a garden and a room created in the faculty building and designed by Taniguchi (fig. 48). Thirty years later, Noguchi collaborated with Taniguchi's son, also an architect, on the design of the Domon Ken Museum Garden in Sakata, Japan (1984).

Taniguchi decided to name the hall Shin Banraisha, meaning "new building for many guests." Taniguchi explained his concept in the following way: "The location of the new building has a lasting mark of *Banraisha* that the pioneer of the Meiji Period, Yukichi Fukuzawa, established . . . The destruction of Banraisha during the war leaves the need for a new structure or *Shin Banraisha* to carry on the spirit of Fukuzawa. With the war over, I thought that architecture symbolizing an open country and new ideas would be appropriate."[22]

Noguchi brought Taniguchi's aims into his own design. The most important part of the project was the room that re-created the world of contemplation: the study. At this time, Noguchi was funded by his Bollingen Foundation fellowship, which allowed him to study not only the traditional Japanese gardens in Kyoto but also traditional architecture

MEMORIAL TO YONE NOGUCHI, FACULTY ROOM AND GARDEN, KEIŌ UNIVERSITY, TOKYO, JAPAN, *1951–52*
Architect: Yoshirō Taniguchi
FIGURE 47
Model
At the same time that Noguchi was designing the two bridge railings for Peace Park in Hiroshima, he was commissioned to design this memorial of highly personal significance. The memorial was an act of reconciliation with his father, who had found it painful to accept the existence of his son and his mixed heritage.

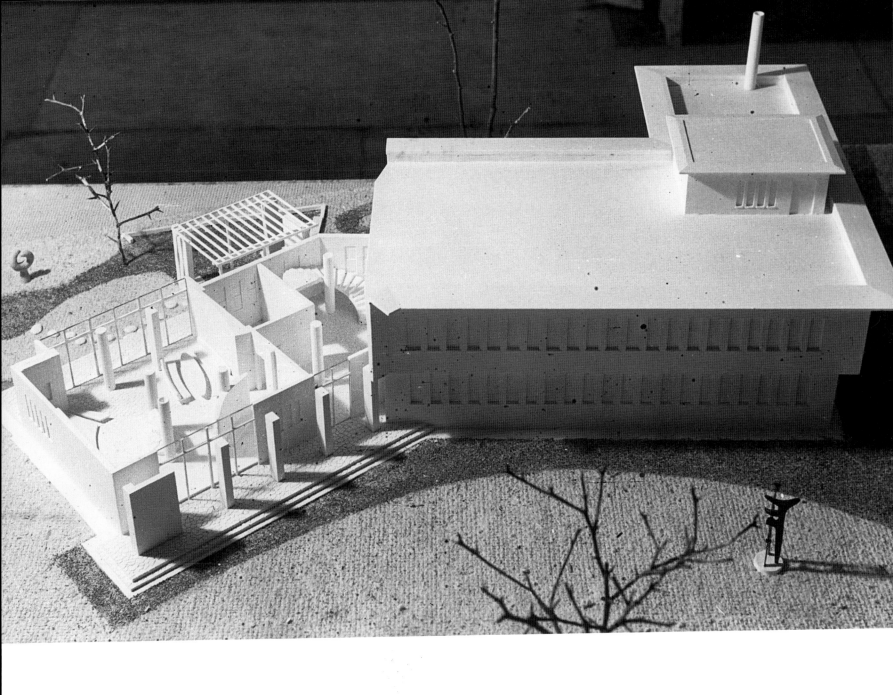

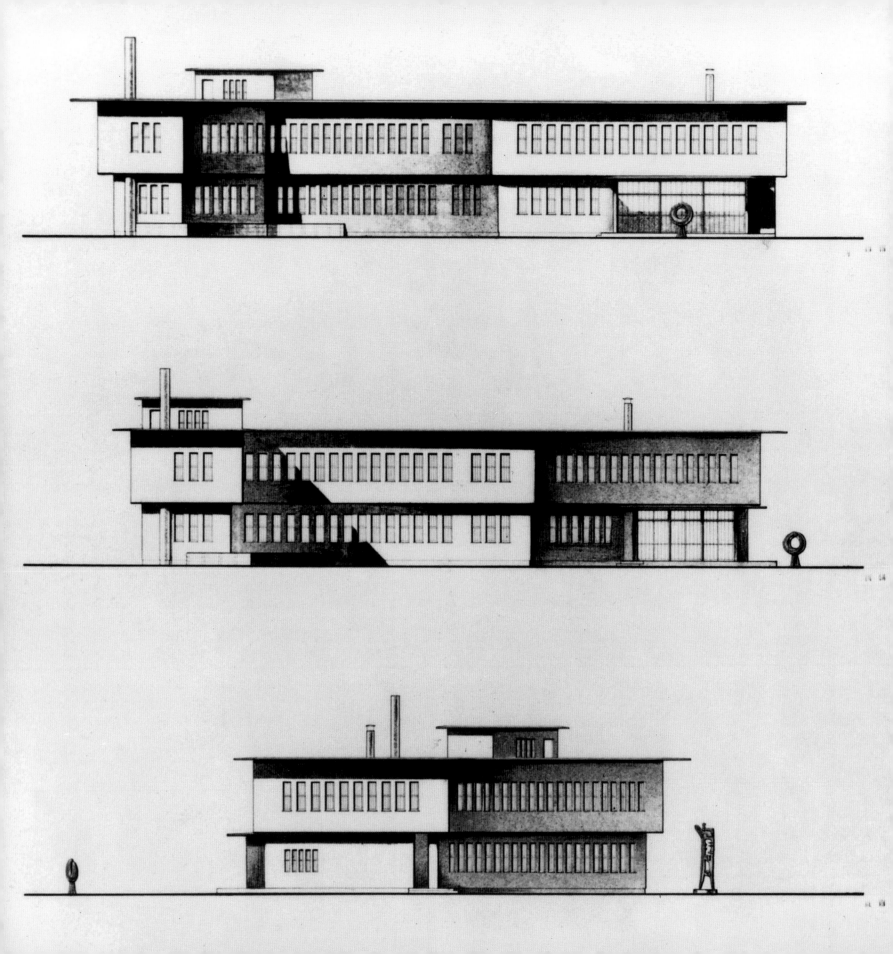

MEMORIAL TO YONE NOGUCHI,
FACULTY ROOM AND GARDEN
FIGURE 48
Elevations
Noguchi designed the garden for Keiō
University as a play of anthropomorphic
shapes created by a dialogue between
textures and materiality. He framed
the view of the landscape as an
element outside the garden with the
placement of three sculptural pieces.

such as the pavilions at the Katsura Imperial Villa. Noguchi's design for the room was, in a very delicate way, reminiscent of Katsura Villa—it can be sensed in the design of the room at Keiō (fig. 49).

Noguchi approached the room with a concept of superimposed layers combining Japanese and Western styles. The layers honored the artist's father, who was known for bridging Eastern and Western literature. This layering also manifested Noguchi's own intention to build a bridge between Eastern and Western sculpture. Within the spirit of the room, Noguchi and his father shared the same dreams, desires, and successes.

Conceptually, the floor of the room consists of three layered surfaces. The first is a stone pavement, the second is an elevated wooden floor intended for sitting and walking, and the third is a tatami. One part of the tatami surface is free of furniture, while the other accommodates a more Western style of seating.

The room's centerpiece is a circular stone fireplace (fig. 50). The circle is flanked by two concrete columns. A large, bisected conical form placed horizontally between the columns directs the smoke and heat to the flue concealed within one of the columns. The verticality of the columns is balanced by the horizontal line of a curved metal element.

Noguchi used only raw materials in this room: concrete, stone, bronze, and rope. He also designed the room's furniture—a long oval table with two rope-wrapped benches, Akari lamps, a simple wood bench, and a three-legged stool (fig. 51).

For the small garden Noguchi produced three sculptures: one made of sandstone, called *Mu* (7 ½ feet), referring to the Buddhist notion of nothingness (fig. 52), the second a geometric iron sculpture called *Gakusei* ("Student," 13 ½ feet), and the third an interlocking metal-plate figure called *Wakai Hito* ("Young Man," 6 feet). A lunar light sculpture was planned for the interior but it is unknown whether one was actually installed.

Noguchi situated the sculptures in relation to the movements of nature within the garden. *Mu*, placed to the west, framed the setting sun. *Gakusei* was to be viewed against the sky, and *Wakai Hito* was initially sited along the path going east but is now located closer to *Mu*. The three sculptures introduce the Western avant-garde tradition to the garden. These pieces continue his aesthetic pursuits from early works, like *Kouros* (1945), and also bring to the viewer surrealist biomorphisms from artists such as Arp and Tanguy as well as the cubist spatial constructions of Picasso.

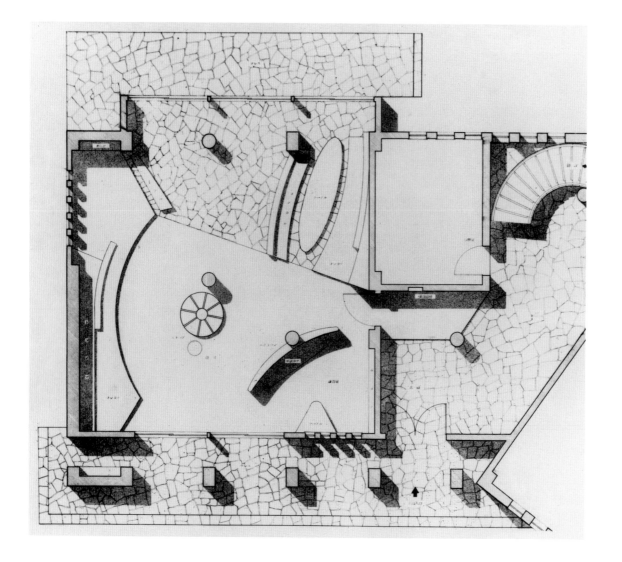

MEMORIAL TO YONE NOGUCHI,
FACULTY ROOM AND GARDEN

FIGURE 49

Room plan

The dialogue between materials that
Noguchi created in the garden
was translated to the room's interior
through the use of natural materials—
stone and rope—and manufactured
ones—concrete.

FIGURE 50

Fireplace detail

The fireplace is the central focus of
attention in the room, reminiscent of
monuments or memorials built
to honor the dead. The fireplace,
like Roman and Greek altars,
is an offering to Noguchi's father.

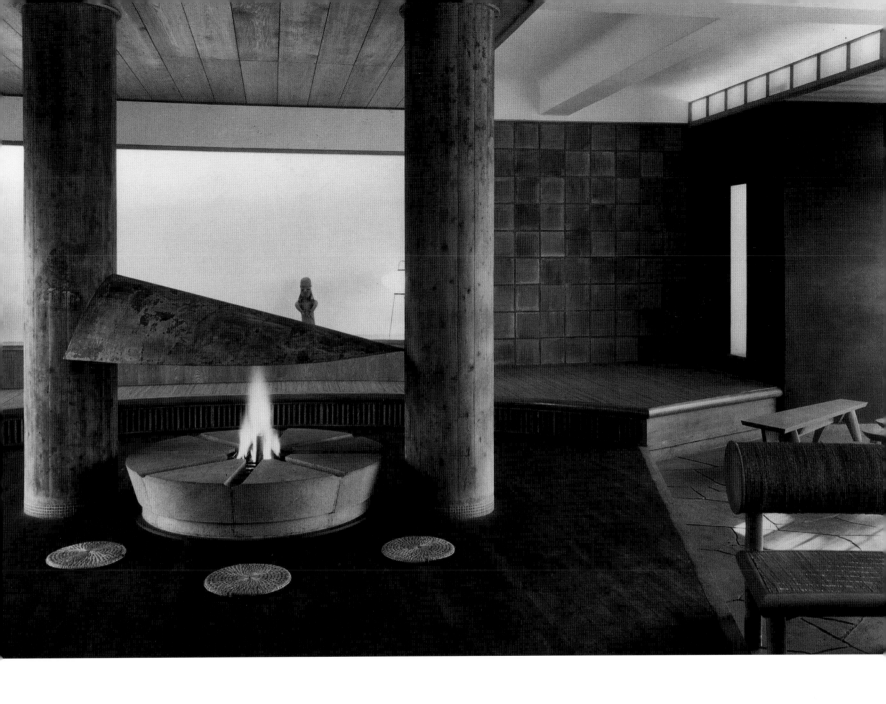

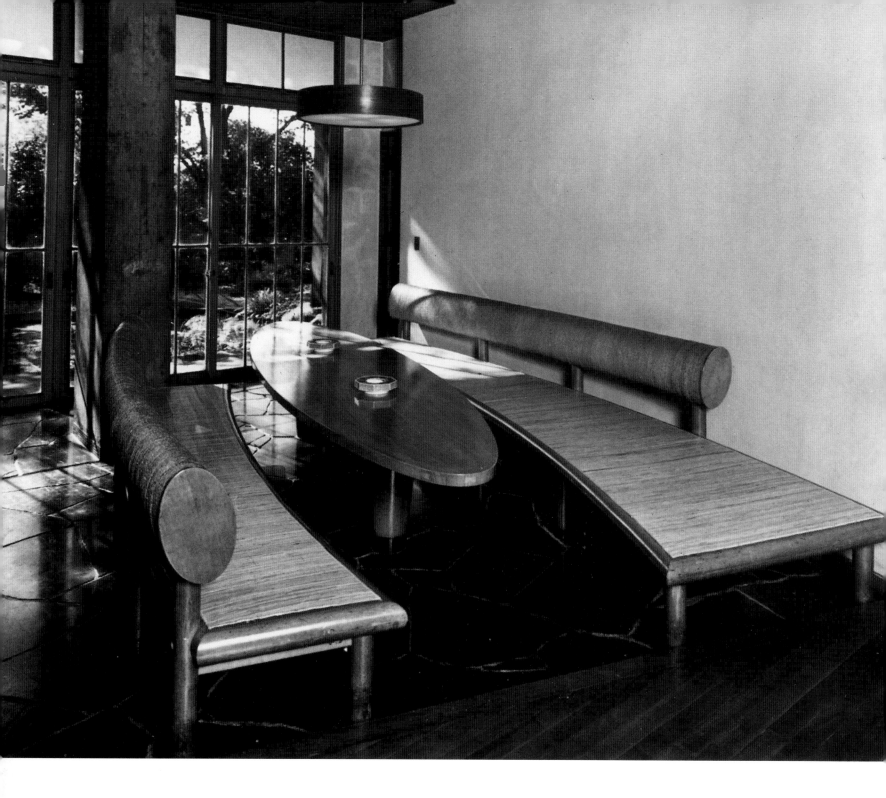

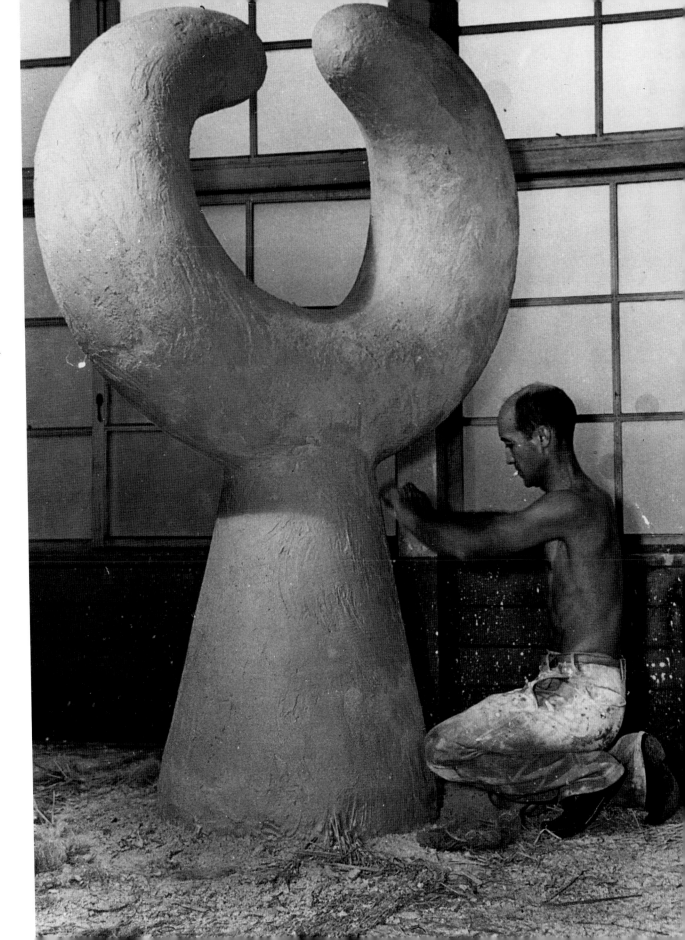

MEMORIAL TO YONE NOGUCHI,
FACULTY ROOM AND GARDEN

FIGURE 51

Detail of benches and table

Noguchi's extensive design of
architectonic, sculptural, and furniture
elements combined Eastern and
Western aesthetics. He continued a
tradition of furniture design that
he had begun in the 1930s that
centered on his concept of bringing
sculpture into the realm of daily life.

FIGURE 52

ISAMU NOGUCHI AT WORK
ON *MU*, *sandstone, 7½ feet*

Mu means nothingness. This stone
sculpture is one of three that
Noguchi made for the exterior garden.
He later reinterpreted the massive
horn-shaped figure in various works
such as his Akari lamps.

WHILE IN NEW YORK DURING THE WINTER OF 1951–52 AT THE TIME OF THE UNITED NATIONS PLAYGROUND, I HAD BEEN ASKED TO WORK ON A GARDEN FOR THE LEVER BROTHERS BUILDING ON PARK AVENUE. THE WHOLE GROUND FLOOR OF THE BUILDING WAS TO BE TRANSFORMED INTO AN OASIS OF ART.[21]

When Gordon Bunshaft, chief architect of Skidmore, Owings & Merrill, commissioned Noguchi, the Lever Brothers Building was already under construction. Noguchi's concept for the outdoor courtyard was a pristine marble stage from which would rise sculptures and planting beds flush with the platform's surface (fig. 53). The rest of the ground floor was envisioned as an informal seating area (fig. 54). The general idea was similar to that for the seating area Noguchi later developed for the upper plaza of the UNESCO Headquarters Building gardens in Paris (1956–58).

Toward the end of 1951 or the beginning of 1952, Noguchi proposed a "marble stage" on which two design concepts might be realized. For both concepts, he conceived the marble platform as a theatrical stage on which a reflecting pool, columnar sculptures, and planting beds were located (fig. 55). Noguchi designed the platform so that spectators would experience the physical form as a distinct architectural element floating free of the building (figs. 56–58). As such, the platform was treated as a freestanding sculpture. This aesthetic concept reappeared in the artist's work for the Beinecke Rare Book and Manuscript Library at Yale University (1960–64).

LEVER BROTHERS BUILDING GARDEN AND GROUND FLOOR, NEW YORK, *1952 (unrealized)*
Architect: Gordon Bunshaft/ Skidmore, Owings & Merrill
FIGURE 53
Plaster model of courtyard
The courtyard of the Lever Brothers Building was the first collaboration between Gordon Bunshaft and Noguchi. Their association was successful throughout the 1960s.

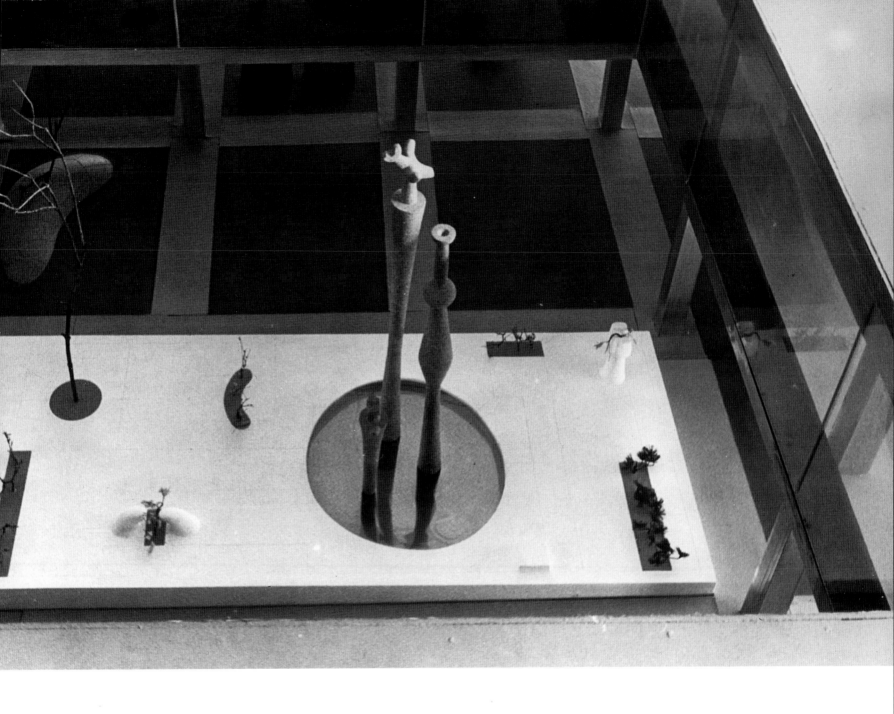

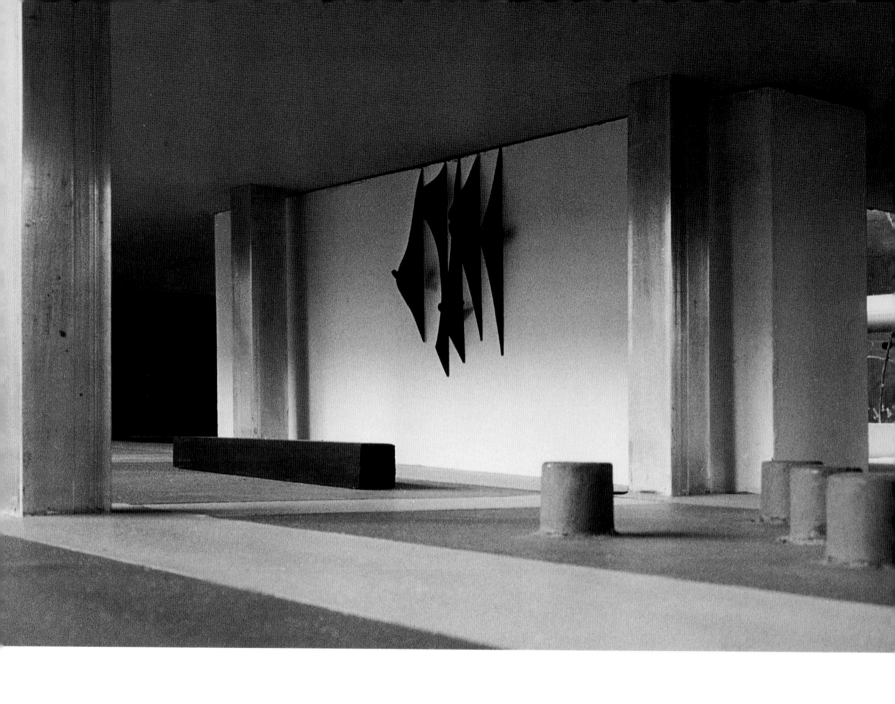

LEVER BROTHERS BUILDING
GARDEN AND GROUND FLOOR
FIGURE 54
*Plaster model of ground-floor
seating area*
Noguchi paid close attention to how
the viewer arrived at the building and
perceived the ground-floor area, and
how to reconcile different elements and
scales. He approached the conceptual
design for the seating area with clear
reference to Constantin Brancusi's work
at Tîrgu Jiu, Romania.

In an initial design, Noguchi arranged a group of three granite columns of varying heights in a reflecting pool to represent the concept of family[24] (fig. 59). This was the first time Noguchi proposed employing a group of freestanding sculptures with this theme, which was realized later in his work for the Connecticut General Life Insurance Company (1956–57). The design was rejected. In an alternative proposal he retained the three granite columns but created a triangulated composition with only one of the columns standing in the reflecting pool (fig. 60). In this arrangement the notion of family was no longer present. The artist also proposed using one of his studies of Brancusi's *Endless Column.* Unfortunately, all of Noguchi's efforts came to naught on this project. Yet although his proposal was not accepted, he did manage to recycle some of the sculptural elements into later works.

While his garden project at the Lever Brothers Building was not realized, it established the groundwork for the collaborative relationship that developed between Noguchi and Bunshaft and strengthened the former's ideas about the possibilities of artist-architect collaborations. In the past, Noguchi had attempted this kind of collaboration in a variety of other situations, but never with the same success this one would have. Bunshaft believed that Noguchi, with his knowledge of architecture, landscape, and space design, was the only artist capable of creating designs that were fully integrated with the architecture. The project laid the foundation for several major environmental projects Noguchi designed and completed later on.

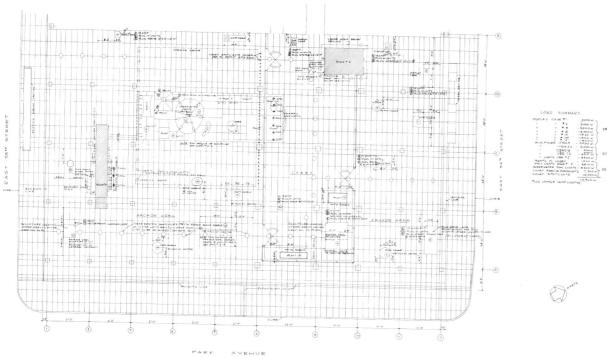

FIGURE 55

Plan, second option

Because the building was under construction, a design for the ground floor existed before Noguchi was commissioned. His concept was to eliminate the bed of green in the central marble planting box and transform it into a stage from which sculptures rose and left apertures in the marble "platform" for planting.

FIGURE 56

Isamu Noguchi with courtyard model

Noguchi applied his experiences in set design, gained while working with the modern dancer Martha Graham in the 1930s, to resolve conflicts of scale and to create theatrical illusion within the courtyard. He also drew on his experience with Japanese gardens and the ways in which the illusion of space was produced within them.

FIGURE 57

Plan, second option

Both the first and second versions of the central court include a marble platform that was conceived to accommodate more important sculptural elements, like a theater stage.

FIGURE 58

Construction details of site elements

A significant influence on Noguchi in this period was surrealist art. Its organic formal vocabulary is recalled in his aesthetic interpretations of Jean Arp's poetic fusion of different realities and appreciation of the essential unity of humankind and nature.

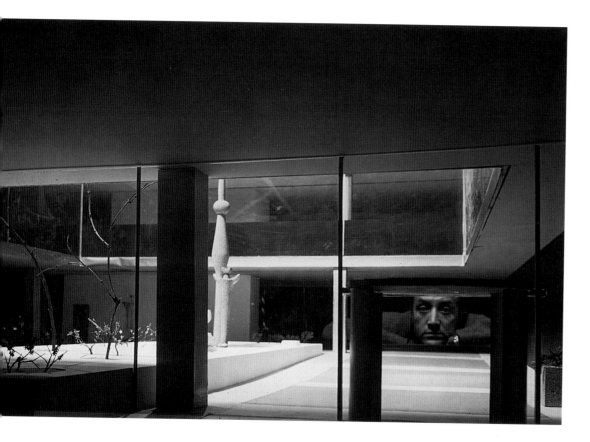

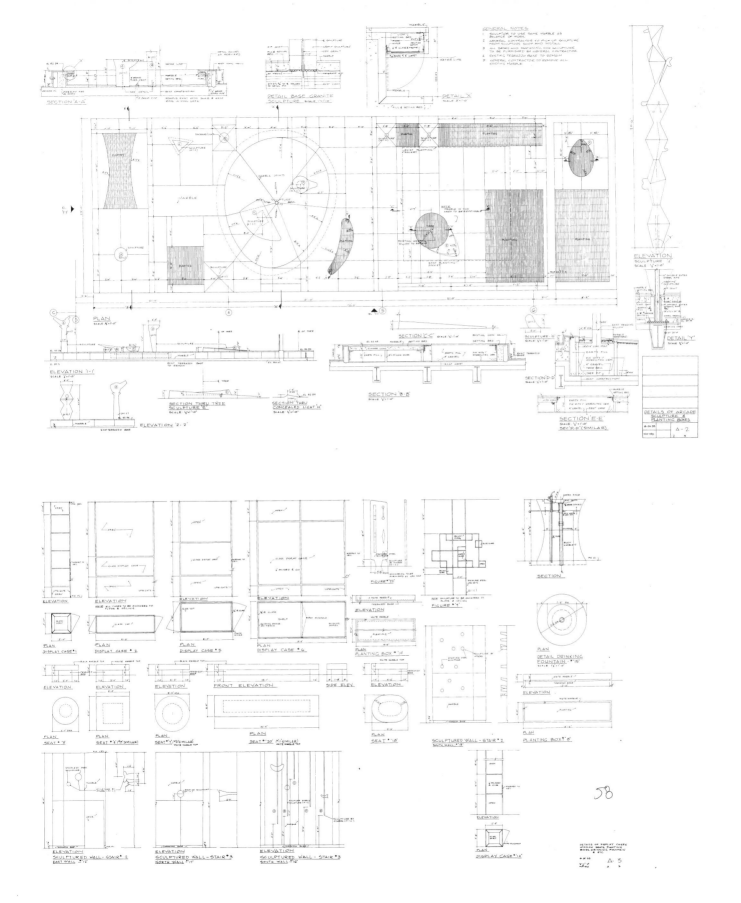

FIGURE 59

*Plaster model of first option
for courtyard*

The artist developed the sculptural
group as representative of the family.
The three sculptural elements, located
inside a pool, were abstracted
from Arp's organic vocabulary, but with
a uniquely Eastern character.

FIGURE 60

*Plaster model of second option
for courtyard*

The second scheme was the beginning
of Noguchi's life-long series of reinter-
pretations of Constantin Brancusi's
work. In 1959, at the Stable Gallery in
New York, Noguchi exhibited *Bird Song*
(now in the University of Nebraska
Sheldon Memorial Art Gallery, Lincoln)
and dedicated the exhibition to
the Romanian artist and the sculptural
values Noguchi associated with him.

THE DIFFICULTY, AS ALWAYS, WAS SCALE: EQUIVALENT SCALE TO LARGE BUILDINGS AND SPACES ARE NOT NECESSARILY MET BY BIGNESS BUT RATHER BY RELATIVE SCALE AND SIMPLICITY OF ELEMENTS. THIS WAS THE QUESTION OF ILLUSION OVER WHICH WE HAD A GREAT DEAL OF ARGUMENT.[25]

Noguchi's gardens were places of imagination in which concepts of illusion, meaning, emotion, and form played integral parts in the re-creation of ritual. In the mid-1950s the artist was asked to create four interior courtyards and a garden that bordered the long facade of the Connecticut General Life Insurance Company (now CIGNA Corporation) Building, in Bloomfield, Connecticut, the same time that the UNESCO gardens project began. Not incidentally, these two large works share many design elements and reflect a strong Eastern sensibility.

From 1952 to 1956, with the exception of the Lever Brothers proposal, Noguchi did not design gardens. Rather, he focused on his personal relationship with Japan. After his marriage to Yoshiko Yamaguchi in May 1952, the couple settled down in an old farmhouse in the rice valley Kita Kamakura. The traditional Japanese structure was owned by the potter Rosanjin Kitaōji, with whom Noguchi had a close relationship. Noguchi meticulously re-created a traditional Japanese atmosphere in this house and studio through which he reabsorbed Japan and the concept of being in harmony with the environment (fig. 61). He sculpted a series of clay pieces that were shown at the new Museum of Modern Art in Kamakura. At the same time he developed the Akari lamps:

INTERIOR COURTYARDS AND GARDEN FOR CONNECTICUT GENERAL LIFE INSURANCE COMPANY BUILDING, BLOOMFIELD HILLS, CONNECTICUT, *1956–57*
Architect: Gordon Bunshaft/ Skidmore, Owings & Merrill

FIGURE 61
View of Noguchi's Kita Kamakura studio, c. 1952
Noguchi learned to understand the Japanese concept of being in tune with nature in Kita Kamakura. There, for the first time, he established a family and re-created the harmonic atmosphere of the traditional Japanese home environment using the clay sculptures he was developing.

OFFICES

OFFICES

OFFICES

OFFICES

TERRACE

0 25 50 75 100

CAFETERIA
MAIN LEVEL

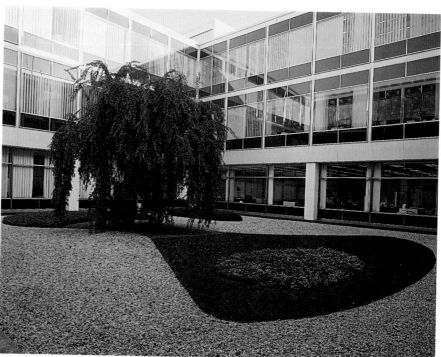

INTERIOR COURTYARDS
AND GARDEN FOR
CONNECTICUT GENERAL LIFE
INSURANCE COMPANY BUILDING

FIGURE 62
Model, c. 1956
This commission represented for
Noguchi an opportunity to resolve
the scale differences between large
buildings and small courtyards. He felt
that the best way to address the
problem was through the use of "rela-
tive scale" and simplicity of elements.

FIGURE 63
Plan
Honoring the simplicity in Japanese
gardens, the four courtyards were
designed with reflecting pools from
which an occasional carved stone rises.

FIGURE 64
View of interior courtyard
One of the elements that Noguchi used
for his design was water. He captured
the building's bucolic setting and
the metaphorical "mirror of nature."

FIGURE 65 *(overleaf)*
View of courtyard
As a counterpoint to the water ele-
ment, Noguchi used a simple gravel
bed in which shaped grass areas took
the form of sculptural elements.

FIGURE 66 *(overleaf)*
View of courtyard
The difference in scale between the
building and the courtyard is resolved
by Noguchi's bench, which is integrat-
ed into the grass area, and the location
of a single tree.

though the Japanese word *akari,* unlike the English word "light," refers only to illumination and not to weight, Noguchi developed this series of fragile lamps with the belief that the quality of lightness they expressed was one people needed in their daily lives. (The Italian writer Italo Calvino, in his 1988 series of essays *Six Proposals for the Next Millennium,* gives voice to the same idea. He advances "lightness" as one of the concepts that humanity needs to take into the future.) Noguchi returned to New York in 1953 to attempt to reverse the denial of a visa for his wife by the United States. The request was denied because of Yamaguchi's past associations with suspected Communists in Hollywood. As a result, the couple spent much of 1954 and 1955 outside the United States. During this period Noguchi continued working on stage designs for the Royal Shakespeare Company and the dancer Martha Graham as well as on his furniture, which was beginning to be manufactured by Knoll International. In January 1957 Yamaguchi and Noguchi divorced.

The landscape design for Connecticut General was the first project Noguchi realized in collaboration with Gordon Bunshaft. In response to the building's bucolic setting, Noguchi used two important elements in his design: water, which emerged as a dramatic participant within the space, and stone (figs. 62–64). He placed four courtyards symmetrically within a gridlike floor plan, creating a checkerboard effect. The viewer perceives the water as flowing under the building from one courtyard to another. Noguchi treated the water as an element of reflection—as a mirror. The sculptural vocabulary comprised biomorphic forms, but in a minimalist style (figs. 65 and 66).

Noguchi used stone in two different ways. Within the four court-yards, it takes the form of stepping-stones, similar to its use in Japanese gardens. In the sculpture group *The Family,* however, the stone is crudely

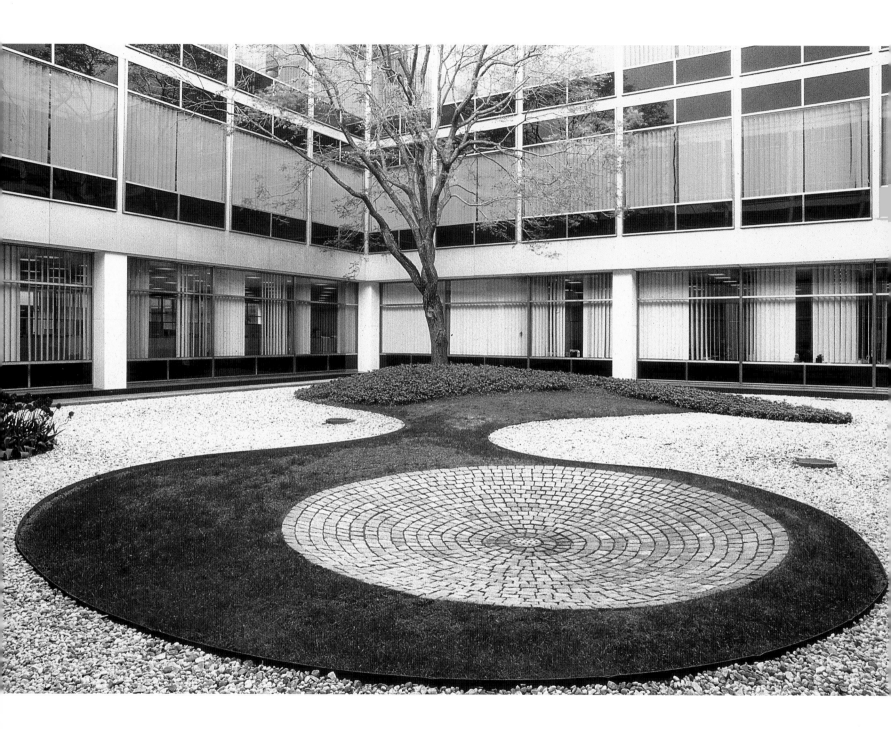

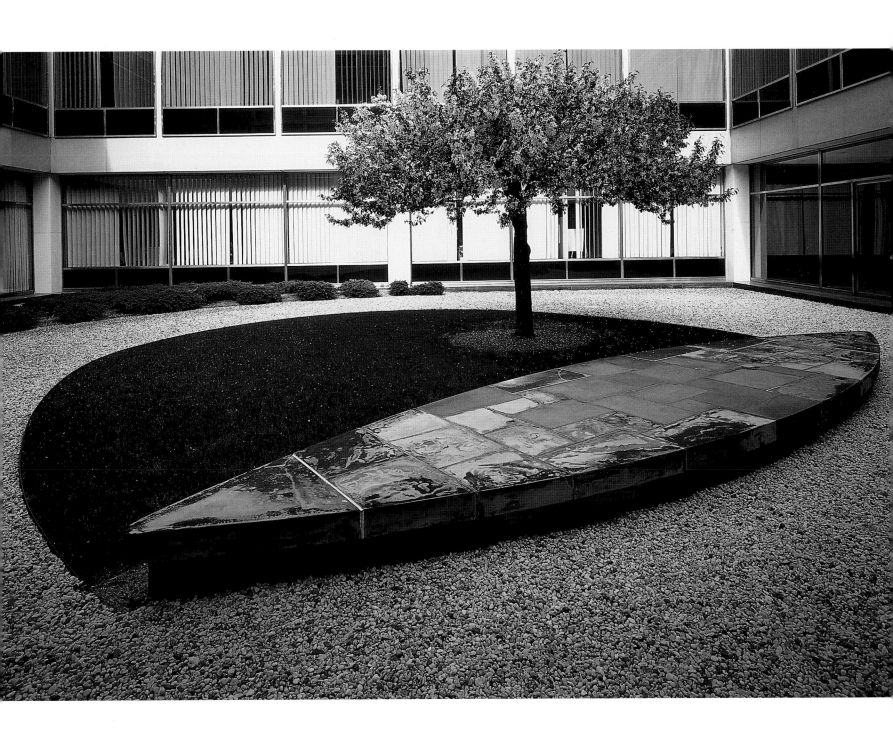

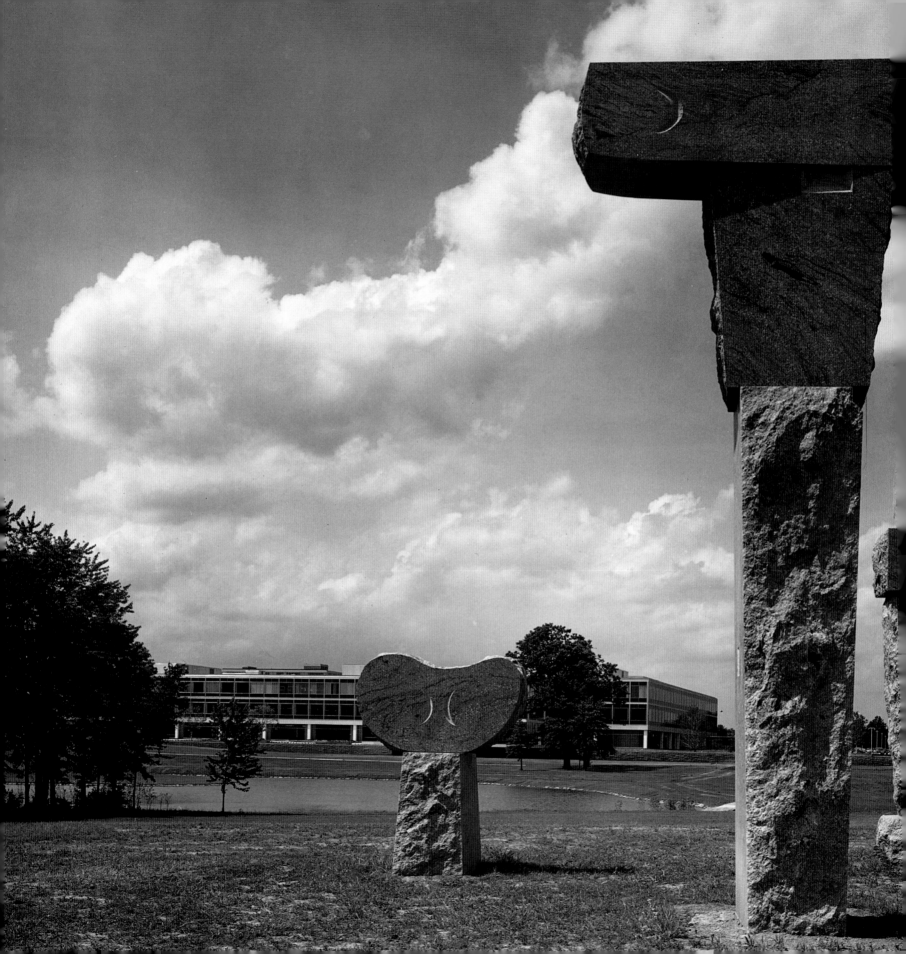

FIGURE 67
The Family, *Stoney Creek granite, three elements: 16 feet, 12 feet, and 6 feet*
The surrealist symbolism of the Lever Brothers Building sculpture group was transformed for this project into partially carved monolithic stone pillars.

carved and megalithic. This sculptural group, reminiscent of the group Noguchi proposed for the Lever Brothers Building, continues the tradition of prehistoric monuments that are inseparable from both their sites and historic context. *The Family* is an attempt to achieve a balance similar to that of these monuments—one of form and spirit, which marked all of the artist's environmental and sculptural work.[26] Ultimately, Noguchi knew how to find the myth and ritual within each stone.

In the original plan, *The Family* was placed close to the building, but as the project proceeded, Noguchi enlarged the scale of the group. Sensing the strong character of the emerging sculptures, Bunshaft developed full-scale wooden mockups that revealed the original site to be inappropriate. Noguchi then suggested situating the sculptures on a nearby hill (fig. 67): "I chose the site where they are now, away from the buildings, at the last minute after the sculptures were on the way. I do not deny that the results seem to have justified the dispute—which teaches me never to be tied to preconceptions, to be open to change and chance to the end."[27] The verticality of the sculpture group is the counterpoint to the horizontality of the architecture.

The new location for *The Family* introduced an Eastern notion of multiple viewpoints. By using framing devices similar to those found in Japanese gardens, Noguchi developed seating areas within the building and the garden that incorporated distant views of the hill and his sculpture. Through this viewer-hill relation, Noguchi realized the concept of *shakkei*—"a landscape captured alive."[28]

"I TOLD HIM HE WOULD PROBABLY COVER THE BASE WITH POWDERED SUGAR AND CALL IT FUJIYAMA," RECOLLECTS THE AMERICAN SCULPTOR ALEXANDER CALDER OF HIS CONTEMPT FOR NOGUCHI'S PROJECT, WHICH SEEMED TO BE ENCROACHING ON HIS OWN.[29]

In 1956 Marcel Breuer, Pier Luigi Nervi, and Bernard Zehrfuss were appointed architects for the UNESCO Headquarters, located at the Place de Fontenoy in Paris. Noguchi and Calder were among the six artists selected for the commission. The UNESCO project set out to exemplify the integration of art and architecture, with the design to be presided over by a committee led by architect Walter Gropius. Unfortunately, the plan did not work out as intended—the artists were included too late in the process and found themselves with assigned locations within finished architects' designs. This produced a breakdown in the collaborative spirit. The art was being added to the architecture in the traditional manner—that is, as mere decoration.

In the fall of 1956 Breuer suggested that Noguchi work on the Patio des Délégués, a triangular area on the upper level at one end of the Secretariat Building. After Noguchi visited the UNESCO construction site, he was convinced that something should be done in conjunction with the large sunken area by Building No. 3[30] (figs. 68 and 69). The plan presented a serious problem because this area had been assigned to Calder. Noguchi's idea was to connect the two UNESCO buildings by creating a bridge, a *hanamichi* ("flowery path"), a concept he had adapted from Kabuki theater[31] (figs. 70 and 71). A linear fountain, symbolizing a river, follows the *hanamichi* that joins both levels. A large waterfall stone with Noguchi's calligraphic rendition of the Japanese word for "peace" (*heiwa*) stands between the gardens. The stone is a pillar and a man (figs. 72 and 73).

After he developed and presented a model of his plan, Noguchi convinced the committee to move forward with his first large-scale garden, the Jardin Japonais, next to the Patio des Délégués. He later recalled in his autobiography, "I gradually became more and more involved, ever more ambitious for [the project] to be something exceptional."[32] Calder's mobile, which was originally planned for the area, was relocated in front of the Conference Building, halfway between the building and the sidewalk.

UNESCO GARDENS, PARIS, FRANCE, *1956–58*
Architects: Marcel Breuer, Pier Luigi Nervi, and Bernard Zehrfuss
³/₅ acre

FIGURE 68
"Nineteen ideas for sculpture and garden," 1957, pencil on paper, 12⁵/₈ by 17⁵/₁₆ inches, inscribed in upper left corner
As Noguchi described in *A Sculptor's World*, the UNESCO commission was an opportunity to show himself the way "toward a deeper knowledge through experience of what makes a garden, above all the relation between sculpture and space which I conceived as a possible solution to the dilemma of sculpture, as it suggested a fresh approach to sculpture as an organic component of our environment."

FIGURE 69
Site plan
The UNESCO artistic committee accepted Noguchi's idea of bridging the Secretariat Building and Building No. 3. This decision, however, meant that Alexander Calder's mobile, which had previously been commissioned for the area, was moved to the front of the Conference Building.

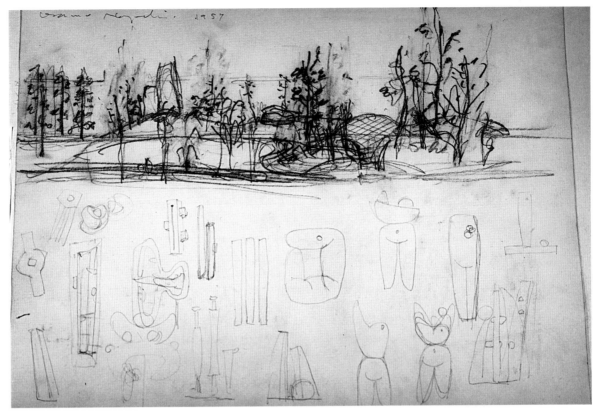

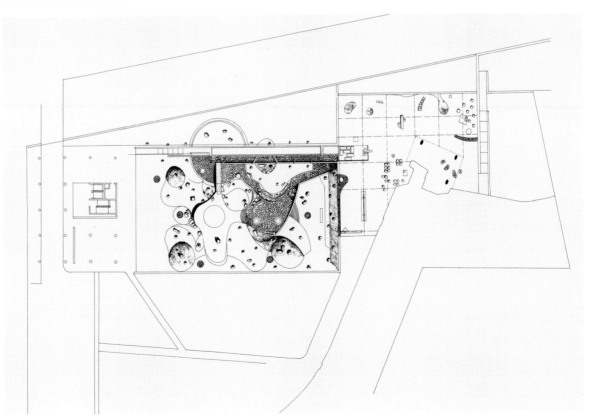

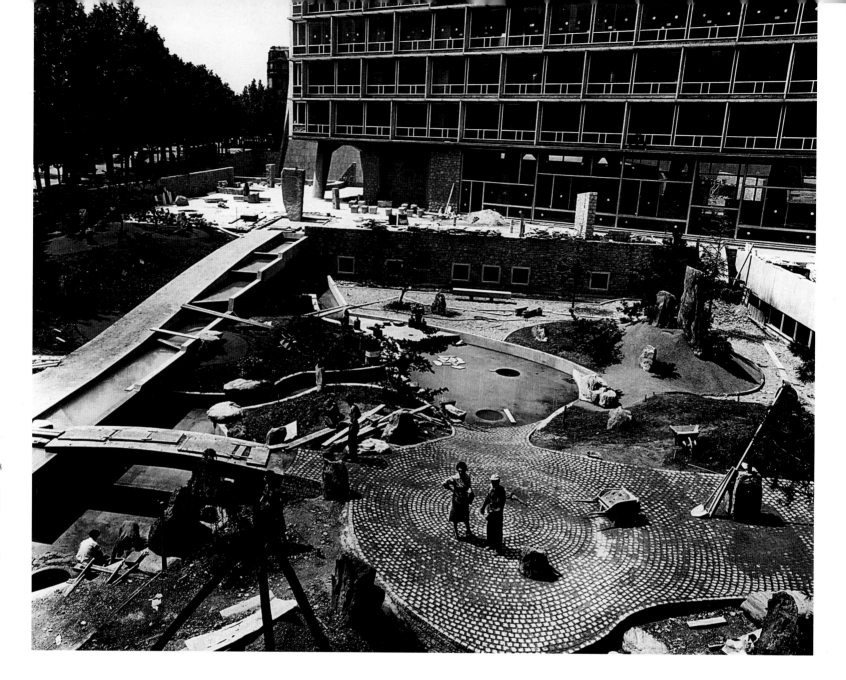

FIGURE 70

Jardin Japonais under construction
In the large sunken area, Noguchi incorporated traditional Japanese garden designs through his use of stone, water, and plants. He also related the garden to the Kabuki theater.

FIGURE 71

View of Jardin Japonais
The lower garden resembles an amoeba and evokes the natural contours of the land. It is a counterpoint to the upper garden, which represents culture.

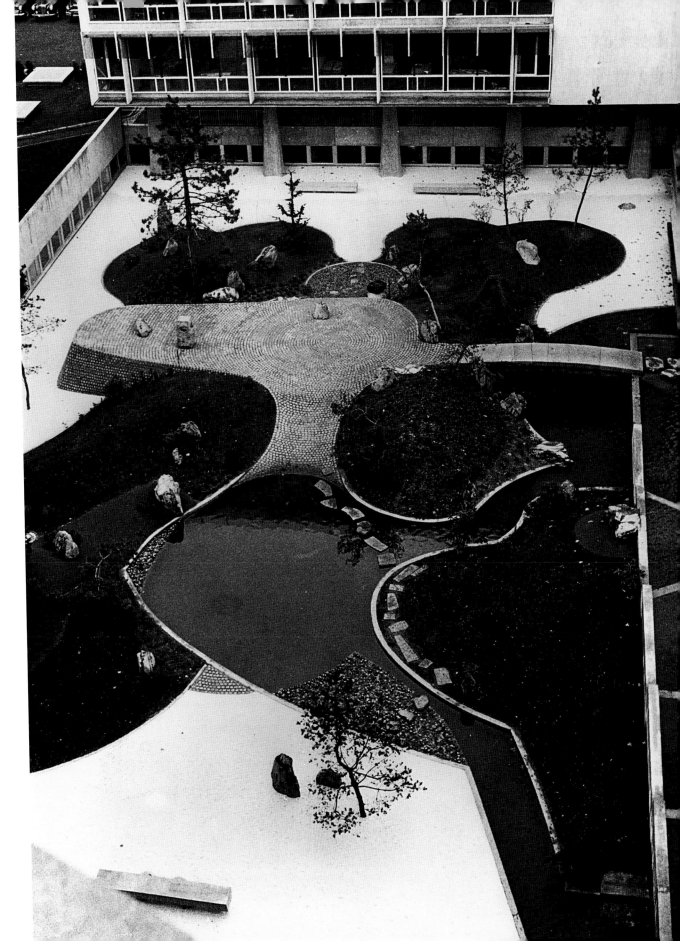

UNESCO GARDENS

FIGURE 72

The Calligraphy of Peace

Noguchi expressed his own commitment to society by carving in the stone that stands within the waterfall a calligraphic sign for peace.

FIGURE 73

Waterfall sculpture

At the Entry Bridge, the *hanamichi* that connects the two UNESCO buildings, Noguchi placed a vertical stone—a fountain, a myth of nature, a symbol of humankind. He sought to connect the worlds of the natural and the human-made.

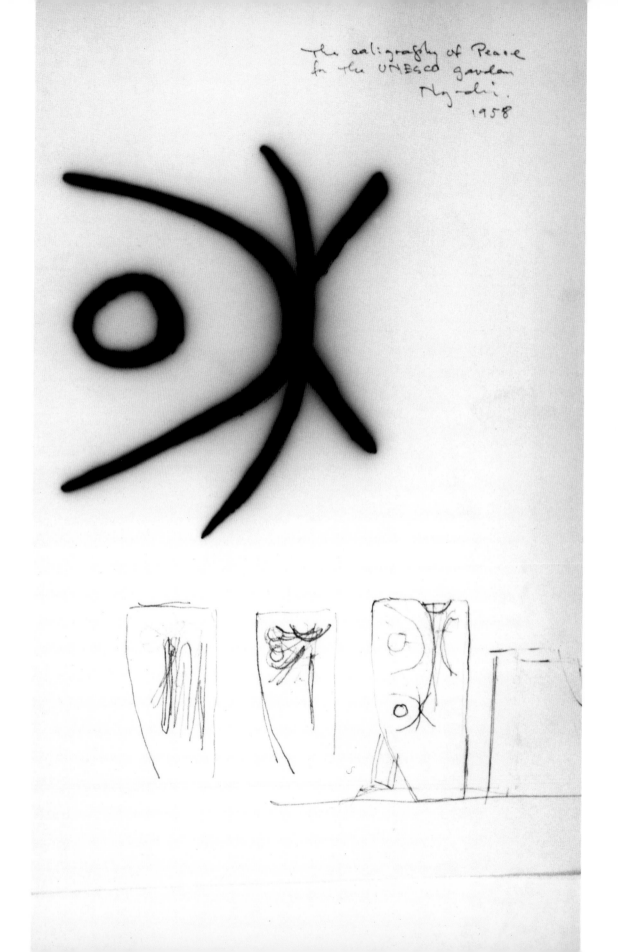

The calligraphy of Peace for the UNESCO garden Noguchi. 1958

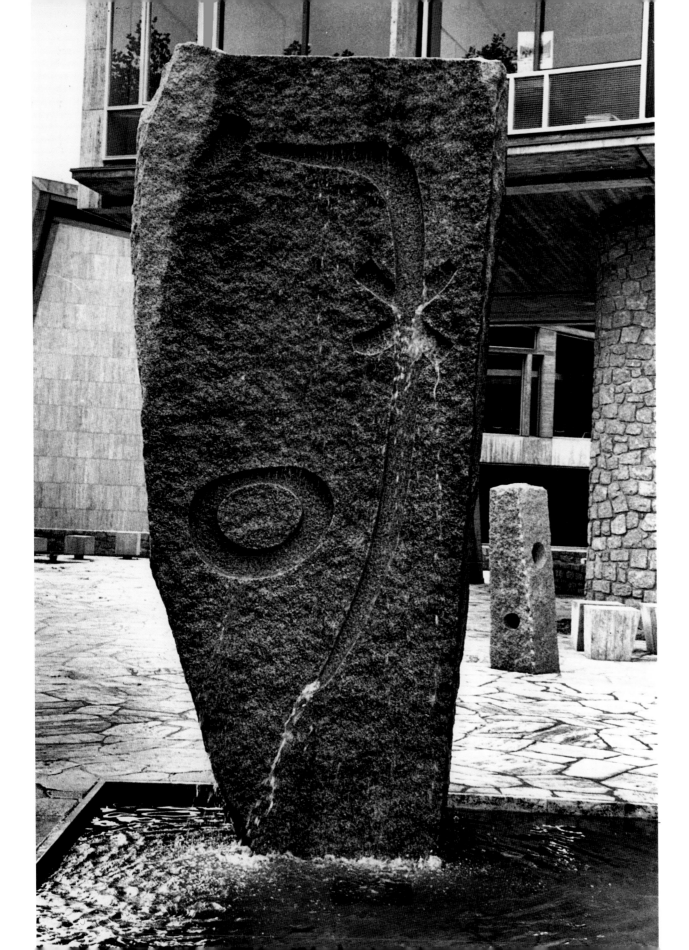

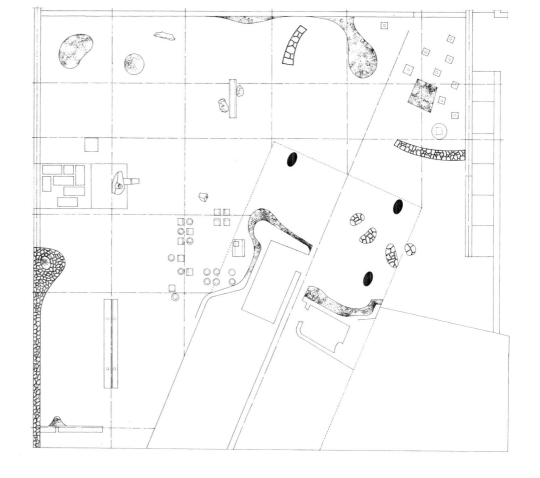

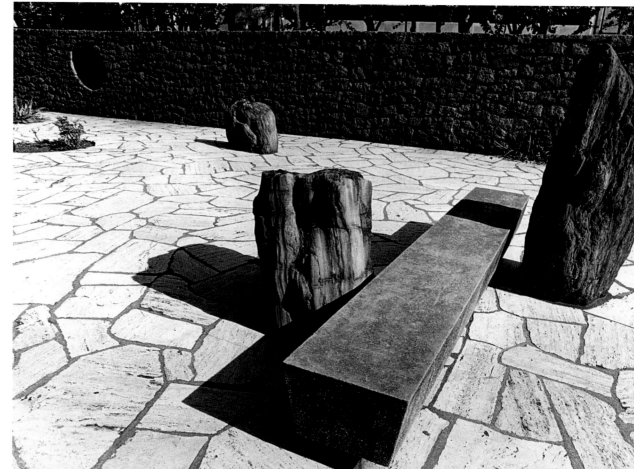

Originally the committee thought that the Patio des Délégués should be designed to serve as an area for informal discussions and private contemplation. Once the commission was expanded, Noguchi approached the patio as a piazza that could serve as a counterpoint to the Jardin Japonais, the "garden" (figs. 74 and 75). Similar to his design for the Lever Brothers garden, the "piazza" is treated as a platform in which sculptures, seating elements, and planting beds all form part of a stage. Noguchi arranged a triangulated and asymmetrical composition of seats as an homage to Constantin Brancusi's *Table of Silence* at Tîrgu Jiu, Romania[33] (fig. 76). As a new and formal variation on the Japanese garden, originally designed for tea ceremonies, the Patio des Délégués evokes an ideal Zen landscape.[34] Like a tea garden, it is composed of interdependent and mutually enhancing elements, all arranged in asymmetric counterpoint (fig. 77).

The Jardin Japonais represents the integration of Noguchi's study of traditional Japanese garden design with his understanding of the social role of public sculptures. He had begun this study five years before his involvement with UNESCO with two small gardens at Keiō University and the Reader's Digest Building in Tokyo. The UNESCO commission illustrates Noguchi's evolving ideas about sculpture: his conviction that sculptural forms generate their own space, that a need exists to integrate sculpture within architectonic space, and that sculpture works as a counterpoint to architecture (figs. 78–80).

The approved proposal was limited by the budget, which did not cover the costs of rocks and trees in the Jardin Japonais. On his own, Noguchi contacted the Japanese government to ask for these materials as a gift. Shortly thereafter, and unfailingly persistent, he traveled to Kyoto to solicit help in gathering the necessary rocks. After several recommendations, he was introduced to the master garden designer Mirei Shigemori, whom Noguchi described enigmatically as "a man of tea."[35] Shigemori took Noguchi to a mountainous area on the island of Shikoku, Japan, the main source of the stone called Io-No-Ao ("the blue stone of Io"), where Noguchi would later build his own studio. Meeting with Shigemori and being exposed to his worldview catalyzed Noguchi's

UNESCO GARDENS

FIGURE 74

Site plan of Patio des Délégués
Noguchi designed the patio as a "piazza" for informal discussions and private contemplation and as a counterpoint to the Jardin Japonais, a garden for performances and movement.

FIGURE 75

Detail of Patio des Délégués
The upper patio was a transition between materials and forms, between unfinished and finished, through the use of natural stone (carved and uncarved), concrete, and organic and geometric forms. The artist had the opportunity to further develop his lifelong interest in the duality of nature and culture.

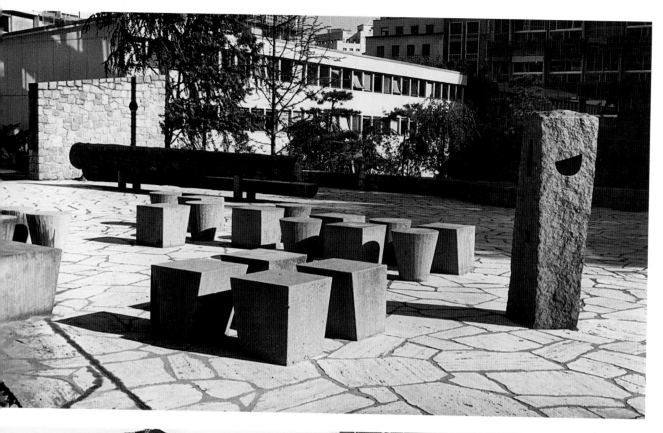

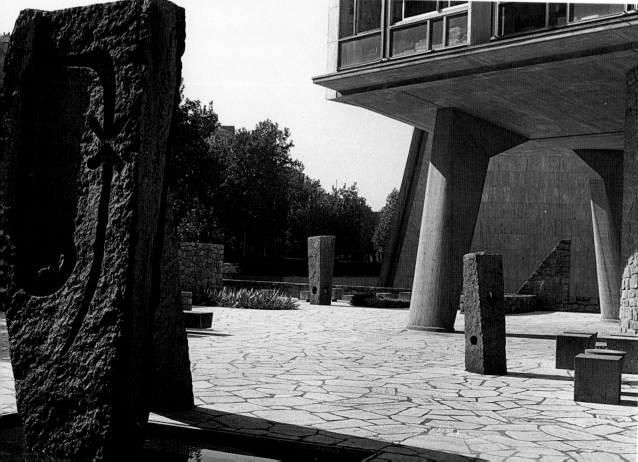

FIGURE 76

Seating area in Patio des Délégués
As an homage to Constantin Brancusi, Noguchi reinterpreted the Tîrgu Jiu geometric seat arrangement and offered a new formal variation on the tea ceremony.

FIGURE 77

View of Patio des Délégués
Noguchi treated the upper patio as a stage. The seating elements, rocks, and planting beds create sculptural space. Meaning and scale are introduced when the visitor enters the space. Noguchi also created a dialogue between the upper level and the raised paved area in the center of the lower garden that he called the "happy land."

FIGURE 78

Site plan of Jardin Japonais
In designing the Jardin Japonais, Noguchi recalled principles of the traditional Japanese ambulatory garden, in which the visitor experiences space through movement and changing points of view.

FIGURE 79

Site plan of Jardin Japonais
The funds allocated for the project were insufficient for the rocks and trees Noguchi required to accomplish his ambitious design. After managing the bureaucratic complexities, Noguchi transported eighty tons of stone, as well as trees and three gardeners, to Paris as a gift from Japan.

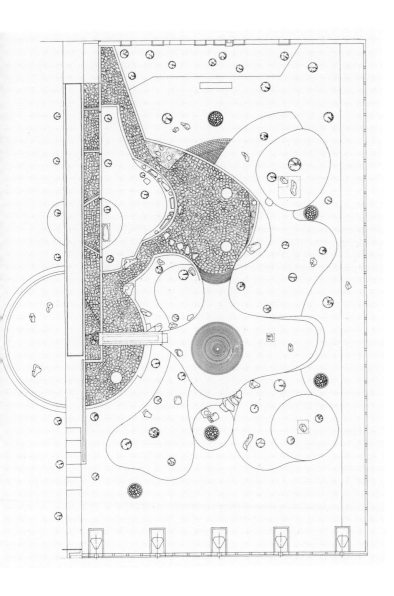
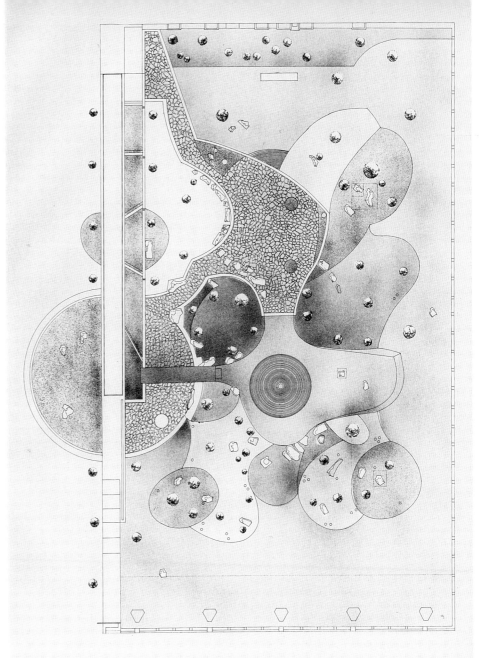

search for the spirit of the rock and ultimately greatly enriched his own sculptural sensibility.

Finally, in the winter of 1956, Noguchi was ready to settle down and work on the project itself after overcoming the vast bureaucratic complexities of transporting eighty tons of stone and trees from Japan to Paris, including camellias, decorative maples, several varieties of dwarf bamboo, and seventy cherry tree saplings, not to mention three gardeners (one of whom was Touemon Sanō, a sixteenth-generation garden designer from Kyoto) (figs. 81 and 82).

In designing the garden, Noguchi demonstrated an acute awareness of the aesthetic forms of his time. While the free-form, biomorphic amoeba shapes of the lower garden evoke the natural contours of the land, they are also linked to the surreal forms and irrational experiences explored in the 1930s by artists such as Jean Arp, Henri Matisse, Joan Miró, Yves Tanguy, and Arshile Gorky. In the Jardin Japonais, Noguchi sought to create a visual and conceptual link between the "garden" and the "piazza" of the Patio des Délégúes by elevating and paving a section of it. While this space, intended for performances, can be viewed from any part of the garden, it is essentially a territory designed for an interior voyage: "The raised paved area in the center of the lower garden recalls the 'happy land.' One arrives on it and departs from it again—with time barriers of stepping stones between—it is the land of voyage."[36] The garden is meant to be walked in. The vista constantly changes, and everything being relative, objects suddenly loom up in scale as others diminish. The real purpose of the Jardin Japonais may be the contemplation of space, time, and life.

What Noguchi brought to the UNESCO project was the lost relation between space, building, and sculpture. Harriet F. Senie, author of *Contemporary Public Sculpture: Tradition, Transformation, and Controversy,* stated that Noguchi, of all artists, was the only one to work with site in a meaningful way.[37] In 1949 Noguchi stated: "A reintegration of the arts toward some purposeful social end is indicated in order to enlarge the present outlet permitted by our limiting categories of architects, painters, sculptors and landscapists."[38]

UNESCO GARDENS
FIGURE 80
Section through Jardin Japonais
This large commission illustrated the artist's conviction that sculptural forms could generate a walkable space as well as his search for the point where architecture and sculpture meet. Establishing a parallel between the treatment of rocks in Japanese gardens and his sculptures, Noguchi used his sculptures as the "bones" in the UNESCO gardens.

FIGURE 81
Noguchi selecting stones in Japan, c. 1957
Stones were critical to Noguchi's work, but the space in between was more essential. As he wrote in *Artnews* in 1949, "Sculpture . . . must be not only the rock . . . but also the space between the rocks and between the rock and a man, the communication and contemplation between."

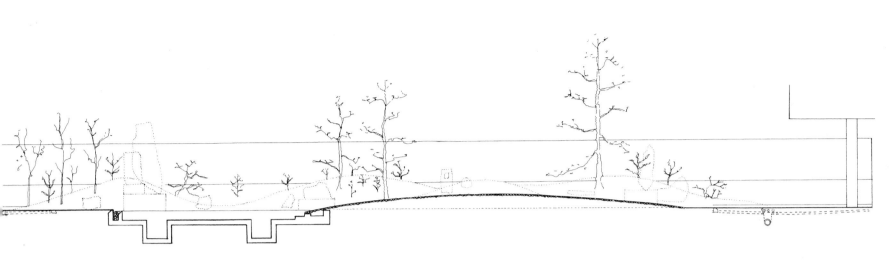

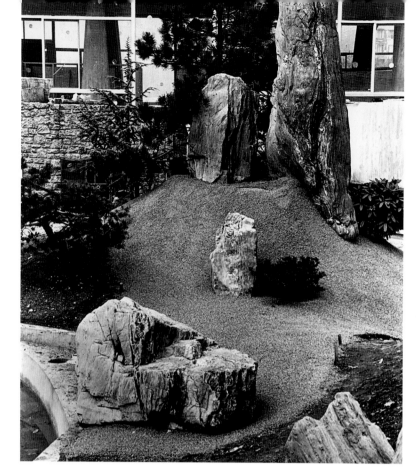

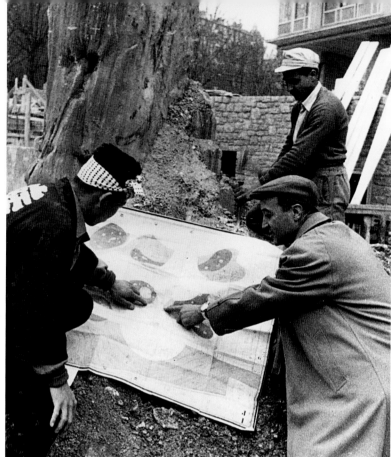

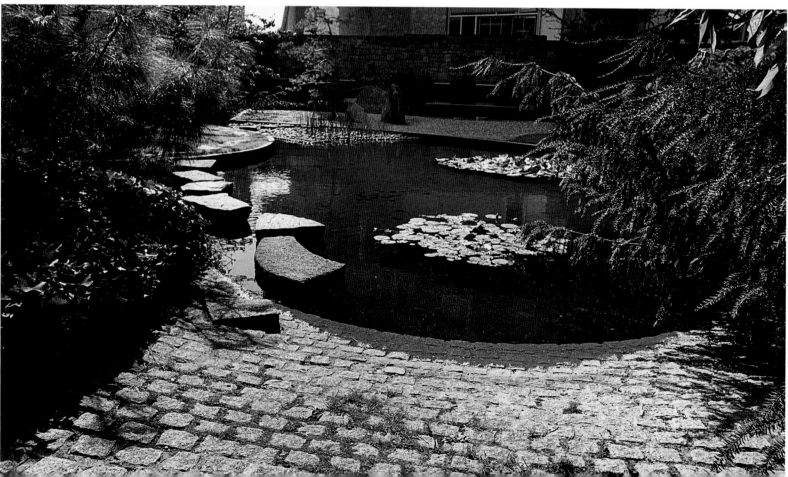

The Jardin Japonais was Noguchi's first large sculptural space. For the artist, this garden served as a sort of laboratory of experiences, a concentration of past and present elements from two cultures. The UNESCO project is a demonstration of Japanese and other important influences on Noguchi. The artist also drew upon his earlier work on playgrounds, referred to ideas he developed in his stage design work with Martha Graham—among them, a general notion of illusionist space that carefully weighs relationship and scale—and, most important, applied his experience of Japan through both its traditional gardens and theater. The UNESCO design was crucial for Noguchi, since it brought him closer to the traditional Japanese expressions of nature employing rocks and water—elements he used widely in later works.

In Japan, Noguchi discovered the many variations of fitted stone patterns for walls and stairways, and the ancient principles of the Kyoto garden, which used rocks as a structural core and treated plants as the ephemeral elements (figs. 83 and 84). Rocks are the basic elements in Noguchi's concept of the garden, the symbols of a continual search for a way to link ritual aspects to our modern times and needs. Noguchi constantly explored the Japanese belief in the mythic capacity of rocks—the ancient notion that they contain the imprint of life, nature, and history. It was these qualities Noguchi sought to stress, while using the basic element of stone to represent the powerful and traditional metaphor of the mountain, which for the Japanese is the highest expression of sculpture. The UNESCO gardens, however, reflect Noguchi's personal interpretation of the overall Japanese philosophy of space in the traditional garden: "While the spirit of the garden is Japanese, the actual composition of the natural rocks is my own . . . Everything in the garden is thus given a personal twist, and so it may not be considered a true Japanese garden . . . More truthfully, I should say I never wanted to make a purely Japanese garden."[39]

UNESCO GARDENS

FIGURE 82

Sacred Mountain
Horai, the symbolic, sacred mountain in Japanese gardens, became one of the elements with which Noguchi created an illusion of scale and perspective the viewer experiences only when moving through the space.

FIGURE 83

Isamu Noguchi working with Japanese gardener during construction, c. 1957–58
Noguchi did not follow Japanese gardening traditions strictly, and this caused more than one conflict between him and Touemon Sanō.

FIGURE 84

Detail of Jardin Japonais
Traditional elements such as stepping-stones (*tobi-ishi*) and water as a reflecting element were incorporated into Noguchi's composition.

PROJECT FOR ASTOR PLAZA
BUILDING, NEW YORK,
1958 (unrealized)
Architect: Carson & Lunden

FIGURE 85
*Noguchi working
with Shoji Sadao, 1959*
At the same time that Noguchi began
to develop a series of sculptures with
new materials, he also began his
twenty-nine-year collaboration with
the architect Shoji Sadao. Sadao
assumed responsibility for Noguchi's
projects after his death in 1988.

FIGURE 86
*Sculptural elements for Astor
Plaza Building*
Working within the theme of transform-
ing the elements of daily life into
sculptural features, Noguchi created, as
he had with his playground equipment,
a formal vocabulary of urban
furniture as manufactured objects.

> SCULPTURE IN THE TRADITIONAL SENSE IS, BY DEFINITION, SOMETHING WITH BUILT-IN VALUES OF PERMANENCE, "FOREVER BEAUTIFUL," SOMETHING OF SHAPE AND MATERIAL THAT "DEFY TIME." BUT THEN THERE IS THE OTHER REALITY OF THE EVANESCENT NEW—THAT TRUTH BORN OF THE MOMENT. CHERRY BLOSSOMS IN OLD JAPAN, OR ONE JUMP AHEAD OF OBSOLES-CENCE IN THE MODERN. I HAVE THOUGHT OF THIS, TOO, AS SCULPTURE.[40]

Noguchi moved back to New York in 1958 after completing his work on the UNESCO gardens. His return stirred within him the usual mixture of elation and depression, and his time abroad had made him all the more sensitive to contrasts between America and Japan, as well as the rest of the world. He had become more conscious of his own sensibility in responding to the different realities he had experienced—the permanence of the old world, exemplified by Japan and India, and the transience of the new, as found in modern-day New York City.[41] Conscious of this new reality, Noguchi began to look for a novel means of expression and new materials that would evidence the contemporary world—one that was industrial and influenced by new technologies and science.

Noguchi began using aluminum sheets to make sculptures that he described as a "timely and weightless way of expression."[42] His friend Edison Price, a manufacturer of lighting equipment, provided technical advice. Noguchi also initiated what would become an ongoing collaboration with the architect Shoji Sadao, who, at the time, was working with Buckminster Fuller. In the 1970s and 1980s Sadao became the collaborating architect for nearly all of Noguchi's projects (fig. 85).

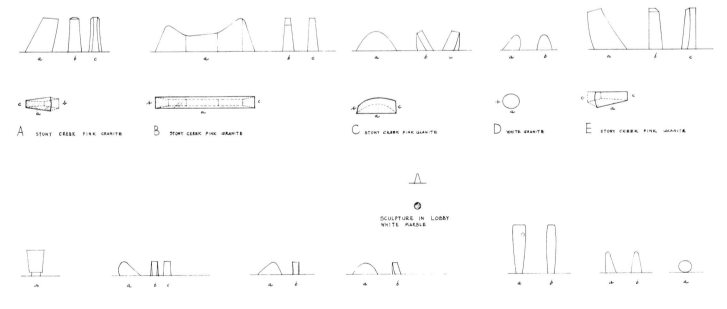

A STONY CREEK PINK GRANITE B STONY CREEK PINK GRANITE C STONY CREEK PINK GRANITE D WHITE GRANITE E STONY CREEK PINK GRANITE

SCULPTURE IN LOBBY
WHITE MARBLE

F BLACK GRANITE G STONY CREEK PINK GRANITE H STONY CREEK PINK GRANITE I THIS PIECE FOR PARK AVENUE
STONY CREEK PINK GRANITE 1 WHITE MARBLE 2 WHITE MARBLE 3 WHITE MARBLE

SCULPTURED FORMS
FOR ASTOR PLAZA
SCALE: 1/8" = 1'-0" SEPT. 3, 1957

PROJECT FOR ASTOR
PLAZA BUILDING
FIGURE 87
Model
Noguchi's concept of sculptural space
began to take on a more defined and
articulated form of expression. His
sculptural vocabulary at this time con-
tinued to reference modernist princi-
ples such as Piet Mondrian's concepts
of dynamic symmetry.

Noguchi was commissioned to design the exterior area in front of the Astor Plaza Building, which was designed by the architectural firm of Carson & Lunden. Very little documentation of the proposal exists other than some photographs of the now lost model. It is known, how-ever, that for this project Noguchi returned to the modernism of Jean Arp, Constantin Brancusi, Paul Klee, and Piet Mondrian. As in the UNESCO Gardens, this modernism was combined with the artist's notions of a reduction to the essential, an economy of means, and a desire to integrate a spiritual expression of Zen into his work (fig. 86).

Noguchi designed the plaza's pavement in an orthogonal pattern that seemed to allude to Mondrian's concept of dynamic symmetry. The pavement was an interpretation of the compositional relationship between the different planes and the ground in which he placed sculp-tures and a grid of trees.[43] The artist joined three discrete elements in a seamless arrangement—freestanding sculptures, sculptures that were conceived as urban furniture, and tree planters—to produce an overall harmony (fig. 87). Within the tree planters, he achieved a spare equilibri-um that is characteristic of Japanese gardens—that is, sculptures, bench-es, and trees are all in balance with one another.

Noguchi's formal knowledge came from his deep understanding of a sculptural space and his belief in the need for physical movement in order that a viewer perceive the three-dimensionality. The real challenge that the artist set for himself was to express his understanding of the evocative aspect of a sculpture—the myth.

Noguchi was commissioned to design the exterior plaza for the First National City Bank Building in Forth Worth, Texas, in 1960. As a counterpoint to the site, Noguchi envisioned a group of sculptures at the building's entrance, organized orthogonally. The elements of the sculpture group were conceived as corners of a virtual square. Noguchi resolved to create this group out of Tsukuba granite (fig. 88) and convinced his client that only rocks from Tsukuba Mountain in Japan were appropriate for the project. His insistence required that a half-mile-long road be built to gain access to the particular rocks he wanted, just as it required the Japanese government to give him eighty tons of rocks.

The First National City Bank Building plaza marks the prelude to a more continuous collaboration between Noguchi and Gordon Bunshaft that yielded a series of gardens in the 1960s. Bunshaft believed that architecture should enrich a visual experience by maintaining contact with the art of its time. He had a firm conviction that Noguchi's unique spatial abilities balanced the rigor of architecture and the freedom of nature. In the architect's quest for original and creative solutions, Bunshaft was a positive challenge to Noguchi's imagination.

The sculpture group for the First National City Bank Building plaza completed the series of family sculptures that Noguchi had designed for the Lever Brothers Building (1952) and the Connecticut General Life Insurance Company (1956–57). These sculptural "families" are particularly significant because they suggest formed space rather than serve as discrete elements that mark locations within an environment. The stones were broken and reassembled to create a balance of crudely carved, fluted, and polished surfaces. Here the monolithic group of stones forms a square and characteristically evokes myth and metaphor.

The First National sculptures are complemented by three planting areas in which native plants, such as cacti and yucca, are arranged (fig. 89). In one of these plantings areas, Noguchi placed the smallest sculpture element; the "child," only six feet tall, stands apart from the others facing

FIRST NATIONAL CITY BANK BUILDING PLAZA, FORT WORTH, TEXAS, *1960–61*
Architect: Gordon Bunshaft/ Skidmore, Owings & Merrill
FIGURE 88
Sculpture group, Tsukuba granite, three elements 20 feet, 12 feet, and 6 feet
The elements in the plaza become metaphorical figures for humanity, for loneliness. When Noguchi interpreted these in his dance set design for Martha Graham's *Alcestis*, they symbolized home.

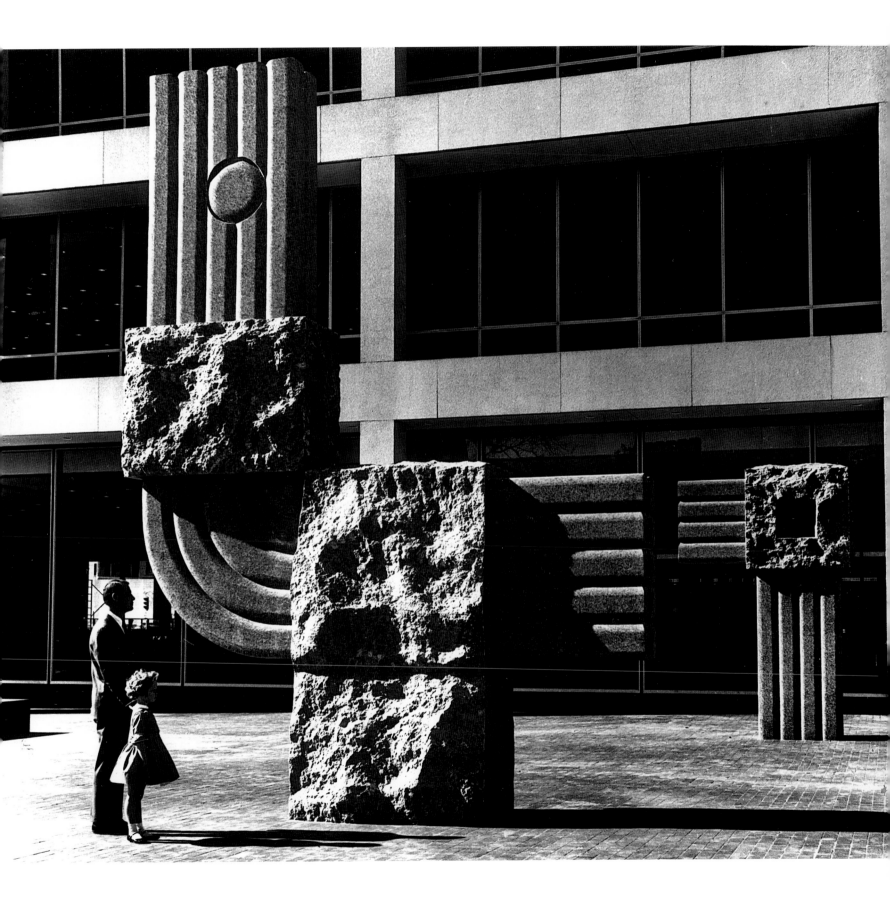

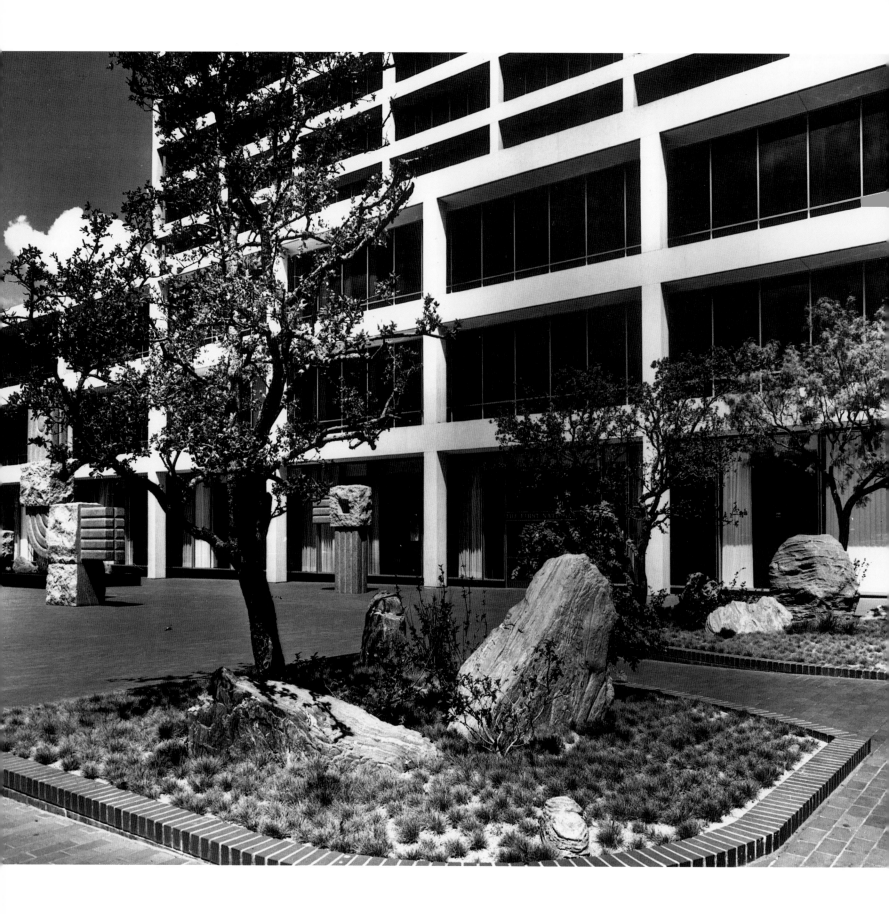

FIGURE 89
*View of planting areas and
sculpture group*
Similar to the Lever Brothers courtyard,
in which the sculptural elements have
a direct relationship with the reflecting
pool, in this plaza the sculptures rise
from the planting beds. Noguchi chose
only native species of flora to represent
the Texas landscape.

south. He had used a similar sculptural arrangement in his Lever Brothers
Building proposal. There, one of the sculptures was to be located inside a
circular pool while the other two were to stand apart from it.

The medium-height figure, the "mother," distinguished by a square
void carved into stone, rises twelve feet from the plaza floor and forms
the upper corner of the virtual square. Together with the tallest figure,
the "father," mother and child frame the entrance to the building.

The father, a twenty-foot-high piece, is characterized by a small cir-
cle at its highest point. Conceptually, this orthogonal sculpture forms
the square's lower corner and faces east. It is placed close to the building
and, as Noguchi wrote in his autobiography, is a symbol of loneliness. In
the 1960s and 1970s Noguchi continued to use orthogonal figures in
work such as his set for Martha Graham's dance *Alcestis* (1960) and his
sculpture *Eros* (1966).

When the First National City Bank Building plaza was completed,
Noguchi described it as a piazza with one sculpture formed by a number
of elements.[45] The concept of the piazza as a theatrical stage became
stronger and more defined for Noguchi as his career matured. From the
"floating" platform designed for the Lever Brothers Building to the
theatrical illusion at the UNESCO Building, Noguchi's concept of plaza
and garden as spatial elements that integrate different pieces into a single
sculptural space had become clearer.

THE GARDEN OF THE YALE LIBRARY IS MADE ENTIRELY OF WHITE MARBLE AND IS INTENDED TO EVOKE A DRAMATIC LANDSCAPE. ITS ORIENTATION IS TOWARD THE LIBRARY BUILDING AND TOWARD THE MAIN READING ROOM. THE LANDSCAPE IS PURELY THAT OF THE IMAGINATION; IT IS NOWHERE, YET SOMEHOW FAMILIAR. ITS SIZE IS FICTIVE, OF INFINITE SPACE, OR CLOISTERED CONTAINMENT.[46]

Edwin John, Frederick William, and Walter Beinecke, brothers and presidents of the Fuller Construction Company, began donating their collection of rare books and manuscripts to Yale University's Sterling Library in the early 1950s. Later, when the Sterling Library ran out of space for its holdings, the two surviving brothers offered to donate money for a new building to house the university's rare book collection.[47]

Originally, Paul Rudolph, dean of Yale's School of Architecture, had wanted to organize a design competition among four leading architecture firms, including Skidmore, Owings & Merrill. Gordon Bunshaft as a rule refused to compete, and the competition never took place because James Babb, chairman of the Yale Building Committee, decided to select one firm only—and that was in fact Skidmore, Owings & Merrill. Three weeks later, Bunshaft was commissioned for the project.

From 1960 to 1964 Noguchi and Bunshaft worked on the library's design. Noguchi understood that Bunshaft saw this project as a once-in-a-lifetime opportunity to make something great and lasting.[48] With Noguchi sharing that desire, both men succeeded. From the beginning Bunshaft's main concept was to create a "column of books, glass-enclosed, of several levels, with proper humidity and light control in a great exhibit hall, with the remainder of the books below ground."[49]

The library's design re-created the spirit of medieval monastic libraries, in which books were venerated objects. The sunken courtyard recalled the cloister that traditionally surrounded such libraries. The design could have been described by the abbot in Umberto Eco's *The Name of the Rose:* "The library defends itself, immeasurable as the truth it houses, deceitful as the falsehood it preserves. A spiritual labyrinth, it is also a terrestrial labyrinth."[50]

Noguchi approached the design of the courtyard with the concept of unitary space in mind, seeing it as an extension of the architecture. He proposed two preliminary concepts, both based on sand mounds from Japanese temple gardens. In the first, he proposed shaping the earth, as he had done in his earthworks and playgrounds from the 1930s and 1940s (figs. 90 and 91). The clients did not approve this concept, however. The second design (figs. 92 and 93) was based on geometry and symbolism taken from elements in the Samrat Yantra Observatory astronomical gardens in India. Noguchi had visited and documented the observatory in 1950, traveling on his Bollingen Foundation fellowship.[51]

Noguchi had two special gallery exhibitions, before and after the Beinecke commission. The first, at the Stable Gallery in New York in May 1959,[52] was an homage to Brancusi and to the sculptural values Noguchi associated with him. The second, at the Cordier and Ekstrom Gallery in New York in April 1965, was an exhibition of Noguchi's stone work done at the Henraux marble quarries in Querceta, Italy—where Michelangelo's spirit permeates the countryside. The Beinecke sunken garden reveals his deep interest in classical Italian sculpture, formal

ISAMU NOGUCHI

SUNKEN GARDEN FOR
BEINECKE RARE BOOK AND
MANUSCRIPT LIBRARY,
YALE UNIVERSITY, NEW HAVEN,
CONNECTICUT, *1960–64*
Architect: Gordon Bunshaft/
Skidmore, Owings & Merrill
Marble, 40 by 50 feet
FIGURE 90
Sand Mountains Garden in Kyoto,
c. mid-1950s
The Beinecke garden is one of two
sunken gardens Noguchi created simul-
taneously with Gordon Bunshaft in
1960. In both cases, Noguchi referred
to dry Zen meditation gardens.

FIGURE 91
First proposal studies, bronze,
c. 1960–61
The first design proposal specified
two mounds as a variation on the white
sand mounds of Zen gardens.

paving patterns, and architecture, and makes particular reference to Michelangelo's Piazza del Campidoglio in Rome (1546).[53] Noguchi was fascinated by Michelangelo and his awareness of the individual's confrontation with the past, his deep understanding of sculpture, space, and stone. Michelangelo was, among his contemporaries, viewed as a master of irregularity, his work arousing perplexity and dissension. Noguchi's sunken garden shares Michelangelo's approach to the relationship between ancient and modern. From a neoplatonic viewpoint, history for both artists was "an eternal returning."[54] At the Piazza del Campidoglio, Michelangelo invented an extraordinary pavement of gray and white stone radiating outward, as if it were an elliptical orbit of symbolic light reflecting and making the natural light of the physical sky ideal.[55] Noguchi's geometric paving pattern shares this cosmological character. His pattern is created by the incision of lines in white marble, which represent magnetic energy lines (fig. 94).

By making the sunken garden invisible from the street-level plaza, Noguchi emphasized the illusory effect of space. The garden changes as the viewer's perspective shifts and as the sculptures are transformed by the sunlight moving across them. During the day, shadows and reflections are picked up and reflected by the glass walls, which enclose the garden and play an important role in Noguchi's concept of drama.[56] Viewed from above, the garden is an enigmatic white space that is reminiscent of the silence and the surreal atmosphere of Giorgio de Chirico's paintings.

Plants were an impossibility in the sunken garden because water leaks posed too great a threat to the book rooms located below the courtyard. Early in the project Noguchi and Bunshaft decided that the garden would be executed entirely in the Vermont marble that was being used on the exterior of the building. The garden was designed as a single sculpture, a minimal white marble platform on which three sculptural elements—a pyramid, a ring, and a cube—were placed to generate symbolic meaning (fig. 95). Noguchi reaffirmed the need for three elements in this and other similar situations by stating that "Three is a very convenient, elemental number. After all, one is a unit, you don't have any place to go. With two, you have a choice, but with *three*, you have an asymmetrical

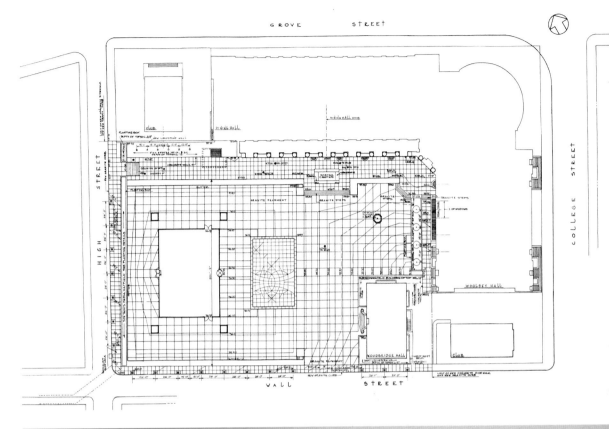

SUNKEN GARDEN FOR
BEINECKE RARE BOOK AND
MANUSCRIPT LIBRARY

FIGURE 92

Site plan

The final design reflected the spirit of
a medieval monastic library and its
relationship with the cloister around
which the life of the library developed.

FIGURE 93

*Plaster on wood model, 6 by 23 1/2
by 36 1/2 inches, c. 1961–62*

The sunken garden was conceived as
a single sculpture. Noguchi modified
his initial concept into another type of
minimalist space in which three white
marble elements rest on a white marble
platform incised with lines resembling
an astronomical pattern.

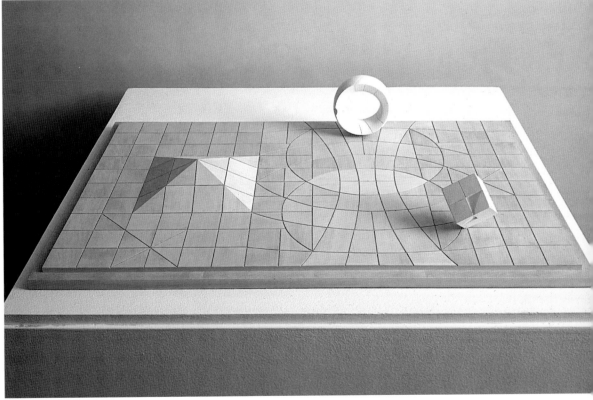

SUNKEN GARDEN FOR BEINECKE RARE BOOK AND MANUSCRIPT LIBRARY

FIGURE 94

Plan and elevation

Cloisters in the Middle Ages were planted with flowers and medicinal herbs as the pharmacy for the monastery. Noguchi's cloister evokes the cosmological symbolism of the geometric elements in the Samrat Yantra Observatory's gardens in India and Michelangelo's Piazza del Campidoglio.

FIGURE 95

View

Three sculptural elements rise from a marble platform: a pyramid, a ring, and a cube balanced on its point. Each element had several interpretations: the pyramid—the geometry of the earth, its past; the circle—the sun, the ring of energy, the zero of nothingness; the cube—chance, the human-made imitation of nature.

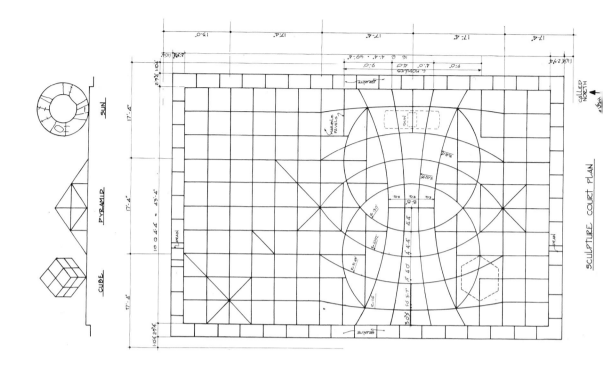

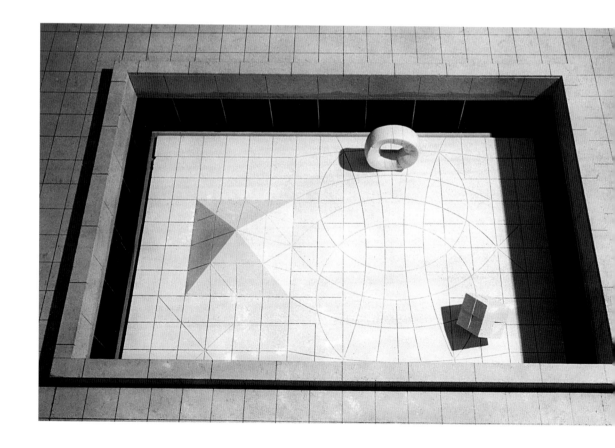

situation. Three is a triangulation."[57] The difference between viewing the garden from above and viewing it from the reading room is that the latter allows the spectator to understand the symbolic relationship among the three elements that appear to grow out of the marble slab (fig. 96): "The sun being more plastic could not stand apart from the rest, the cube and the pyramid had each to relate to each other and to the topography as a whole."[58]

Noguchi's design made use of the pyramid to symbolize the geometry of the earth or the past; its apex introduced another point, infinity. The pyramid shares the symbolism of the mound that covers bodies of the dead: it is a stone mound; it introduces perfection. The pyramid conveys the twofold meaning of integration and convergence. It is the ideal image of synthesis.

A ten-foot-tall circular disk—a sun—represents energy, the source of life. The circle has a hole in its center, signifying "the abyss, the mirror, the question mark."[59] In his autobiography, Noguchi gives another interpretation: "the circle as zero, the decimal zero, or the zero of nothingness from which we come, to which we return."[60]

For this commission Noguchi experimented with the concept of the ring and developed ten versions of the sun. He explained that "The tactile evolution of sculpture is, of course, more complicated than words, and impossible to describe."[61] These sculptural studies culminated in the realization of the large public sculpture *Black Sun* (1969), commissioned for the Seattle Art Museum by the National Endowment for the Arts.

The third element, the cube, stands on a corner point and symbolizes chance, the human condition and its relationship with nature, science, and technology. Noguchi later reinterpreted this concept of a cube on its point in his public sculpture *Red Cube* at the Marine Midland Bank Building in New York (1968). According to Noguchi, the elements in the sunken garden might yield infinite interpretations when contemplated—this, he argued, was the purpose of education. This conviction was also evident in his argument that playgrounds be places of experimentation for children.

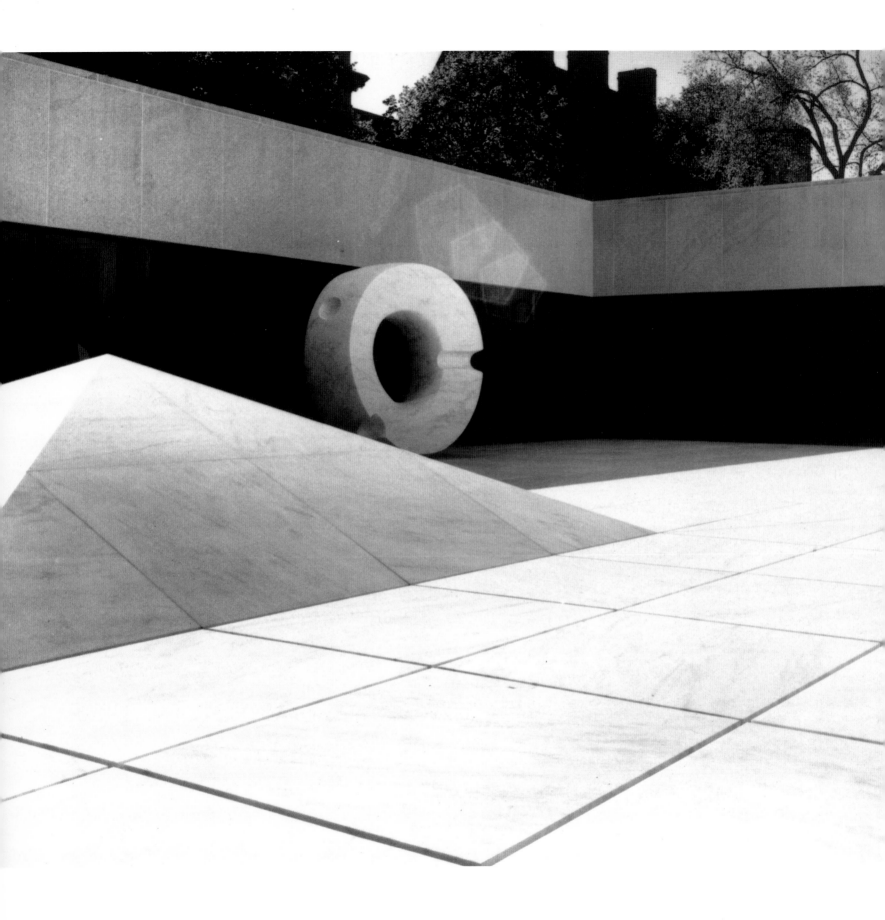

SUNKEN GARDEN FOR
BEINECKE RARE BOOK AND
MANUSCRIPT LIBRARY

FIGURE 96

View

Since the symbolism that appeared
in the column ornamentation of
cloisters often expressed the teaching
of virtue, the universe is expressed
through the symbolic triangular rela-
tionship between Noguchi's elements
at the Beinecke.

IN THE FALL OF 1960 BILLY ROSE, THE NEW YORK SHOWMAN, PROPOSED THAT I MAKE A SCULPTURE GARDEN FOR THE NEW NATIONAL MUSEUM BEING BUILT IN JERUSALEM, ISRAEL. I DECLINED. THIS HE WOULD NOT ACCEPT, CONTENDING THAT ONE WHO VOLUNTARILY INCARCERATED HIMSELF IN A WAR RELOCATION CAMP COULD NOT REFUSE SUCH A CHALLENGE. AN ARGUMENT MORE TO BE APPRECIATED WERE I JEWISH. BUT WHY NOT JEWISH? THE MAN IN THE FOREIGN OFFICE IN TOKYO HAD SAID, "FOR THE PURPOSES OF ART, YOU ARE JAPANESE"?[62]

While Noguchi was working on the sunken garden for the Beinecke Library, he was also commissioned to design the Billy Rose Sculpture Garden in Jerusalem. This garden was one of the most meaningful for Noguchi. Billy Rose sought out the artist for this garden because of his experiences in the Poston relocation camp and his continual search for identity. Rose was convinced that Noguchi could identify with the Jewish experience of rejection. And he was right—Noguchi's response to this project was a personal one.

The commission was to create a five-acre sculpture garden at an outdoor site allocated by the Israel National Museum for the permanent display of the Rose collection, which contains works by American and European artists from the nineteenth and twentieth centuries, including Charles Bourdelle, Alexander Calder, Charles Moore, Auguste Rodin, David Smith, and Noguchi himself. Rose donated his collection to the museum along with funds for its installation. Noguchi traveled to Israel to visit the site in 1961 and was fascinated by its location and character, a rock-strewn hill overlooking the city—"a challenge indeed!"[63] After his visit Noguchi felt connected with the country and people. As he later explained, "My going to Israel was in a way like going home and seeing people like myself who craved for some reason or other a particular spot on earth to call their own . . . The Jew has always appealed to me as being the endless, continuously expatriated person who really did not belong anywhere."[64]

The Billy Rose Sculpture Garden is not a garden for contemplation like those at the Beinecke Library and the Chase Manhattan Bank plaza. Instead, visitors enter a human-scaled space and encounter the vocabulary of undulating earth forms that Noguchi had developed in his projects of the 1930s and 1940s. This work represents Noguchi's successful

BILLY ROSE SCULPTURE GARDEN, ISRAEL NATIONAL MUSEUM, JERUSALEM, ISRAEL, *1960–65*
Architects: Dora Gad and Alfred Mansfeld
5 acres
FIGURE 97
Plaster, wood, and cardboard study model, 7 by 69 by 40 inches, 1960
For the Billy Rose Sculpture Garden, Noguchi designed a monumental series of five curved retaining walls using natural rock from the site.

FIGURE 98
Model, 7 by 69 by 40 inches, c. 1960–61
The architecture was fragmented into square pavilions in thirty-six-by-thirty-six-foot units to accentuate the characteristics of the topography. Noguchi's terraces reinforced the architectural concept by creating a parallel set of organic forms that allowed the sculptural garden to merge with the landscape.

FIGURE 99
Noguchi at construction site, c. 1961–65
Noguchi stated in his autobiography, "At the office of Alfred Mansfeld the Museum architect, in Haifa, working together and alone, I devised a model showing five curved retaining walls . . . Straight, they would have been of little interest."

FIGURE 100
Site plan and elevations
Located at the top of a hill known in the Bible as Neva Shaanan, or "place of tranquillity," the sculpture garden incorporates its surroundings and the character of the Judean hills into the design. Noguchi created a metaphor where the essence of place, nature, past, and present were all brought together.

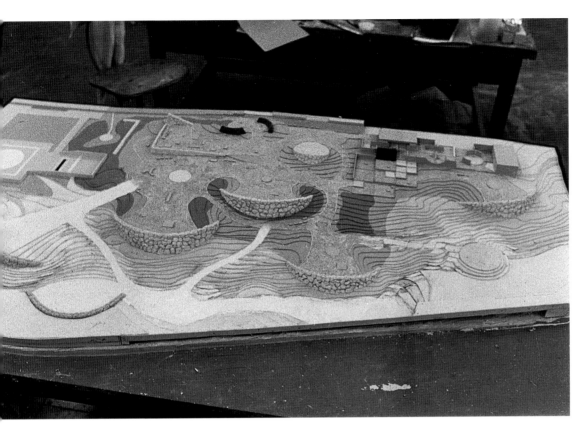
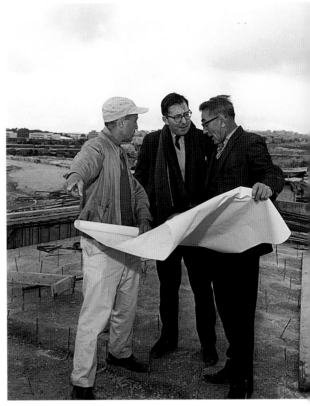
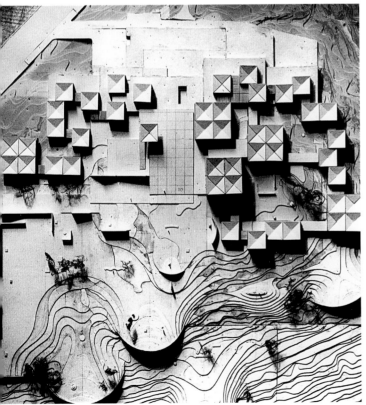
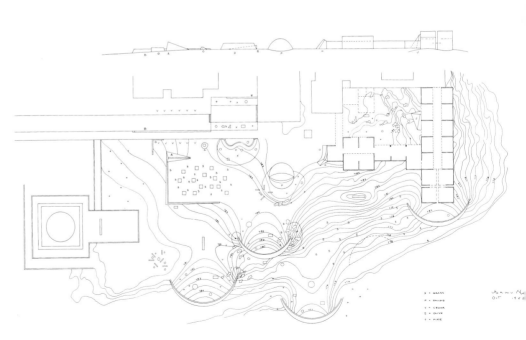

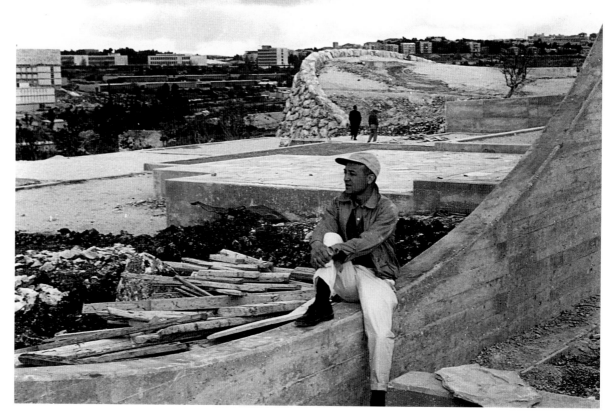

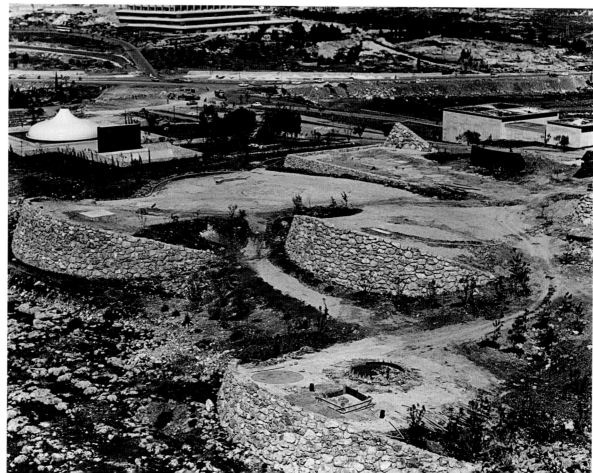

realization of his idea of the garden as one totally sculpted space experience that transcends the individual sculptures.[65]

Noguchi had learned the history of stone carving in Brancusi's studio by studying Michelangelo, and in Japan by learning about the stone spirit. On the other hand, the artist was aware of himself as part of the present, aware of himself in confrontation with the past. The combination of these circumstances and insights helped him to understand the relationship between earth, human history, and the future.

This sculpture garden was conceived as a large-scale earthwork. Noguchi divided his time between working by himself and working with the museum architects, Dora Gad and Alfred Mansfeld. Noguchi's first idea was five curved, rubblestone retaining walls (figs. 97 and 98). The double-curved walls were thirty feet high over a one-hundred-foot length. According to Noguchi, the walls were sculptures: "No, it is a piece of the earth itself, extending all the way to China."[66] He interpreted the ancient concept of the wall as an element of protection. The earthwork walls can be linked to land formations such as English Neolithic walls, Roman defensive ramps, medieval fortifications and castle moats, and the Great Wall of China (figs. 99 and 100). They also can be associated with the spirit of the Garden of Eden and humanity's drive to re-create a portion of Paradise by reworking the surrounding land in a search for tranquillity. Noguchi explained that "I hoped to create an undulating and walkable landscape, something memorable born out of the adversity of the terrain . . . a place, a garden, even a monument, but not a monument to any individual, rather to the people who would visit it and have hope."[67]

The sculpture garden was a gift to Israel. The walls create mounds within the landscape. As Noguchi explained, "They are like the hills of Judea; like the wings of prayer touching the sky. The sea of stones so characteristic of Israel's hills laps into the garden and coalesces in the crests of the giant arcs"[68] (figs. 101–3). Noguchi used rocks selected from the site to build the walls, and he chose olive trees and Jerusalem pines for the garden.

The sense of drama that Noguchi always brought to his gardens became here a living experience for the viewer. The sculptures can be

BILLY ROSE SCULPTURE GARDEN
FIGURE 101
Noguchi at construction site, c. 1963–65
Noguchi identified with the Jewish experience of rejection and responded in a very personal manner.

FIGURE 102
Aerial view of sculpture garden
The sense of drama that Noguchi always brought to his gardens became a living experience for the visitor. The sculptures can always be seen in contact with the earth and the sky as visitors walk up and down the hillside.

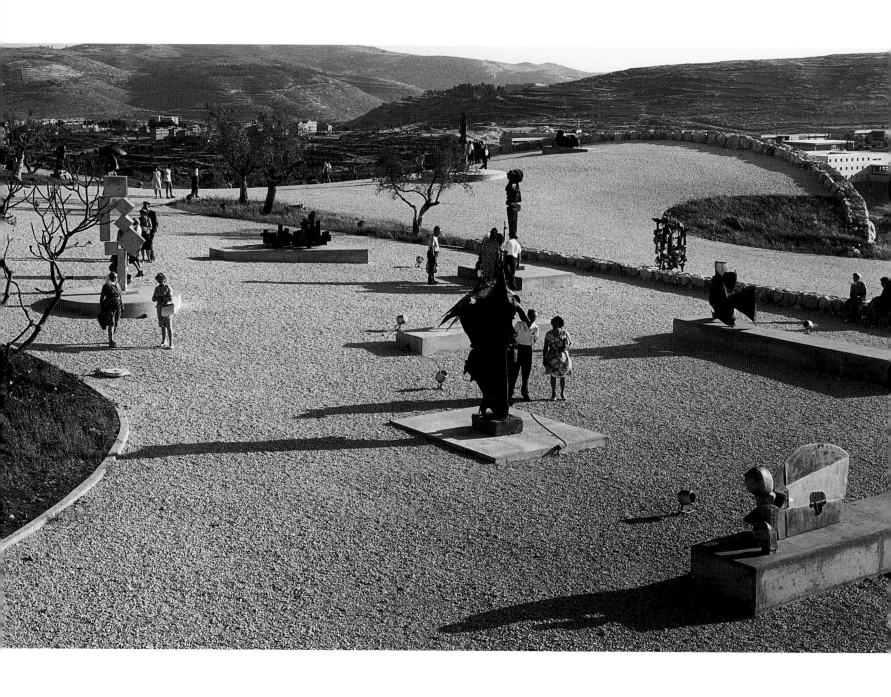

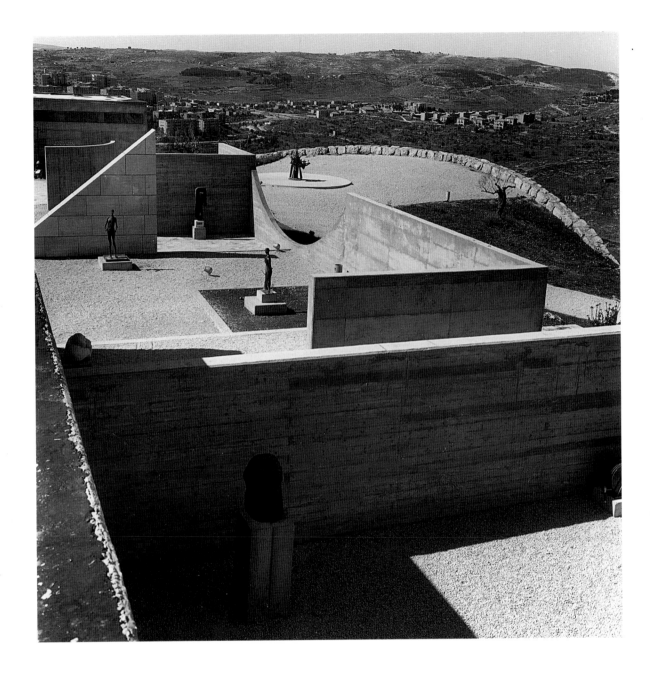

FIGURE 103

View

This garden is a magnificent example of
Noguchi's concept of sculptural space.
The viewer walks through the garden,
the sculpture, experiencing a dialogue
between the earth and the sky.

FIGURE 104

South terrace

Noguchi added a sequence of architec-
tural spaces adjacent to the museum
building for smaller sculptural pieces.

133

GARDENS, PLAZAS, AND PARKS

seen from a variety of perspectives, ever in contact with earth and sky, as visitors traverse the hillside. At the top of this hill—named in the Bible Neva Shaanan, or "place of tranquillity"—Noguchi placed a long, carved, horizontal fountain, the water of which flowed down cut stones.

Noguchi conceived this nontraditional design for the site as a series of roofless chambers on wide terraces rising from the earth. After the walls were finished in 1964, Noguchi realized that these terraces were not the best location for the collection's smaller sculptures. His solution was to create a small-scale outdoor exhibition area closer to the museum building. He proposed building a square stage adjacent to the building as the framework for a sequence of "architectural spaces"[69] defined by concrete geometric partitions that would provide a background for the pieces. The proposal was, as critic and curator Martin Friedman pointed out, a creative afterthought (fig. 104). The added expense that this entailed made Rose nervous, leading him to propose budget cuts, but Noguchi's persistence prevailed (fig. 105).

Designed by Gad and Mansfeld, the museum covers approximately twenty-two acres. More than twenty pavilions based on a series of thirty-six-by-thirty-six-foot units are roofed by hyperbolic shells supported on central columns. The architecture, like the sculpture garden, echoes the site topography and provides a continually changing series of spatial experiences that are reminiscent of the ancient Greek acropolis. Noguchi's original idea was to design the garden so that it would be integrated with the museum building, but Rose felt strongly that a boundary between the two was necessary. He wanted them to be separate, and Noguchi conceded by designing a self-contained space. Despite the concessions, Noguchi's design succeeded as a great, innovative garden that marked a personal victory for the artist in the way that space was treated to become a framework for sculptures. Noguchi proved to Rose that he was an architect and at the same time a sculptor who could blend gardens into hills.[70] For Noguchi was an architect—he had designed space using the basic tools of architects. As the artist began to see himself more as an architect he became more critical of his collaborators.

BILLY ROSE SCULPTURE GARDEN
FIGURE 105
Noguchi at Billy Rose Sculpture Garden, c. 1965
The harmonic relationship of elements that Noguchi brought to this commission was related to his earthworks of the 1930s. In both cases he sculpted the earth, in which rocks, trees, and sculptures were embedded.

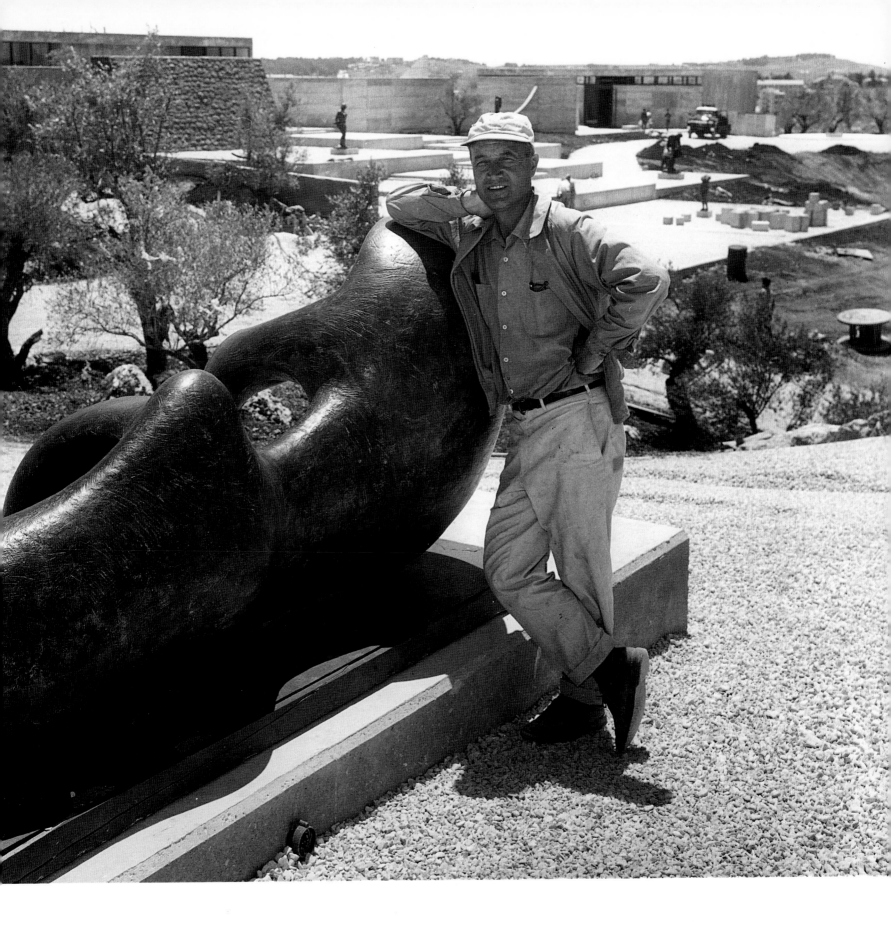

I FOUND MYSELF GETTING INVOLUNTARILY INVOLVED IN THE DESIGN OF A LARGE PROJECT TO REMAKE A PORTION OF RIVERSIDE PARK AS A CHILDREN'S PLAYGROUND FOR NEW YORK. IT WAS AS IF I WAS NO LONGER FREE TO CHOOSE—THE WORK CHOSE ME.[71]

This playground was initially conceived as part of a much larger plan for Riverside Park (fig. 106). Carried out over five years, it generated numerous proposals. The playground, which was conceived as a memorial to Adele Levy, was commissioned by Levy's niece Audrey Hess, who had originally proposed the U.N. playground to Noguchi. Recalling his previous experience with New York City's parks commissioner, Robert Moses, Noguchi felt he needed to associate with an architect of strong conviction. The artist persuaded Louis I. Kahn to join him (fig. 107). In August 1961 Noguchi and Kahn began a collaborative work period that would last almost five years. They shared a belief in cosmic order, history, and Euclidean geometry[72] (fig. 108). Noguchi was enthralled by Kahn's ideas of space and beauty: "I do not believe that beauty can be created overnight. It must start with the archaic first."[73] The collaboration was based on a continual exchange of ideas and documentation, with Noguchi bringing his models and work to and from Kahn's studio in Philadelphia. In the beginning, Kahn worked intermittently on Riverside Park until both men became fully involved in the project. Kahn eventually earned the artist's admiration. Noguchi explained: "Through all this there could not have been a more devoted and interested collaborator than Louis I. Kahn. A philosopher among architects, I came to feel that each meeting was an enrichment and education for me, and that I should not mind how long it took or how many models I had to make."[74]

As a result of the endless series of changes required by New York City's Department of Parks and Recreation, the artist and the architect collaborated on five different designs for Riverside Park.[75] Mayor Robert F. Wagner finally approved the project in June 1965. It could not, however, be realized before the next mayoral election, and when John Lindsay was elected, his new parks commissioner, Thomas Hoving, canceled the project. As in the 1930s and 1940s, in the 1960s Noguchi again found Robert Moses preventing him from building playgrounds.

RIVERSIDE DRIVE PLAYGROUND, NEW YORK, *1961–66 (unrealized)*
Architect: Louis I. Kahn

FIGURE 106
Isamu Noguchi working on Riverside Drive Park model in his Long Island City studio, c. mid-1960s
Audrey Hess commissioned Noguchi's design for the Riverside Drive Playground in 1960 as a memorial to her aunt, Adele R. Levy. After five years and five proposals, city and community politics prevented the project from being realized.

FIGURE 107
Isamu Noguchi with Louis I. Kahn in New York, 1961
Noguchi considered asking Philip Johnson to associate with him on the Riverside Drive Playground but decided to work with Louis I. Kahn.

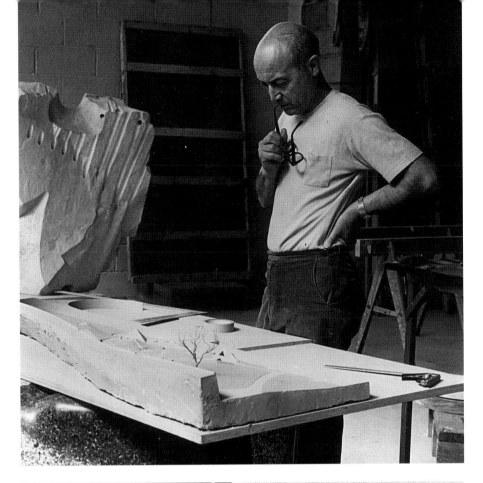

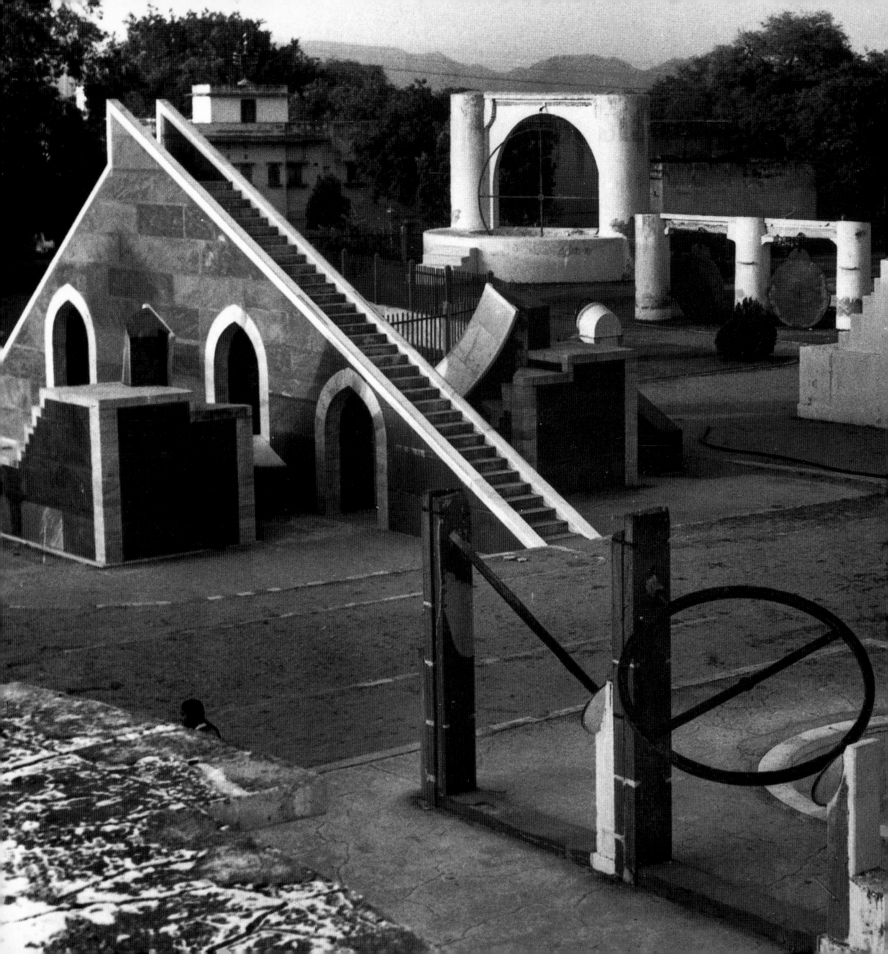

RIVERSIDE DRIVE PLAYGROUND
FIGURE 108
*Astronomical observatory built by
Maharajah Sawai Jai Singh II in
Jaipur, India, c. 1734*
Noguchi and Kahn shared a fascination
with the Jaipur observatory. Like
Noguchi, Kahn used as references the
geometry of the forms and elements
at the observatory. Kahn first
discovered the observatory through
Noguchi's photographs in the 1960
edition of *Perspecta*.

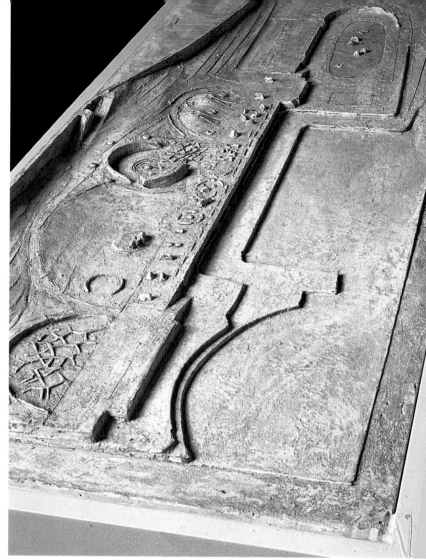

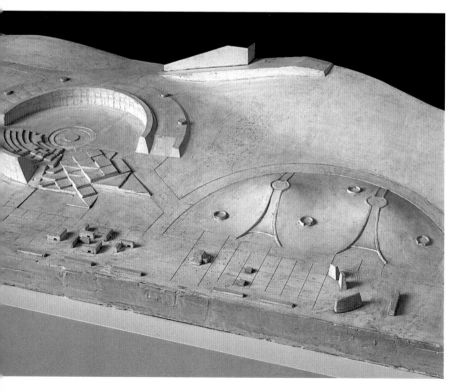

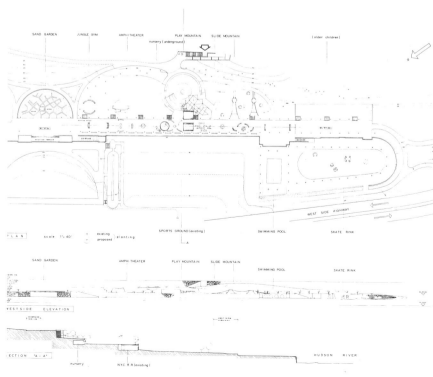

SAND GARDEN JUNGLE GYM AMPHI THEATER PLAY MOUNTAIN SLIDE MOUNTAIN (older children)

nursery (underground)

WEST SIDE HIGHWAY

PLAN scale 1"=40' existing planting
proposed

SPORTS GROUND (existing) SWIMMING POOL SKATE RINK

SAND GARDEN AMPHI THEATER PLAY MOUNTAIN SLIDE MOUNTAIN SWIMMING POOL SKATE RINK

WESTSIDE ELEVATION

SECTION "A-A"

nursery NYC R R (existing) HUDSON RIVER

FIGURE 109

First proposal study, 1961
Of all the proposals made by Noguchi and Kahn, the first covered the largest area. The initial sketch for the park featured only four basic elements: a circular amphitheater, a semicircular sand garden, a mound, and a skating rink.

FIGURE 110

Detail of bronze model (original in plaster) of first proposal, 1961
The underground nursery building rested beneath a cylindrical amphitheater. The slide tumuli were reminiscent of Noguchi's mounds and served as counterpoints to the semicircular area planned as the sand garden at the side of the nursery building. The esplanade was furnished with Noguchi's freestanding play elements.

FIGURE 111

Detail of bronze model (original in plaster) of first proposal, 1961
The core of the first proposal plan was a nursery building placed near Riverside Drive in the shape of a cup. Both Noguchi and Kahn designed an unrestrained space for children to play freely.

FIGURE 112

Plan and elevation of first proposal, 1961
The first proposal shared many basic elements with Noguchi's previous playgrounds and earthworks, including a similar concept of place and a yielding of architecture to shaped earth—ideas the artist had initially experimented with in Jefferson Memorial Park.

The team of Noguchi and Kahn suffered from political and social antagonism toward their new social interests in this public project.

During its five years, the project suffered major transformations in both design and site dimensions. Initially, the site area for plans submitted in December 1961 had been between West 101st and West 105th Streets (fig. 109). This first plan reflected Noguchi's ready collection of references: traditional Japanese gardens, Brancusi's *Table of Silence*, the Great Serpent Mound in Ohio, and the pyramids of Peru. Here, simple geometric forms from Noguchi's earliest earthworks and playgrounds were employed (fig. 110).

The intention was to supply a landscape in which children and adults of all ages could find enjoyment. The overall concept was based on the triangular relationship of three circular and semicircular forms, plus a longitudinal play area facing the Hudson River. A semicircular mazelike play area was situated in the northern section of the site. The nursery building, placed close to Riverside Drive, was the park's focus. Shaped like a circular cup, the nursery defined a central space that functioned as a fountain and a pool area during the summer and a sun trap during the winter. The architecture, in a sense, disappeared, enveloped by this play area. Noguchi proposed a semicircular play mound, with slides for climbing and sitting, to be placed close to the nursery. The existing esplanade was shown in a model furnished with Noguchi's playground equipment (figs. 111 and 112).

Even before the New York City Parks Department had made its first revisions, the scheme was changed. Because the western boundary had been moved to exclude the existing esplanade, a second design proposal was developed in which the main entrance was shifted to the south. The designated area extended from 101st to 103rd Street (figs. 113 and 114). The second version began to develop complex relationships between voids and masses, walls and stairs, and architecture and the earth. Three pyramidal structures were grouped around a central rectangular play area and surrounded by a long monumental staircase. Noguchi maintained a naturalistic play area that included slides positioned on earthen mounds and mazes intended to create a poetic relationship between children and the earth (fig. 115).

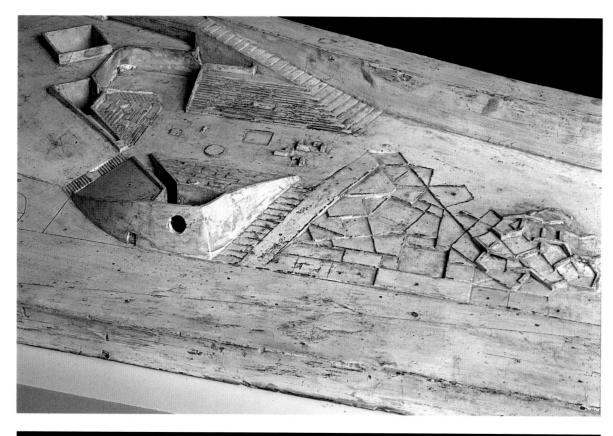

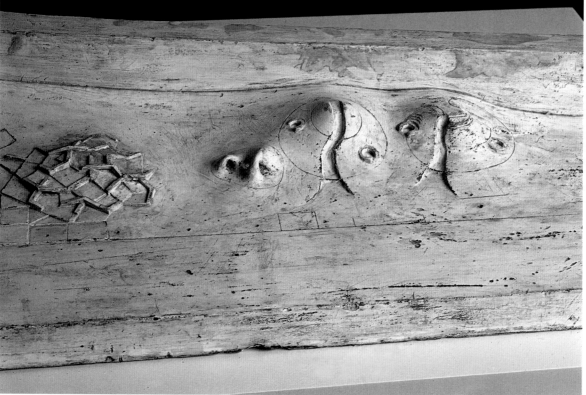

RIVERSIDE DRIVE PLAYGROUND

FIGURE 113

North end of bronze model (original in plaster) of second proposal, 1962
Before the Parks Department had reviewed the Noguchi-Kahn proposal, the site boundaries were changed and the esplanade was no longer a part of the design area.

FIGURE 114

South end of bronze model (original in plaster) of second proposal, 1962
The basic elements from the first proposal were transformed both in their shapes and locations in the second proposal: three pyramidal structures defined a central rectangular play area, and the two earth mounds were changed to include three slides.

FIGURE 115

Plan and elevation of second proposal, 1962
The second site was located between West 101st and West 103rd Streets. In the second version, Noguchi shifted the scheme to the southern area of the site.

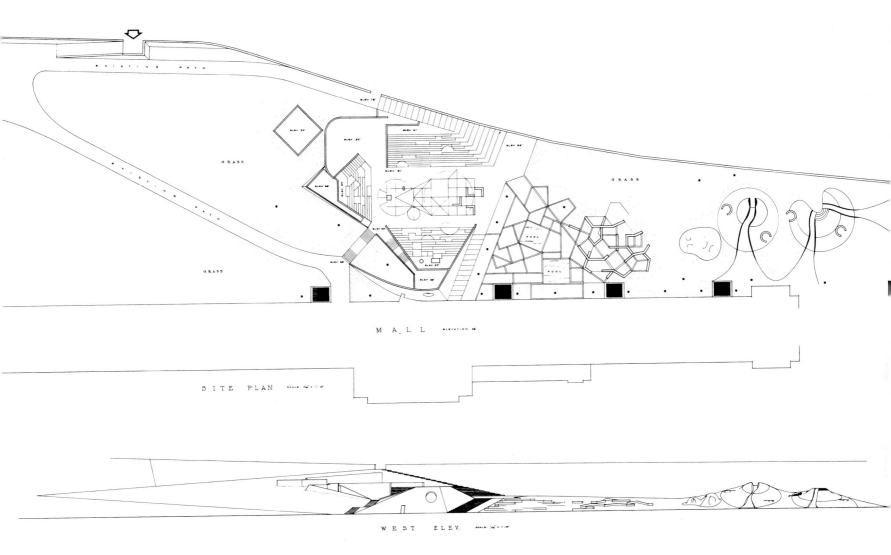

MALL ELEVATION 36'

SITE PLAN SCALE: 1/16" = 1'-0"

WEST ELEV. SCALE 1/16" = 1'-0"

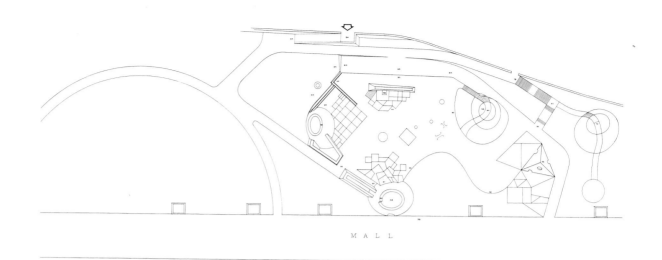

MALL

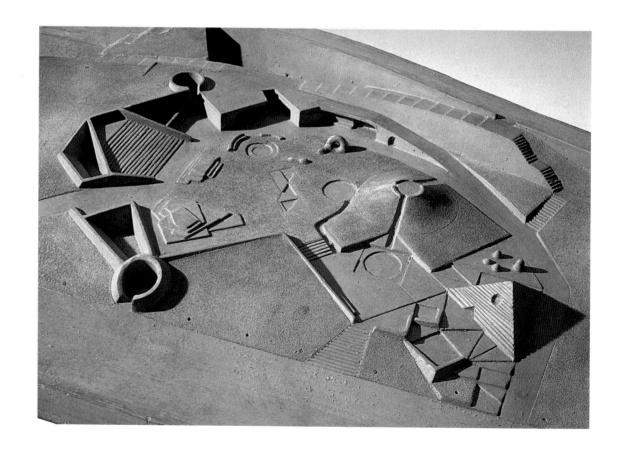

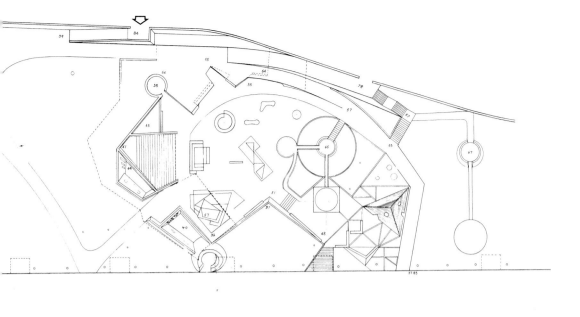

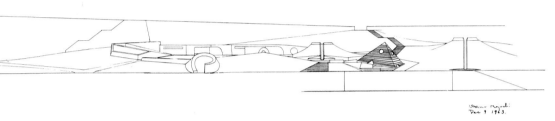

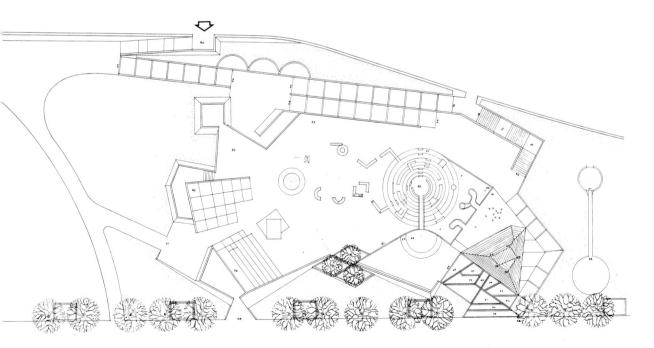

FIGURE 116

*Plan and elevation of
third proposal, 1963*
The third scheme responded to strong
criticism from the Parks Department,
and the boundaries were again
changed. The early forms of the first
proposal were gradually transformed
with bolder sculpting of the earth.

FIGURE 117

*Plaster model of third proposal,
4 1/2 by 35 1/2 by 19 1/2 inches, 1963*
The three pyramidal structures
were transformed into an undulating
play area and a retaining wall.

FIGURE 118

*Plan and elevation of third
proposal, 1963*
A pyramid element with tunnel holes
and two separate mounds—a conical
play mountain and a mound with a
slide—strengthened the role of the
play sculptures in the overall design.

FIGURE 119

*Site plan of fourth proposal,
April 1964*
The fourth design version included
slight changes in the shapes of
the elements and a new bank of
amphitheater seating.

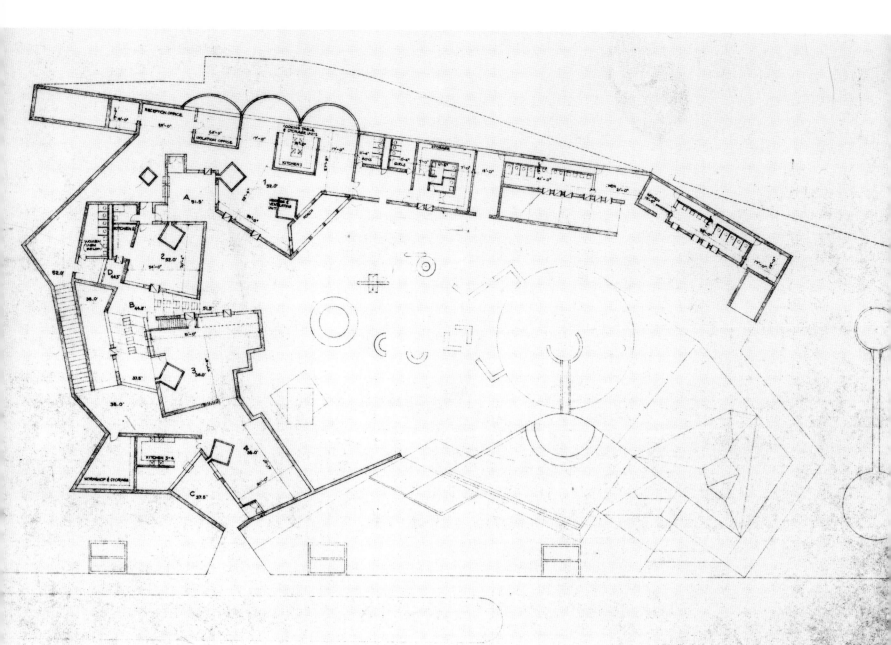

In October 1963, after strong criticism from the Parks Department, Noguchi and Kahn presented a third scheme. The area of the site was now further reduced; it stretched from 102nd Street to midway between 103rd and 104th Streets (fig. 116). The three pyramidal structures had been transformed into a retaining wall reminiscent of fortification architecture. Subsequent schemes included minor changes in the shapes of the amphitheater setting and the tetrahedral pyramid (figs. 117 and 118).

Noguchi and Kahn's later versions proposed the development of smaller and different areas within Riverside Park. Architecture, in these versions, assumed a stronger presence. The last three employed geometric shapes derived from elements of the eighteenth-century Samrat Yantra Observatory in India (figs. 119–25). In an odd juxtaposition of roles, Noguchi was responsible for inspiring Kahn, whose admiration for the astronomical observatory began in 1960 when he saw Noguchi's photographs of its instruments published in the Yale architectural journal *Perspecta*. The central area of these later proposals can be seen as an organic void contained between vertical walls. The hillside was carved to create a platform on which pools, walkways, mounds, tetrahedral pyramids, and play pieces were located.

Throughout the project, a lack of interest from the Parks Department, paired with antagonism from wealthy neighborhood residents, created a long series of objections and fruitless meetings. These frustrations were only a part of the painful process that would result in five different sets of models and plans being abandoned and unrealized.

The unique collaboration between Noguchi and Kahn left the artist with intense memories of admiration for the architect. Despite Noguchi's eventual dislike for architects, he carved a commemorative sculptural group dedicated to Kahn and fought to resolve bureaucratic obstacles to convince the Kimbell Art Museum in Fort Worth, Texas, to accept the work as a gift. In 1983, seven years after Kahn died, Noguchi finally installed *Constellation*, his sculptural homage to the architect, at the Kimbell.

RIVERSIDE DRIVE PLAYGROUND
FIGURE 120
*Underground-level plan of fourth
proposal, April 1964*
The main access stair from street level
to the play area was transformed
into a linear element and became a
prominent feature in the project
as a result of changes in the geometry
of the architecture.

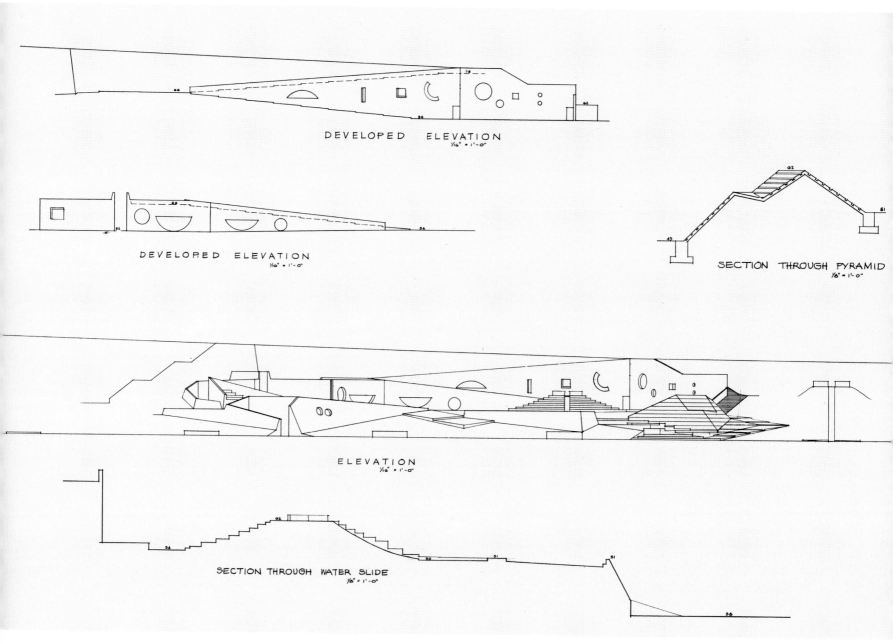

DEVELOPED ELEVATION
1/16" = 1'-0"

DEVELOPED ELEVATION
1/16" = 1'-0"

SECTION THROUGH PYRAMID
1/8" = 1'-0"

ELEVATION
1/16" = 1'-0"

SECTION THROUGH WATER SLIDE
1/8" = 1'-0"

FIGURE 121

*Sections and elevations of fourth
proposal, April 1964*

Changes in the conical play mountain
and in the central play area
exhibit refinements in the relationships
between the park elements.

FIGURE 122

*Bronze model (original in plaster)
of fifth proposal, November 1965*

The fifth design proposal, produced at
the end of 1964, encompassed a very
small area between West 102nd and
West 103rd Streets. Noguchi and Kahn
presented a simplified version that
omitted elements like the central coni-
cal play mountain.

FIGURE 123

*Site plan of fifth proposal,
November 1965*

Kahn's influence is obvious in the
treatment of the architecture.
The mound at the southern end, as
a fountain element, was tied to
the main play area through a stair
and ramp system.

FIGURE 124 *(overleaf)*

*Interior elevations and design of fifth
proposal, November 1965*

The system of staircases and ramps
became the articulating element,
a spatial link between the different
areas of the playground.

FIGURE 125 *(overleaf)*

*Sections of fifth proposal,
November 1965*

The play elements in the central play
area in the fifth proposal were simpli-
fied and reduced to a small climbing
pyramid, a play court, a splint, and a
sand pit. Each piece became a model
for the play equipment Noguchi later
realized in Kodomo No Kuni, Atlanta,
and Moere Numa Park.

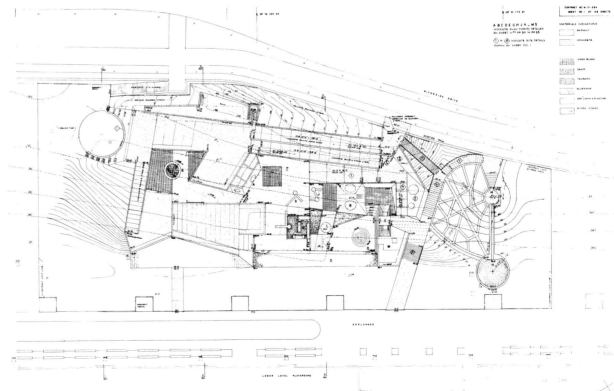

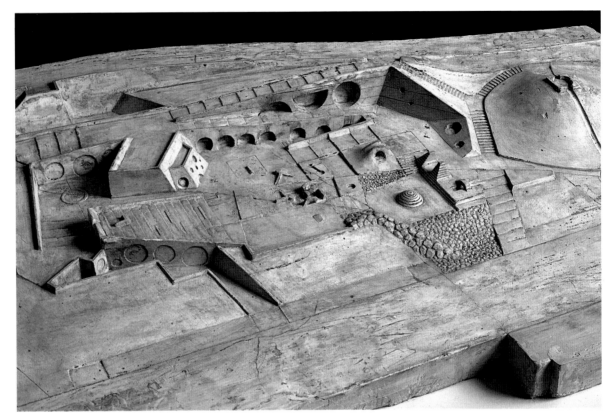

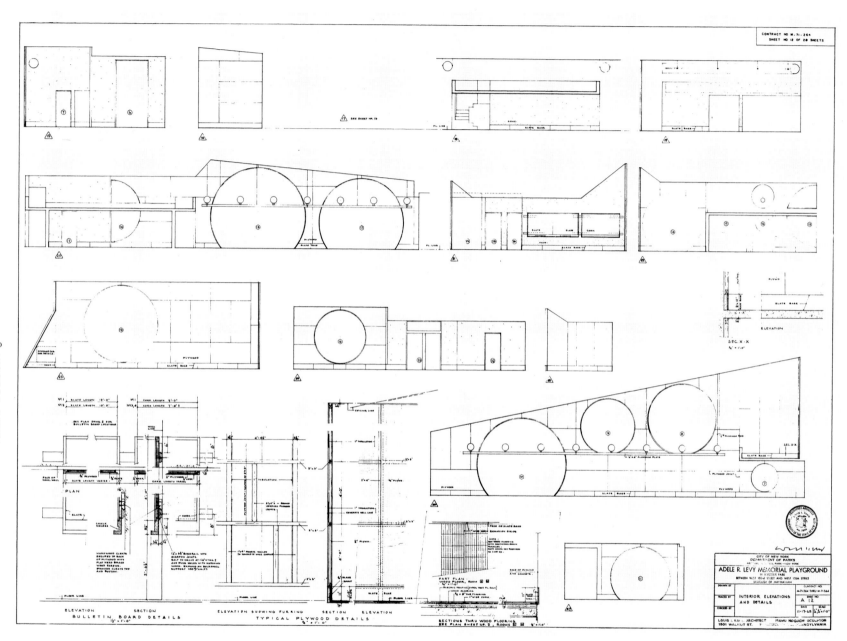

ELEVATION SECTION
BULLETIN BOARD DETAILS

ELEVATION SHOWING FURRING SECTION ELEVATION
TYPICAL PLYWOOD DETAILS

SECTIONS THRU WOOD FLOORING
SEE PLAN SHEET NO. 2, ROOMS

INTERIOR ELEVATIONS
AND DETAILS

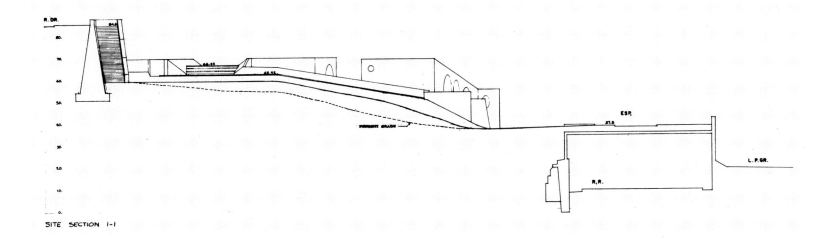

SITE SECTION 1-1

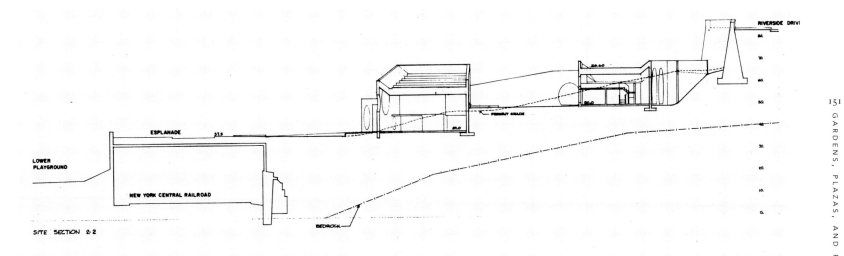

SITE SECTION 2-2

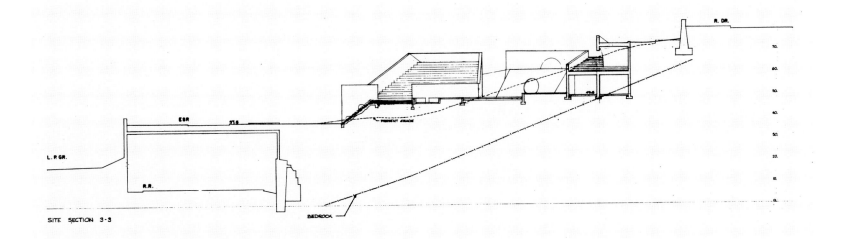

SITE SECTION 3-3

Skidmore, Owings & Merrill had begun work on the Chase Manhattan commission in the spring of 1955, before Noguchi began designing the sunken garden (fig. 126). He was already working on two other major projects: the sunken garden at the Beinecke Library at Yale University and the Billy Rose Garden in Jerusalem.

In the mid-1950s the city of New York allowed Chase Manhattan Bank to close off one block of Cedar Street in the Wall Street district, where the new bank was to be located, and build a rectangular tower, setting aside 70 percent of the site as public space. Ironically, it has been suggested that it was Robert Moses who most influenced the city's granting of permission for this project.[77] In 1959 David Rockefeller established a special committee for the bank's art acquisition program charged with purchasing and commissioning works of art for all parts of the building. Apparently, the committee was driven by the same trend to integrate the arts with architecture that had influenced the UNESCO art committee in 1956. Three years later, when Bunshaft asked Noguchi for advice in planning the plaza, the artist proposed a circular sunken garden and a major sculpture for the upper plaza (figs. 127 and 128). He received the garden commission but was disappointed to learn that the art committee had requested proposals from Alexander Calder and Alberto Giacometti for sculptures to be placed near the building. The committee, however, would not agree on any selection until 1973, when Jean Dubuffet's giant sculpture *Four Trees* was finally selected.

Impatient, Noguchi traveled to Japan in search of stones for the project well before he had received the bank's permission to proceed. He almost lost the largest stone because of the bank's inability to make quick decisions: "It took [the bank] a year to decide and, in the meantime, the great big stone (which is the most beautiful thing) was sold and I had a hell of a time trying to get it back again. It had been shipped to the other

SUNKEN GARDEN, CHASE MANHATTAN BANK PLAZA, NEW YORK, *1961–64*
Architect: Gordon Bunshaft/ Skidmore, Owings & Merrill
60 feet in diameter
FIGURE 126
Isamu Noguchi with first of seven weathered rocks to be placed in his "sculptural water garden"
Noguchi designed a rock water garden as a result of the building entry being moved away from an existing circular well.

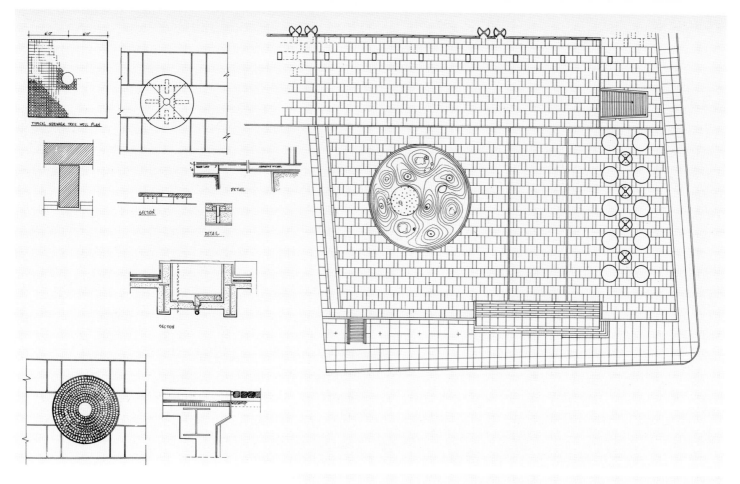

TYPICAL SIDEWALK TREE WELL PLAN

DETAIL

SECTION

DETAIL

SECTION

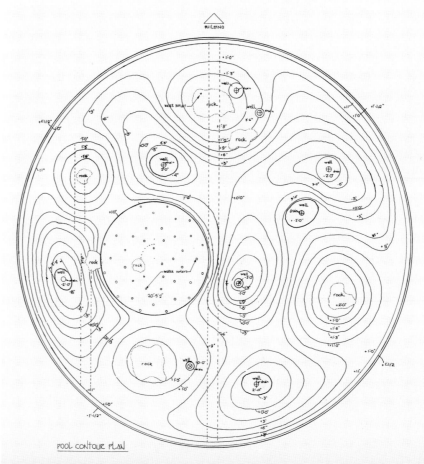

BUILDING

rock

POOL CONTOUR PLAN

end of Japan by somebody who had purchased it. I used every kind of pull I had to get it back"[78] (figs. 129–31).

In his New York studio Noguchi explored the idea of tension through the "levitation" of his work: "I wished to stress weight in the elements composing the sculptures, so that their weight would enhance the effect of floating in a gravitation field."[79] During his summer at the American Academy in Rome, he had developed other ideas for pieces that rested on the ground: "The floor of this studio, its coolness, fascinated me, the very idea of walking, standing, or lying on the hard cement became significant—that delicate point of contact of bare feet on the floor."[80]

Each of these ideas and experiences was transferred to the Chase Manhattan project. This garden was a culmination of the artist's interpretations and study of meaning in Japanese garden stones that began with his experiments at UNESCO in 1956. It was also his contribution of spiritual and symbolic significance to a modern reality: "Nature and non-Nature. There will come other gardens to correspond to our changing concepts of reality; disturbing and beautiful gardens to awaken us to a new awareness of our solitude."[81]

Noguchi said of the Chase Manhattan project, "It is my Ryōan-ji."[82] He was referring to the most famous Zen garden for contemplation, located at the Ryōan-ji Temple in Kyoto, Japan. Ryōan-ji is the supreme example of a dry garden; in it fifteen stones in five unequal groups are arranged asymmetrically in a rectangle of raked sand. The raked sand symbolizes water.

At Chase Manhattan Bank plaza, seven natural stones from the Uji River in Japan float on a wavy granite surface (fig. 132). Granite mounds serve, as at Ryōan-ji, to support the composition. Raked gravel is replaced by concentric circles of granite pavers interrupted by serpentine lines that allude to the stylized sea waves in Chinese paintings. The rocks are not part of the earth: they are "levitating"; they are human-made sculptures, but they are natural. This transposition was Noguchi's intention: "An unnatural thing of will as is our whole technological age—like going to the moon."[83] The undulating surfaces become shadows when the garden is flooded with a small amount of water in the summer. The

SUNKEN GARDEN, CHASE MANHATTAN BANK PLAZA

FIGURE 127

Site plan and details

Gordon Bunshaft asked Noguchi to study the new Chase Manhattan Bank site in the Wall Street district. In response to the six underground floors of the main building, the artist proposed a sunken water garden.

FIGURE 128

Site plan

The sunken garden created a place for contemplation in downtown New York City. Noguchi's reduction of materials suggests the Japanese attitude toward essence as reflected in Zen gardens.

SUNKEN GARDEN, CHASE
MANHATTAN BANK PLAZA
FIGURE 129
View
As at Ryōan-ji, the ultimate example
of a Zen contemplation garden,
Noguchi "floated" seven rocks on an
undulating granite surface. The
artist created a metaphor: the natural
rocks became human-made sculptures.
The rocks were not part of the earth—
they were "levitating."

stones emerge like small mountains in a pond, and the metaphor shifts
from dry gardens to Japanese ponds and the principles of "hide and
reveal" in Kaiyu stroll gardens. Katsura Imperial Villa, of the Edo Period
(1618–1868) in Japan, was the site of the first such gardens.

The Chase Manhattan and Beinecke Library sunken gardens
share concepts that emphasize changes in perspective and transforma-
tion in daylight. Contemplative and timeless gardens, both extend
the idea of reflection to the mythical dimension of the mirror. The
mirror is identified with the sun goddess Amaterasu, an essential
image in Japanese Shinto tradition; it also links a person to his or her
reflection. This link is a metaphor for the universal conflict
between reality and appearance that Plato posits in *The Republic* in
his lesson for approaching life. Platonic horizons governed by
illusion stimulated Noguchi's imagination. Noguchi was a master in
using water's surface to bring out these different readings.

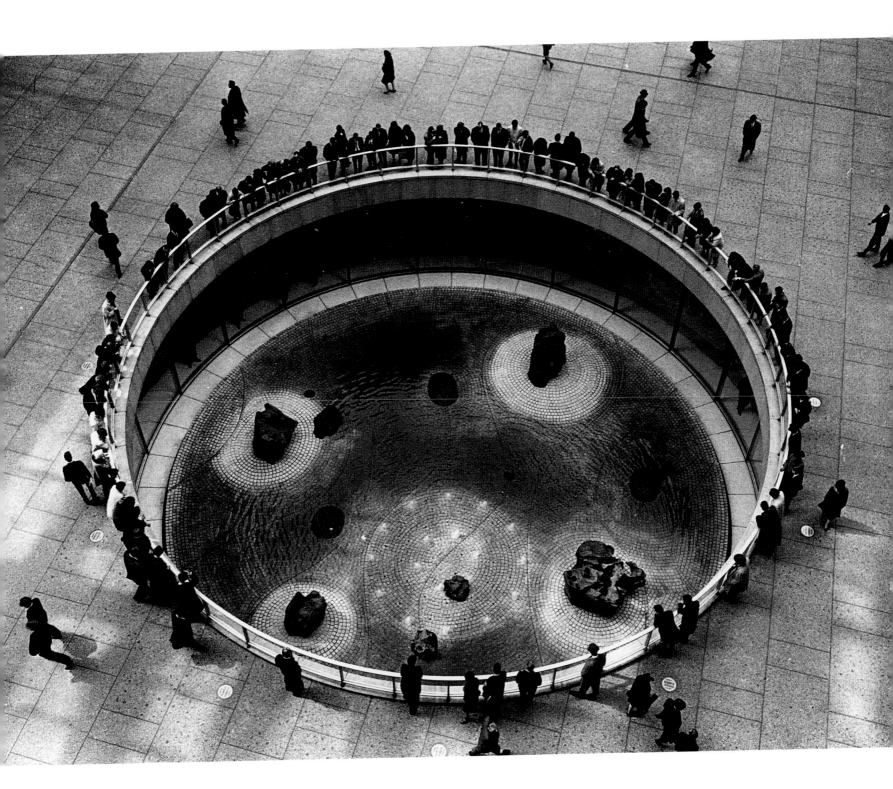

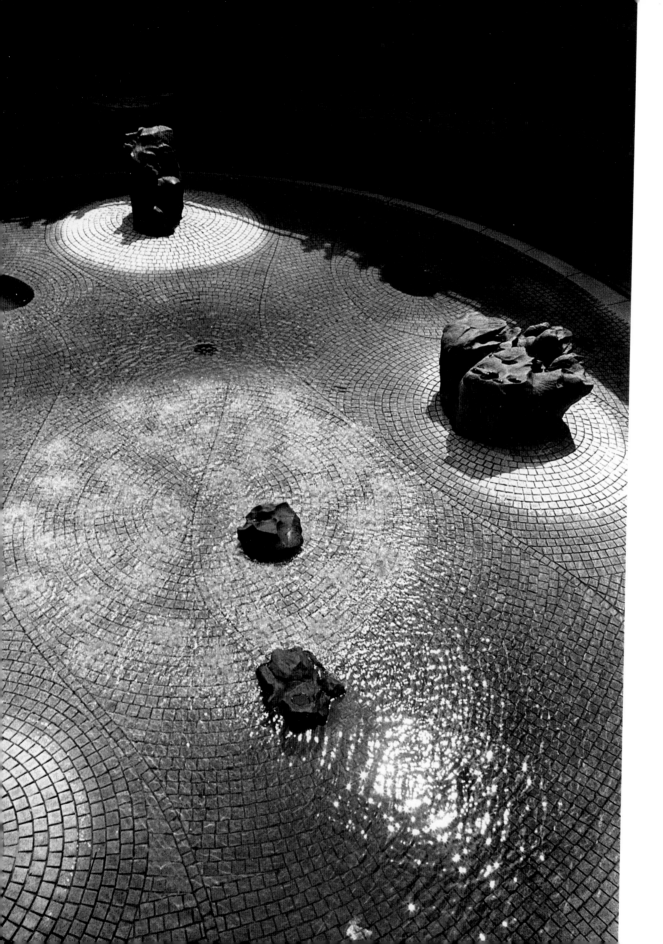

SUNKEN GARDEN, CHASE MANHATTAN BANK PLAZA

FIGURE 130
View

During the summer months water is introduced, and a transformation occurs. The stones emerge, like small mountains, from a pond. The water enters beneath the smaller stones through forty-five vertical pipes that produce bubbling effects.

FIGURE 131
View

Serpentine lines that evoke the stylized sea waves of Chinese paintings interrupt the concentric circles of granite pavers that symbolize the raked gravel of Ryōan-ji.

FIGURE 132
View

The natural rocks from the Uji River float on an undulating surface. The gentle pattern in the pavement suggests water in the winter months when the garden is dry.

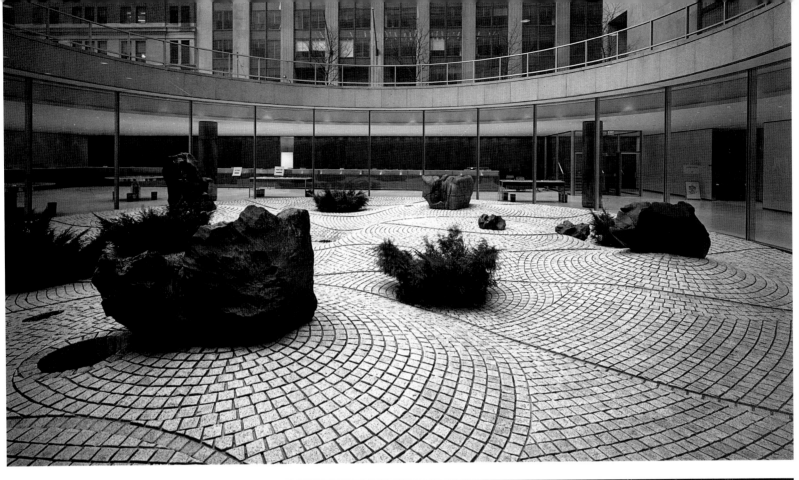

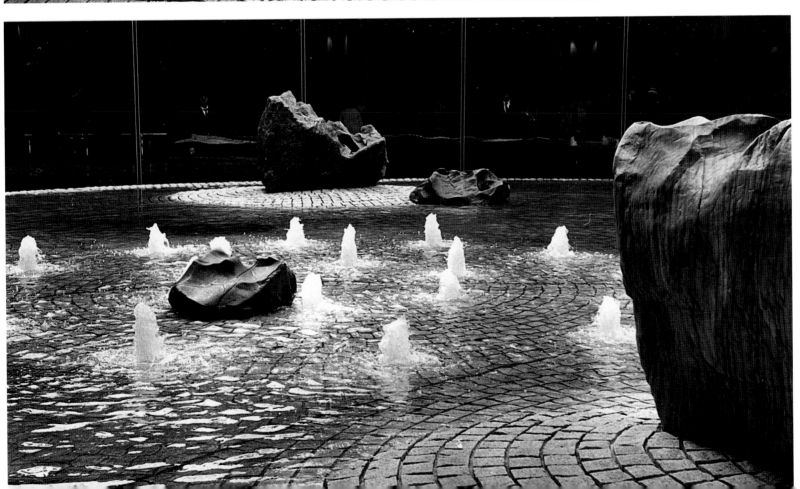

> I QUITE CLEARLY ATTEMPTED TO MAKE A GARDEN WITH NO ANTECEDENTS. THAT IS TO SAY, THE
> HALF HAVING TO DO WITH THE PRESENT—THE OTHER BEING ROOTED IN ROCK AND HISTORY. I
> WANTED TO MAKE A SORT OF ARCHAEOLOGICAL RECORD FOR THE FUTURE OF THE DISCOVERIES
> OF SCIENCE THROUGH THEIR SYMBOLS.[84]

GARDENS FOR IBM
HEADQUARTERS, ARMONK,
NEW YORK, *1964*
Architect: Gordon Bunshaft/
Skidmore, Owings & Merrill
FIGURE 133
*Noguchi studying sculpture models
for the IBM gardens in his Long Island
City studio, c. 1964*
After the contemplative sunken gar-
dens at Yale and in lower Manhattan,
Noguchi designed a more descriptive
garden in which the symbols of science
are inscribed "as in Egypt, for future
generations to read."

In 1964 Noguchi worked for the last time with Gordon Bunshaft, on a
garden design for two courtyards at the new International Business
Machines (IBM) Corporation Headquarters in Armonk, New York.
The two rectangular courtyards contained inside the building are divided
by an escalator core enclosed in glass walls. The courtyards reflect the
concept of duality, of the present confronting the past and future of
human-made nature (figs. 133 and 134).

Humanity's past is represented in the south court. The combination
of water, rocks, and trees symbolizes the most ancient periods, the
origins of the life-giving aspects of gardens (fig. 135). The references
span human history: the Garden of Paradise, the Garden of the Poets,
and the gardens of ancient Persia and India.

Water—and its sound, a symbol of life in the Garden of Paradise (or
Eden)—is represented by a still, rock-lined pool into which a vertical
stone fountain trickles water (fig. 136). Around this fountain, Noguchi
situated the only benches in the entire project, which created a place for
meditation. He carefully selected dogwoods, magnolias, and pines—
trees from the Old and New Testaments. For this project Noguchi did
not bring in stones from some remote area in Japan but instead used
fragments of on-site bedrock from excavation blasts (figs. 137 and 138).

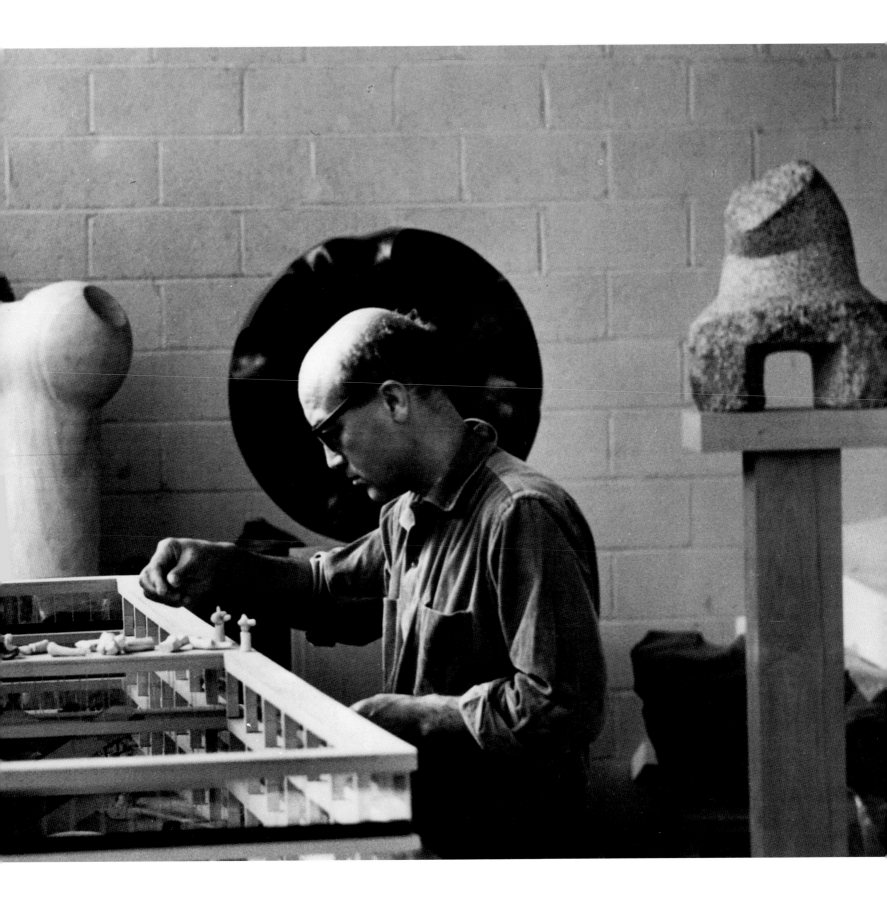

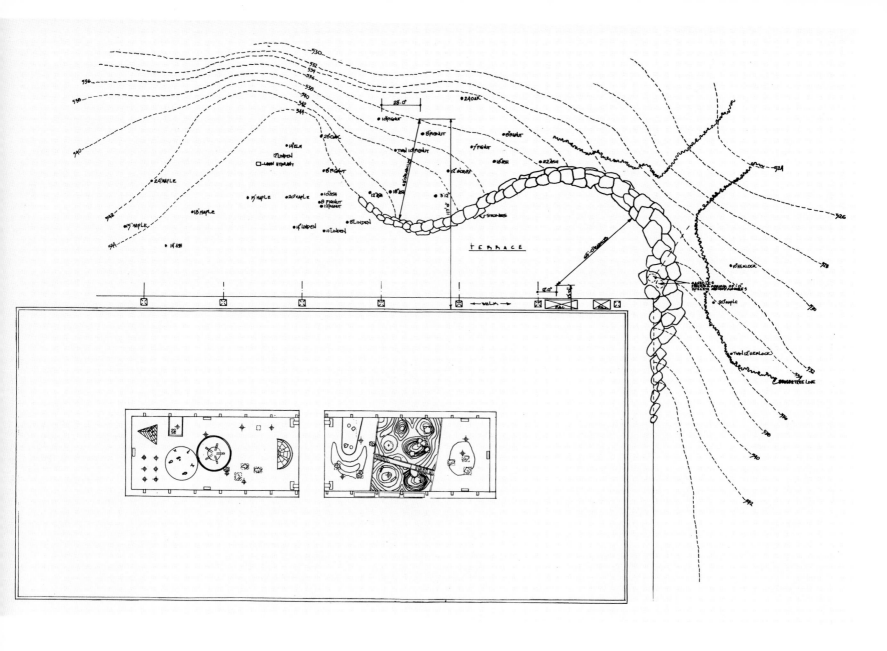

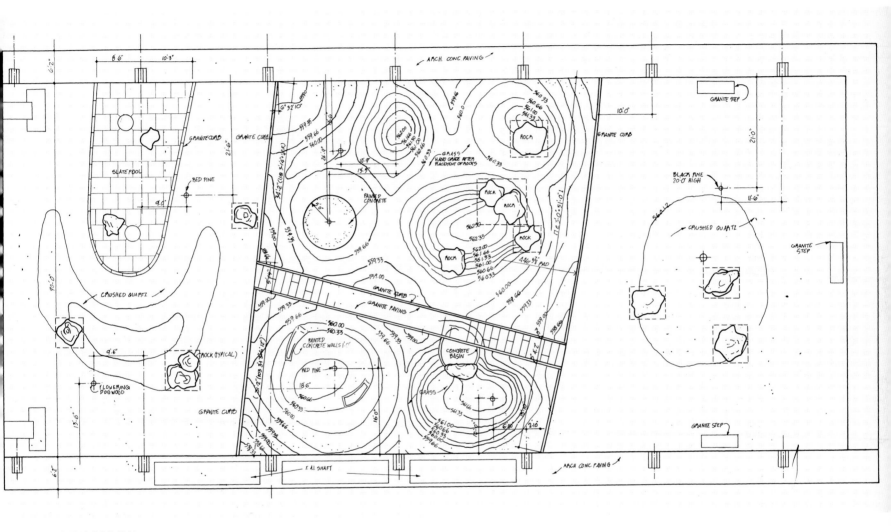

GARDENS FOR IBM
HEADQUARTERS

FIGURE 134
Site plan
Noguchi conceived the area in two
parts: one representing the past of
human civilization, and the other the
future—a symbol of nature and culture.

FIGURE 135
Site plan of south court
Water, rocks, and trees in the south
court represent the past. These
elements are symbols of life from
ancient gardens.

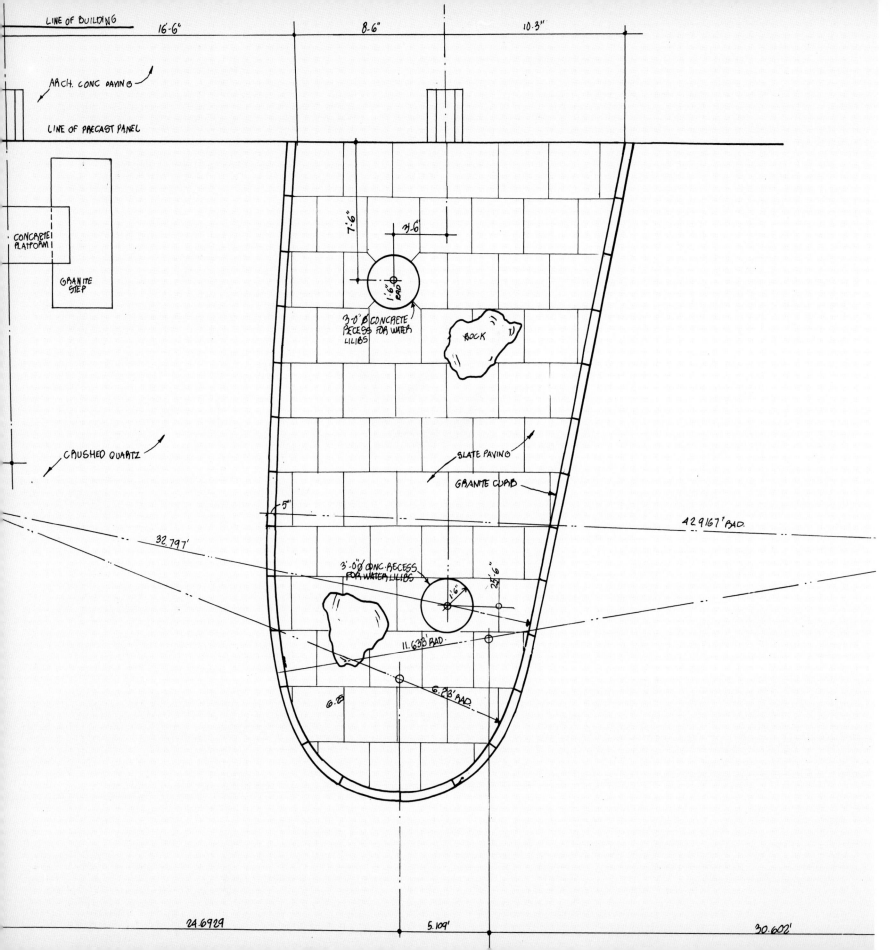

GARDENS FOR IBM
HEADQUARTERS

FIGURE 136
Detail of pool
Noguchi used water to associate
myth and ritual with modern life.
Water was historically the symbol of life
and fertility as well as of submersion
and destruction.

FIGURE 137
View of south court
On gently shaped lawn areas, Noguchi
arranged a composition of blasted
rocks, re-creating a natural landscape.

FIGURE 138
*Noguchi and worker at the IBM
gardens construction site, c. 1964*
Noguchi used the fractured bedrock
from the site. He was conscious that
the rocks were not particularly beauti-
ful, but he drew beauty from them.

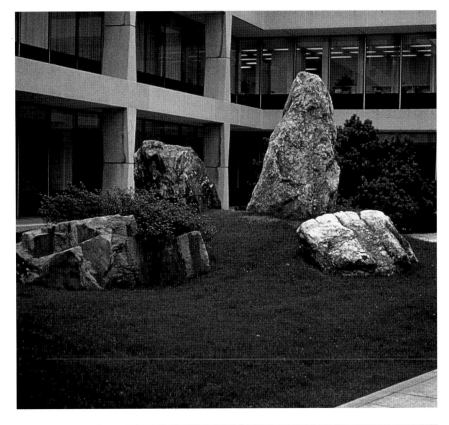

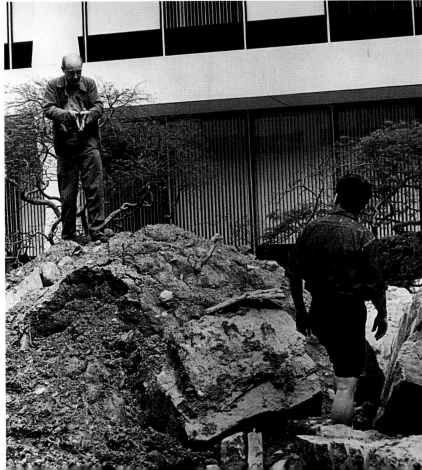

Noguchi had already employed such symbolic elements in the UNESCO gardens and the sunken garden for Chase Manhattan Bank plaza. Each garden, however, was a different experiment in his search for a new meaning, a new concept, a new discovery of place or person, a new symbolic intention, a new chapter. As Jorge Luis Borges wrote in "The Garden of Forking Paths," a chapter in his *Fictions*, "I also imaged a Platonic hereditary work, passed on from father to son, to which each individual would add a new chapter or correct, with pious care, the work of his elders."[85] Noguchi dismissed the traditional orthogonal Garden of Paradise model, which divided the garden into quarter sections symbolizing the different facets of the world, by introducing a diagonal granite path that crossed an open area of blue grass (figs. 139 and 140).

In the north court, Noguchi created a garden of science, a garden of humankind's future. There, he addressed the accomplishments of science with a gesture that could be seen as an homage to Buckminster Fuller, the man who deepened Noguchi's knowledge of science. Five elements emerge from a bleak gravel platform: a black granite pyramid, a concave red-painted cement fountain, a low black cement dome, a white marble sundial, and a free-standing bronze sculpture (figs. 141–45). On the central black dome Noguchi carved diagrams of nuclear formulations, stellar constellations, and computer circuits. These carvings create a dialogue between the dome and the white marble sundial, on which Noguchi carved formulas that were critical to scientific development (figs. 146 and 147). Between the two pieces rests the red fountain, its water acting as a receptor for the sounds of the universe. Almost diago-

nal to the sundial, the black pyramid is located at the northeastern corner of the court. The pyramid symbolized the infinite, the ideal image of synthesis (fig. 148). Noguchi initially imagined, and actually preferred, the garden without plantings and his bronze sculpture of two interlocking helixes; the inclusion of trees and the sculpture was at the insistence of Bunshaft, who admired the artist's pieces based on the helical structure of DNA.

The IBM courtyards marked the end of a unique, more than decade-long collaboration between an architect and an artist. Noguchi later explained, "The architect with whom I have worked most is Gordon Bunshaft of Skidmore, Owings & Merrill. It is due to his interest that projects were initiated, his persistence that saw them realized, his determination that squeezed out whatever was in me."[86] The relationship between the two, however, did not work as a true example of an integration of the arts. The artist was never given the opportunity to be fully involved in Bunshaft's design processes; the architect always allotted him a fixed site within which to work. Within these restrictions, however, Noguchi proved his strong versatility in bringing fresh concepts to each project. In collaboration with Bunshaft, Noguchi not only created the most innovative gardens built in the 1950s and mid-1960s but finally was able to realize his ideas for gardens in the United States, particularly in New York City. In the 1970s, with Noguchi's clear understanding of himself as a complete artist, he created with his long-time friend and collaborator Shoji Sadao the architecture firm of Noguchi Fountain and Plaza, Inc., so that he would have more influence over his commissions.

GARDENS FOR IBM
HEADQUARTERS

FIGURE 139

View of south court

The south court, divided into three sections, represents different landscapes and topographies. A diagonal path crosses over the hilly, bluegrass center between two raked gravel areas.

FIGURE 140

Detail of grass area of south court

Noguchi thought of the living elements in his gardens as things to control and manipulate—not as core elements in his designs.

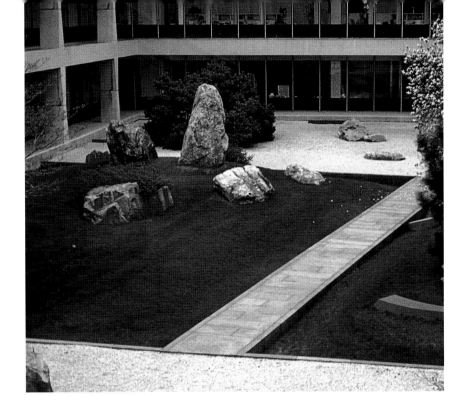

PART PLAN OF SOUTH COURT - ALTERNATE № 2

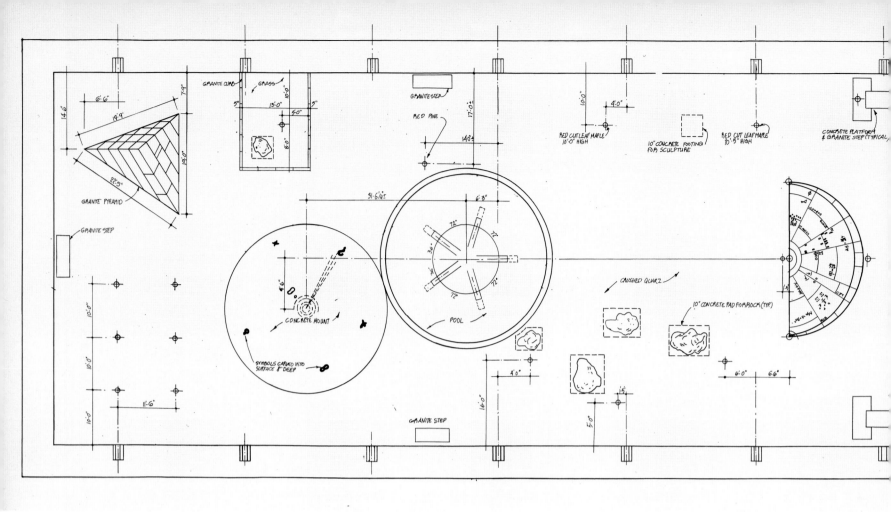

GARDENS FOR IBM
HEADQUARTERS

FIGURE 141

Plan of north court

The north court is a garden of science, a garden of humankind's future, a contemporary interpretation of the garden of paradise. (In ancient Persia, paradise was a "walled-in park," referring to the enclosed preserves of kings.)

FIGURE 142

Astronomical instruments built by the Maharajah Jai Singh II in Jaipur, India, c. 1734

Noguchi's deep connection to science was expressed in the north court at IBM in his reinterpretation of the geometry of the astronomical instruments at Jaipur.

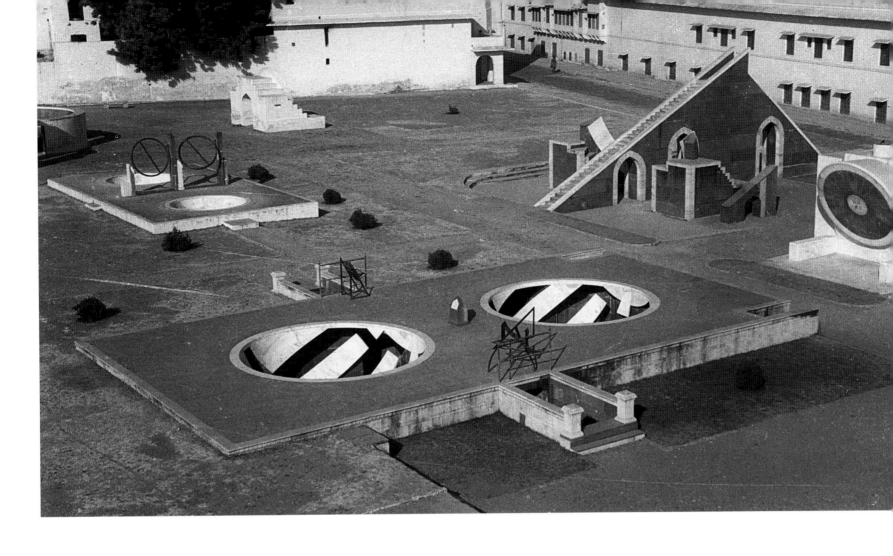

GARDENS FOR IBM
HEADQUARTERS
FIGURE 143
View of north court
Science is represented by five elements:
a black pyramid, a red fountain, a
black dome, a white sundial, and a
bronze sculpture.

FIGURE 144
View of north court
The Western vocabulary of forms set
within a gravel platform that recalls the
raked surfaces in Zen gardens reveals
Noguchi's affinity for duality. Everything
had a double meaning: the circle, in
ancient Western history, represented not
only the sun and moon but also the
canopy of heavens, and God and
heaven; the square symbolized humans
and earth. In Zen Buddhism, the circle
represented the perfection of humanity
in unity with the primal principle.

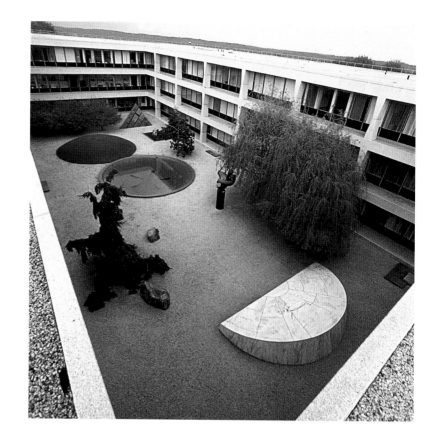

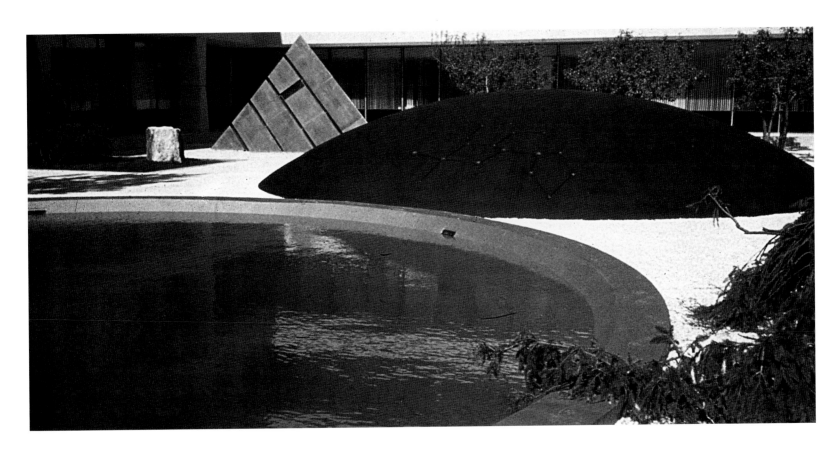

FIGURE 145

North court at night

Though Noguchi preferred a less
crowded composition that did
not include the helix sculpture or trees,
Gordon Bunshaft insisted that the
garden include plantings and bronze
interlocking helixes based on the
structure of DNA.

FIGURE 146

Details of dome in north court

The black-painted dome, as Noguchi
wrote, signified "man emerging from
the earth to explore the universe." The
artist was exploring this notion in his
floor pieces of the 1960s.

FIGURE 147

*Details of white marble sundial in
north court*

The half-circle of the sundial, in relation
to the other geometric elements, a
tetrahedron and a circle, along with the
unnatural colors—black, red, and
white—emphasize Noguchi's abstrac-
tion of human nature.

FIGURE 148

Details of pyramid in north court

As he often did, Noguchi borrowed
from the mythic symbolism of ancient
civilizations. The black pyramid
symbolized the mountain, the meeting
place of heaven and earth, eternity.

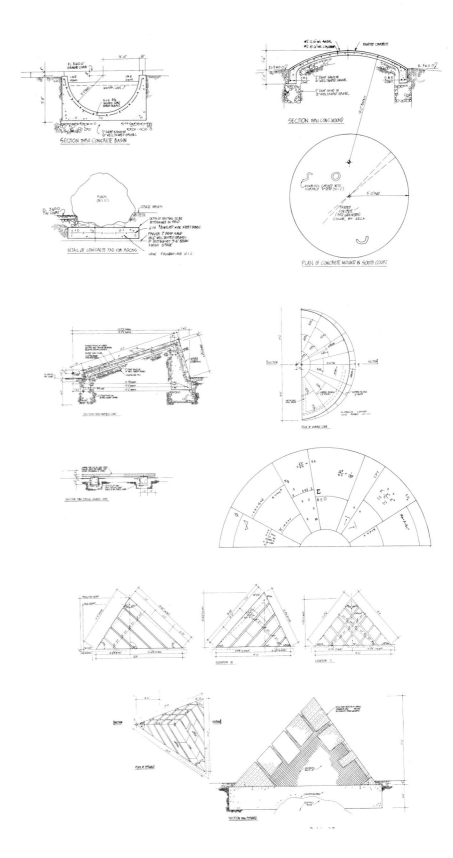

THE GREAT FOUNTAIN, PROJECTED TO BE THE MOST SIGNIFICANT OF MODERN TIMES, WILL RISE FROM THE PLATEAU OF PRIMAL SPACE. IT WILL BE AN ENGINE FOR WATER, PLAINLY ASSOCIATING ITS SPECTACLE TO ITS SOURCE OF ENERGY, AN ENGINE SO DEEPLY A PART OF DETROIT. IT WILL RECALL AND COMMEMORATE THE DREAM THAT HAS PRODUCED THE AUTOMOBILE, THE AIRPLANE AND NOW THE ROCKET, A MACHINE BECOME A POEM.[87]

In 1968 Noguchi published his autobiography, *A Sculptor's World;* a circle was closed, and a new era had begun. He pursued novel interests in which to invest his creativity, and he felt stronger and more determined to develop unique visions. In 1969 Noguchi established a second studio on Shikoku Island, Japan, which he had discovered during his search for stones for the UNESCO gardens. At this time, he began to divide his time equally between his studios in Japan and New York.

This renascence meant that Noguchi's work moved from the relatively intimate scale of building and garden toward the more grandiose metropolitan scale of sculpture and city. His art was directed toward a new technology as a point of departure for creative horizons. Almost thirty years before humans traveled to the moon, Noguchi imagined his work being viewed from outer space: the result was *Sculpture to Be Seen from Mars* (1947). In 1968 Noguchi used technology to balance *Red Cube* on one of its points. These large-scale public sculptures served as a prelude to many similar commissions that Noguchi designed in the 1970s and 1980s.

In 1970 Kenzo Tange asked Noguchi to design fountains for Expo '70 in Osaka. The artist created nine different prototypes. In them, Noguchi worked with his ideas of scale, water, motion, and futuristic computer technology. In 1971, in response to his Expo '70

PHILIP A. HART PLAZA, DETROIT, MICHIGAN, *1971–79*
Architects: Isamu Noguchi and Shoji Sadao/Noguchi Fountain and Plaza Inc.
Associate Architect: Smith, Hinchman & Grylls, Inc.
8 acres

FIGURE 149
Site plan of first proposal, 1971
In the 1970s Noguchi was finally given the opportunity both to realize his ideas about urban spaces on a very large scale and to develop further his sculptural forms with water, into which he introduced technology and created sculptural elements that seemed to derive from outer space.

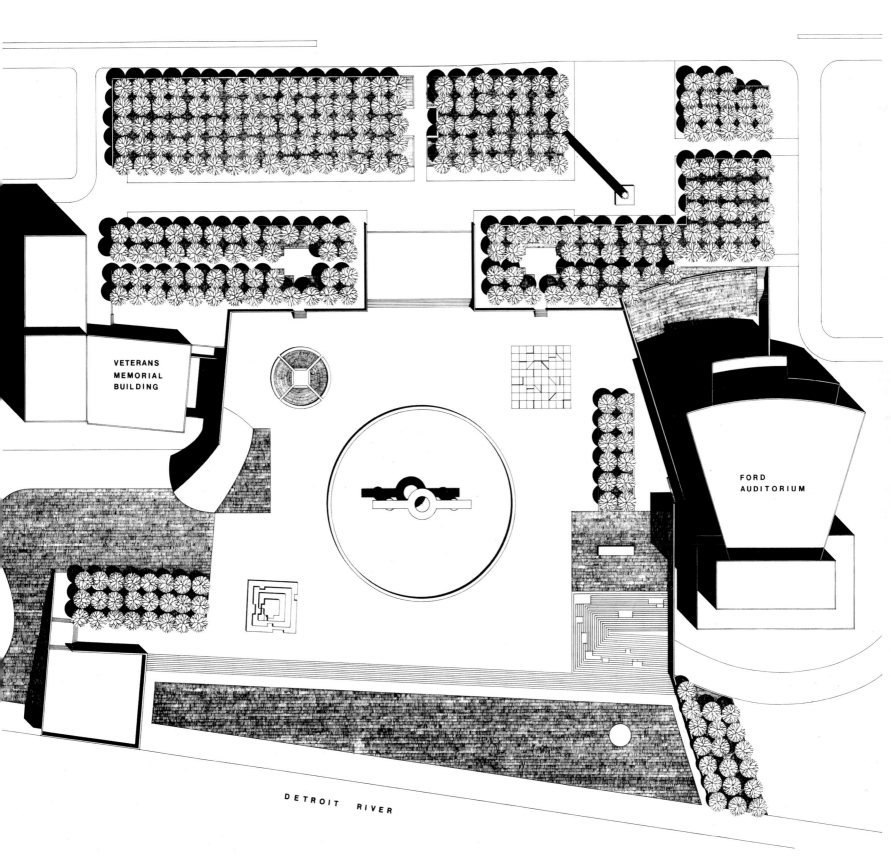

VETERANS
MEMORIAL
BUILDING

FORD
AUDITORIUM

DETROIT RIVER

ISAMU NOGUCHI

Civic Center Plaza & Fountain

City of Detroit

Noguchi Fountain & Plaza Inc.

12 Arrow Street
Cambridge, Massachusetts

333 East 69th Street
New York, New York

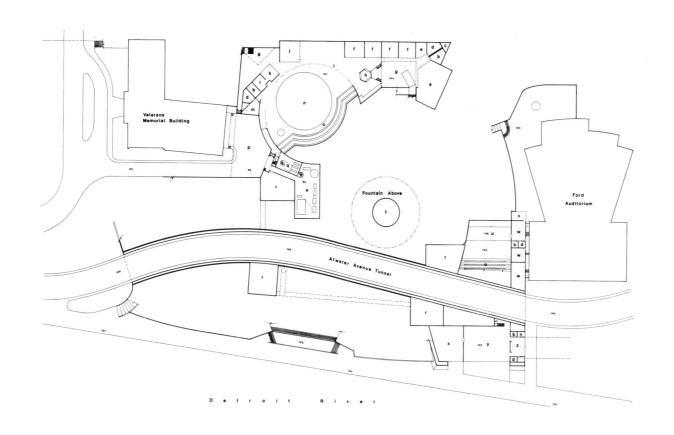

Veterans Memorial Building

Ford Auditorium

Fountain Above

Atwater Avenue Tunnel

D e t r o i t R i v e r

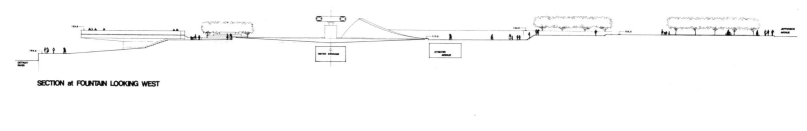

SECTION at FOUNTAIN LOOKING WEST

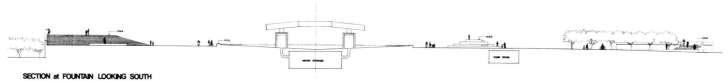

SECTION at FOUNTAIN LOOKING SOUTH

FIGURE 150

Underground-level plan, 1973
The underground level was a surprise addition during a meeting with Mayor Coleman Young. Afterward, Noguchi redesigned the proposal to create a sunken amphitheater.

FIGURE 151

Sections and elevations, 1971
The underground level emphasized Noguchi's intention to retain the fountain as the singular sculptural element, the prominent centerpiece in the plaza. All service areas, restaurants, and dressing rooms were located below the plaza, around the sunken amphitheater stage.

fountains, the artist was invited to submit a design for a fountain in downtown Detroit—the first realized work of Noguchi Fountain and Plaza—as part of the plans for the civic center's new plaza. Anne Dodge had bequeathed two million dollars to build a fountain as a memorial to both her husband and son. The site was located between the Detroit River and a commercial development.

Noguchi submitted his idea for a fountain in conjunction with an ambitious and unsolicited plan for the entire plaza. He intended to create facilities for theater, ice-skating, and community festivities (fig. 149). By the time he presented the proposal, the project was already in the development process. Coincidentally, the chairman of the Fountain Committee, Robert Hastings, was also principal of Smith, Hinchman & Grylls, the architecture firm charged with the design of the whole plaza.

The concepts for both the fountain and the plaza were accepted. Noguchi was authorized to reformulate the entire eight-acre site. This was not the first time his vision for a project exceeded his patron's original intentions—for example, with the UNESCO gardens Noguchi transformed an initially small commission into a larger, more expanded (and more expensive) project.

Noguchi wanted to create a clean, open area that would provide enough flexibility for a wide range of pedestrian activities. He presented the project to Detroit's mayor, Coleman Young, who accepted it with enthusiasm: "[The mayor] saw what we were doing, our models, our plans and so forth. The first thing he said was, 'Well, where's the ethnic festival?' You see, the ethnic festival was something that had been going on for years along the river. I immediately said, 'Well, downstairs, Mr. Mayor.'"[88]

Until that point no "downstairs" had existed. Martin Friedman has stated that, as with other projects, the design changed as the process unfolded. The original site was a parking lot, and from the beginning it had been assumed that the plaza would be raised sixteen feet above the existing level to minimize soil and structural problems. For that reason it was built entirely on piles. In order to create the "downstairs," two acres from the underground level were retrieved to create a hollow in the plaza for the amphitheater (figs. 150 and 151). Noguchi's solution offered two

PHILIP A. HART PLAZA

FIGURE 152
View
Noguchi's concept was to create a flexible open space that could accommodate various pedestrian activities.

FIGURE 153
Pylon at entrance, stainless steel, 120 feet high
Noguchi positioned a stainless-steel pylon to mark the entrance to the civic center. The pylon was part of Noguchi's lifelong homage to Brancusi.

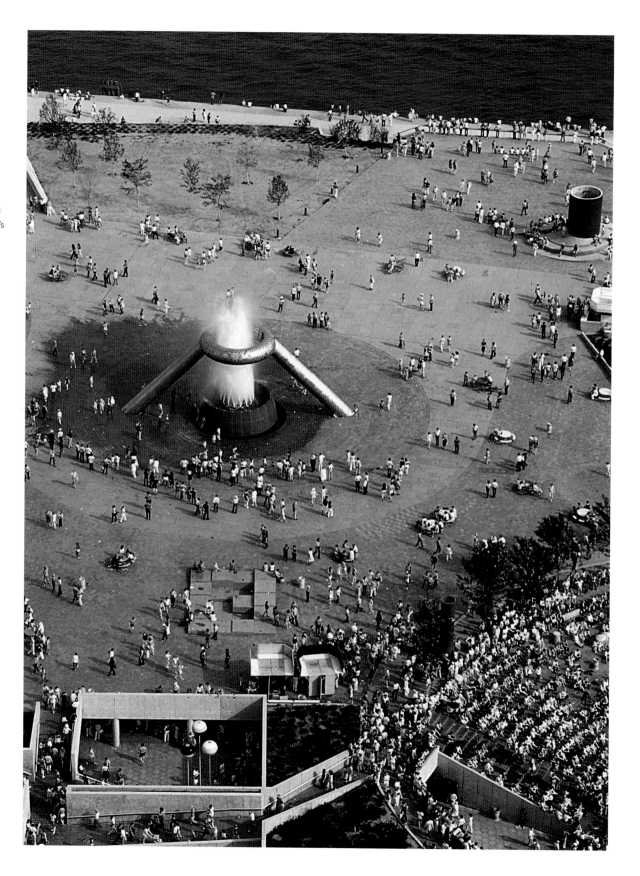

levels: parking, restaurant, and performance facilities on a lower level—
which preserved the simplicity of the plaza to emphasize the fountain
as the dominant image—and the plaza with central fountain and
120-foot-high stainless-steel pylon as a gateway on an upper level.
Perhaps Noguchi was competing with Brancusi's cast-iron column at
Tîrgu Jiu. Ultimately, as the artist stated, "What is important above all
is the sense of space that Hart Plaza supplies. An opening to the
sky and to the Detroit River. A horizon for people"[89] (figs. 152 and 153).

The plaza was a neutral platform for the fountain, a ring on cylindri-
cal legs—a symbol of the future, of outer space. Noguchi created a
complex play of water with the aid of technologically sophisticated com-
puterized systems that underscored the powerful design of the fountain
as a water sculpture (figs. 154–56). A new metaphor was introduced: the
water play represented a process of transformation; the fountain and its
space change over time. Noguchi paired art with technology, as he
had for Expo '70. By moving between them and manipulating light,
movement, and sound, he continued a twentieth-century art tradition,
following in the footsteps of László Moholy-Nagy and Lucio Fontana.

During the seven years it took to complete the Philip A. Hart
Plaza, Shoji Sadao was responsible for resolving both the physical and
political issues inherent in such a complex urban project. Just as the real-
ized earthworks at the Billy Rose Sculpture Garden are the result of
years of utopian aspirations, the Philip A. Hart Plaza reflects a compila-
tion of ideas for urban spaces that Noguchi had begun to express in
1949: "I see sculpture strengthened and find the means of again becom-
ing the great myth-maker of human environment. In it man may find
surcease from mechanization, in the contemplation and enjoyment of a
new spiritual freedom. It will be a time when the enjoyment of leisure
will be the measure of a good life."[90]

PHILIP A. HART PLAZA

FIGURE 154

Water play for Dodge Fountain
Noguchi told Martin Friedman that
"To spend $2,000,000 on a fountain isn't
easy." Noguchi not only experimented
with shapes and materials but also
with water movement and how it might
transform the shape of the sculpture.
He explored twenty different combina-
tions of water flow.

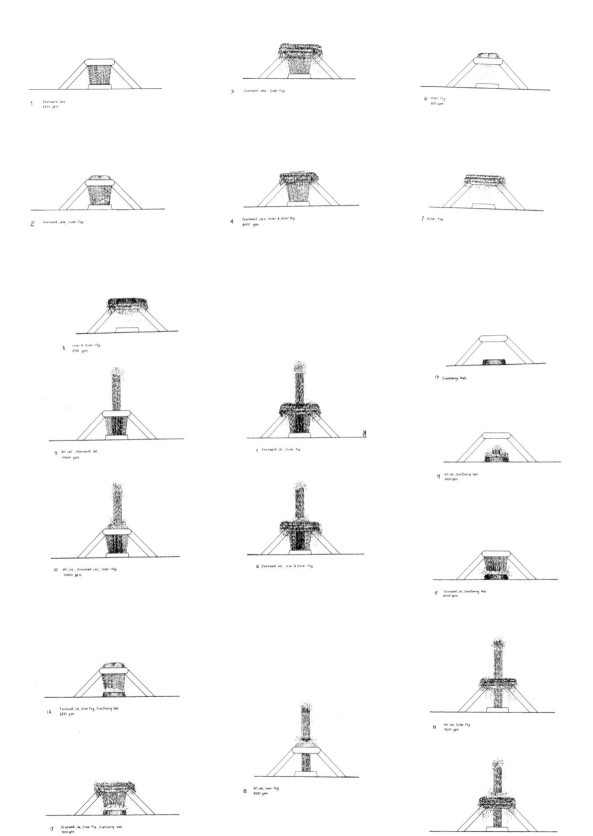

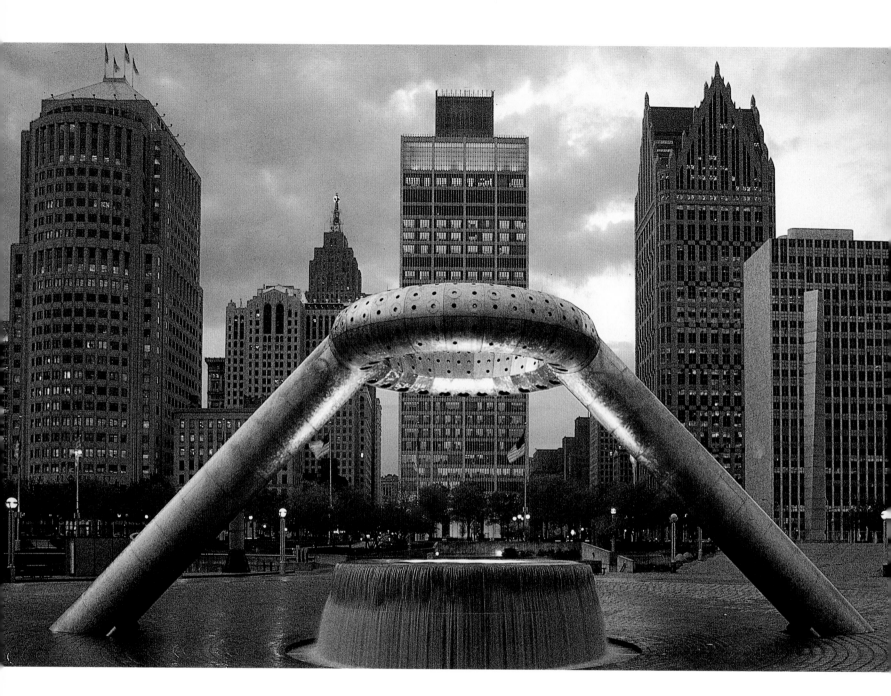

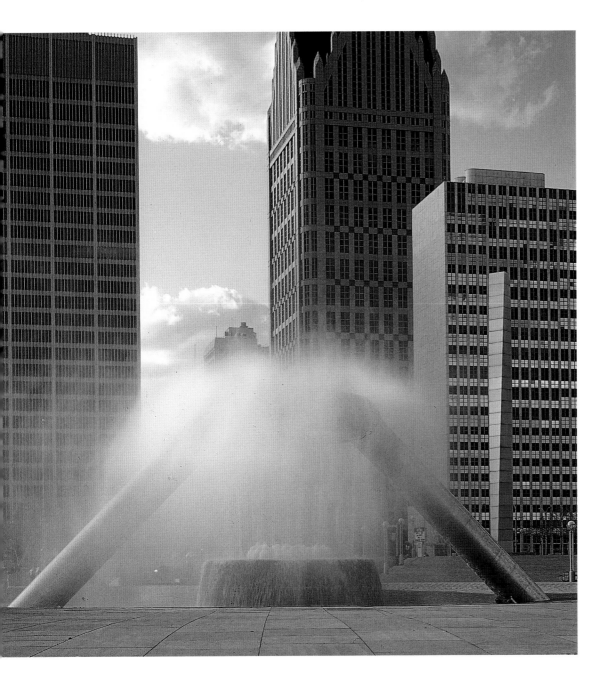

FIGURE 155

*Night view of Dodge Fountain,
stainless steel, 24 feet high*
The water sculpture became a gigantic
experiment for Noguchi in which a
complicated lighting system compli-
mented the water movements.

FIGURE 156

View of fountain
The water is confined between the
upper ring and the pool below to
provide a public amenity and a stage
for performances.

I LIKE THE IDEA OF STRETCHING THE POSSIBILITIES OF SCULPTURE, AND IF YOU GET THE ARMY

INTO DOING IT, MY GOD! I MEAN, THINK OF WHAT THEY WERE ABLE TO DO IN VIETNAM.

VIETNAM WAS THE LARGEST AND MOST SPECTACULAR SCULPTURAL EFFORT EVER, THEY DEFOLI-

ATED THE LAND, THEY BUILT AIRPORTS . . . THEY TRANSFORMED THE WHOLE TERRAIN.[91]

Strangely, Noguchi's comments were expressive of his attitude toward the unlimited expectations and possibilities that might have resulted from his 1977 earthwork proposal for the new East-West Center in Honolulu. In late 1939, just after the completion of *News*, the bas-relief for the Associated Press Building entrance in New York, the Dole Company invited Noguchi to visit Hawaii to work on some advertisements and to exhibit at the Honolulu Academy of Art. As a result of this trip, and at the suggestion of Lester McCoy, chairman of the Honolulu Parks Board, Noguchi had designed playground equipment for Ala Moana Park—the park McCoy had built in 1940. Noguchi's work, unfortunately, was never realized. Despite this disappointment, the artist had a long-lasting affinity for the culture and the people of Hawaii, whose ethnic mix was much like his own.

In October 1974 Noguchi received an invitation to participate in a competition for a sculptural piece for the interior of the new Municipal Building in Honolulu. Later, the Art Commission moved the site to an area outside the Municipal Building that faced onto South King Street. Noguchi presented a stainless-steel model for *Sky Gate* and was given the commission to build it with the condition that he design a master plan for the surrounding municipal area. The fee for the sculpture was payment for the entire project. The sculpture was completed in 1977 after numerous administrative problems.

Once Alfred Preis, of the State Foundation on Culture and the Arts and also the East-West Center, saw Noguchi's master plan, he asked the artist to design a large sculpture for the center's new building near the entrance to the University of Hawaii campus. Noguchi took a Japanese approach in developing his proposal for the center, using the concept of borrowed scenery, *shakkei*, to capture the surrounding landscape. This principle is essential to many types of Japanese gardens in which mountains and hills are "captured alive" within the gardens.

The project, as Noguchi explained in notes dated March 25, 1977, "would take into account the beautiful hill behind them which I proposed to borrow as an element of mass by building a rock sculpture to complement it on the open corner of their new building."[92] In this way, the artist connected the East-West Center building to the hill behind it.

The proposed earthwork was to be seventy feet long and more than twenty feet wide, built in the shape of a saddle and constructed on a rubblestone foundation. The result would be "an enclosure toward the building like an amphitheater for dance and other performances in the open as well as . . . a pleasant place to read and study among the rocks."[93]

With the help of a friend, Paul Yamanaka, Noguchi was able to find in Hawaii the stones he needed for the piece. Yamanaka also convinced Noguchi to use the U.S. Army's help in moving the rocks. As Noguchi searched for stones, he was taken to Kukaniloko, the site of Hawaii's sacred rocks. The rocks are referred to by Hawaiians as birthstones, because according to tradition members of the royal family revered them in order to bear children.

Noguchi was enchanted with the place and, through Yamanaka's instigation, became involved in designing an earth mound to enclose the sacred rocks as an homage to the indigenous people: "To honor what was historically honored by Native Hawaiians, I proposed an earth mound enclosure to protect the birthstones of royalty from the encroaching pineapples."[94]

Noguchi conceived the work *Sacred Rocks of Kukaniloko* as an eighty-foot-high, grass-covered, ring-shaped mound that enclosed and protected the sacred rocks that were only three feet above the ground (fig. 157). Stepping-stones allowed access to them within the inner space of the ring. A central rock for a woman in labor was surrounded by a group of rocks for the high chiefs. The artist brought into this work the symbolism of the Henges, the large circular enclosures of the Iron Age that were ceremonial places. With this gesture, he approached the magical beliefs embodied in earth monuments with an openness and an understanding of cultural history. Noguchi's earthwork would function like the prehistoric stones that were located at a focal point in the landscape, bringing together the sky, the horizon, and the land.

Noguchi's ring can be understood as similar to the Zen expressions for that which is inexpressible—Zen masters often draw a circle. The essence of this circle is the expression of nothing superfluous, nothing lacking.

Noguchi, interested in local Hawaiian myths and lore, returned to his earthworks to bring these myths to reality. His *Sacred Rocks of Kukaniloko*, like other large-scale projects, also shared the symbolism of earlier, smaller sculptures. The earthwork shares the gravity of *This Earth, This Passage* (1962) and the enchantment of *The Magic Rug* (1970). Noguchi described the ring as "a containment, something magic. Merlin drew it in sand."[95]

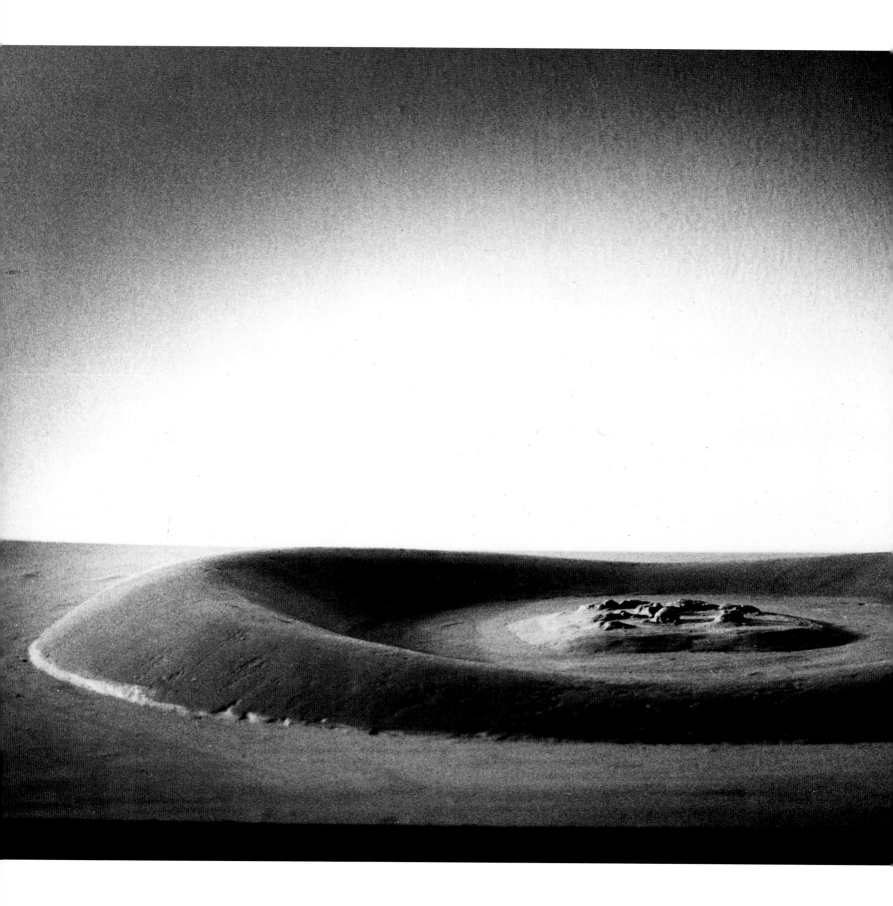

SACRED ROCKS OF
KUKANILOKO, HONOLULU,
HAWAII, *1977 (unrealized)*
FIGURE 157
Bronze model, 25 inches long
Noguchi's strong relationship to the
earth is expressed in this proposal,
in which he balanced forms and the
creation of space in a grand earthwork,
an eighty-foot-tall grass-covered
mound that enclosed and protected
the sacred rocks.

| I RATHER ENJOY IT WHEN SOMEBODY SAYS, "ALL RIGHT I HAVE THIS PROBLEM—
I CAN'T GET THIS THING TO WORK." THAT'S THE SITUATION I AM OFTEN BROUGHT
INTO, WHETHER IN THE THEATER OR WITH ARCHITECTS.[96]

Sōfu Teshigahara, *ikebana* master and founder of the Sōgetsu Flower Arranging School in Tokyo, commissioned Noguchi to design the lobby of the school's new building in 1977. Noguchi would collaborate, once again, with Kenzo Tange, with whom he had completed work in Peace Park in Hiroshima (1951–52) and the Expo '70 fountains.

Tange's design included an auditorium space below the ground floor that projected into the lobby in the form of a stepped ziggurat. Teshigahara asked Noguchi to transform the railings on the intrusive form and the awkward space into a suitable exhibition space for flower arrangements. Noguchi accepted the commission for several reasons. Most important was that this problem challenged his imagination. He saw it as an opportunity to provide a solution that would surpass the limited abilities of architects and also assert his hybrid identity as both sculptor and architect.

Teshigahara put no limitations on Noguchi: "In the same way that he let Tange do whatever he pleased, he let me do whatever I pleased. He had no interest in seeing what I was doing—he merely wanted me to do it."[97]

Noguchi faced the ziggurat and filled the lobby with granite slabs and called it *Tengoku* ("heaven"). The metaphor took the form of an indoor mountain on which water would run, like a small stream that appears and disappears in an evocation of nature. The granite slabs

TENGOKU, SŌGETSU FLOWER ARRANGING SCHOOL, TOKYO, JAPAN, *1977–78*
Architect: Kenzo Tange
FIGURE 158
Interior garden plan, 1976
The interior landscape for the Sōgetsu Flower Arranging School gave Noguchi the opportunity to create a sculpted space for cultural events and social interaction.

TENGOKU, SŌGETSU FLOWER
ARRANGING SCHOOL
FIGURE 159
Interior garden plan, 1977
Noguchi utilized the stepped
"ziggurat" projection formed by the
basement auditorium to create
a series of stone terraces in the form
of a mountain.

became the ground for ephemeral flower arrangements: "Railings were replaced by boulders, the steps were realigned to meet the water flow, and the ceiling was opened up with squares of sky"[98] (figs. 158 and 159).

Noguchi's abstraction of a mountain was also an interpretation of the *tokonoma*—the area in traditional Japanese houses that is reserved for flower arrangements and scrolls: "In a sense it's the most sacred spot in a Japanese house. It is heaven, and what I've done there is heaven, you see."[99] Noguchi evoked the symbolism of the Chinese myth of the Altar of Heaven (a circular mound described in Chinese sacred text), the pyramid, and the infinite in this work. He also incorporated the symbolic nature of water, a stream, and life (fig. 160).

Noguchi marked the entrance to the building with a forty-foot-high helical pylon (fig. 161). This variation on the helical pylon situated at the entrance to the Philip A. Hart Plaza in Detroit (1971–79) was made of granite rather than stainless steel. It was a symbol of humankind in relation to creation. Noguchi had used this symbol in other projects, such as the Republic Fountains for the Chicago Art Institute (1976–77). The pylon was also an interpretation of *tokobashira*, a "ritual post" that is traditionally placed inside Japanese houses.

Tengoku is evidence of Noguchi's maturing abilities as an artist; the work expresses a synthesis of symbolism and tradition that remains open to infinite interpretations. His use of the dual relationship between nature and human-made technology is expressed by a contrast between rough and smooth surfaces.

The work shares many of the qualities evident in the work of the Italian architect Carlo Scarpa.[100] Like Scarpa, Noguchi penetrated the essence of materials. Both men pursued the same philosophical approach of learning by doing. Scarpa, like Noguchi, adhered to the tradition of craftsmanship exemplified by architects such as Charles Rennie Mackintosh and Frank Lloyd Wright, and combined this pursuit with a thorough knowledge of history.

Noguchi's *Tengoku* is a precise composition of water, stairs, light, and garden, which, together, created a metaphor (fig. 162). Scarpa used the same elements to create metaphors. At the entrance to the Architectural Institute at the University of Venice (1966), Scarpa transformed the traditional concept of gate into a metaphor; it became a garden—displayed as a museum piece—through the incorporation of steps and a pool of water. Scarpa understood the aesthetics and ethics of Japanese life; he understood, like Noguchi, the Japanese principle of creating a seamless mix of beauty and utility (fig. 163).

Scarpa died suddenly in 1978 in Sendai, Japan, en route to Hiraizumi, a city that fell to ruins in the twelfth century. Bash-ō Matsuo, a seventeenth-century poet, dedicated a series of haiku to Hiraizumi:

> Even the long rain of May
> Left untouched this Gold Chapel
> A glow in deep shade.[101]

Noguchi, like Scarpa, conceived of spaces as whole works, in which images referred to one another as well as to the infinite. Ultimately, Noguchi's work for the Sōgetsu lobby was a sculptural space, a stage for cultural events and flower arrangement, an intimate space for personal contemplation.

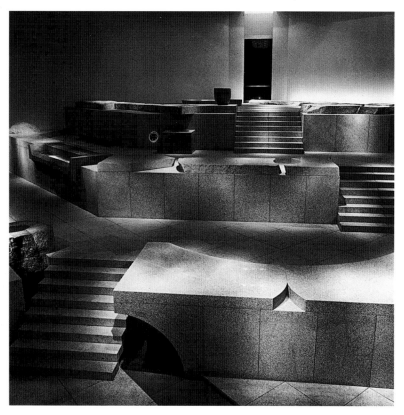

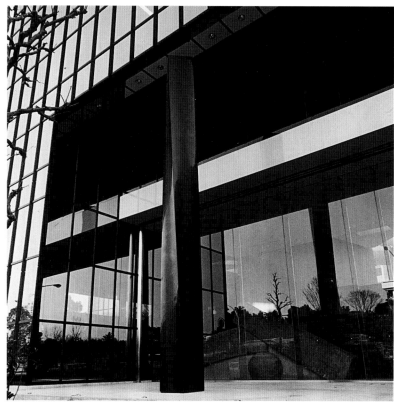

TENGOKU, SŌGETSU FLOWER
ARRANGING SCHOOL

FIGURE 160

View of lobby

The dramatic treatment of the space,
including a stream connecting the
granite terraces, the ceiling evoking
the sky, and the polished and
rough surfaces of the stone, expresses
nature and myth.

FIGURE 161

Granite pylon, 40 feet high

At the entrance to the building,
Noguchi symbolized the vertical male
figure with a forty-foot-high granite
pylon. The artist would never be able
to escape the representation of the
human being as a center of sculpture.

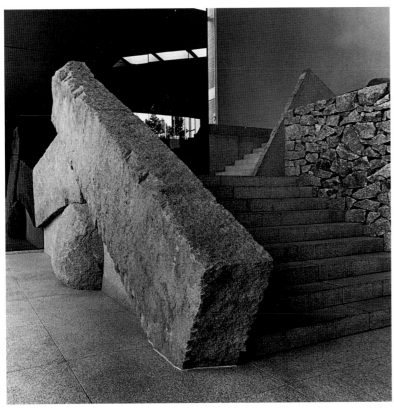

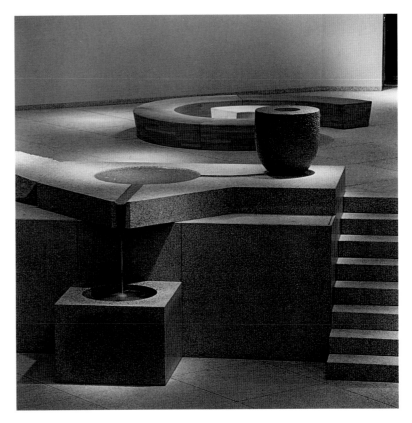

FIGURE 162

Detail of interior garden

The finished surfaces and the unworked stones in dialogue with water, as a symbol of life, become platforms to display avant-garde flower arrangements.

FIGURE 163

Detail of interior garden

Sōgetsu brings together through "artifice" the directness of nature and the imagination of the viewer. Noguchi brought into his work of art the interaction between human beings and nature.

THE NATURE OF TREES AND GRASS IS ONE THING. BUT THERE ARE MANY DEGREES OF NATURE. CONCRETE CAN BE NATURE. INTERSTELLAR SPACES ARE ALSO NATURE. THERE IS HUMAN NATURE. IN THE CITY, YOU HAVE TO HAVE A NEW NATURE. MAYBE YOU HAVE TO CREATE THAT NATURE.[102]

When Noguchi was commissioned to design an outdoor sculpture garden for the Houston Museum of Fine Arts, the concept was not a new one for the institution. Since 1931 various proposals had been submitted. In 1936 Ruth London presented a detailed plan for the garden. In the 1950s, the architect Ludwig Mies van der Rohe had designed the Brown Pavilion (a new exhibition wing). He was then commissioned for an outdoor sculpture court. Mies presented a site plan and proposed a garden featuring a terrace built from Roman travertine tiles surrounding a shallow reflecting pool. The proposal shared the same vocabulary as Mies's Barcelona Pavilion, designed in the 1940s. The sculpture court was never realized.

Almost twenty years later, in 1978, Noguchi was asked by the museum to design a sculpture garden. The invitation was made following the recommendation of Alice Pratt Brown, a museum trustee and benefactor, who had recently visited the Billy Rose Sculpture Garden in Jerusalem.

It took eight difficult years to complete the Cullen Sculpture Garden. During that time, Noguchi made several design proposals. The architect Shoji Sadao, who had helped the artist on earlier projects, assisted him with technical, political, and administrative problems.

The sculpture garden was located on a one and a half acre site near the museum at the corner of Montrose Boulevard and Bissonnet Street. The site's limitations were one of the most challenging aspects of the project, since Noguchi's main task was to create the illusion of a larger space within this urban context. This concept was not new to Noguchi, however. It had been present in his early projects, such as the UNESCO gardens and in his set designs, and it was part of his most recent projects to date, such as *Tengoku*, at the Sōgetsu Flower Arranging School.

Noguchi's initial thought was to conceive of the sculpture garden as an island; this idea was discarded. He then presented the preliminary design for what would become the actual garden, a broad red carnelian granite terrace that framed a series of low earth forms in which he used walls of varying heights to define different areas. Initially Noguchi

LILLIE AND HUGH ROY CULLEN SCULPTURE GARDEN, MUSEUM OF FINE ARTS, HOUSTON, TEXAS, *1978–86*
Architect: Shoji Sadao/Fuller & Sadao
1 1/2 acres

FIGURE 164
Plan, 1984
Noguchi's later projects reflected his thoughtful use of illusion to create a sense of vastness. Like the Japanese, Noguchi created illusion through isometric manipulation that moves the viewer's eye from one point to another.

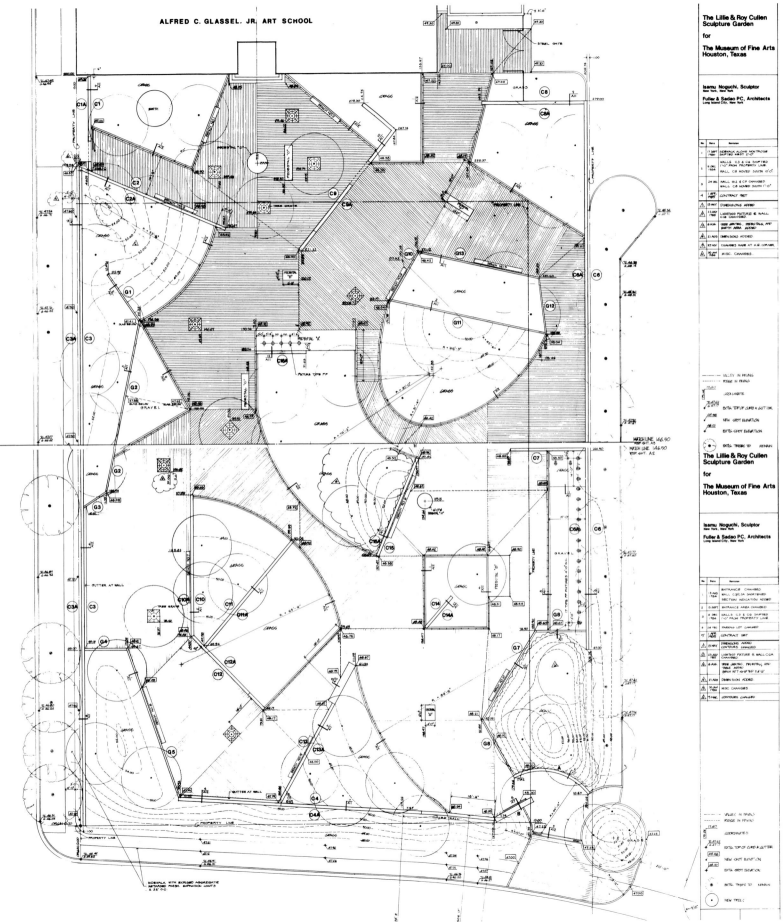

ALFRED C. GLASSEL. JR. ART SCHOOL

The Lillie & Roy Cullen
Sculpture Garden

for

The Museum of Fine Arts
Houston, Texas

Isamu Noguchi, Sculptor
New York, New York

Fuller & Sadao PC, Architects
Long Island City, New York

The Lillie & Roy Cullen
Sculpture Garden

for

The Museum of Fine Arts
Houston, Texas

Isamu Noguchi, Sculptor
New York, New York

Fuller & Sadao PC, Architects
Long Island City, New York

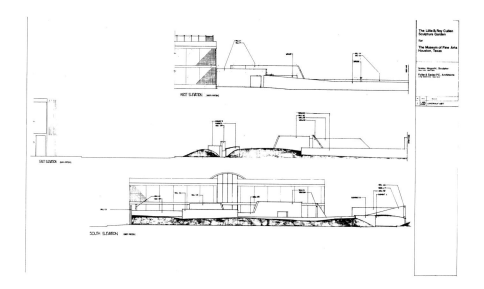

FIGURE 165

Elevations, 1984

After eight years of changes and
different proposals, Noguchi shaped
the space by erecting walls of different
heights and forming lawn mounds.

FIGURE 166

View

Convinced that cities needed new
nature, Noguchi created in the Cullen
Sculpture Garden a flexible environ-
ment that allowed for quiet reflection.

FIGURE 167

View

Though not as dramatic as the Billy
Rose Sculpture Garden in Jerusalem,
the Cullen Sculpture Garden exhibits a
similarly innovative character in its
sequence of spaces and arrangement
of sculptures.

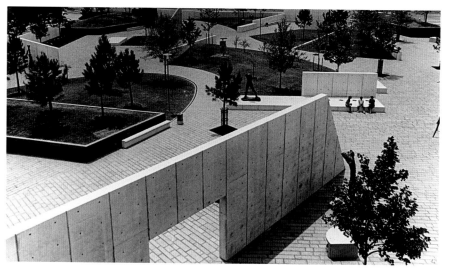

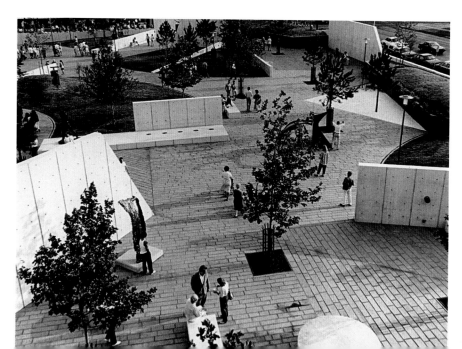

proposed to surround the site with an eight-foot-high concrete wall (fig. 164).

Once Noguchi sent his proposal to the museum, in 1979, the project underwent many changes during the painfully long process that was perpetually troubled by one or another resisting sector: "First I raised the area to cope with a flood. Then I considered sinking it. I was driven to creating walls, but this was unacceptable, at least on the outside. After eight years of changes and reductions in scale, the garden is now illusionistic"[103] (fig. 165).

Noguchi finally shaped the space as he had in Jerusalem, creating various perspective points for the viewer and changing the scale of different elements in the garden. Some of the concrete walls rose high enough to soften the noise from traffic and the urban surroundings. Noguchi formed grass-covered lawns into mounds to emphasize variations in scale and carefully selected native plants and trees that reinforced a concept of year-round change and beauty[104] (figs. 166 and 167).

In both the Cullen and Billy Rose sculpture gardens, Noguchi employed freestanding geometric walls that referred to the forms of the Samrat Yantra Observatory in India, which Louis I. Kahn used in his architecture. Noguchi's sculpture garden has an original contemporary character that is more memorable as a space for public enjoyment than as an exhibition space for art. It encourages the visitor to discover its less formal and more innovative seating; it is an artwork in itself. Noguchi created a flexible environment that tolerated spatial multiplicity within its unity. The artist's conception linked the garden to ideas of illusion typical of Japanese gardens and classical gardens beginning with the Renaissance.

Noguchi recalled the fantastical elements of the sixteenth-century Bomarzo Garden in Italy, the state manifesto of Versailles, and the poem of the garden at Ermenouville in France, where the garden was designed as a journey. Similarly, he introduced a classical dimension that placed all elements in measured harmony—a closed and coherent world in which universal harmony reigns throughout nature, art, and myth. Noguchi converted into reality the concept that he taught his students: "In the city, you have to have a new nature."[105]

I HAVE TREMENDOUS CURIOSITY . . . I HAVE AN UNFINISHED ROAD TO WALK. BY THE TIME I
APPROACH SOMETHING, I'M OFF ON ANOTHER MILE.[106]

Kitty Roedel, executive director of the Land Trust of Dade County, brought Noguchi to Miami in 1978 after seeing Play Mountain in the traveling exhibition "Noguchi's Imaginary Landscapes" in Denver, Colorado, with the hope that he might redesign a decrepit park along Biscayne Boulevard (fig. 168). After receiving the commission, Noguchi convinced the city of Miami to tear down an old library that stood on the site and obstructed the view to the water from the boulevard. The twenty-eight-acre park design was transformed into a scheme for a comprehensive waterfront complex.

Noguchi did not foresee the difficulties that would arise in the following years with regard to the project. After the design's initial conception was submitted, it was subjected to various criticisms and budget cuts, and it suffered continuous changes as a result of administrative turnovers and new commissioners.

Noguchi traveled constantly to Miami in an effort to resolve the various problems with the project. In 1978 he wrote that these problems had not discouraged his own conviction for his ideas: "The following years, with continuous changes, have seen the development of my largest space sculpture. Now in construction are the twenty-eight acres which will cap an effort of fifty-three years to actually make *Play Mountain*"[107] (figs. 169–73).

BAYFRONT PARK,
MIAMI, FLORIDA, *1980–96*
Architect: Shoji Sadao/Fuller & Sadao
28 acres
FIGURE 168
Plan of original site, 1967
Noguchi wanted to create a space for public amenities to help revitalize downtown Miami. As Kenneth Kahn, director of the Dade County Arts and Science Council stated, "The trouble with downtown Miami is that it's safe but boring."

FIGURE 169 *(overleaf)*
Plan
The numerous difficulties did not discourage Noguchi's belief in his ideas for Bayfront Park.

FIGURE 170 *(overleaf)*
View, c. 1985–86
Two amphitheaters, a light tower, a giant fountain, and the monument to the space shuttle *Challenger* were completed six years after Noguchi's death; the artist had only designed one amphitheater, a rock garden, and the tower.

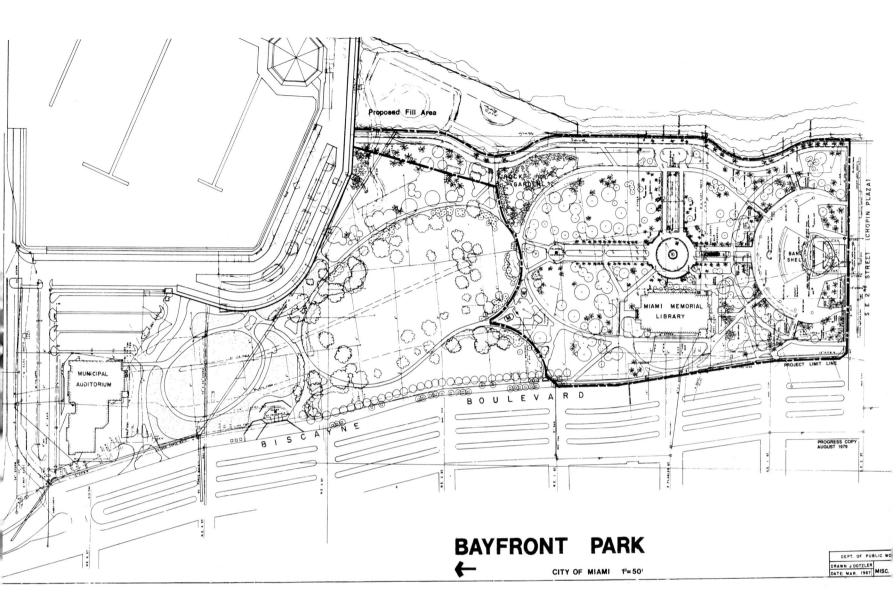

BAYFRONT PARK

← CITY OF MIAMI 1"= 50'

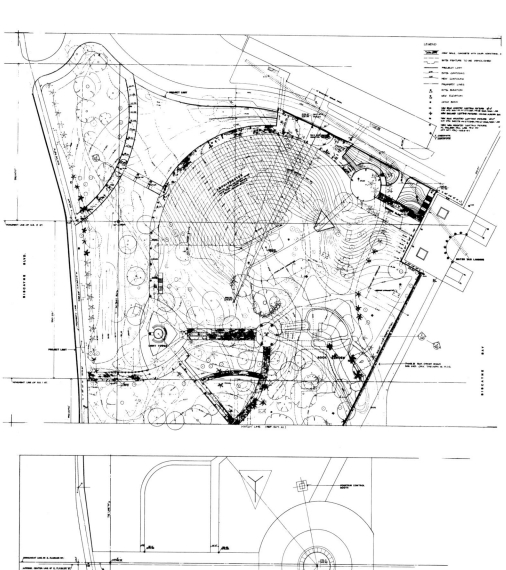

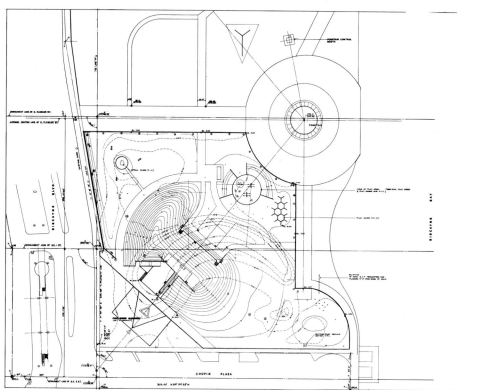

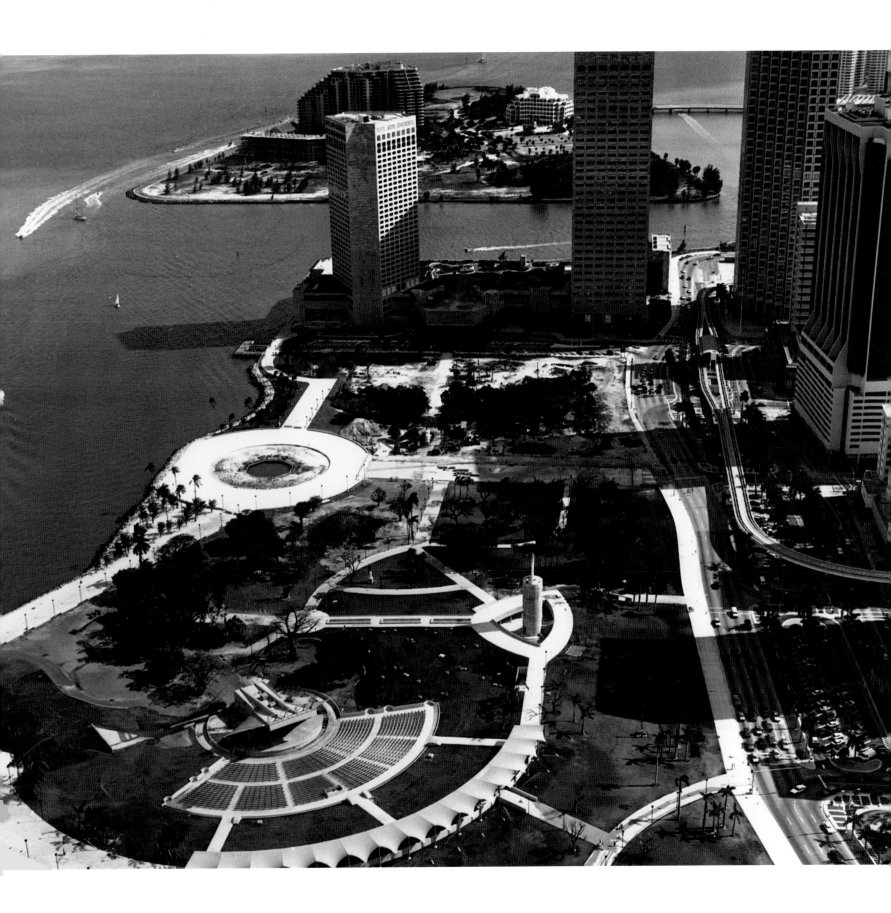

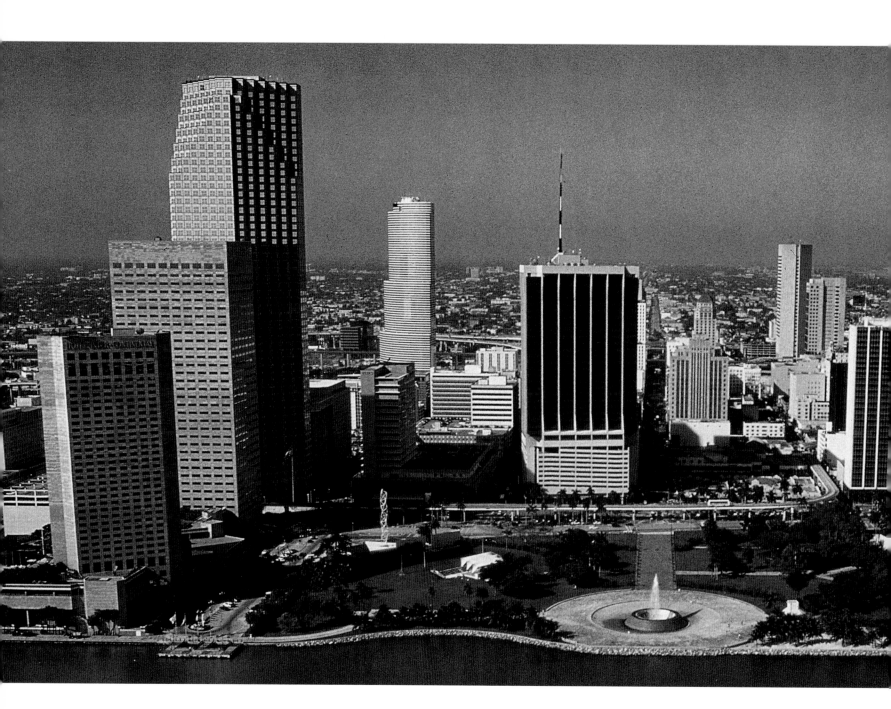

BAYFRONT PARK
FIGURE 171
View
The project architect, Shoji Sadao,
took responsibility for Bayfront
Park after Noguchi's death, intent on
realizing the artist's visions in full.

Bayfront Park was conceived as an opportunity to enrich the city of
Miami. Noguchi planned two amphitheaters, a light tower, a giant foun-
tain for the south end, and a monument to the space shuttle *Challenger*
(figs. 174 and 175). He did not see his project completely realized;
Bayfront Park was completed almost six years after his 1988 death. He
did, however, finish one of the two amphitheaters, a rock garden, and a
tower equipped with laser beams.

After Noguchi's death, Shoji Sadao took responsibility for the
Miami project and Moere Numa Park (begun 1988). Sadao finished
Bayfront Park in accordance with Noguchi's wishes and realized the
artist's vision of placing his white marble spiral slide, *White Slide Mantra*
(1986)—the sculpture he designed for the 1986 Venice Biennale—in the
park (fig. 176). Studies for *White Slide Mantra* had begun as early as
1966 as representations of the relationship between play and sculpture.

Noguchi did not have the opportunity to challenge the project's
problems and to fully explore his vision for Bayfront Park. Miami lost
the chance to witness Noguchi's practice of transforming his work
through the design process.

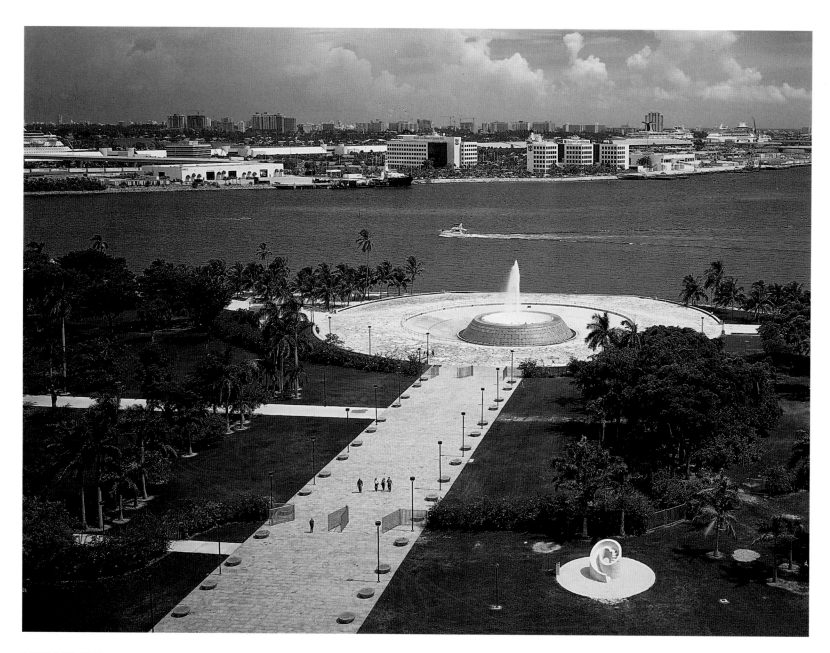

BAYFRONT PARK
FIGURE 172
White Slide Mantra *and Claude Pepper Fountain*
The promenade between Biscayne Boulevard and the waterfront culminates in a public space, designed around a water sculpture or fountain, that is characteristic of Noguchi's later work.

FIGURE 173
Claude Pepper Fountain, stone, 1986
Noguchi planned for this fountain, as he had for the Dodge Fountain at Philip A. Hart Plaza in Detroit, an elaborate water play and light spectacle that would serve as public entertainment and attract attention to downtown Miami.

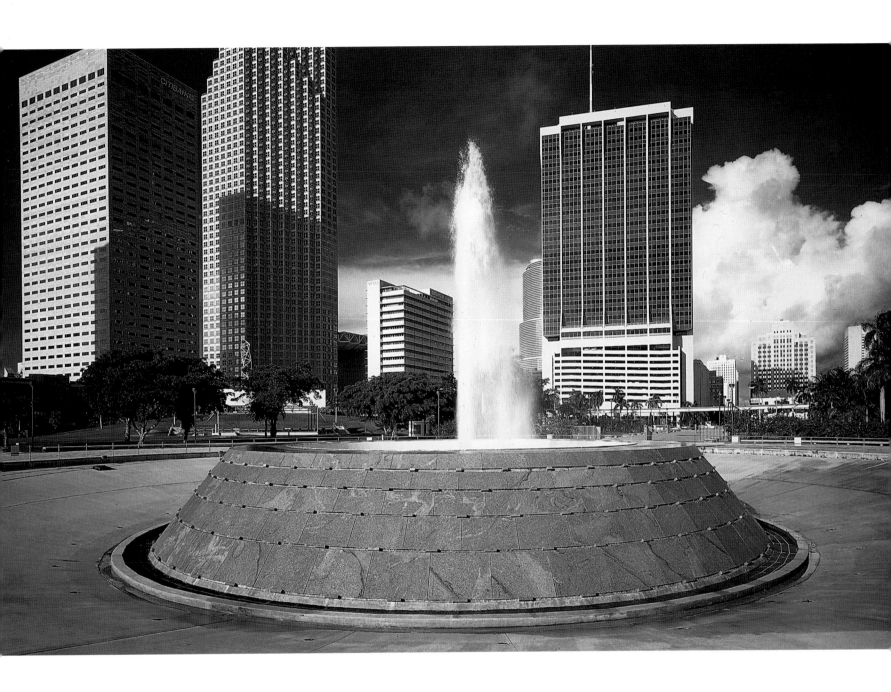

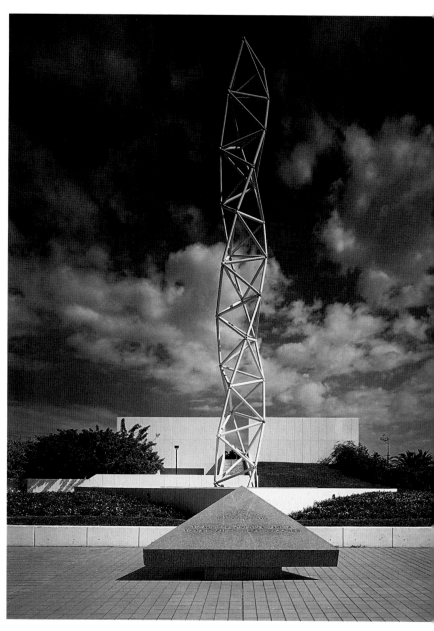

BAYFRONT PARK
FIGURE 174
Light Tower
The tower was planned as a ninety-foot-high technological sculpture that would be illuminated at night by a combination of different light systems, including lasers, that would create a major event for the city. Budget cuts compromised Noguchi's vision for the tower.

FIGURE 175
Challenger Monument, *steel, 1986*
Challenger Monument demonstrates Noguchi's deep connection with technology and his admiration for the scientific community.

FIGURE 176
White Slide Mantra,
Carrara marble, 1986
Noguchi recalled in his 1987 museum catalog, "When asked to represent the United States at the forthcoming Biennale in Venice, I decided to take the occasion to show a spiral slide I had devised in 1966 as representative of my long interest in the idea of play as it relates to sculpture . . . I hope that the *Slide Mantra* would find its final site in the park I am doing in Miami, Florida."

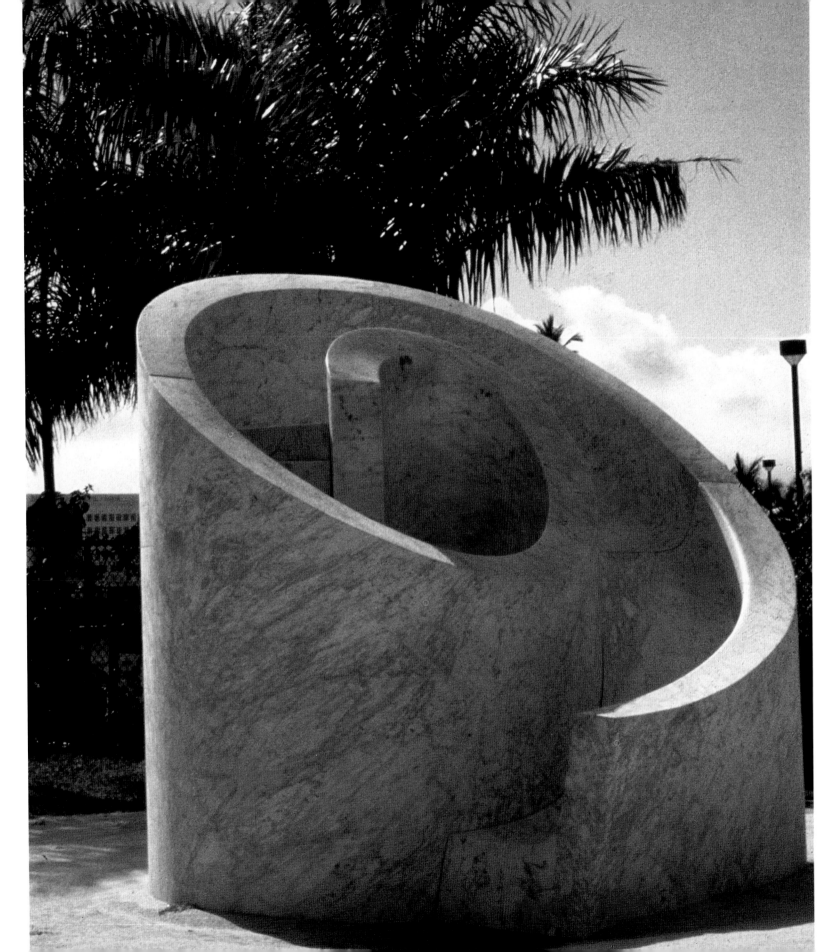

THIS INDEED IS THE DIRECT FUNCTION OF THE BASE; IT FRAMES AND CREATES AN OBJECT OF IMPORTANCE. AND YET I AM BOTHERED BY IT. IT TENDS TO REMOVE SCULPTURE FROM MAN'S OWN PROPORTION AND CONTACT. IT SUPPLIES A FICTIONAL HORIZON. THIS IS THE CHIEF REASON WHY I HAVE ATTEMPTED AN INTEGRATION OF SCULPTURE AND BASE: BASES THAT BITE INTO THE SCULPTURE, SCULPTURE THAT RISES FROM THE EARTH.[108]

During the last decade of his life Noguchi received numerous and difficult large-scale public commissions. In 1979 he was commissioned to design a plaza in the Fiera district of Bologna; the client requested that it make close reference to the nature of the surrounding architecture. Again, Noguchi had the opportunity to collaborate with his friend the architect Kenzo Tange. Tange had been asked by Bologna to plan a new complex of office towers, theaters, and shops in the Fiera district. He had designed the main towers around an open area that needed to be transformed into an attractive public space that would enhance the architecture.

This piazza was Noguchi's last collaboration with Tange (figs. 177 and 178). Their relationship had lasted almost four decades, beginning with the Hiroshima memorials of the 1950s. The association is comparable in importance to the one between Bunshaft and Noguchi, both in the number of projects and the length of time working together. Curiously, such duality always existed throughout Noguchi's life and work—he kept one studio in Long Island, New York, and one on Shikoku in Japan; he maintained one long and intense architect-artist collaboration in New York with Bunshaft and another in Japan with Tange. A similar duality manifested itself in the artist's sculpture: nature/human-made nature, gravity/lightness, East/West. As he described it, "Concepts appear and disappear. How easy it is to lose track of them in the myriad relationships, of depth to shallowness, of volume to plane, of density to clarity, small to large, palpable life to something dead."[109]

The artist proposed an integral concept of space that was, at the same time, a concept of structure: "In the land of the piazza, I thought Bologna would be fitting for a grand gesture."[110] He interpreted this as a unification of the pedestrian piazza space with the creation of a "gate": "With the assistance of the architect Gabor Acs, a gate in the form of a giant beam of granite [placed on a pyramidal base] rises at the entry"[111]

PIAZZA, FINANZIARIA FIERE DI BOLOGNA, FIERA DISTRICT, BOLOGNA, ITALY, *1979*
Architect: Kenzo Tange
FIGURE 177
Plan
The piazza in Bologna conveys Noguchi's masterful ability to unite form and space through the scale and proportion of elements. By creating a "gate," a giant beam, the artist joined the two public spaces around Kenzo Tange's new office complex.

FIGURE 178
Beam construction details
To emphasize relative scale, the giant beam of granite was placed on a pyramidal base at the entry.

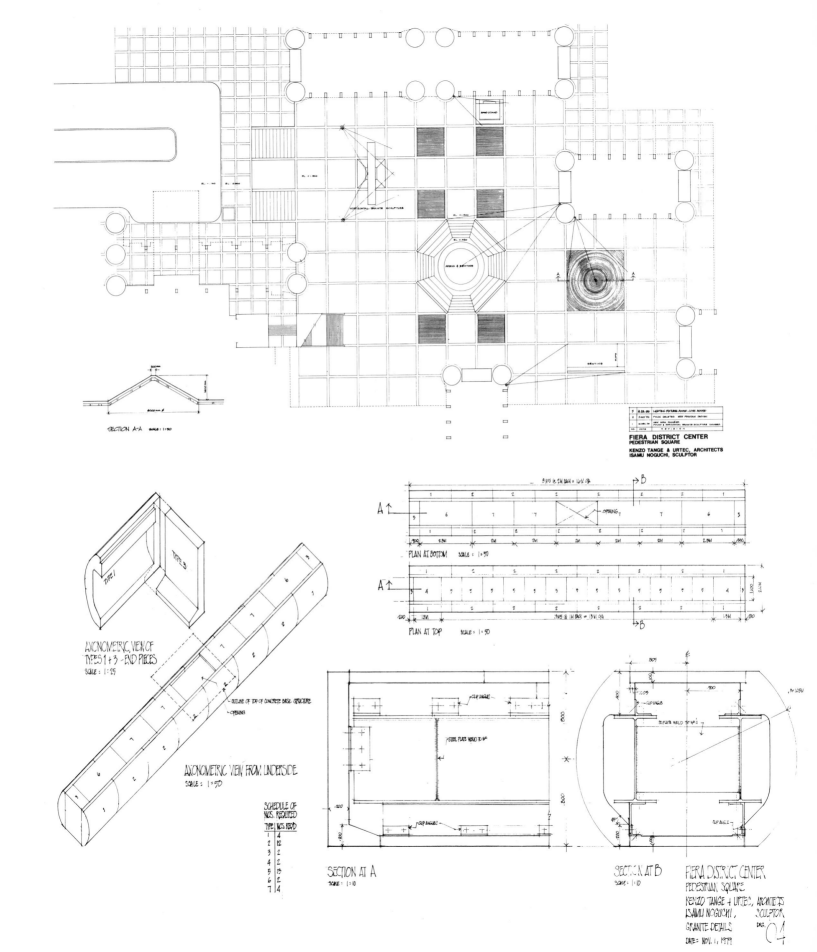

SECTION A-A SCALE : 1:50

FIERA DISTRICT CENTER
PEDESTRIAN SQUARE
KENZO TANGE & URTEC, ARCHITECTS
ISAMU NOGUCHI, SCULPTOR

PLAN AT BOTTOM SCALE : 1:50

PLAN AT TOP SCALE : 1:50

AXONOMETRIC VIEW OF
TYPES 1 + 3 - END PIECES
SCALE : 1:25

AXONOMETRIC VIEW FROM UNDERSIDE
SCALE : 1:50

SCHEDULE OF
NOS. REQUIRED

TYPE	NOS. REQ'D
1	4
2	12
3	2
4	2
5	13
6	2
7	4

SECTION AT A
SCALE : 1:10

SECTION AT B
SCALE : 1:10

FIERA DISTRICT CENTER
PEDESTRIAN SQUARE
KENZO TANGE + URTEC, ARCHITECTS
ISAMU NOGUCHI, SCULPTOR
GRANITE DETAILS
DATE : NOV. 1, 1979 DRG. 04

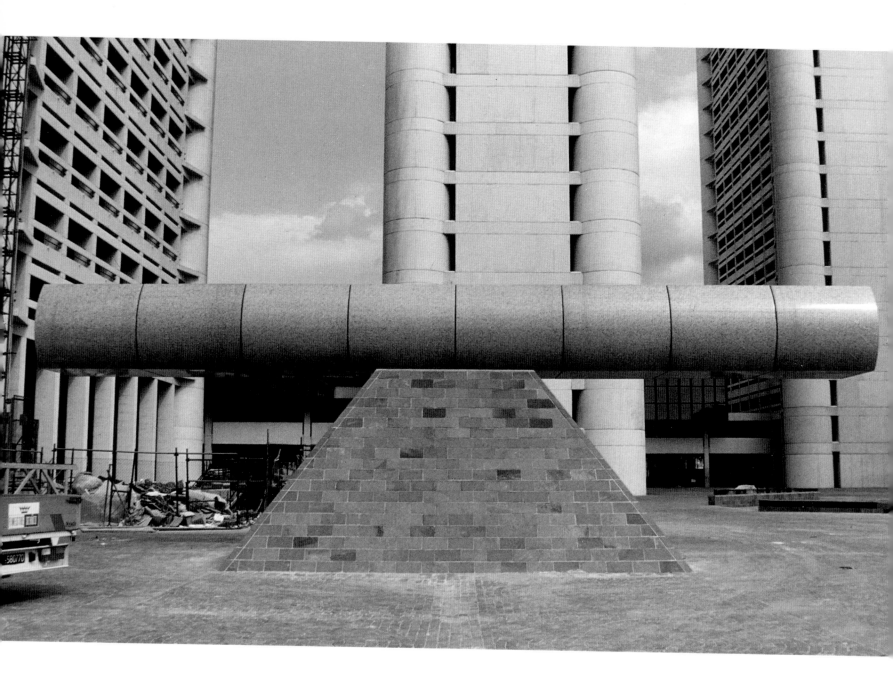

PIAZZA, FINANZIARIA FIERE
DI BOLOGNA
FIGURE 179
View of beam, granite, 52 1/2 feet
By placing the horizontal beam
on a base, Noguchi not only
expressed the tensions of gravity
but also delineated a fictional horizon.

(fig. 179). The viewer approaches it by way of a low stairway that rises at a gentle grade. An octagonal depression that lies farther beyond the "gate" was designed as a performance space within the piazza. This piece shares the vocabulary and symbolic interpretations of Noguchi's studio sculptures, such as *Night Wind* (1970), in which the concept of base and balance is the essence of the work. Similarly, the design recalls the Republic Fountains at the Art Institute of Chicago (1976–77); the horizontal orientation of the two works creates a symbolic equilibrium with the verticality of the surrounding buildings.

The piazza reveals Noguchi's extraordinary sense of scale—a sense Tange recognized. Indeed, Noguchi developed an intuitive sense of scale through his experiments in his gardens and set designs: "I think everything is relative in size and it's all a question of relative scale."[112]

The concept of scale is not the same as the concept of size; scale is relative size. It is rooted in the concept of comparison. From Vitruvius to Le Corbusier, scale has been a useful tool in architecture. For this design Noguchi used scale to emphasize the importance of his interests. He made use of different architectural aspects of scale: one aspect is scale relative to other elements. In general, for architects scale is perceived as a set of relationships among elements, not as distinctions in individual size. This gave Noguchi the opportunity to emphasize one design concept in particular. In other cases, he obtained scale as a result of relationships between one element and the whole.

Noguchi also worked with the principles of scale relative to the human body. In his dance sets, and in his environmental designs, he reshaped the space between the elements as a part of the sculptural components. As one of his major concerns, Noguchi defined the space between as the element of contemplation and communication. One of the artist's goals since he conceived his first environmental design was to state his social commitment, to make spaces more meaningful, and to treat sculptures as a complete space. His concepts of energy, gravity, lightness, movement, myth, and symbolism were the core of his designs. He brought to his last sculptural works, such as the Bologna piazza, a mature ability to combine all of these multiple layers.

Noguchi, in his last decade, had, or made for himself, opportunities to express the synthesis of some of his lifelong interests in gardens and sculptures. *California Scenario*, a contained public space, "became a dramatic landscape, one that is purely imaginary; it is nowhere, yet somehow familiar,"[114] like the bold landscapes Noguchi had developed in the 1960s with Gordon Bunshaft.

In 1980 Henry Segerstrom, a developer and descendant of a family of California lima bean farmers, approached Noguchi with a modest commission to design a fountain for a small park between two office towers. Noguchi, as he typically did in such situations, envisioned a much larger and more ambitious project and was able to convince Segerstrom to go beyond his original idea and commission the design of the entire 1.6-acre site in an Orange County shopping mall (figs. 180–82).

Noguchi transformed the undiscovered space between the two reflective glass office towers and the massive white-painted walls of an adjacent parking garage into an imaginary landscape that was a symbol of the topographical diversity of California. The essence and nature of the state's diverse landscape; its deserts, forests, farmlands, and bodies of water; and its natural energy reserves were represented by seven major sculptural pieces. These elements—mounds, a pyramid, a meandering stream, a fountain, and stones—were part of Noguchi's fundamental formal vocabulary and were reinterpretations of elements from earlier projects (figs. 183–85). His use of scale and carefully calculated relationships between these elements engages the viewer in infinite possibilities of interpretation, the illusion of space, and unlimited viewpoints.

For *California Scenario* Noguchi created a narrative. He conveyed the tale of Ts'ui Pen, the protagonist in Jorge Luis Borges's "The Garden of Forking Paths." Like Ts'ui Pen, Noguchi conceived a labyrinth of symbols, an image of the universe and its relation with time. The work, like "The Garden of Forking Paths," presents every object, both cultural and

ISAMU NOGUCHI

CALIFORNIA SCENARIO, COSTA MESA, CALIFORNIA, *1980–82*
Architect: Shoji Sadao/Fuller & Sadao
1.6 acres
FIGURE 180
Plan, 1981
Commissioned by Henry Segerstrom, Noguchi's *California Scenario* is a dramatic landscape that captures the viewer in a spatial illusion as he or she walks through the garden. The formal vocabulary of the six sculptural elements and a sculpture titled *The Spirit of the Lima Bean* creates a metaphor for the universe. Each element is related to the others in scale to allow the viewer to perceive the infinite possibilities for interpretation. *California Scenario* adheres to traditional stroll garden principles of moving perception.

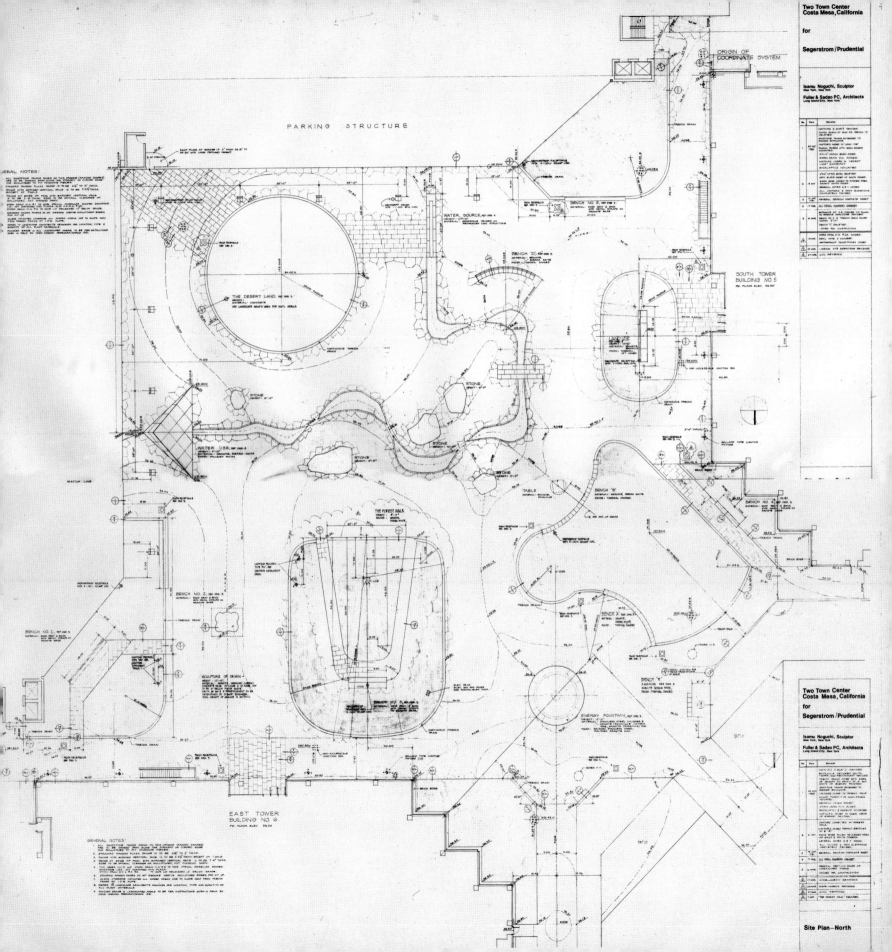

214

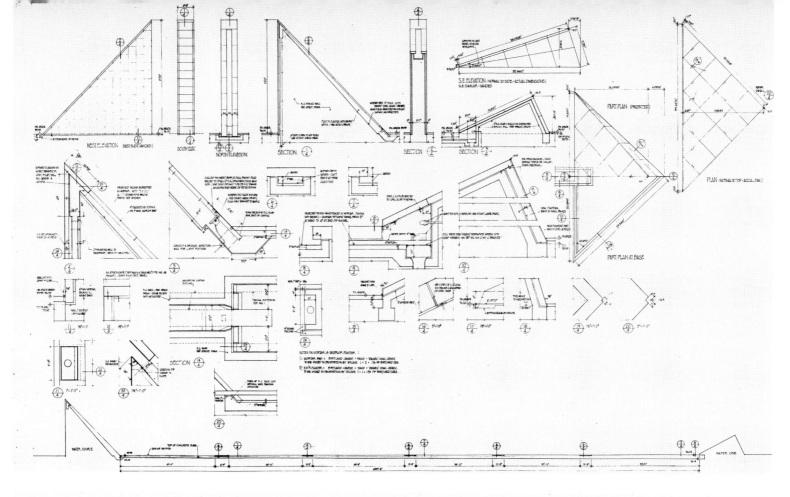

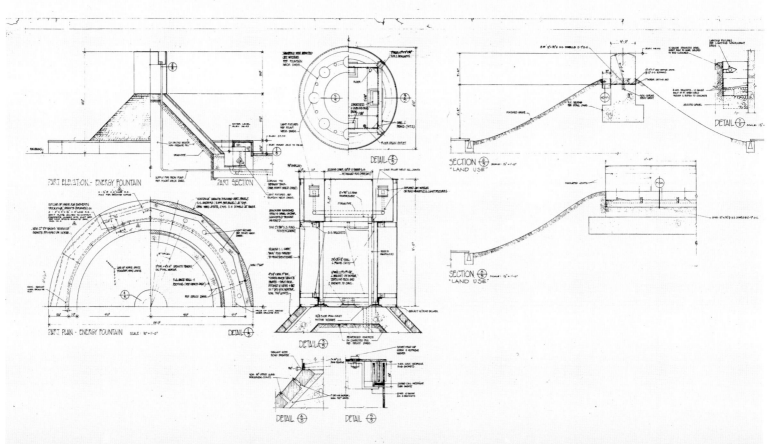

CALIFORNIA SCENARIO

FIGURE 181

Details of Water Source, Water Use,
and runnel, 1981
Water Source, a thirty-foot-tall
triangular sandstone fountain, brings
water from its apex into a winding
watercourse that culminates in *Water
Use,* a polished white granite pyramid.

FIGURE 182

Details of Energy Fountain
and Land Use, *1980*
To the north Noguchi located *Energy
Fountain,* a stainless-steel cylinder set in
a granite cone.

natural, within a web of symbols; each symbol, in turn, is altered in the course of time.

One of the most dramatic elements, *The Spirit of the Lima Bean*, is a twelve-foot-high mound of stone that represents the culmination of previous sculptural studies such as *The Illusion of the Fifth Stone* (1970). In both sculptures, Noguchi plays with artifice: "The stones seem to lock together. The degree of artifice is not readily visible. Are these natural boulders? No. The whole seems natural. A whole." He continued, "But just a pile [of rocks] did not constitute a sculpture for me. The concealment had to be closer to have it become a whole. But the stones retained their natural skin, which I valued beyond deception"[115] (fig. 186).

Noguchi created a theatrical stage, a scenario in which culture and nature become the same artifice and in which the viewer experiencing these timeless spaces becomes the interpreter of the symbol. The landscape designer Diana Balmori notes aptly in "The Case of the Death of Nature: A Mystery," "Nature was Culture's idea. Culture, when it wants to convince anybody that it is really right, just says that it's Nature."[116]

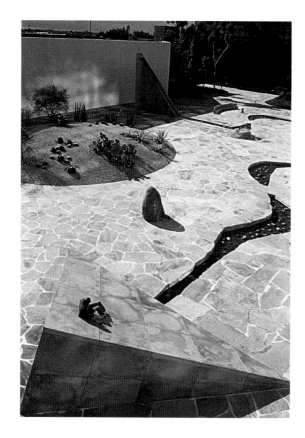
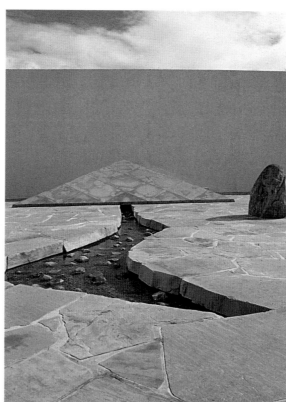
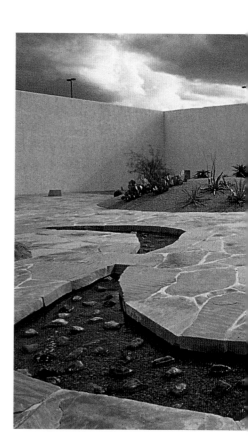

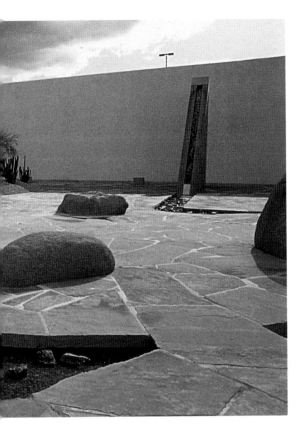

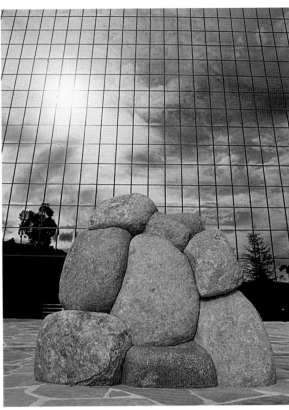

FIGURE 183

View of Water Use

Noguchi balances geometric and organic shapes, like the granite pyramid *Water Use*, as a counterpoint to the meandering stream flowing through and over small stones resting on a bed of gravel. He also creates a theatrical stage in which movement plays the protagonist's role in the sculptural space.

FIGURE 184

Detail of Water Source

The *Water Source* design for *California Scenario* was a variation on the triangular element in a fountain designed for the Massachusetts Institute of Technology in 1964, in collaboration with the architect I. M. Pei. The fountain's geometry is reminiscent of forms in the Samrat Yantra Observatory in Jaipur, India.

FIGURE 185

View of water and Desert Land

Desert Land, a low circular gravel mound planted with desert species, is juxtaposed with *Land Use*, an eight-foot-high oval knoll of honeysuckle, and *Forest Walk*, a rectangular hillside rimmed by redwoods and planted in the center with wild flowers and grasses in a tribute to California landscapes.

FIGURE 186

The Spirit of the Lima Bean,
granite, 144 inches high

The twelve-foot-high mound of stone *Spirit of the Lima Bean* is the most dramatic element in *California Scenario*. Here Noguchi played with artifice, making the stones appear to be locked together but also to look natural as a whole.

> BY SCULPTURE WE MEAN THOSE PLASTIC AND SPATIAL RELATIONSHIPS WHICH DEFINE A MOMENT
> OF PERSONAL EXISTENCE AND ILLUMINE THE ENVIRONMENT OF OUR ASPIRATIONS.[117]

With initial negotiations for *California Scenario* underway, Noguchi received the commission for a sculpture sited in the Japanese American Cultural and Community Center (JACCC) plaza, located in the heart of Los Angeles's Little Tokyo. The one-acre enclosed plaza was positioned between the JACCC, the James Irvine Japanese Garden (Seiryu-en), and the Japan American Theater.

After Noguchi visited the site, he approached the commission in his usual style, recommending a series of changes for the plaza, which was already under construction. Attached to a letter dated July 3, 1979, Noguchi sent a drawing of his proposal and suggested moving the theater from the center to the periphery, raising the entire plaza to one level, because the building under construction was elevated from the plaza by approximately eight feet, and building an amphitheater "which might even include a sculpture"[118] (fig. 187).

Noguchi's suggestions were welcomed and he began a complete design: "The sculpture proposal which had attracted me back to California was transformed into my designing a large plaza. This became the setting for the sculpture *To the Issei*"[119] (fig. 188).

PLAZA FOR THE JAPANESE
AMERICAN CULTURAL AND
COMMUNITY CENTER, LOS
ANGELES, CALIFORNIA, *1980–83*
Architect: Shoji Sadao/Fuller & Sadao
1 acre

FIGURE 187
Site drawing, 1981
As in earlier projects, the initial commission was for a sculpture that Noguchi transformed into a large-scale design.

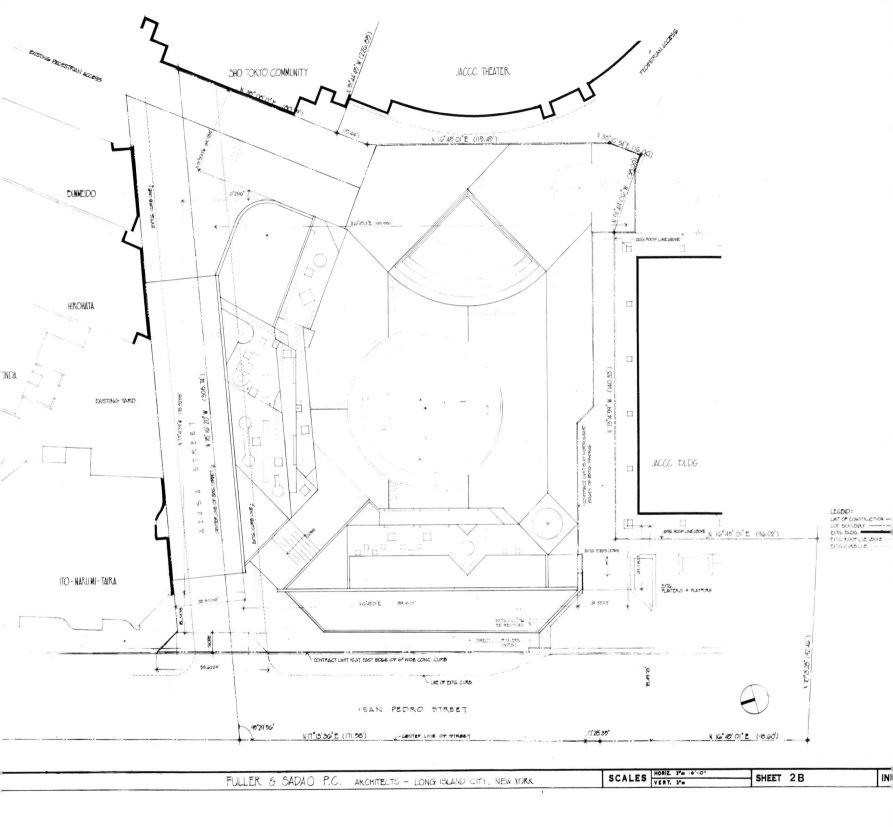

SHO TOKYO COMMUNITY

JACCC THEATER

EXISTING PEDESTRIAN ACCESS

PEDESTRIAN ACCESS

N 39°00'11"E (90.78')

N 73°44'45"W (276.05')

N 16°45'01"E (115.45')

N 35°10'34"E (16.00')

BUNMEIDO

HIROHATA

ONDA

EXISTING YARD

ITO - NARUMI - TAIRA

AZUSA STREET

JACCC BLDG.

SAN PEDRO STREET

N 17°13'36"E (171.58') CENTER LINE OF STREET N 16°45'01"E (18.60')

LEGEND:
LIMIT OF CONSTRUCTION
LOT BOUNDARY
EXTG. BLDG.
EXTG. ROOF LINE ABOVE
EXTG. CURB LINE

FULLER & SADAO P.C. ARCHITECTS — LONG ISLAND CITY, NEW YORK

SCALES
HORIZ. 1"= 16'-0"
VERT. 1"=

SHEET 2B

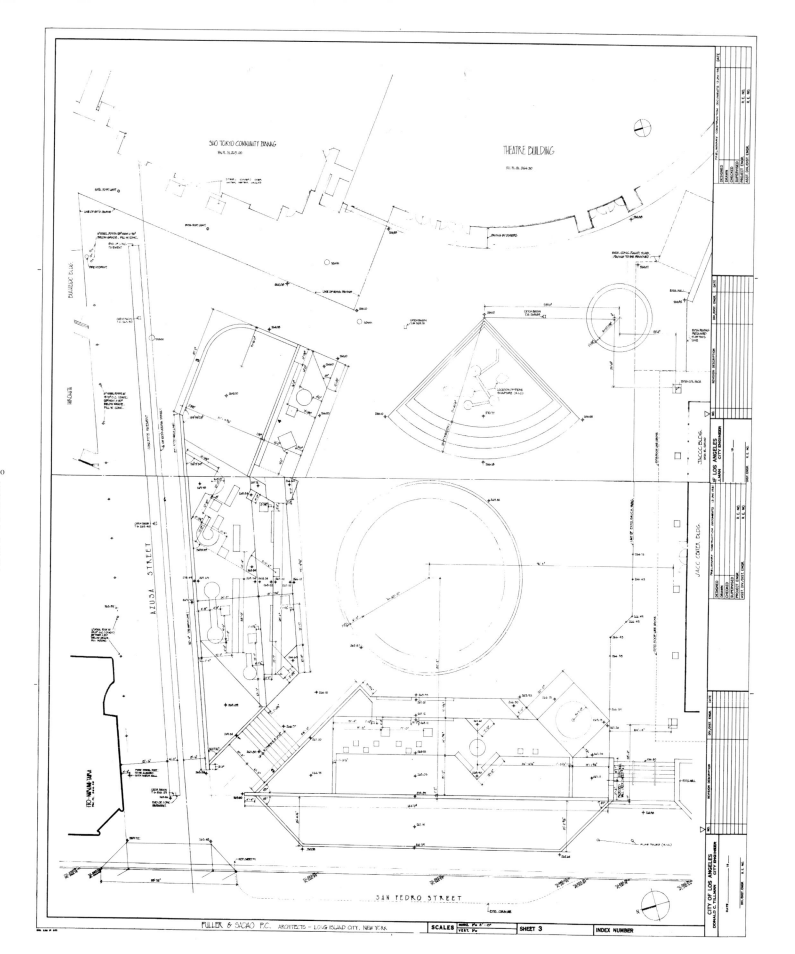

PLAZA FOR THE JAPANESE AMERICAN CULTURAL AND COMMUNITY CENTER

FIGURE 188

Plan

With the plaza under construction, Noguchi recommended a series of changes to convert the JACCC plaza into a gathering place that could be used day and night to complement the adjacent theater.

FIGURE 189

Section A, c. 1981–83

The large plaza became the setting for *To the Issei*. Noguchi placed the sculptural group on a wedge-shaped stage in front of the Japan American Theater.

FIGURE 190

Section C, c. 1981–83

The JACCC plaza is one of Noguchi's "environments of leisure," created for public performances and events.

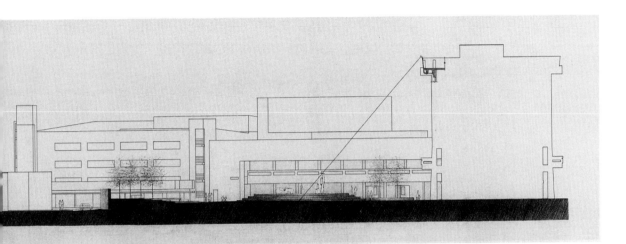

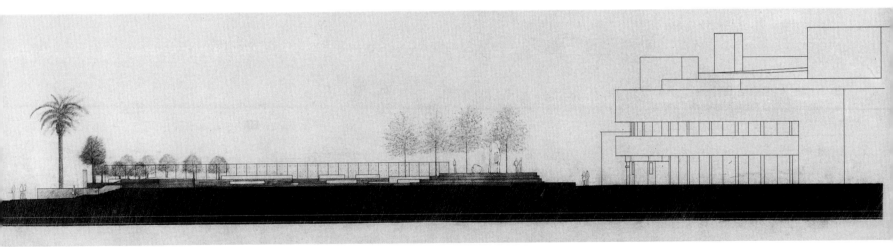

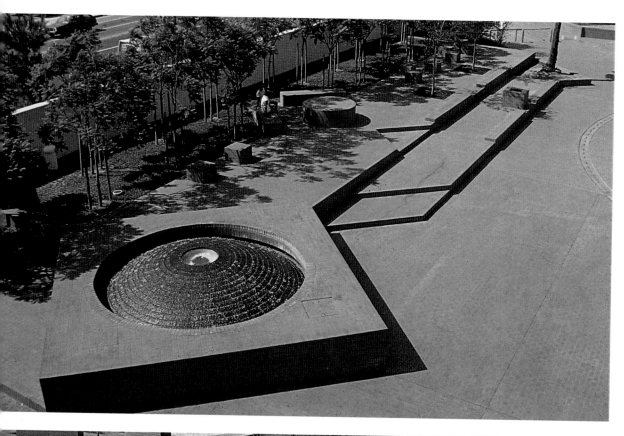

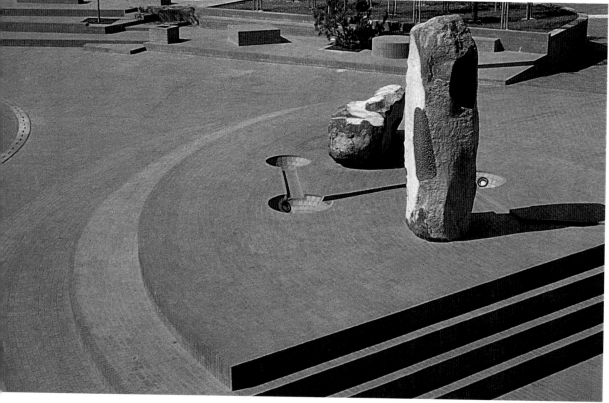

PLAZA FOR THE JAPANESE
AMERICAN CULTURAL
AND COMMUNITY CENTER

FIGURE 191

View

The geometry of the seating
arrangement is reminiscent of
some of Noguchi's earlier work
for the Lever Brothers Building
and at UNESCO gardens.

FIGURE 192

To the Issei, *basalt, two elements,
120 inches long*

The partially carved basalt sculptural
group *To the Issei* was formed by one
horizontal and one vertical element.
It marked the focal point of the plaza,
mediating the scale between the
pedestrians and the architecture sur-
rounding the plaza.

Whereas *California Scenario* can be seen as the culmination of
Noguchi's enclosed gardens, the JACCC plaza represents a "place of
gathering" in which the artist's concept of art having social significance
is successfully realized. Noguchi defined the concept as a transformation
of a dream into reality, of reality into a dream (figs. 189 and 190). Art is
brought into daily life and daily life into art.

Noguchi achieved this concept with admirable simplicity. The
artist used a series of circular red brick patterns to emphasize the
plaza's center—the circle, the symbol of the world. Steps, fountains,
plantings, and benches were located around this true center
(fig. 191). The plaza became a symbol for the bicentennial celebra-
tion of Japanese-American culture. Noguchi's basalt sculpture
To the Issei was placed on an elevated platform-stage in front of the
theater building (fig. 192). It is formed by two juxtaposed twenty-
ton elements: one horizontal piece ten feet long, one twelve-foot-
high standing pillar. Both pieces are partially carved, underscoring
ritual, metaphor, and infinite interpretations. *To the Issei* may be
interpreted in many ways—as a concept of togetherness, as one gen-
eration, age, or time. *Issei* also means "the greatest man of his time."

MY CONCERN TO PRESERVE THE EVIDENCE OF THIS CONTINUING EXPERIMENTAL DEVELOPMENT WAS THE DECISION TO ESTABLISH A MUSEUM. A GARDEN MUSEUM WOULD TIE TOGETHER AS WELL THE OTHER ASPECTS OF MY INVOLVEMENT WITH ENVIRONMENT: THEATER SETS, THE GARDENS, LIGHT SCULPTURES (AKARI).[120]

When, in 1981, Noguchi decided to transform an old factory building across the street from his studio in Long Island City, New York, into a museum, he had a vision of how to present his work in his own space. For the artist, this was also an affirmation of his duality, his two identities, Japanese and American. At this time he also had two homes, one on Shikoku in Japan and the other in New York City.

Noguchi wanted the individual symbolism of both places to characterize the aim of his art. He expressed this contrast in 1958 after returning from Japan: "Returning, I was always struck by the contrasts of America, Japan, and the rest of the world; the difference in materiality, or should one say, the concepts of reality, which is not just a question of place but of the modern versus the old world—the permanent reality of the past and the fluid reality of the present."[121]

The two-story New York factory was converted into the Isamu Noguchi Garden Museum, which featured a garden at the center of the museum's triangular footprint (figs. 193 and 194). For this work, the artist not only chose to link Western and Eastern expression but also paid homage to Brancusi's *Endless Column* with his own *Helix of the Endless*. In addition, he paid a tribute to stone with his monolithic sculptures.

THE ISAMU NOGUCHI GARDEN MUSEUM, LONG ISLAND CITY, NEW YORK, *1981–85*
Architect: Shoji Sadao/Fuller & Sadao
FIGURE 193
First-level plan
Reflecting his independence from the traditional boundaries of the art world, Noguchi chose an old factory as the site of his garden museum in Long Island City.

FIGURE 194
Second-level plan
The two-story museum with a central garden emphasizes the artist's peripatetic nature, his diversity.

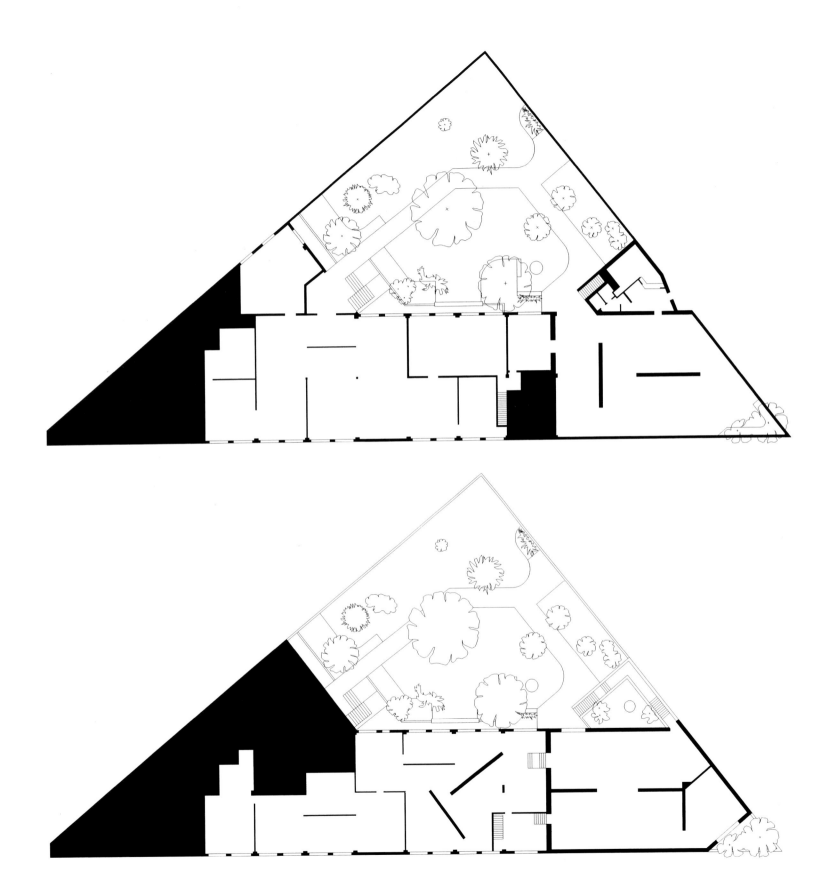

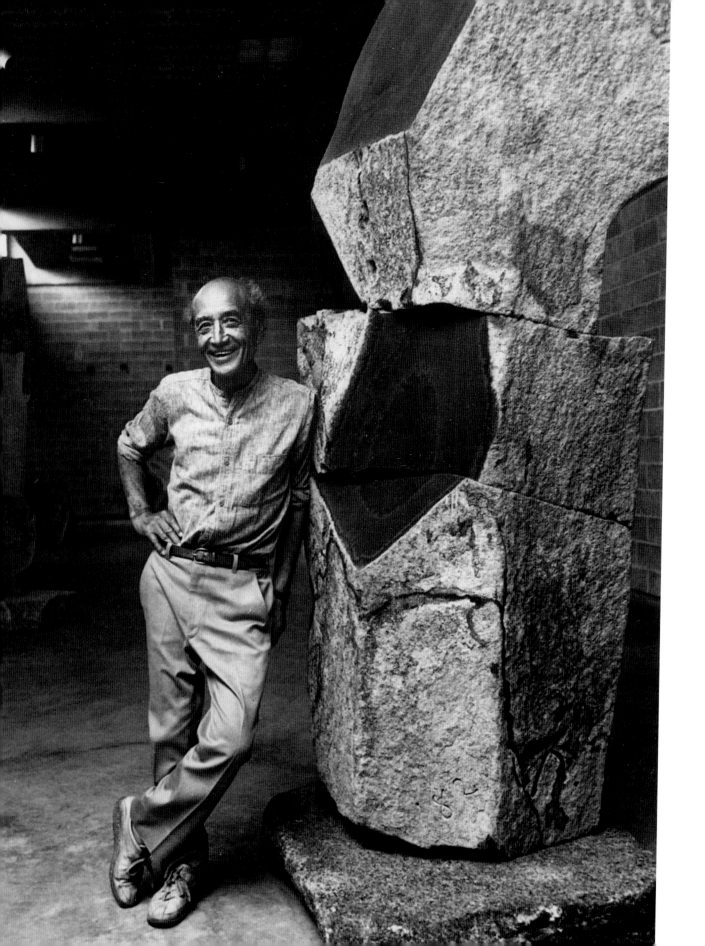

Isamu Noguchi with Brilliance *at
the Isamu Noguchi Garden Museum*
With the design of the museum
Noguchi honored his dualism. At
the entrance he located his
mature works, his homage to stone.

The museum is a garden of memories, reflecting the artist's life. In Renaissance Italy, Duke Pierfrancesco "Vicino" Orsini created Bomarzo. The duke's garden, like Noguchi's, mirrored his dreams and myths, and expressed the dualism of nature and culture. Bomarzo expressed a double conceit: the sculptures and grottoes looked like artworks that were reshaped by nature. In Noguchi's case, nature was viewed as something to be manipulated. The plants in the gardens, as he described, "come and go"; the stones and the sculptures were the "bones" (figs. 195–97).

Noguchi carefully arranged his sculptures, set designs, and environmental projects throughout the thirteen areas of the building (fig. 198). As Bruce Altshuler points out, Noguchi placed his work "on a stage of physical and emotional experience."[122] His studio was located above the museum, with vistas onto the garden, and became a place of contemplation.

Noguchi found his other home in Japan, in 1983, in Mure on the island of Shikoku and in its history, tradition, and tatami rooms. Masatoshi Izumi, Noguchi's stonecutter, restored a Japanese farmhouse according to traditional building practices as a place for the artist to live and work (figs. 199–201). In 1952 Noguchi had created a studio in an old farmhouse that belonged to the pottery master Rosanjin Kitaōji.

Noguchi dreamed of converting this second workplace in Japan into another museum. He expressed this desire in 1982 in the catalog for "Isamu Noguchi at Gemini": "It is hoped that my work place in Japan at Mure Cho . . . may become recognized as a branch of the New York Museum"[123] (figs. 202–4). The Isamu Noguchi Museum in Japan opened on May 14, 1999.

THE ISAMU NOGUCHI GARDEN MUSEUM

FIGURE 196

View

The garden, a combination of plants native to Japan and the United States, was, as Noguchi stated, "a dialogue between myself and the primary matter of the universe. A meditation, if you will."

FIGURE 197

View

In the garden Noguchi laid out his great stones, his homage to Brancusi—*Helix of the Endless*—as his place, half of himself.

FIGURE 198

Detail of interior

Inside the museum, thirteen areas are arranged so that sculptures can be appreciated in relation to human motion.

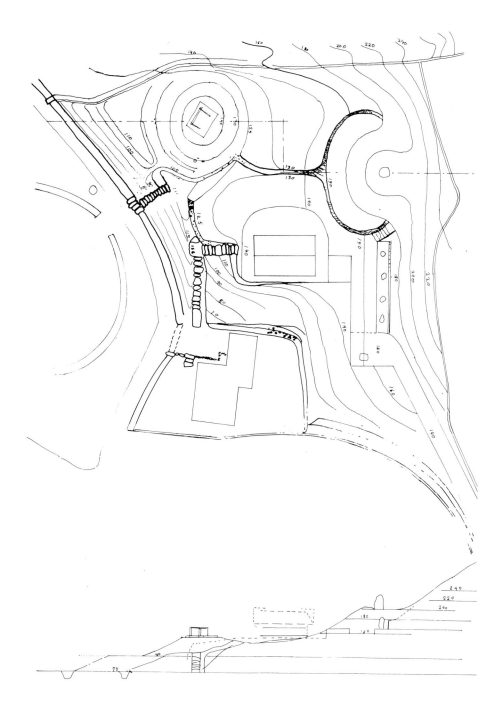

THE ISAMU NOGUCHI
GARDEN MUSEUM

FIGURE 199

*Plan of Noguchi's studio
on Shikoku*

Before creating the Isamu Noguchi
Garden Museum, Noguchi built
a studio in Mure on the Japanese
island of Shikoku. Ultimately he
assumed his duality by devoting
two environments to his art, one
in Japan and one in America.

FIGURE 200

*View of Noguchi's studio
on Shikoku, c. 1986*

When Noguchi returned to Shikoku,
he returned to the archaic—to
stone, the origin of the symbol of
nature and humanity.

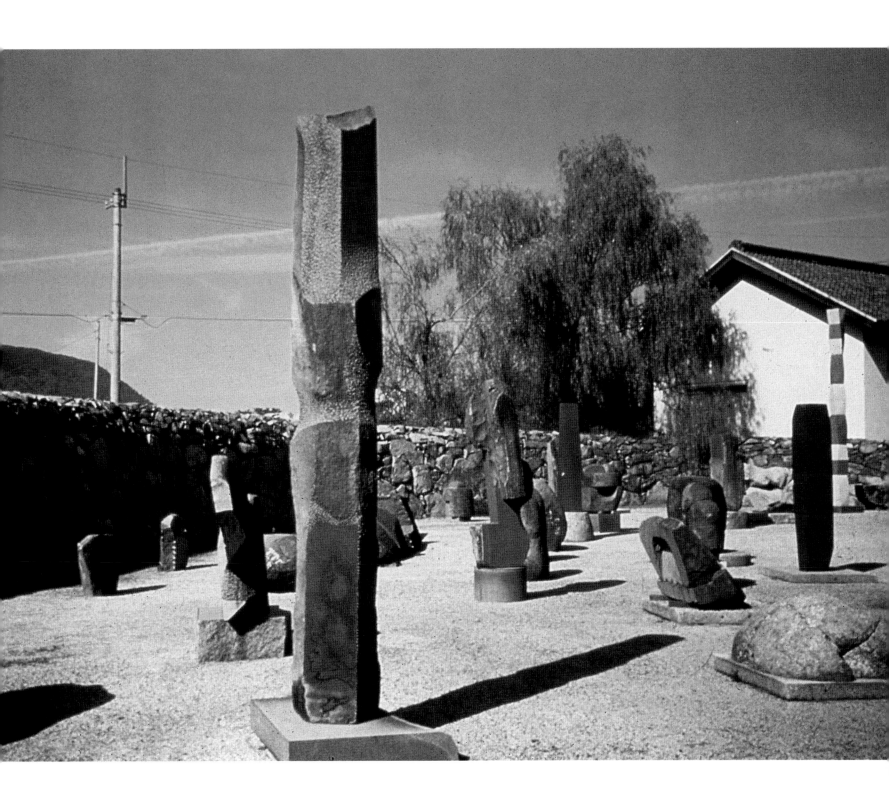

THE ISAMU NOGUCHI
GARDEN MUSEUM

FIGURE 201

Noguchi's studio on Shikoku

The Long Island City museum and the studio in Mure on the island of Shikoku, in close relation to their cultural surroundings, achieved what Noguchi had described in his early years as his understanding of New York and Japan. One was an urban social event, the other a retreat.

FIGURE 202

View of garden at Noguchi's studio on Shikoku

On Shikoku Noguchi carved his dramatic stones. Working with harder materials—granite and basalt—he became more aware of the concept of time, from geological time to cosmological time, in relation to stone.

FIGURE 203

View of garden at Noguchi's studio on Shikoku, c. 1986

Noguchi, who understood the spirit of tradition in the Japanese garden, also understood the art of emptiness and gave definition to the invisible and the inaudible in his garden on Shikoku.

FIGURE 204

View of garden at Noguchi's studio on Shikoku

At Mure, Noguchi also created a garden, but a different one, in which water and stone defined a peaceful place for contemplation.

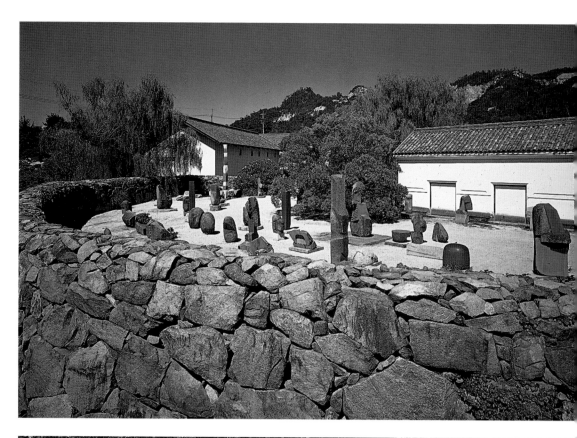

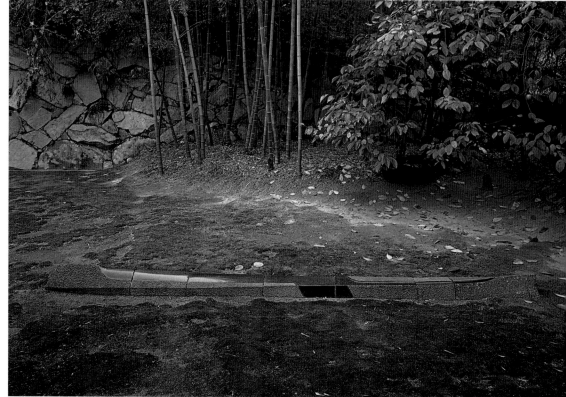

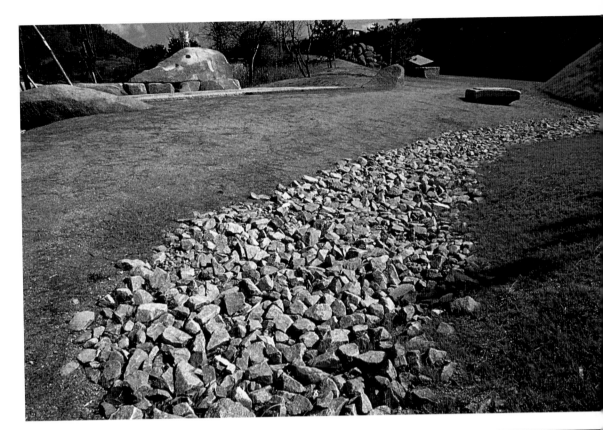

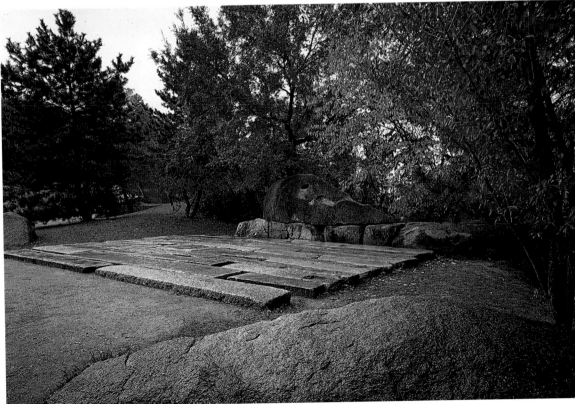

I HAD COME TO THINK THAT THE DEEPER MEANING OF SCULPTURE HAD TO BE SOUGHT
IN THE WORKING OF HARD STONE. THROUGH THIS MIGHT BE REVEALED ITS QUALITY OF
ENDURING. THE EVIDENCE OF GEOLOGIC TIME WAS ITS LINK TO OUR WORLD'S CREATION.
TO SEEK SUCH A SCULPTURE OF TIME TAKES TIME.[124]

Yoshio Taniguchi, son of the architect Yoshirō Taniguchi, with whom
Noguchi had completed the memorial to his father at Keiō University
(1951–52) and the public sculpture for the National Museum of Modern
Art in Tokyo (1966), was commissioned to design a museum to house
the photography of Domon Ken (1909–90) on a site in Sakata, Ken's
birthplace in northern Japan. The location was at the base of a small
mountain in a park, four kilometers from the city. Taniguchi designed the
building based on the philosophical concept of transformation over time.
To accomplish this objective, he conceived an artificial lake in which the
changes of nature would be perpetually reflected. He also planned two
gardens, one designed by Hiroshi Teshigahara, the other by Noguchi.

In 1983 Taniguchi first asked Noguchi to consider designing a sculp-
ture garden for the Domon Ken Museum. Dore Ashton quotes the archi-
tect's memories of his first encounter with Noguchi: "That evening I asked
him to design a sculpture garden for the museum. He said, 'Why should I?'
I said, 'Do it for me.' You know, Isamu never said yes right away."[125]

Eventually, Noguchi accepted the commission to design the garden.
Fascinated by the landscape of the area and in agreement with
Taniguchi's architectonic approach to the building's design, Noguchi

reinforced and enhanced the architectural concept of change over time. Architecture and sculpture each complemented the other with particular associations relating to juxtapositions between nature and culture. The sculpture garden was located on the lakeshore where the water, the architecture, and the mountain were visually connected by the garden in the tradition of *shakkei* (borrowed scenery). Noguchi's spatial resolution was also intrinsically linked to concepts of time, nature, and emptiness.

Noguchi included in the Domon Ken Museum garden relationships to the prehistoric pillar, the garden, the spirit of Zen, and the concept of *ma*. *Ma*, a fundamental principle in Japanese kabuki theater, represents the emptiness of time and space, the potentiality within an empty space. Noguchi defined *ma* within the garden as a void contained by three walls and a fourth "wall" suggested by a bridge that also framed the view onto the lake. Movement was introduced through four descending stone platforms over which water flowed into the lake. The metaphor of a single granite sculpture, a simple stone, a human, the artist standing in the middle of the flow, emerged: "Flowing water symbolizes passing of time, time of Japanese history after the war. And it is Domon who stands in the middle of this flow"[126] (fig. 205).

Noguchi incorporated, as he had in earlier works, the most ancient metaphor—that of the stone pillar, partially carved, standing off center. Like one of Michelangelo's *Prisoners*, the half-carved figure emerges from the basalt, the earth, and the spirit of the stone. Two small plantings of bamboo in one corner bring organic nature into the sculptural garden.

The Domon Ken Museum garden reflects Noguchi's success in capturing the essence of what a garden is. The artist extracted this from his lifelong experimentation with ideas of sculptural space and emptiness. The master garden designer Mirei Shigemori, born in 1896, once explained, "In an art of emptiness, a definition is given of the invisible, the inaudible, and therefore, that which does not appear, but it should be realized that the content is an expression which sees something in the invisible, which hears something in the inaudible."[127] In his mature work, Noguchi returned to the spiritual essence of nature and sculpture—to stone. The Domon Ken garden was emphatically a "place of the spirit."[128]

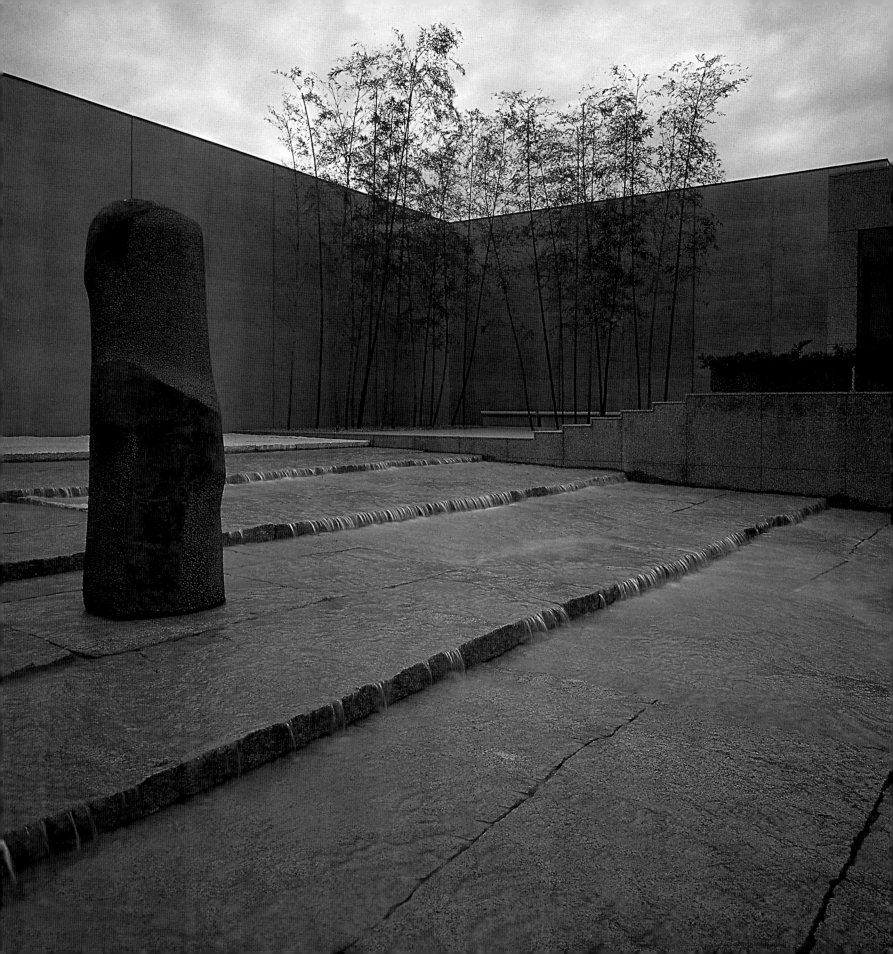

DOMON KEN MUSEUM OF
PHOTOGRAPHY GARDEN,
SAKATA, JAPAN, *1984*
Architect: Yoshio Taniguchi
30 by 36 feet
FIGURE 205
View
This is one of Noguchi's most beautiful
and poetic gardens. It consists of four
stone terraces over which water flows
along a single granite pillar that acts as
a focal point bringing together the
sky, the horizon, and the land. It directs
and extends the viewer's vision
outward and emphasizes humankind's
relationship to nature.

THE MOMENT OF CONFRONTATION WITH THE PROBLEM AT HAND. AT THIS MOMENT HE MAY MOMENTARILY BE SAID TO BE AN ARTIST, A COMPLETE ARTIST, OTHERWISE, HE IS NOTHING. HE MAY OF COURSE, BE A SPECIALIST SUCH AS I HAVE DESCRIBED, HE MAY EVEN BE ABLE TO GIVE EVERY REPLY IN TERMS OF HIS SPECIALIZED CRAFT, BUT THIS SEEMS HARDLY LIKELY. RATHER IN MAINTAINING AN OPEN WORLD, WITH ITS MULTIPLICITY, AND THE VARIETY OF ITS SITUATIONS, I BELIEVE HE WILL WANT TO BREAK ALL LIMITS.[129]

In Sapporo, a city located on the northern Japanese island of Hokkaido, Mayor Itagaki invited Noguchi to design a park and proposed three potential sites. After visiting the three locations, in March 1988, he selected the city's 454-acre landfill—a place the city had eventually planned to transform into a public park. The area was known as Moere Numa—*moere,* which means "still surface of water" in Ainu (the language of Hokkaido's indigenous population), and *numa,* "marsh" in Japanese.

The vision of this immense site, "almost as big as Central Park,"[130] reinforced Noguchi's desire to amplify his concept of sculpture. As recalled by Dore Ashton, Noguchi had remarked, "I'm nearing the limits," explaining his desire to "make sculpture part of a larger scheme."[131] He intended to give form to this land and create a monumental walkable sculpture. Noguchi completed only the park's master plan, a model at the scale of one to three thousand (fig. 206). With the artist's unexpected death one month after the plan's completion, the client questioned the possibility of continuing the project.

Noguchi's strong enthusiasm, however, ultimately inspired the city to implement the master plan with the supervision of Shoji Sadao as executive architect and Junichi Kawamura of Architect 5 Partnership—the associate architect who had already signed on to the project. After ten years of development and construction, in July 1998 Moere Numa Park, based on Noguchi's master plan, was partially opened to the public. Final completion of the park is scheduled for the year 2004.

Continuing his lifelong interest in the dialogue between nature and human-made nature, Noguchi organized the site using a system of pure geometric forms (circles and squares) with a monochromatic palette of materials. The design included a meandering river, a cherry-tree forest,

MOERE NUMA PARK,
SAPPORO, JAPAN, *1988–*
Master plan designed by Isamu Noguchi
Architect: Shoji Sadao/Fuller & Sadao
Associate Architect: Junichi Kawamura/
Architect 5 Partnership
454 acres
FIGURE 206
Model of playground, 1988
Noguchi was given his largest project in early 1988, just a few months before his death. The artist, who completed only the master plan, saw Moere Numa Park as the opportunity to expand his concept of sculptural space.

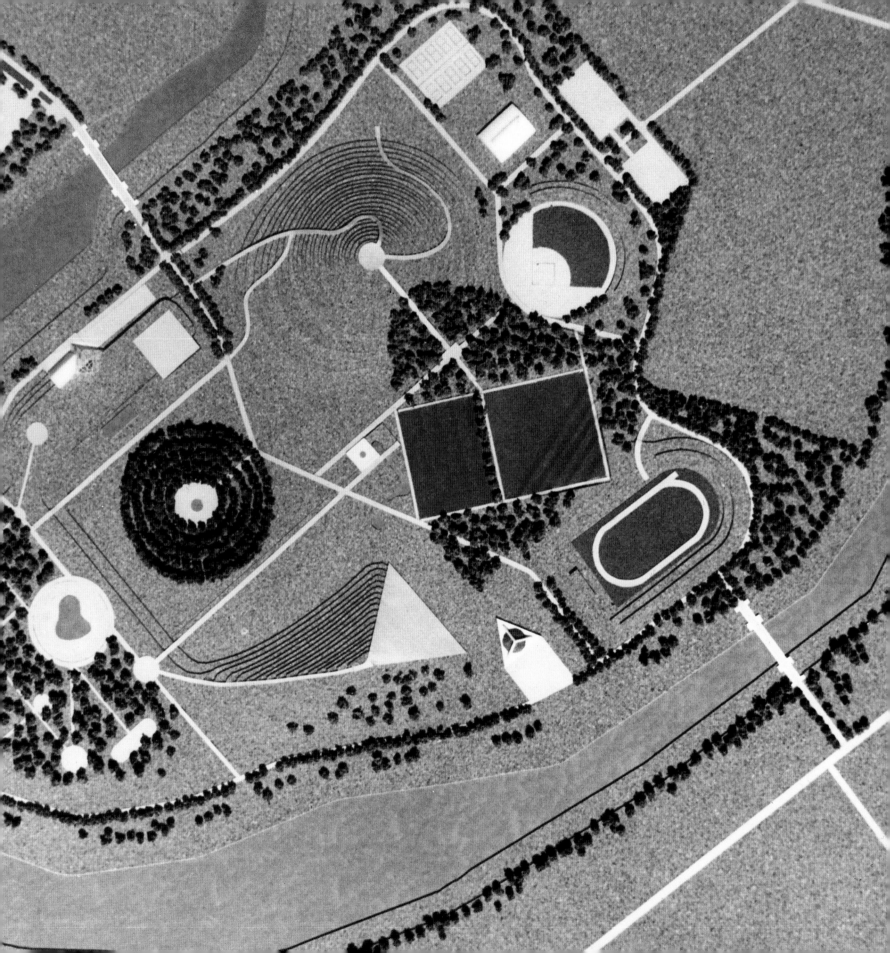

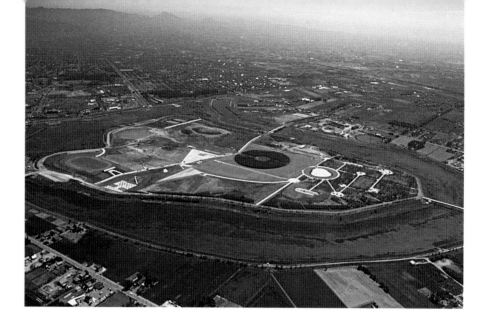

FIGURE 207

Aerial view

The park, partially opened to the public in 1998, was realized under the supervision of architect Shoji Sadao. The park manifested, at a large scale, the sculptural environments for social interaction that Noguchi designed throughout his life.

FIGURE 208

View of Play Mountain

In 1933 Noguchi, experimenting with playgrounds, conceived an early model of Play Mountain. At that time, he presented his model to the New York City parks commissioner, Robert Moses, who promptly rejected it. Sixty-four years later, his idea was translated into a ninety-foot-high earthwork.

FIGURE 209

Detail of park element

Visitors are encouraged to walk on, to climb on, and to explore many of the structures in the park. The simple geometry and palette of materials were determined by Noguchi's earlier work.

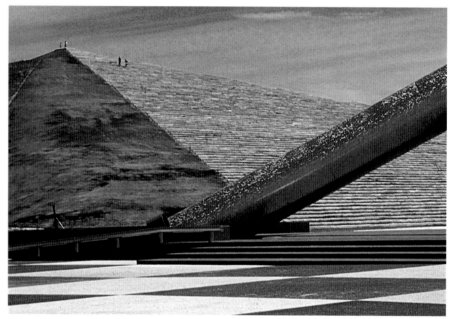

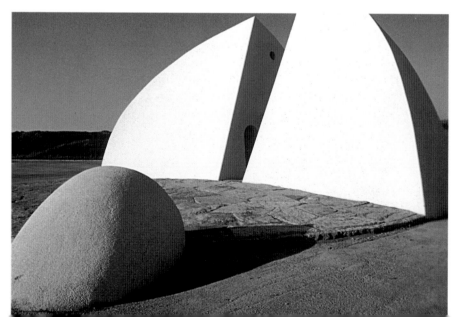

seven playground areas, a baseball diamond, an outdoor amphitheater, a glass pyramid civic center, and two mountains: Mount Moere, the 164-foot-high "tell," and a 90-foot-high reinterpretation of Play Mountain (1933) in which one of the triangular faces is terraced by ninety-nine stone steps (figs. 207–9). The concept of surprise, the educational component, and the colors of the artist's playground equipment of the 1930s and 1940s were each brought into Moere Numa Park. Noguchi conceived a place where social ritual would occur based on his deep belief that public enjoyment of sculpture is more significant than individual possession of it. As in the UNESCO gardens and Billy Rose Sculpture Garden, visitors are encouraged to walk, to climb, and to explore Moere Numa (figs. 210–12).

The park reflects Noguchi's mastery of the understanding of public art's social value and his introduction of these ideas into Japanese culture. Opportunities for public art have expanded in Japan during the 1990s, but these works still remain decorative afterthoughts because few artists are brought into early development phases of projects. Moere Numa Park, as Noguchi envisioned it, will become a gathering place like Central Park in New York. Olmsted pioneered the idea of bringing public open spaces to urban environments. Noguchi, like Olmsted, was a pioneer in the way he approached sculpture. Olmsted's Central Park was conceived in terms of representing bucolic nature, creating a rustic setting with curved paths and shapes, allowing nature to grow wild. Noguchi, in contrast, designed Moere Numa Park as a sculpture, with sharp corners and orthogonal paths and with living elements under strict control.

Noguchi's extensive body of work and Sadao's many years in collaboration with him allow this park to beautifully reflect the artist's belief in the role of sculpture. Because this became a permanent retrospective exhibition of Noguchi's work, curiosity leaves visitors wondering what new twist the artist would have introduced.

In each of Noguchi's works, in each sketch, in each construction site, something changed, something was new. Is Moere Numa the conclusion of Noguchi's six-decade career? Or does it continue indefinitely? As Borges stated: "I could not imagine any other than a cyclic volume, circular. A volume whose last page would be the same as the first and so have the possibility of continuing indefinitely."[132]

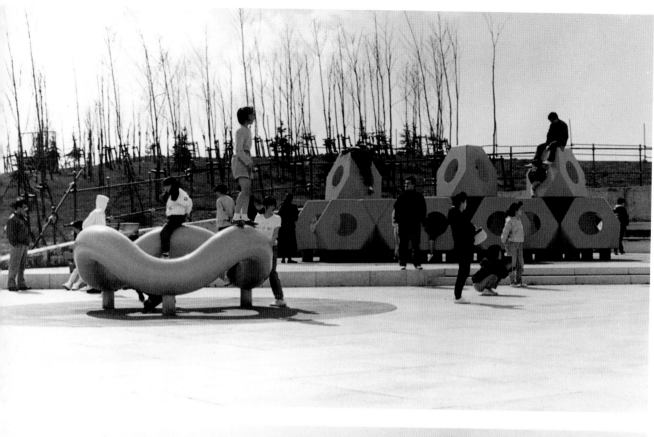

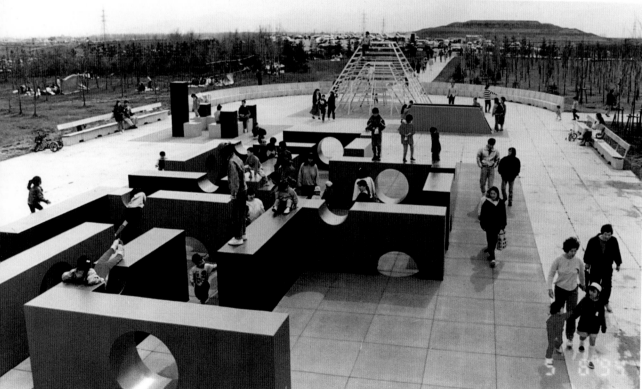

MOERE NUMA PARK

FIGURE 210

Detail of playground, 1998
The design, which accommodated a
river, a forest, an outdoor amphitheater,
and two mountains, also included
seven playground areas in which
appear pieces reminiscent of Noguchi's
work from the 1930s and 1940s.

FIGURE 211

Play equipment
In contrast to the monochromatic color
palette of the park, the play equipment
clearly bears the artist's signature in
its vibrant palette of colored shapes set
into a concrete stage.

FIGURE 212

Detail of playground, 1998
The play equipment—cubes, hexagons,
trapezoidal monkey bars, cylinders—
creates a spatial relationship that
echoes the relationship of the larger
earthworks to the whole.

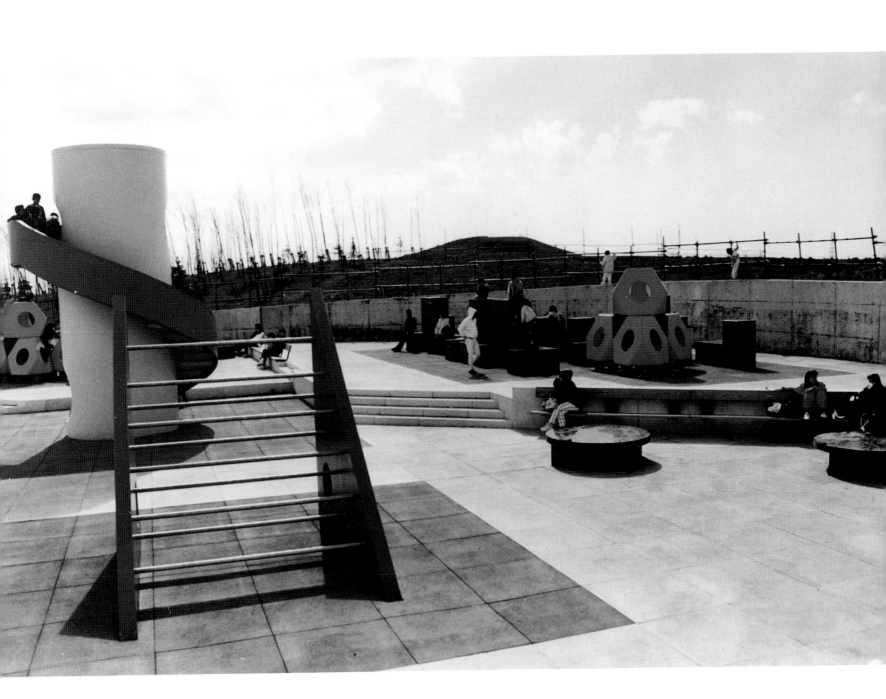

I TOOK REFUGE IN A VACANT STORE ON EAST 76TH STREET AND MOVED EVENTUALLY
TO A FANCIER PLACE, HAVING ACQUIRED FANCY FRIENDS, TO THE HOTEL DES
ARTISTES. THE CONTRASTS OF POVERTY AND RELATIVE LUXURY MADE ME MORE
AND MORE CONSCIOUS OF SOCIAL INJUSTICE.[1]

In 1932, after having traveled extensively throughout the world support-
ed by a Guggenheim Fellowship, Noguchi returned to New York and
once again faced the problem of making a living. Personal experiences
and new insights gained from his travels made him think more critically
about political and social issues, something that would find its way into
his work throughout his career.

This perspective on society led Noguchi to focus his attention on
particular events and people that he believed were beneficial to humanity.
As a result, he made proposals for and worked on several memorials
during his life. Some were components of parks or gardens, or memorial
parks themselves; others were freestanding pieces.

Noguchi's freestanding memorials were, like his gardens, conceived
as metaphors, in that all of the elements were woven into one narrative.
Language, literature, and architecture are intrinsically connected. Vitruvius,
in one of his passages in *The Ten Books on Architecture*, re-created the
beginning of humanity and identified the origins of architecture within
the origins of language. Noguchi, whose childhood was spent acquiring a

CARL MACKLEY MEMORIAL
(HOSIERY WORKERS'
MEMORIAL), PHILADELPHIA,
PENNSYLVANIA, *1933 (unrealized)*
FIGURE 213
Noguchi with plaster model of
Carl Mackley Memorial *(lost)*
Noguchi's own experiences of both
poverty and relative luxury made him
more conscious of social injustice. He
conceived the *Carl Mackley Memorial*
to represent the tools of the
Philadelphia Hosiery Workers' Union.

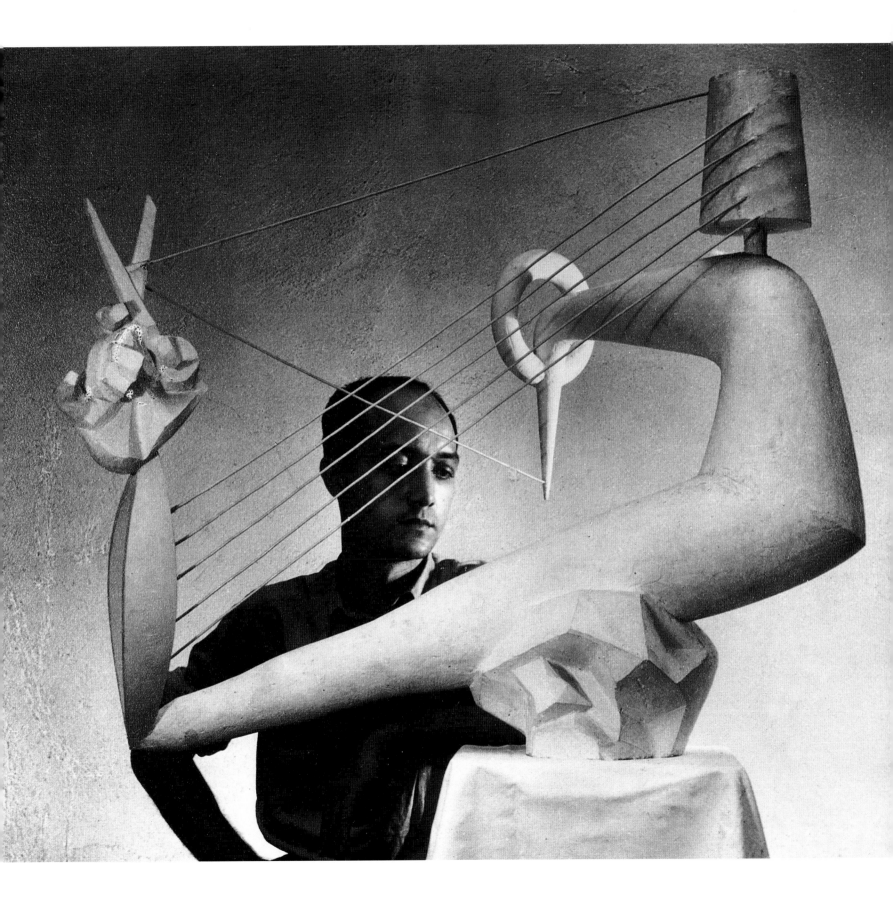

BOLT OF LIGHTING . . .
MEMORIAL TO BEN FRANKLIN,
1933
FIGURE 214
Model
Looking for ways to communicate
through sculpture, Noguchi abstracted
Franklin and his kite in *Bolt of
Lighting . . . Memorial to Ben Franklin.*

BELL TOWER FOR HIROSHIMA,
HIROSHIMA, JAPAN,
1950 (unrealized)
FIGURE 215
*Terra-cotta and wood model
(proposed height 70 feet)*
Bell Tower, designed for Hiroshima's
Peace Park, reflects Noguchi's
interest in "floating mass," the Zen
concepts of gravity and weight,
and the sound created by the wind—
symbolic of mourning the war dead.

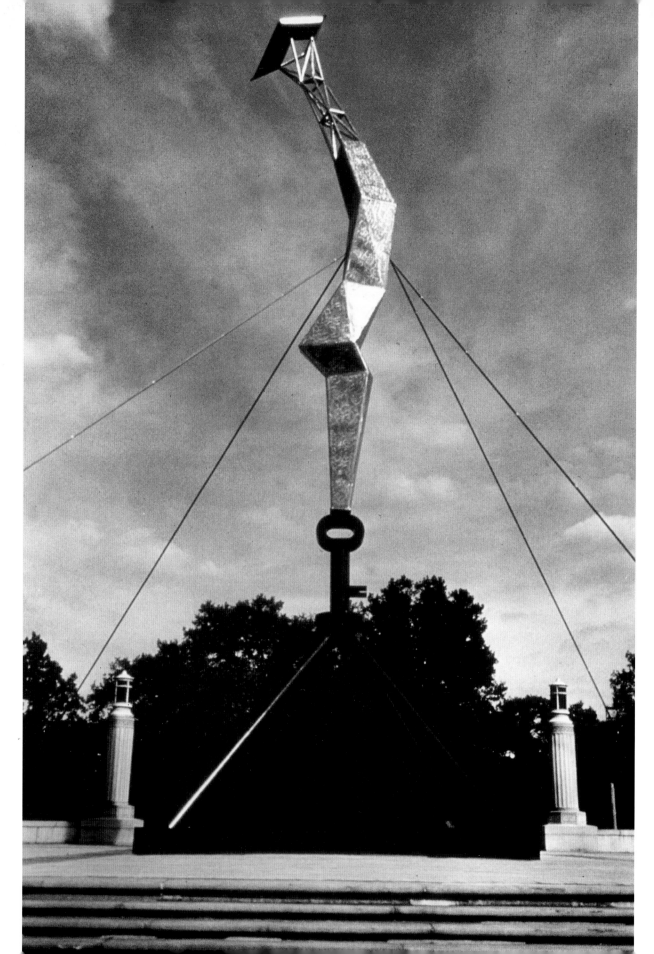

Model for THE BELL TOWER

broad knowledge of classic literature, brings order to the viewer's reality. Jorge Luis Borges describes such a relationship in his foreword to *Obra Poética, 1923–1976:* "The taste of the apple . . . lies in contact of the fruit with the palate, not in the fruit itself; in a similar way . . . poetry lies in the meeting of the poem and the reader, not in the lines of symbols printed on the pages of a book. What is essential is the aesthetic act, the thrill, the almost physical emotion that comes with each reading."[2]

By 1933 Noguchi wanted to find a new form of expression: "I wanted other means of communication—to find a way of sculpture that was humanly meaningful without being realistic, at once abstract and socially relevant."[3] He wrote, "I was not conscious of the terms 'applied design' or 'industrial design.'"[4] With this in mind, Noguchi designed two memorials: *Carl Mackley Memorial (Hosiery Workers' Memorial)*, an abstraction of sewing machinery to be located in the community housing development of the Philadelphia Hosiery Workers' Union (fig. 213); and *Bolt of Lighting . . . Memorial to Ben Franklin*, which was devised as a hundred-foot-tall lightning bolt topped with a kite, a reference to the discovery of electricity (fig. 214). Franklin's kite was also reminiscent of Noguchi's childhood.

In 1984, supported by the Fairmount Park Art Association, a modified stainless-steel version of *Bolt of Lighting* was installed on East River Drive in Fairmount Park, Philadelphia. The actual memorial, as described by Noguchi, is very close to the artist's original concept.

Both memorials were included in a solo exhibition of Noguchi's proposals for public works conceived during this period. Play Mountain (1933) and *Monument to the Plow* (1933) were also part of the solo exhibition at the Marie Harriman Gallery in 1934. Unfortunately, the critic from the *New York Sun*, Henry McBride, chose to focus his review on Noguchi's mixed parentage rather than on his artistic vision.[5] "I hate to apply the word 'wily' . . . what other word can you apply to a semi-oriental sculptor . . ."[6] In addition to making such comments, McBride believed that Noguchi did not have the capacity to enrich the American art scene. It seems that McBride, like Gutzon Borglum (to whom Noguchi had been apprenticed in 1922), was unimpressed with

MEMORIAL TO THE DEAD, HIROSHIMA, JAPAN, *1952 (unrealized)*
FIGURE 216
Site model (proposed dimension 20 feet)
While Noguchi was working on *Bell Tower*, he proposed the *Memorial to the Dead* to commemorate the atomic bombing of Hiroshima. The artist thought of this memorial as a concentration of energies, "the arch of peace with the dome of destruction."

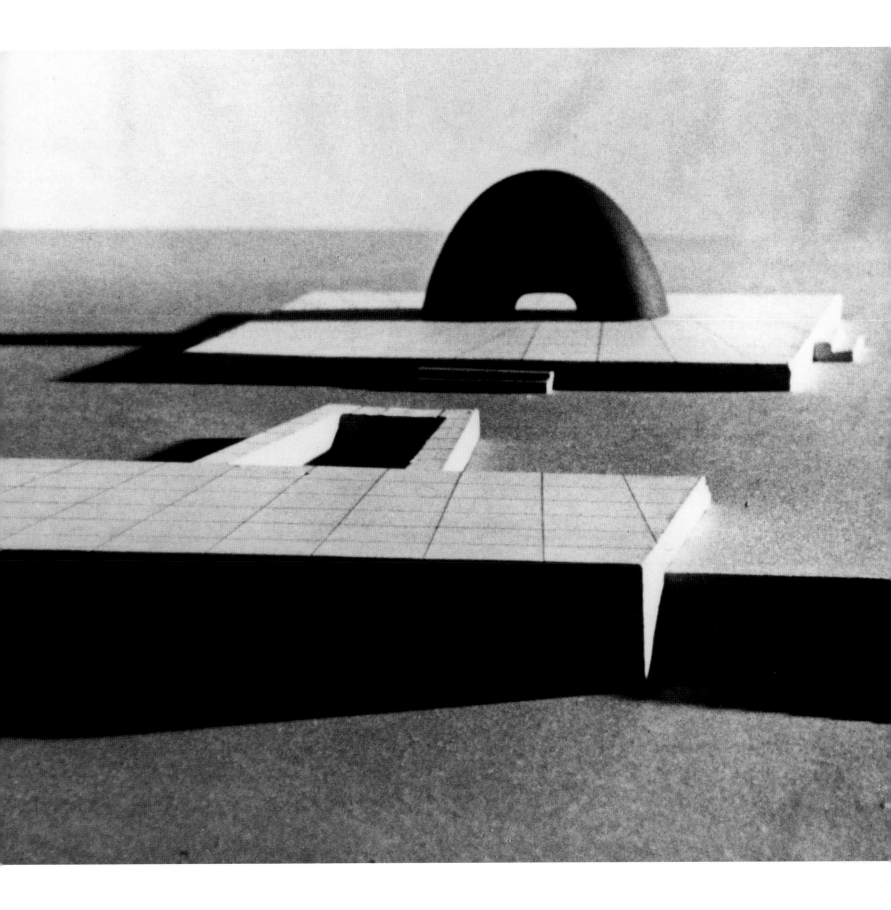

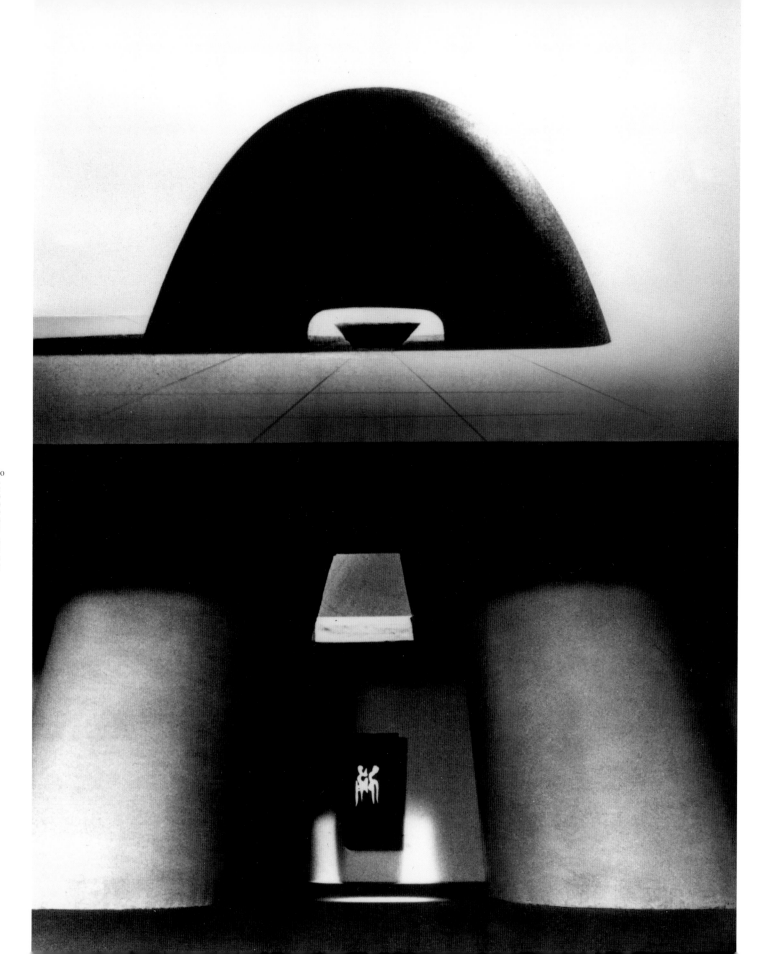

Noguchi's unusual talents and visions for the future. Because of an inability to see beyond surface issues into the substance of the artist's work, both McBride and Borglum sought to discredit it.

In the early 1950s, while Noguchi was designing the Reader's Digest Building garden and the bridge railings for Peace Park in Hiroshima, Japan, he designed two other commemorative structures related to the memory of the atomic bomb in Hiroshima. In 1950 the artist proposed *Bell Tower for Hiroshima*, an abstraction of a large-scale Eastern wind chime (fig. 215). He made two models of his proposals, in terra-cotta and wood. During this time Noguchi was experimenting with terra-cotta in Seto and later near Kita Kamakura with the great potter Rosanjin Kitaōji. The bell tower was conceived as an open structure soaring seventy feet high, in which various fragments—bones, bells, helmets, sun, moon—symbolizing a universe in which the world is broken by destruction were hung from horizontal rods to create a thick mass. This concept of "floating mass" was an exploration in lightness and gravity, and it was employed in a series of sculptures of which *Cronos* (1948) was the first. The tower proposal, however, was never realized.

Memorial to the Dead (1952) was conceived in response to a request from the mayor of Hiroshima and the architect Kenzo Tange, with whom Noguchi was working on bridges for Peace Park. *Memorial to the Dead* was intended to commemorate the two hundred thousand people who died as a result of the atomic bomb. The main requirement was that the memorial have an underground level to encompass the repository of names. Noguchi approached this challenge by proposing two rectangular platforms, each complementing the other. One platform represented the "cave," which featured a rectangular void as an entrance, "a cave beneath the earth (to which we all return)."[7] The other, featuring a massive black granite parabolic arch rising toward the sky, symbolized peace (figs. 216 and 217). The form had been derived, as Noguchi remarked, from the prehistoric roofs of Haniwa houses. Haniwa were hollow clay representations of possessions owned by the deceased elite during their lifetime and chosen to adorn their mounded tombs during the Tumulus period (250–552 CE). Underground, the repository of names was placed in a granite box extending out from the wall.

MEMORIAL TO THE DEAD
FIGURE 217
Detail of model
The memorial was to symbolize both birth and death, from the prehistoric roofs of Haniwa houses to the metaphor of the cave.

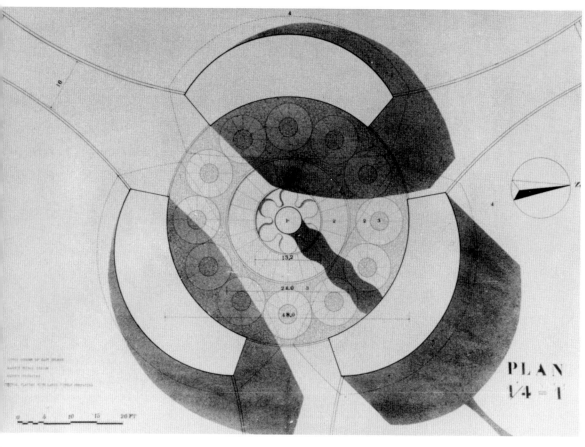

PLAN
1/4 = 1

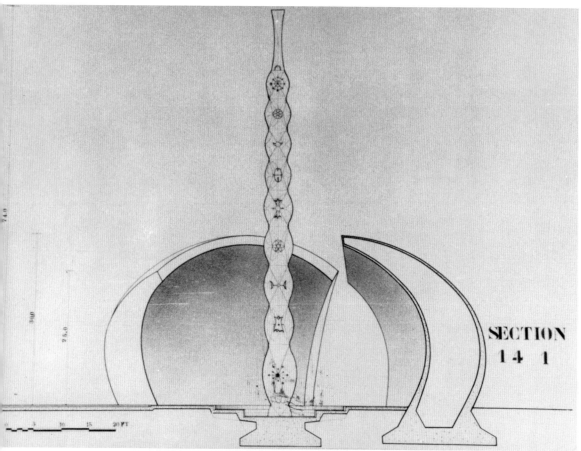

SECTION
1/4 1

MEMORIAL TO BUDDHA,
NEW DELHI, INDIA,
1957 (unrealized)
FIGURE 218
Plan
Because Noguchi was more interested
in commemorating Buddha's holy birth
than the origin of his religion, he
proposed a design based only on the
leaves of a giant lotus for his entry
to the competition commemorating the
2,500th anniversary of Buddhism.

FIGURE 219
Section
The memorial was composed of a
lotuslike enclosure from the
center of which rose a seventy-
foot-high bronze spire.

TOMB FOR JOHN F. KENNEDY,
ARLINGTON, VIRGINIA,
1964 (unrealized)
FIGURE 220
Model view
Invited to collaborate on the design
of John F. Kennedy's tomb,
Noguchi proposed placing the flame
beyond the stone platform so
that it would rise from the grassy earth.

FIGURE 221
Model view
Around the grave Noguchi suggested
a large beach of pebbles with
sizable interstices that would permit
the insertion of cut flowers.

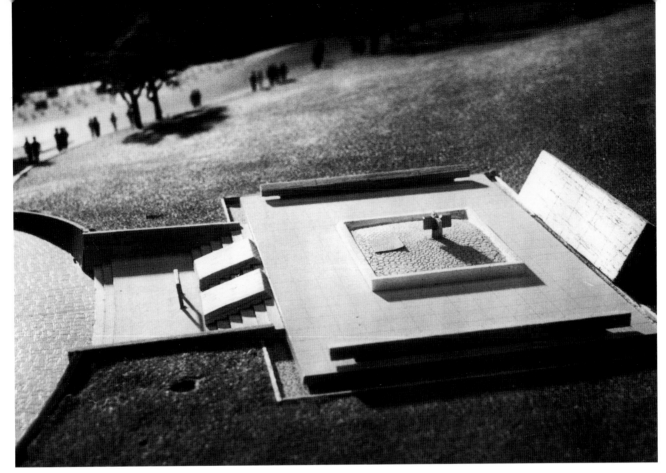

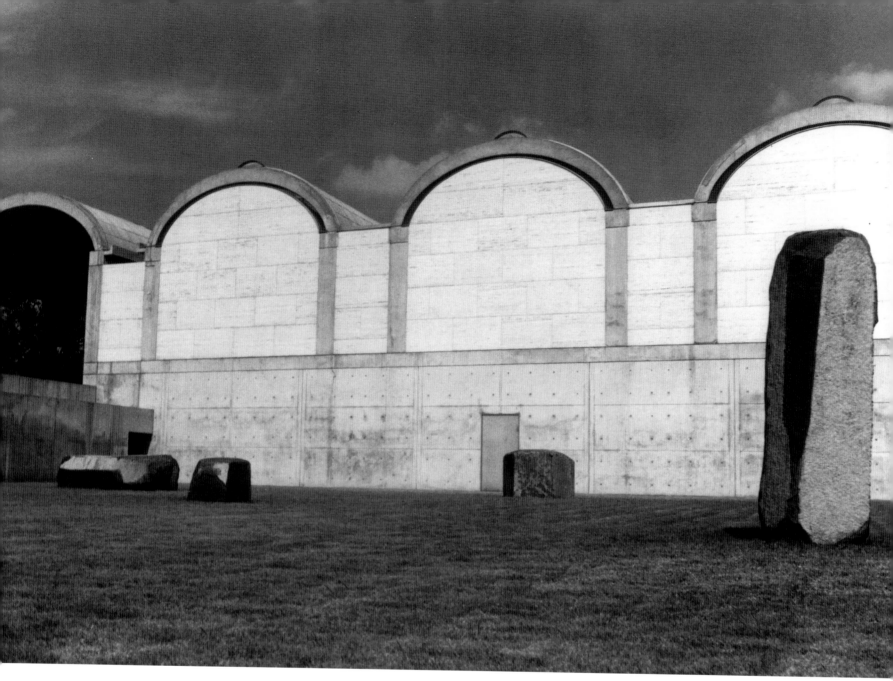

CONSTELLATION, KIMBELL
ART MUSEUM, FORT WORTH,
TEXAS, *1980–83*
Basalt, four elements, 100 by 100 feet
FIGURE 222
View
In this basalt sculptural group Noguchi
returned to the essence of material, to
stone. His homage to Louis I. Kahn
used ancient Japanese principles in the
treatment of the stones' surfaces.

The committee in charge of granting approval for the memorial rejected Noguchi's efforts. The strongest opposition came from Hideto Kishida, an architect and one of Tange's teachers. Hideto reasoned that neither Tange nor the mayor had consulted with the committee prior to extending the invitation to Noguchi. Later, Noguchi wondered, "Was it because I was an American, or was it a case of *Giri* not having the proper authorization, to which my design fell victim?"[8]

In 1957 Noguchi, along with a group of young Japanese architects, entered a competition for a memorial commemorating the 2,500th anniversary of the birthday of Buddha, to be built in New Delhi. The team presented a design based on an abstraction of a lotus blossom, referring to the theme of recurrent change and rebirth (fig. 218). It was a seventy-foot-high cast-bronze sculpture, a sort of ringed parabolic dome composed of three separate spheroid sections resembling lotus petals. At the center, a stamenlike column held nine lotus-petal-shaped niches, each containing a statue of Buddha (fig. 219). The column Noguchi designed reflected Brancusi's sculptural vocabulary, exemplified by *Endless Column*, while adhering to traditional Buddhist conventions: "What we have attempted is to present the familiar—the lotus, the domed stupa, the ringed spire—in the creative form of our day, making new for us the old."[9] The entry was not selected.

In the summer of 1964 the architect John Carl Warnecke asked Noguchi to help him with a proposal for the design of President John F. Kennedy's tomb at Arlington National Cemetery, in Virginia. Noguchi suggested removing the massive stone from its platform and placing it beyond this area so that it would appear to rise from the mound, creating a visual break (fig. 220). Noguchi also suggested creating a mound surrounded by beach pebbles rather than grass in recognition of Kennedy's appreciation of the sea and its beauty (fig. 221).

Noguchi felt honored, and appreciated the opportunity to contribute and be accepted as an American. His initial enthusiasm ultimately turned into a double disappointment. Warnecke at first agreed to share credit with Noguchi but changed his mind in the middle of the design process. On some level, Noguchi knew that the issue of his mixed parentage, as it had in Hiroshima, took precedence over his skills as an artist: "My trips to Washington have all been unhappy. However perversely I could not help feeling that I had been rejected by America as I had been by Japan with the Hiroshima *Memorial to the Dead*."[10]

Noguchi's last memorial, completed in 1983, was an homage to Louis I. Kahn at the Kimbell Art Museum in Fort Worth, Texas. Entitled *Constellation*, the memorial is formed of four basalt figures reminiscent of prehistoric menhirs. The four stones have a combination of polished and carved surfaces (fig. 222). As Noguchi explained, the process of carving allowed the sculptures to emerge from the stones of their own volition. This combination of polished and carved faces establishes a dialogue between the memorial and the concrete and travertine facade of Kahn's museum—a dialogue that speaks of a notion of beauty shared by the artist and the architect.

Each of the memorials adds another dimension to Noguchi's concept of sculptural space. "The essence of sculpture," the artist once remarked, "is for me the perception of space, the continuum of our existence. All dimensions are but measures of it, as in relative perspective of our vision lie volume, line, point, giving shape, distance, proportion. Movement, light, and time itself are also qualities of space. Space is otherwise inconceivable."[11] Noguchi's memorials, like his other works, combine archaic forms of prehistoric civilization with his vision of the present and future. What is unique about the memorials is that they share a formal vocabulary with the gardens and are sculptural spaces in themselves.

Chapter 5
FOUNTAINS

MY FIRST RECOLLECTION OF JOY WAS GOING TO A NEWLY OPENED EXPERIMENTAL KINDER-
GARTEN WHERE THERE WAS A ZOO, AND WHERE CHILDREN WERE TAUGHT TO DO THINGS
WITH THEIR HANDS. MY FIRST SCULPTURE WAS MADE THERE IN THE FORM OF A SEA WAVE.[1]

One of Noguchi's major interests was the exploration of different ways to use water with sculptural forms. This interest was not limited to the large-scale fountains that he designed in the early 1970s but was also reflected in the consistent use of water as a symbolic element in most of his environmental projects.

Water brings a diverse set of universal meanings to Noguchi's gardens. From Gardens of Paradise to ancient, classical, and modern architecture, water was used in gardens' fountains and irrigation systems to form networks of connections representing life. From the gardens at the Alhambra Palace in Granada, Spain, to Villa d'Este in Tivoli, Italy, to the Taj Mahal in Agra, India, water transforms built space into a sensual encounter that is much more than simply visual experience.

This relationship with water has also been explored in modern architecture. Mies van der Rohe designed, for his German Pavilion at the Barcelona World Exposition (1929), a rectangular reflecting pool— a mirror to accentuate the sensual character of the pavilion's travertine walls and to extend the emptiness of its space. In Frank Lloyd Wright's Fallingwater (1936), a natural river beneath the house became

FORD FOUNTAIN FOR THE
1939 NEW YORK WORLD'S FAIR,
1938
Magnesite (destroyed)
FIGURE 223
View
The Ford Fountain, the only one of three proposals accepted for the 1939 New York World's Fair, was the first of many fountains Noguchi designed. The sculpture, a chassis of a Model T, was placed in a pool with bubbling water jets.

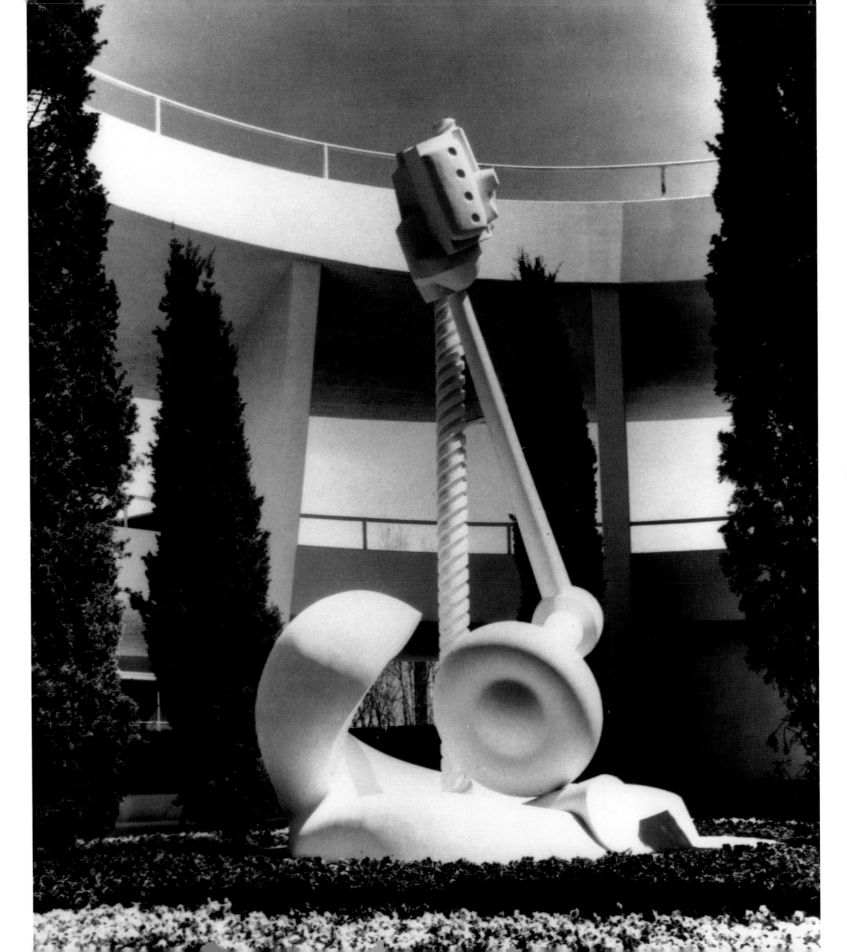

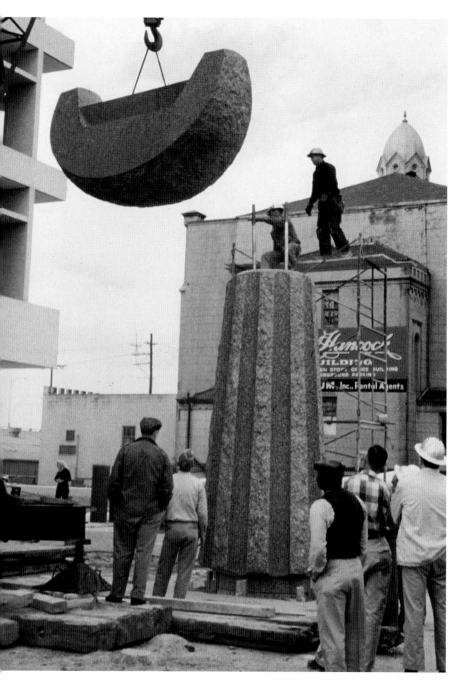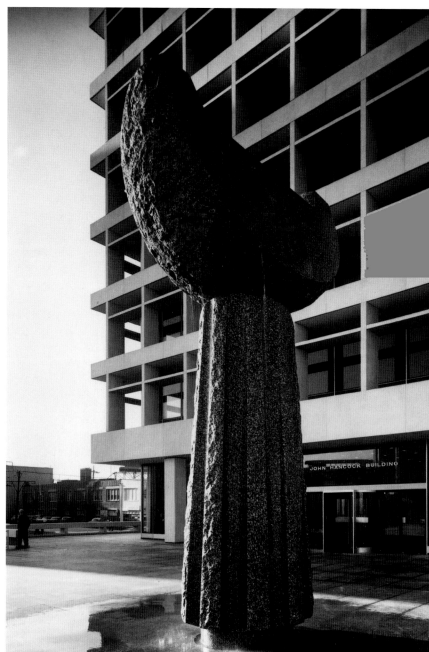

MISSISSIPPI FOUNTAIN, KAIG
AND BESTHOLL BUILDING
(FORMERLY JOHN HANCOCK
INSURANCE COMPANY
BUILDING), NEW ORLEANS,
LOUISIANA, *1961–62*
Architects: Skidmore, Owings, & Merrill
Granite, 16 feet high
FIGURE 224
Installation of Mississippi Fountain
Skidmore, Owings & Merrill
originally proposed placing a tree in
the plaza, but instead Noguchi
designed a T-shaped fountain. The
water falls from its top.

FIGURE 225
View
The Mississippi Fountain shares
the monolithic qualities of
much of Noguchi's work; it is also
a symbol of solitude.

an integral part of its architecture. The Water Pavilion (1969), designed by Carlo Scarpa for the Brion Family Cemetery in Treviso, Italy, included a lake that symbolically linked the real world with the world of death through reflection.

As part of this tradition, Noguchi designed fountains for UNESCO (1956–58), waterfalls for Play Mountain (1933), a reflecting pool for the Lever Brothers Building (1952), and a sunken water garden for the Chase Manhattan Bank plaza (1961–64). In addition, at the request of the architect Richard Neutra, whom Noguchi had met in Los Angeles in 1935, the artist designed a swimming pool for Josef von Sternberg's house: "The water flows down a slope on which fat von Sternberg could lie before jumping into this first lozenge-shaped pool."[2]

Through his experimentation with water, Noguchi suggested its multiple meanings. Sometimes he abstracted nature; other times he re-created the myth of the mirror or contemplated the future. In each case Noguchi produced a unique and meaningful experience. His use of water was strongly rooted in, and borrowed from, Japanese stroll gardens, Persian gardens, and both Western and Eastern traditions.

Back from Mexico in 1937, after finishing his mural *History Mexico*, Noguchi entered as many competitions as possible in order to make a living. In 1938 he submitted three proposals for the 1939 New York World's Fair—the first was a frieze for the Medical Building, and the second a study for the Union Building in collaboration with architect Paul Goodman and painter Philip Guston. The third, a fountain for the Ford Motor Company Building, was the only proposal that materialized, but it was later destroyed. The Ford Fountain for the World's Fair was located at the bottom of a ramp called the Road of Tomorrow.[3] It was "an engine with chassis rampant!"[4] in a pool (fig. 223). In making this fountain, Noguchi introduced a new material to his palette—magnesite ($MgOCl_2$). The use of this material demonstrated Noguchi's active search for novel means of expression. This attitude toward newness and technology was enriched by his relationship with Buckminster Fuller, who, as a visionary of the future, was developing cellular structures.

In 1956–58 Noguchi designed a stainless-steel waterfall wall in combination with his ceiling design for the lobby of 666 Fifth Avenue in New York City. The waterfall shared the same design concept of contoured louvers that Noguchi had used in the ceiling. This was based on a previous wall sculpture, which was not realized, for a bank in Texas.

From 1961 to 1962, in the midst of his decade-long collaboration with Gordon Bunshaft of Skidmore, Owings & Merrill, Noguchi designed the Mississippi Fountain for the plaza in front of the Kaig and Bestholl Building, formerly the John Hancock Insurance Company Building in New Orleans. The initial idea was to place a tree in the plaza, but when this idea was rejected, Skidmore, Owings & Merrill asked Noguchi to design a fountain. The Mississippi Fountain, titled as an homage to the river, shares the monolithic quality of the artist's sculptures for the Connecticut General Life Insurance Company Building (1956–57) and the First National City Bank plaza (1960–61).

The twelve-foot-high granite fountain rises from an elevated terrace located in front of the building (fig. 224). The water cascades from the fountain's top into a pool at the base. Noguchi designed the top in a T-shape, reminiscent of the sculpture *Mu* (1951–52), which was designed for the faculty room and garden at Keiō University (fig. 225).

In 1964 Noguchi collaborated with the architect I. M. Pei on an unrealized fountain, Eastman Court Fountain, for the Massachusetts Institute of Technology (MIT), in Cambridge, Massachusetts. Like some of Noguchi's sculptural spaces, the MIT fountain is a large work composed of three distinct elements—a triangle, a circle, and a half-cylinder (fig. 226). The triangle and the half-cylinder are located at right angles to one another and connected by a narrow channel of water (fig. 227).

In the 1970s Noguchi wanted to invest his energy in extensive urban projects and to experiment with large-scale water sculptures using new materials and technologies. In 1970 Kenzo Tange, who was responsible for Expo '70 in Osaka, Japan, asked Noguchi to take control of the design of all the exposition's fountains. Noguchi completed nine designs for fountains located in artificial lakes that ran from east to west on the north side of the Festival Plaza (fig. 228).

EASTMAN COURT FOUNTAIN, MASSACHUSETTS INSTITUTE OF TECHNOLOGY, CAMBRIDGE, MASSACHUSETTS, *1964 (unrealized)*

FIGURE 226
Detail of plaster model
Noguchi consistently gives water dual meaning: it stands in for both nature and technology. The fountain the artist proposed for MIT reinforced that duality between nature and human nature by the use of geometric forms: a triangle, a circle, and a half-cylinder.

FIGURE 227
Detail of plaster model
The triangular element in the MIT fountain was later reinterpreted by Noguchi for *California Scenario*. The geometry reflects forms in the Samrat Yantra Observatory in India.

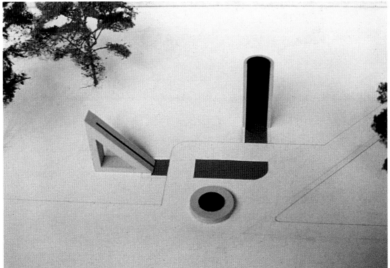

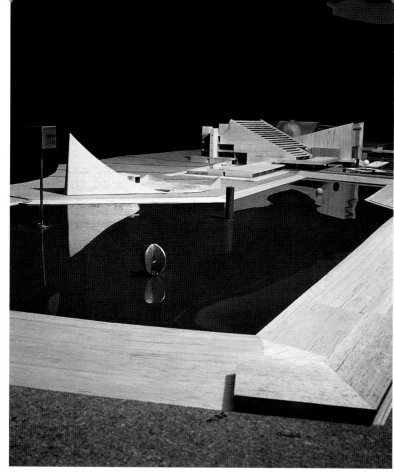

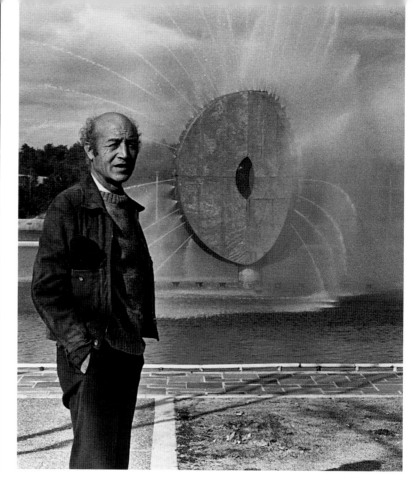

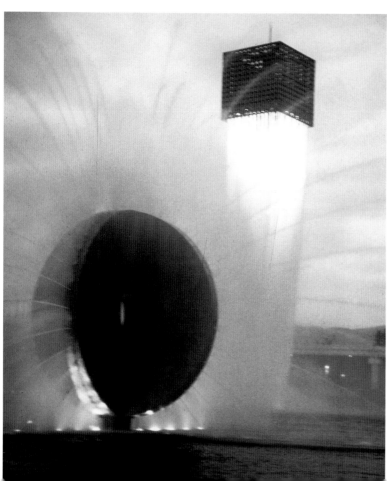

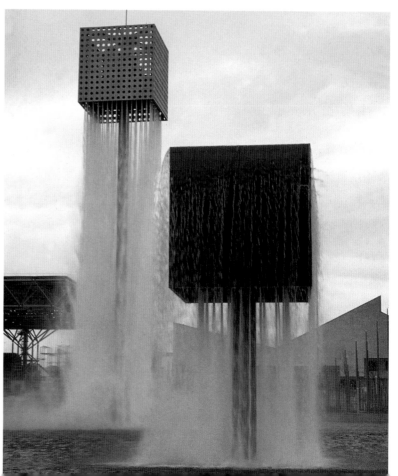

FOUNTAINS FOR EXPO '70,
OSAKA, JAPAN, *1970*
Stainless steel, nine fountains
FIGURE 228
Model
Noguchi examined the tradition of
fountains, introducing motion
and technology from the modern era,
in his designs for Expo '70.

FIGURE 229
Detail
Noguchi designed the fountains in
relation to the Pond of Dreams and the
Pond of the Earth. The water sculptures
became dancers moved by water
and sound and transformed by light.

FIGURE 230
Isamu Noguchi at Expo '70
Noguchi's water sculptures for
Expo '70 challenge the common idea
of fountains that only spout upward.

FIGURE 231
Detail
The nine water sculptures designed by
Noguchi required elaborate technology.
Noguchi once said, "My fountains
jetted down one hundred feet,
rotated, sprayed, and swirled water,
disappeared and reappeared as mist."

The fountains were designed so that each one related to the name of a corresponding lake—the Pond of Dreams and the Pond of the Earth. The water sculptures represented a symbolic transition in human history, from nature to the cosmos (fig. 229). Noguchi placed sculptural cubes on hundred-foot-high "floating" platforms and arranged yellow and gray hollow cylinders and oval shapes as if they were playground equipment. Water was sprayed through jet nozzles, bringing light and motion to the lakes (figs. 230 and 231). Here, the stone stages of Noguchi's gardens were transformed into water stages. The elevated sculptural forms, with their exuberant and dramatic water play, extended the artist's concept of drama into an entirely new and different realm (figs. 232 and 233). Subsequently, the Expo '70 site was transformed into a permanent park and the fountains remain as technological milestones in Noguchi's personal metaphor for a stroll garden. After this, Noguchi designed many large-scale water sculptures, including the impressive Dodge Fountain (1971–79) at the Philip A. Hart Plaza in Detroit.

In 1974 Noguchi returned to interior work and to a more intimate scale. At the request of architect Shinichi Okada, he designed a fountain group for the Supreme Court Building in Tokyo. Using minimalist concepts, Noguchi designed six identical black granite fountains. They were placed on a gravel bed, and the water moved over the stones into the gravel (fig. 234). After completing these fountains, Noguchi created two more crudely carved basalt fountains; one is now located in the Japanese wing at the Metropolitan Museum of Art in New York City, and the other is in the garden of the Isamu Noguchi Garden Museum in Long Island City.

In 1974 Noguchi entered a competition held by the Society of the Four Arts in West Palm Beach, Florida. Robert Morris, who proposed a massive earthwork maze, won the competition. Nevertheless, the society elected to construct Noguchi's stainless-steel tetrahedron fountain with triangular openings on each side, titled *Intetra, Mist Fountain*. In a rectangular court defined by three small-scale buildings, *Intetra*—the myth, the pyramid—appears, as Noguchi explained, from outer space, amid a formal linear mall of palm trees (fig. 235). The water play, in contrast to that of

FIGURE 232

Detail

Noguchi's theatrical sense was evident in his fountain design. Cubes, spheres, and cylinders combine with exuberantly choreographed water displays in a dramatically illuminated presentation evoking forms from outer space.

FIGURE 233

Detail

The fountains' simple geometries and bold colors recall Noguchi's playgrounds and play equipment.

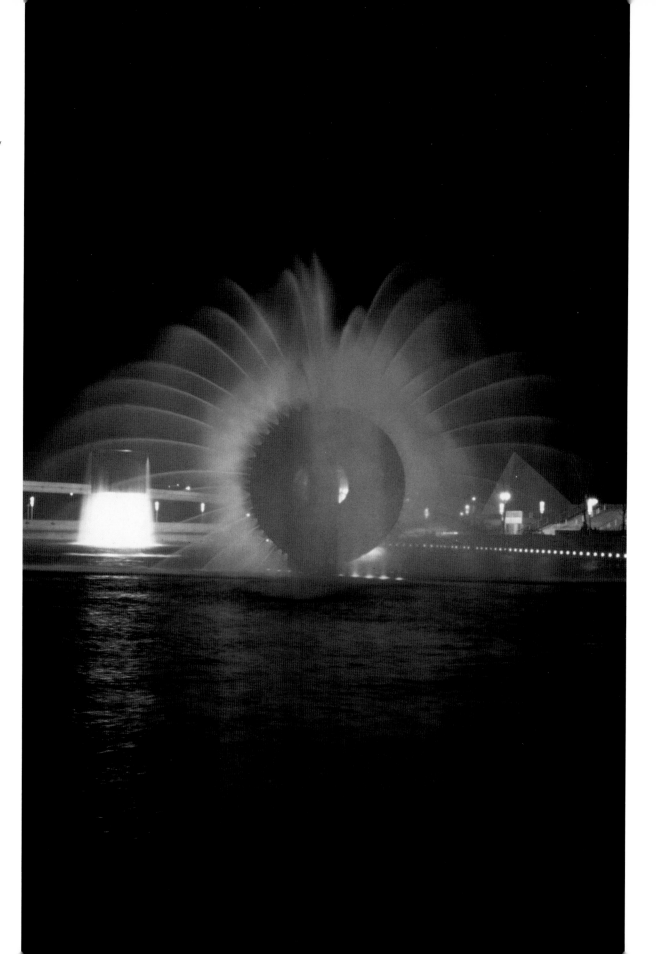

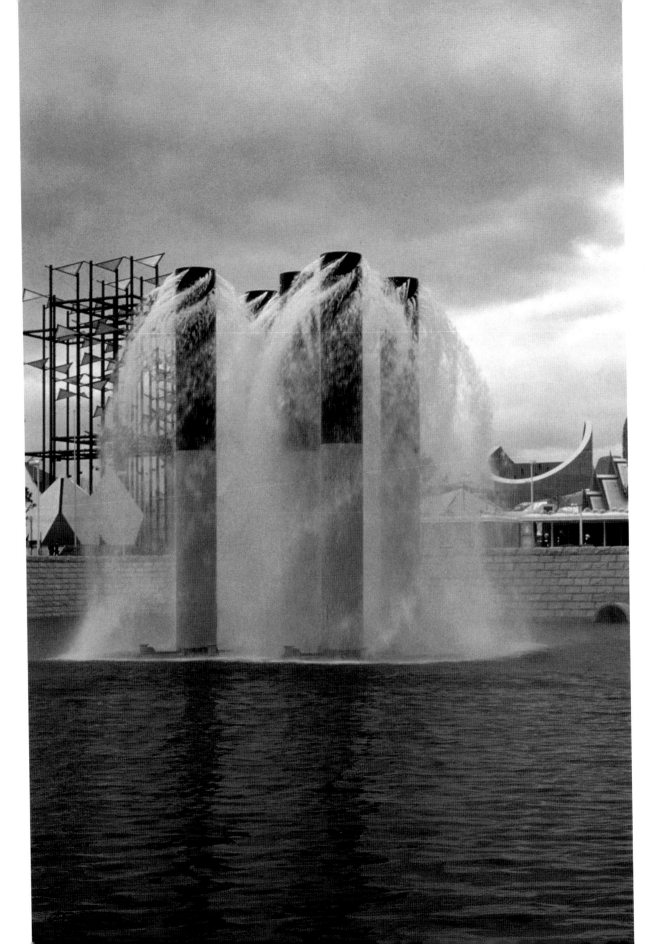

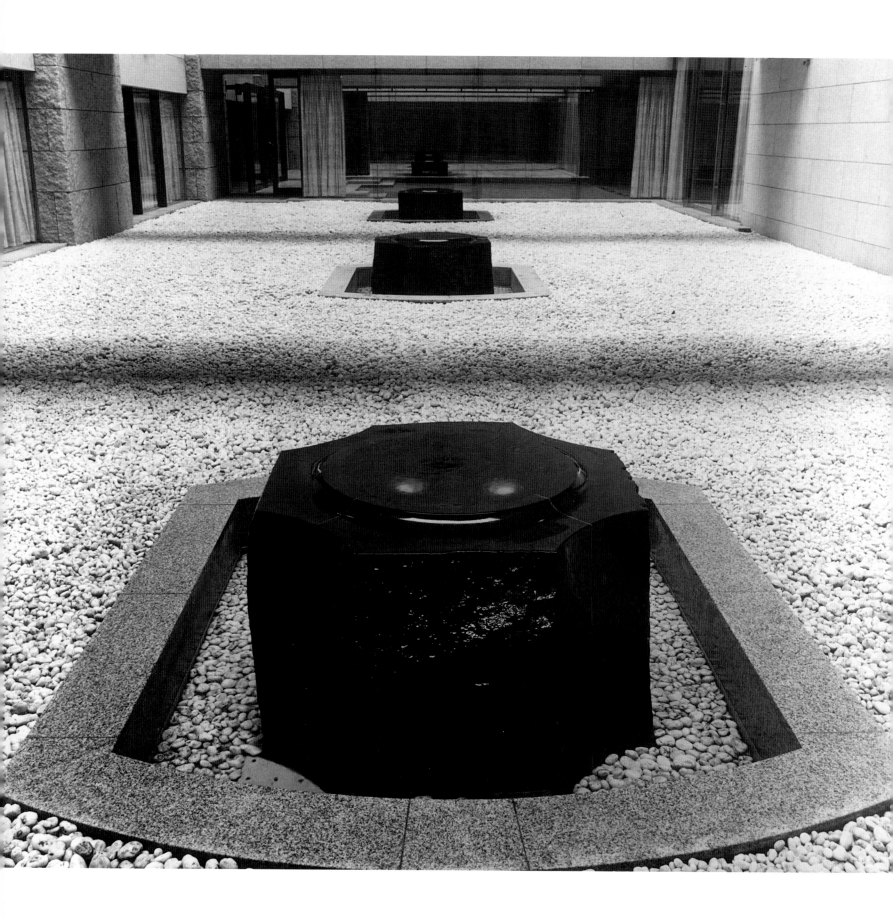

the Dodge Fountain in Detroit, is a secret treasure inside the pyramid; it is visible only as vapor misting from the openings (fig. 236).

In 1976, while Noguchi was involved with *Intetra*, he was selected as a consultant by the Omaha, Nebraska, Arts Committee of the Riverfront Development Program for the American Bicentennial. He proposed Friendship Fountain, a 150-foot-high steel-frame structure to be erected in the middle of the Missouri River (fig. 237). The fountain was conceived as a symbol of the spirit of cooperation and friendship between the states of Iowa and Nebraska and was designed as an ecological element in which the river was used as a natural resource for water and energy. Noguchi conceived a hydraulic device that symbolized the power of nature and the ingenious human use of natural resources (fig. 238).

In 1976 Noguchi began to work with the Skidmore, Owings & Merrill offices in Chicago after an almost ten-year hiatus. Noguchi's task was to design a narrow exterior space between the new Art Institute of Chicago and the sidewalk. He designed two granite fountains titled *Celebration of the 200th Anniversary of the Founding of the Republic*. The fountains, one vertical and the other horizontal, were each forty feet in length. They were located in a narrow pool intentionally unaligned with the building's edge (fig. 239). The vertical element symbolizes humankind and its inventions. The horizontal line created by the second element works to break the scale of the building's vertical presence. Finally, the horizontality of the stone treatment of the vertical element breaks the scale of the facade.

SUPREME COURT BUILDING
FOUNTAINS, TOKYO, JAPAN,
1974
Architect: Shinichi Okada
Granite, six fountains
FIGURE 234
View
The combination of sculptural form and water at the Supreme Court Building in Tokyo was a departure from the grandiose scale of the Expo '70 fountains. Noguchi employed the conceptual simplicity of mirror images, designing six identical granite fountains to sit on one gravel bed.

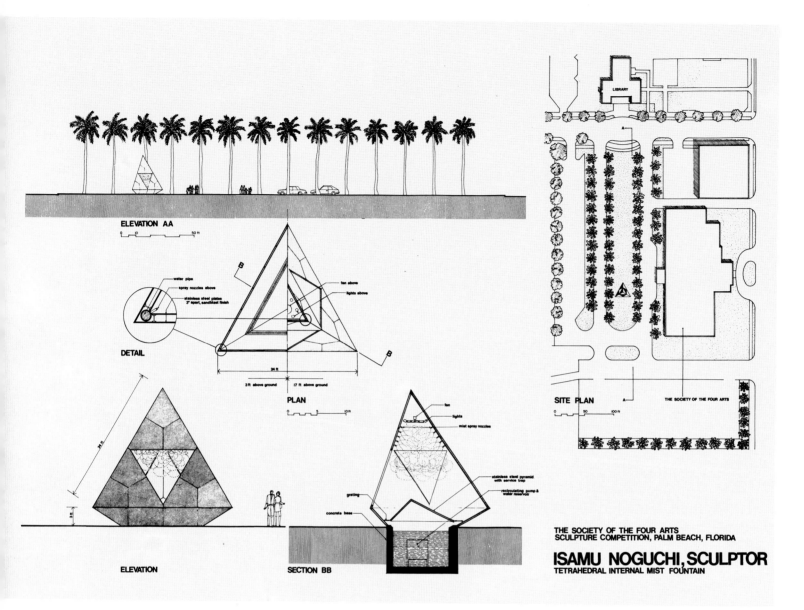

ELEVATION AA

DETAIL

water pipe
spray nozzles above
stainless steel plates
3" apart, sandblast finish

fan above
lights above

B

B

24 ft

3 ft above ground 17 ft above ground

PLAN

0 5 10 ft

fan
lights

mist spray nozzles

stainless steel pyramid
with service trap

recirculating pump &
water reservoir

grating

concrete base

ELEVATION

SECTION BB

SITE PLAN

0 50 100 ft

A

LIBRARY

THE SOCIETY OF THE FOUR ARTS

THE SOCIETY OF THE FOUR ARTS
SCULPTURE COMPETITION, PALM BEACH, FLORIDA

ISAMU NOGUCHI, SCULPTOR
TETRAHEDRAL INTERNAL MIST FOUNTAIN

INTETRA, MIST FOUNTAIN,
SOCIETY OF THE FOUR ARTS,
WEST PALM BEACH, FLORIDA,
1974–76
Stainless steel, 24 by 18 feet
FIGURE 235
Plan and elevations
This fountain evoked aspects of ancient
Egypt and combined them with
modern technology. The pyramidal
structure is suggestive
of a science-fiction spacecraft.

FIGURE 236
View
Intetra not only defied accepted
notions of hydrodynamics but was also
a contemporary adaptation of the
traditional Japanese idea of space-time,
which is based on an understanding
of the way a human being views nature
and the cosmos at any given moment.

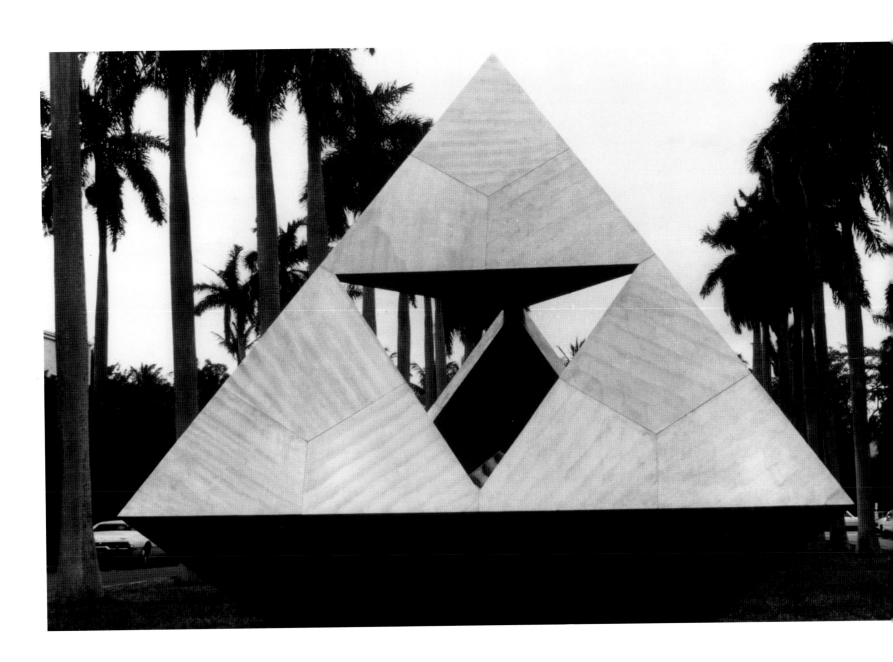

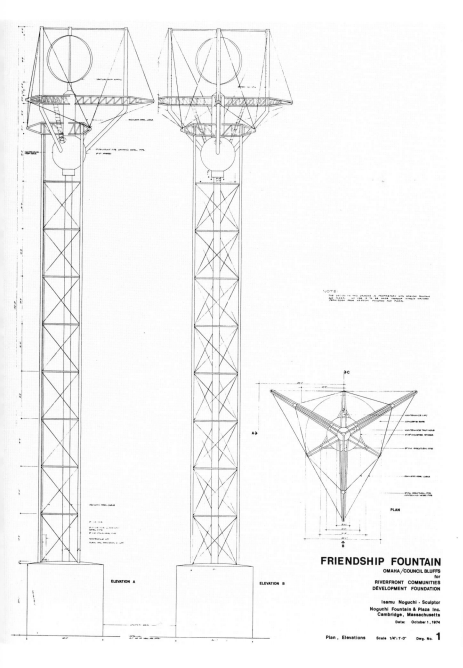

ELEVATION A

ELEVATION B

PLAN

FRIENDSHIP FOUNTAIN
OMAHA/COUNCIL BLUFFS
for
RIVERFRONT COMMUNITIES
DEVELOPMENT FOUNDATION

Isamu Noguchi - Sculptor

Noguchi Fountain & Plaza Inc.
Cambridge, Massachusetts

Date: October 1, 1974

Plan, Elevations Scale 1/4": 1'-0" Dwg. No. 1

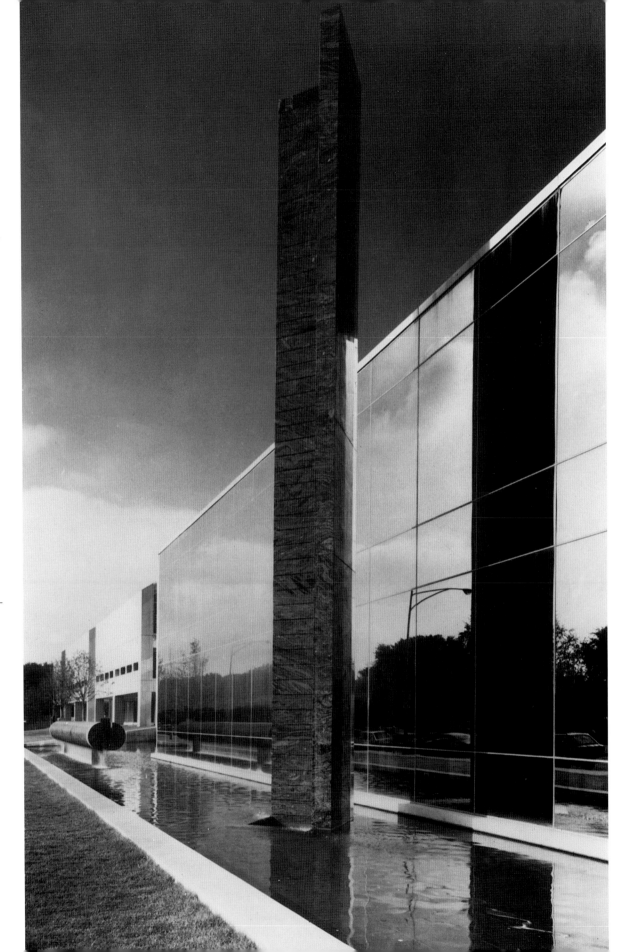

FRIENDSHIP FOUNTAIN,
MISSOURI RIVER BETWEEN
OMAHA, NEBRASKA,
AND COUNCIL BLUFFS, IOWA,
1976 (unrealized)
Proposed height 150 feet
FIGURE 237
Elevations and plan
Friendship Fountain was conceived to
celebrate the American bicentennial
and was inspired, Noguchi stated, by
prairie windmills and irrigation systems.

FIGURE 238
Model
Friendship Fountain, a steel-frame
structure, was designed to drop five
hundred gallons of water a
minute from its top using the Missouri
River as a natural water resource.

REPUBLIC FOUNTAINS, ART
INSTITUTE OF CHICAGO,
ILLINOIS, *1976–77*
Granite and stainless steel,
two elements, 40 by 40 feet
FIGURE 239
Celebration of the 200th Anniversary
of the Founding of the Republic
Noguchi used scale to create a grand
gesture with an important role in
the surrounding architecture. The
fountain's two elements capture all of
the character of the surroundings—the
reflective glass facade of the School
of the Art Institute, the park and the
lake that it faces, and the Sears Tower—
in their materials and position.

Chapter 6
INTERIORS

IF MEANING IS THE PROVINCE OF THE ARTS, SO IS ORDER. WHEN THE VERY MEANING
OF LIFE BECOMES OBSCURE AND CHAOTIC, HOW NECESSARY IS THE ORDER WHICH
WITH THE PRACTICE OF THE ARTS LEADS TO HARMONY, AND WITHOUT WHICH THERE
IS ONLY BRUTALITY. I THINK OF SCULPTURE ESPECIALLY AS THE ART OF ORDER—THE
HARMONIZER AND HUMANIZER OF SPACES.[1]

The desire to bring order to space was, for Noguchi, a state of mind. It was a matter of bringing order to his personal disorder, to his continuous search for home and identity. He focused on creating a way to channel art into a harmonious relationship with society. With his interiors, the artist introduced another dimension to his work, establishing a dialogue between human memories of natural light and human-made light.

Noguchi brought order to chaos by creating narratives in his gardens. He also brought new meaning and significance to existing industrially fabricated objects. He designed tables, chairs, lamps, and radio stands as sculptures to be integrated into daily life. Within this framework, Noguchi developed his Akari lanterns starting in 1952 as interpretations and transformations of the traditional Gifu lanterns. Choosing the Japanese word *akari*, he introduced to interior space the double meaning of *light* as "illumination" and as "weightlessness" and played with the concepts of art and function, reflection and mirrors.

He also made concepts of technology and energy more accessible to a wider audience through his lunar sculptures, first developed in 1943.

CEILING FOR AMERICAN
STOVE COMPANY BUILDING,
SAINT LOUIS, MISSOURI, *1948*
Plaster and electricity
FIGURE 240
View
The interiors designed by Noguchi shared the character of his freestanding sculptural work as harmonizers and humanizers of space.

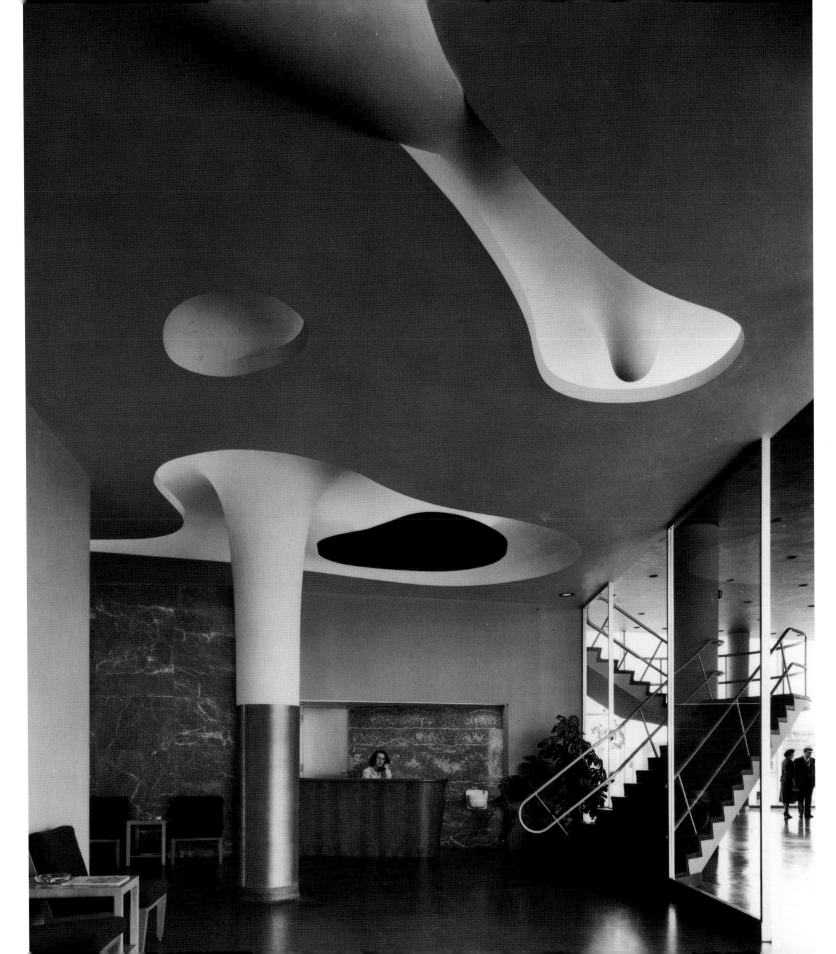

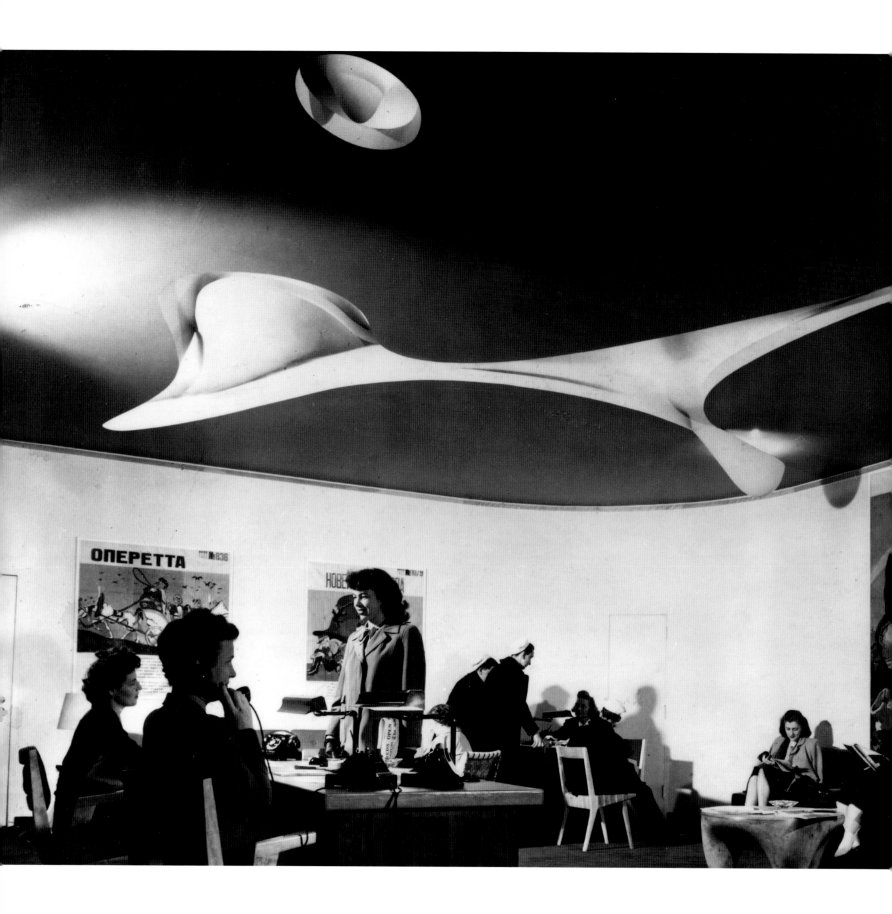

His experimentation with light, space, and sculpture yielded readings other than the traditional relationship between architecture and light. Noguchi created a relationship between the two that was integral to the sensory perception of architecture and reflected the visual and emotional experience of luminosity beyond the particularities of place. He also rethought the interrelations of architecture, visual perception, and sculpture. Noguchi continued emphasizing the visual perception of interactions between light and space, between architectural surface and architectural form.

One of the most relevant examples in architecture is the Pantheon, built in Rome during the reign of Hadrian, between 118 and 125 CE. The Pantheon captures natural light through an unglazed oculus that illuminates the void. Everything in the building is subordinate to this principle. Standing beneath the oculus, as the earth rotates, the viewer's perception of the void is absorbed in the cosmic moment that follows the movement of a light column, which creates a metaphor of the cosmos with a human being at its center. In Hadrian's case, that individual was himself. The relationship that Noguchi established between architecture and light was not, as in the Pantheon, a natural one between sunlight and architecture but rather one between artificial light and architecture—linking technology to architecture. The center, in Noguchi's case, was not a person, but space.

The lunar sculptures were, essentially, indoor sculptures, based on the acknowledgment that humans spend more time indoors than outdoors. The light source of the sculptures was hidden behind thin free-form sheets of magnesite. Noguchi called these self-contained objects *Lunars:* "I myself was not satisfied with the limited dimensions possible, the fragmentary approach, for the eventual realization should be an entire space. I thought of a room of music and light, a porous room within a room—in the void of space."[2]

Between 1946 and 1952 Noguchi designed a series of interior spaces that combined his interest in outdoor sculpture with a desire to work with reflective light and an attempt to define a space for which the human being was not the center point. The undulating surfaces of his ceiling reliefs share a formal vocabulary with his playgrounds and can

CEILING FOR TIME-LIFE
BUILDING, ROCKEFELLER
CENTER, NEW YORK,
1947 (destroyed)
Architect: Wallace K. Harrison
FIGURE 241
View
Noguchi saw light sculptures as protection "from the beast of the night." He understood that they should take up an entire space and wrote, "I thought of a room of music and light."

LUNAR VOYAGE,
S.S. ARGENTINA, *1947 (destroyed)*
Magnesite, 8 feet
FIGURE 242
View
From 1933 on, Noguchi was interested
in light sculptures with an integrally
embedded light source. He used a
new cementlike material—magnesite—
that allowed him to create free
forms as self-contained objects.

CHUO-KORON GALLERY,
TOKYO, JAPAN, *c. 1952*
FIGURE 243
Interior view
In Chuo-Koron's interior the horizontals
and verticals, the East and the West,
are neatly balanced. They are symbol-
ized by a wood screen, a bench, and a
table. Gradually Noguchi abandoned
such projects. He didn't like the idea
of becoming a decorator, nor did he
want to design "fancy rooms just
because someone could afford them."

also be read as moonscapes. For Noguchi, the ceiling became a large lunar sculpture that defined space. His first ceiling was for the American Stove Company Building in Saint Louis, Missouri (1948). Here, the artist used forms to provide indirect lighting and to direct attention toward the elevator (fig. 240). The documentation of this project and the wall sculpture *Lunar Landscape* were part of the exhibition *Modern Relief* at the Museum of Modern Art in New York in 1951.

In subsequent projects, Noguchi created a strong spatial character in his ceilings that was used to reshape or redefine the spaces below. As in his gardens, he transposed forms and experiments from one area of design to another, using the same concept of space. In 1947, collaborating with the architect Wallace K. Harrison, Noguchi designed a ceiling for the waiting room and reception area of the Time-Life Building in New York as a free form above the reception desk (fig. 241). In that same year, Noguchi also designed *Lunar Voyage*, a sculpture for the stairwell of the Home Line's ocean liner S.S. *Argentina*, but the piece was destroyed in 1959 (fig. 242). Around 1952 Noguchi designed the interior of the Chuo-Koron Gallery in Japan (fig. 243). Like earlier interiors, this one was inspired by sensual impressions from human spaces. The room became the universe in which metaphorical value took the form of light, shape, and texture.

In 1956–58, at the request of the architect Robert Carson, Noguchi designed the lobby ceiling and waterfall wall for 666 Fifth Avenue in New York (fig. 244–46). Both pieces shared the same vocabulary. The design was derived from an unrealized idea that Noguchi had worked on in 1952, in collaboration with Carson, for a ceiling sculpture composed of contoured louvers in a Texas bank.

From 1974 to 1975 Noguchi designed *Shinto*, a cubic prism suspended in the lobby of the Bank of Tokyo Building in New York. The prism hung from the four columns that supported the building's gilded, coffered ceiling (figs. 247 and 248). Once again, the artist created a dialogue between old and new, gravity and lightness. And again, unfortunately, the work was destroyed; this time in 1980. Noguchi wondered, "Why did they decide to destroy it in the dead of night after it had hung there for five years?"[3]

666 FIFTH AVENUE CEILING AND WATERFALL, NEW YORK, *1956–58*
Architect: Robert Carson/ Carson & Lundin
FIGURE 244
View of the lobby
Noguchi was horrified when the architect Robert Carson proposed that he adapt an unrealized sculpture of contoured louvers for an elevator-lobby ceiling at 666 Fifth Avenue and asked him to propose a waterfall wall design in addition.

FIGURE 245
Waterfall model, wood and painted-sheet-metal model, 18 by 68 1/2 inches, 1957
A stainless-steel waterfall and the ceiling above share the same formal vocabulary of contoured louvers, which are abstractions of the geological strata of minerals.

FIGURE 246
Side view of waterfall, stainless steel, 12 feet high
Noguchi altered the perception of the ceiling and the waterfall by altering the materials and positions of the contoured elements. By changing the orientation from horizontal to vertical, the shapes and rhythm of these components were perceptually altered.

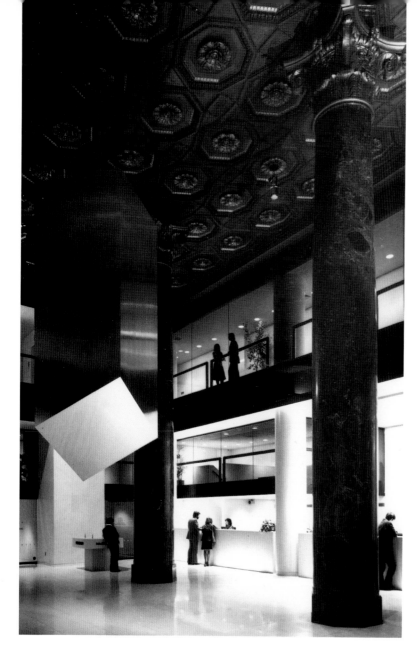

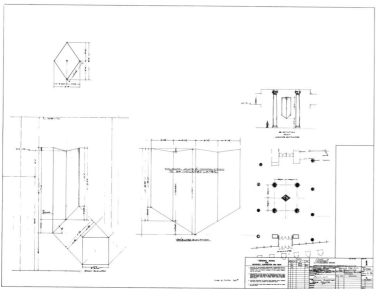

SHINTO, BANK OF TOKYO
BUILDING, NEW YORK,
1974–75 (destroyed April 1980)
Aluminum, 17 feet
FIGURE 247
View
The looming presence of *Shinto*
defined a void. The space
assumed different shapes as
viewers walked around it.

FIGURE 248
Sections, elevations, and plan
The suspended cubic prism *Shinto*
came from Noguchi's experimental
work with gravity and weightlessness.

MARTHA GRAHAM DANCE
THEATER, NEW YORK,
1976 (unrealized)
FIGURE 249 *(overleaf)*
Model
The circular geometry of Noguchi's
proposed theater alluded to
Graham's dance. The dancer's move-
ments seem to flow out
from and return to her body.

Noguchi's early experiments involving space and its relation to sculpture took place in the context of the theater while the artist was producing set designs for Martha Graham. His opportunity to experiment with symbolism and interchange between East and West resulted from a fostering and supportive relationship with Graham.[4] As a result his sculptural sets allowed him a fluid exchange between sculpture and theater, garden and theater, garden and sculpture: "There is joy in seeing a sculpture come to life on the stage in its own world of timeless time. Then the very air becomes charged with meaning and emotion, and form plays its integral part in the re-enactment of a ritual. Theater is a ceremony; the performance is a rite. Sculpture in daily life should or could be like this. In the meantime, the theater gives me its poetic, exalted equivalent."[5]

The collaboration between Noguchi and Graham ended in 1976 with the artist's proposal for the Martha Graham Dance Theater, an experimental theater and museum for the modern dance pioneer and the sets he had designed for her (fig. 249). The project was to be a tribute not only to his friend Graham but also to Buckminster Fuller, whose geodesic geometry was used to create the theater's dome. Although Noguchi developed a model for this work, it was never associated with a particular site.

As a part of his sculptural process, Noguchi took the spaces and sites in which he worked as his own. He can be defined by his concept of the complete artist: "To me the complete artist is one who is devoted to seeking the furthest implications of his art. To this end there are essentially no hard boundaries of categories in the arts—the only limitations are in the artist himself with the strength, inspiration, and ability of the moment."[6]

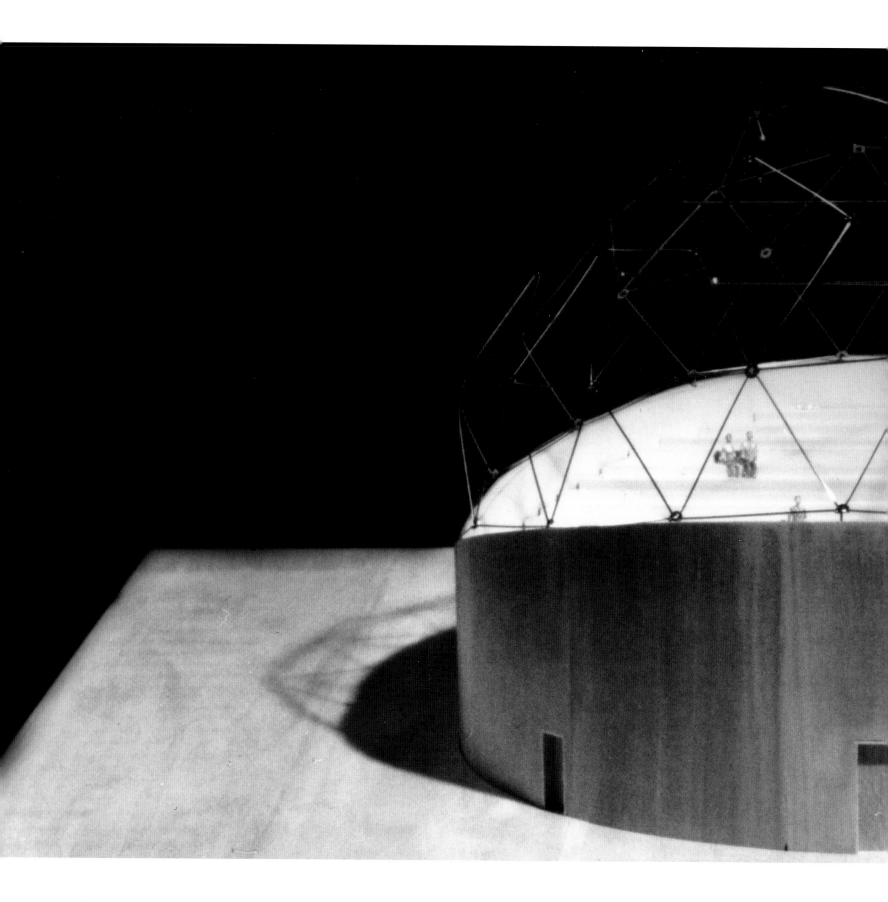

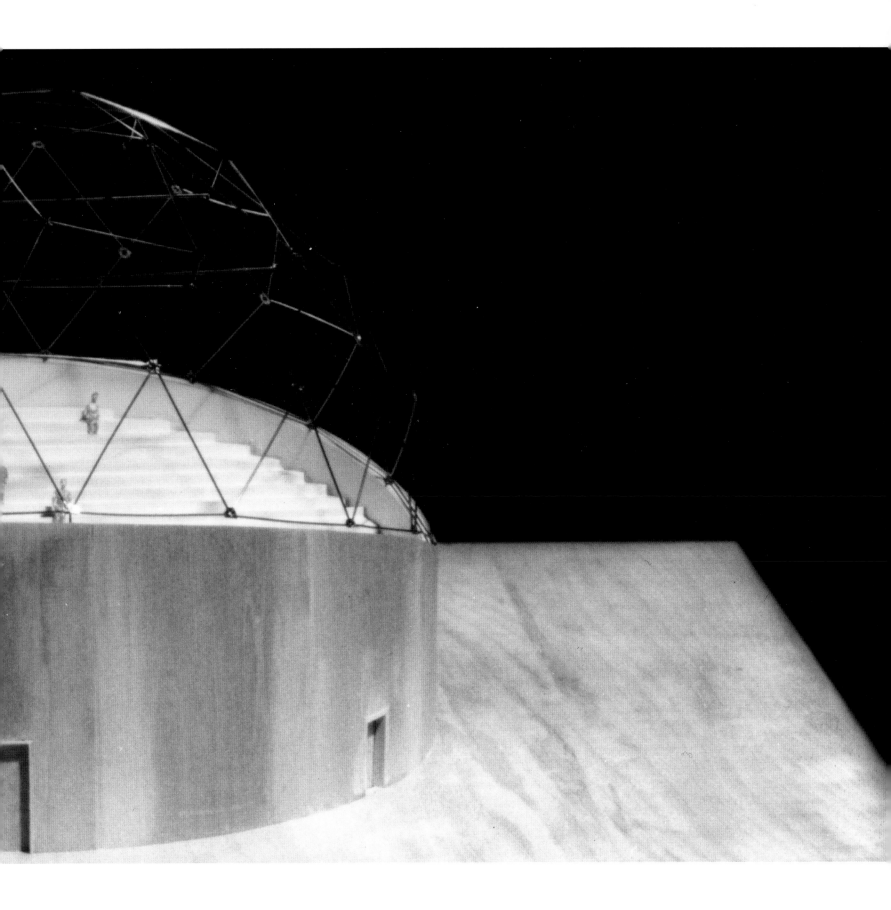

MUSICAL WEATHERVANE,
1933 (unrealized)
FIGURE 250
View
Musical Weathervane "was to be wired
so as to be luminous at night." This
unrealized sculpture was Noguchi's
first experiment with incorporating light
into his sculptures.

HISTORY MEXICO, ABELARDO
RODRIGUEZ MARKET,
MEXICO CITY, MEXICO, *1936*
Colored cement on carved brick,
6 ½ by 72 feet
FIGURE 251
View
In Mexico, Noguchi found an opportu-
nity to express his social ideals in
large public sculpture. *History Mexico*
narrates the political situation
in Mexico and points to the future.

Chapter 7
PUBLIC SCULPTURES

WHILE I WAS LED TO CONCEIVE THE WHOLE AMBIANCE AS SCULPTURE, THERE ALSO REMAINED THE POSSIBILITY OF INDIVIDUAL SCULPTURES FOR A GIVEN SITE WHICH I FELT CONGENIAL.[1]

Noguchi's individual sculptures share the symbolic and social relevance expressed in his other work. They link aspects of ancient history and nature to a modern, human-made context. Like his gardens and set designs, these works were the result of Noguchi's experimentation with geometry, science, Western and Eastern traditions, nature, and materials. And they were always conceived within a larger frame of reference that was both functional and timeless.

Such sculptures were modern interpretations of stone pillars from prehistoric times, the "male" connectors between earth and sky. Noguchi's sculptures were connections between ancient ritual and modern technology. Not only did his work evoke the "male" image, but it also brought the many myths associated with diverse historical cultures to a contemporary setting.

Noguchi's formal language of cubes, pyramids, circles, and mounds shares the timeless quality of ancient megalithic monuments. The individual sculptures are inseparable from their sites and mythological connections. His sculptures also refer to Brancusi and to such countries as Japan, Greece, and India.

Noguchi's early sculptures demonstrate his search for a way to bring social relevance to sculpture without being literal. His first public

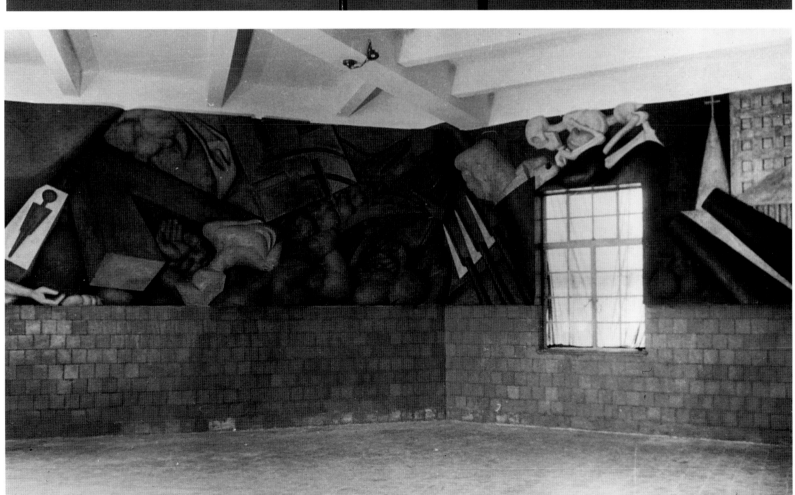

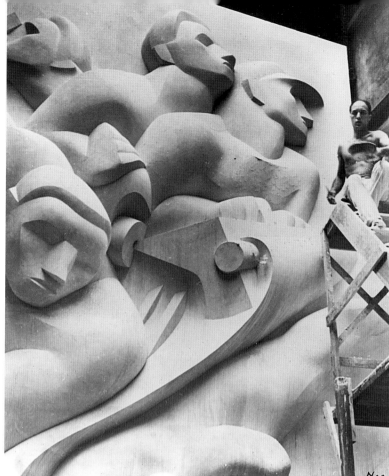

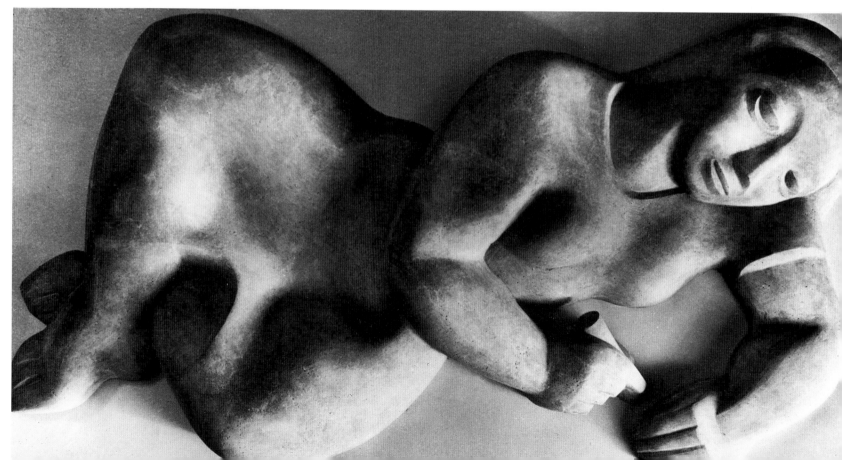

UNION BUILDING FOR
NEW YORK WORLD'S FAIR,
1938 (unrealized)
FIGURE 252
Plaster model, 6 by 13 by 10 inches
Noguchi entered several competitions
in the late 1930s. This decorative
top for the Union Building at the 1939
New York World's Fair reflects
Noguchi indomitable desire to try
many varied tasks.

NEWS, ROCKEFELLER CENTER,
NEW YORK, *1939–40*
Stainless steel casting, 20 by 17 feet
FIGURE 253
*Noguchi working on the plaque for the
Associated Press Building*
Noguchi attempted to avoid the clichés
of American art and won a competition
for the Associated Press Building with-
out abandoning his ideals. The dynam-
ic, diagonally composed bas-relief
recalls reporters and their iconography.

THE LETTER, POST OFFICE
BUILDING, HADDON HEIGHTS,
NEW JERSEY, *1939*
Magnesite
FIGURE 254
View
The relief sculpture *The Letter* was
completed one year after *News*. This
relief puts in evidence Noguchi's
exceptional ability to respond to the
character of a place.

sculpture was *Musical Weathervane* (1933), made of metal (fig. 250).
Here, a social relationship with society was forged through the
interpretation of a simple object—small Chinese flutes. It was con-
ceived during a study on a mountain "with flutings that would make
sounds like those of an aeolian harp."[2] Noguchi's idea of integrating
sound with sculpture came from his experiences in China, where he
saw small hollow gourds tied to pigeons; the gourds created whooing
sounds as the birds flew about.

In 1935, after several unsuccessful attempts at getting into the Works
Progress Administration (WPA) Art Program, Noguchi attempted to
support himself by making portrait sculpture, which he found unsatisfy-
ing. Despairing, the following year he left New York for Hollywood.
There he continued to make portraits in order to make a living until he
left for a trip to Mexico. By this time, Noguchi was well acquainted with
the socially and politically involved artists of Mexico. He had met José
Clemente Orozco, who had arrived in the United States in 1927. Because
of his participation with Diego Rivera in the Mexican revolution, Orozco
became a political symbol for the young American artists of Noguchi's
generation. Noguchi was not only fascinated with what Orozco represent-
ed but also with the revolutionary role of artists in Mexico: "How
different Mexico! Here I suddenly no longer felt estranged as an artist;
artists were useful people, a part of the community."[3]

In Mexico, with the help of the artists Marion and Grace Greenwood,
Noguchi became involved in the realization of a mural at the Abelardo
Rodriguez marketplace, located behind the cathedral in Mexico City.
Marion was working, at that time, on her own mural on one of the walls
at the Abelardo market. Created from colored cement on carved brick,
six and a half feet high by seventy-two feet long, Noguchi's mural—
his first large public work—was titled *History Mexico* (fig. 251). The
mural, executed in 1936, reflected the way Noguchi saw the history of
Mexico at that time: "At one end was a fat 'capitalist' being murdered by
a skeleton (shades of Posada!). There were war, crimes of the church, and
'labor' triumphant. Yet the future looked out brightly in the figure of an
Indian boy, observing Einstein's equation for energy."[4]

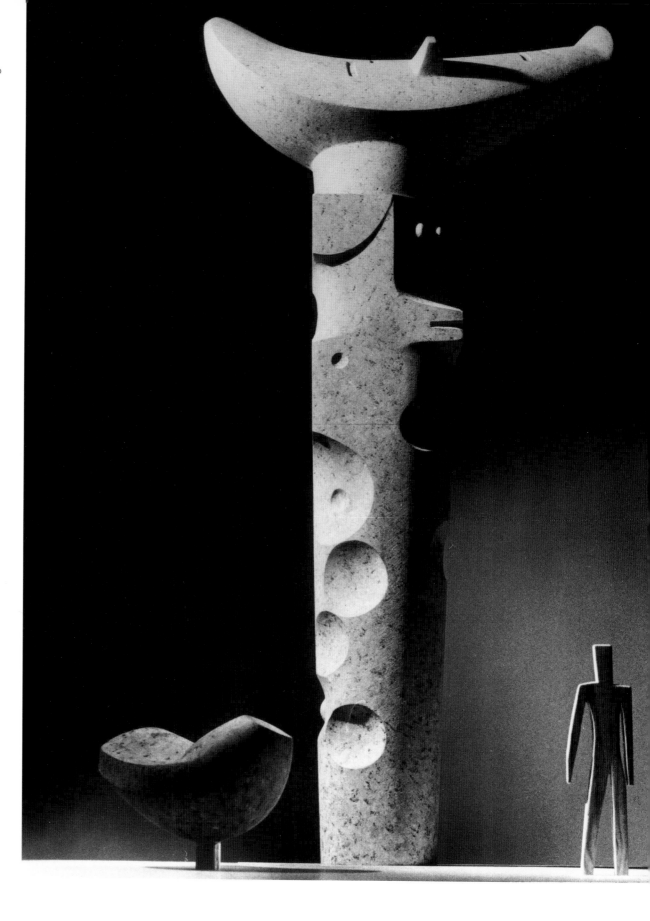

ARRIVALS BUILDING, IDLEWILD
INTERNATIONAL AIRPORT,
NEW YORK, *1956–58 (unrealized)*
Greek marble, Tamba granite,
and bronze
FIGURE 255
Model
In 1956 Noguchi proposed a "family"
sculpture group for the Arrivals
Building. The pristine, polished sculp-
tures shared the values Noguchi
associated with Brancusi and his Paris
pieces such as *Integral* (1957–58).

GATE (MON), NATIONAL
MUSEUM OF MODERN ART,
TOKYO, JAPAN, *1966*
Iron, 407 by 114 1/2 by 177 1/2 inches
FIGURE 256
View
In the late 1960s Noguchi began
to receive commissions for large-scale
public sculptures. *Gate* was
the first such commission he worked
on in Japan.

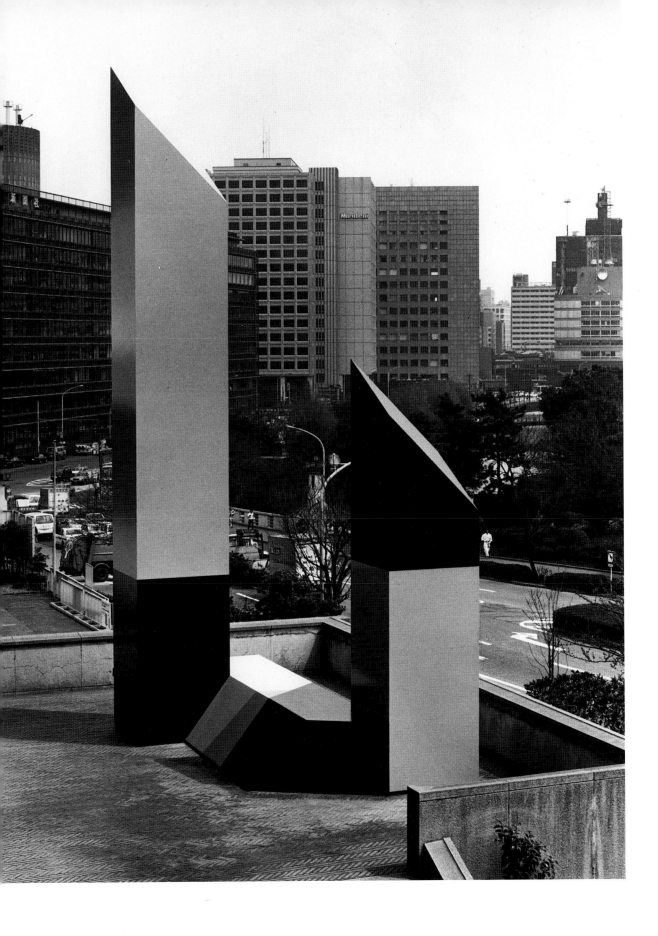

Noguchi included the Einstein equation as a representation of the future. While focused on Mexico's political and social aspects, he had not forgotten his own interest in science. He sent a telegram to Buckminster Fuller asking for an explanation of Einstein's formula $E=mc^2$. Fuller replied with a fifty-word telegram explaining the relationship between mass and energy.

Noguchi finished *History Mexico* in seven months. During that time, he had the opportunity to meet the painter Frida Kahlo, with whom he became enchanted. Their short-lived romance came to a theatrical end when Diego Rivera, Kahlo's husband at the time, held the gun that he always carried up to Noguchi and threatened, "Next time I see you, I'm going to shoot you."[5]

After finishing the mural, Noguchi wrote an article entitled "What Is the Matter with Sculpture?," which was published in *Art Front*, the official publication of the Artists' Union of New York between 1934 and 1937. In that article, Noguchi defended his position that sculpture needed to deal "with today's problems."[6] He also expressed his interest in technology and in the use of new materials, concluding, "It is my opinion that sculptors as well as painters should not forever be concerned with pure art or meaningful art, but should inject their knowledge of form and matter into everyday, usable designs of industry and commerce."[7]

Leaving Mexico, Noguchi returned to New York City and the necessity of finding a way to make a living. He put his energy into competitions. In 1938 Noguchi made three proposals for the New York World's Fair. The first design, which remained unrealized, was for the Union Building, with the architect Paul Goodman and the painter Philip Guston (fig. 252). In the second, also unrealized, Noguchi proposed a bas-relief frieze for the Medical Building representing the human body as the central object of experimentation in modern medicine. The third, a fountain for the Ford Motor Company Building, was completed for the 1939 World's Fair.

In 1938 Noguchi won two competitions. One was for the execution of a bas-relief over the entrance to the new Associated Press Building at Rockefeller Center, New York (fig. 253). The Associated Press plaque,

RED CUBE, MARINE MIDLAND BANK PLAZA, NEW YORK, *1968*
Red-painted steel, 24 feet high

FIGURE 257
Installation of Red Cube
Red Cube was fabricated of steel plates. Unlike earlier solid stone cubes it had a hole in the center.

FIGURE 258
View
Red Cube, part of Noguchi's tipped-cube series, sits balanced on its point. It represents the triumph over gravity.

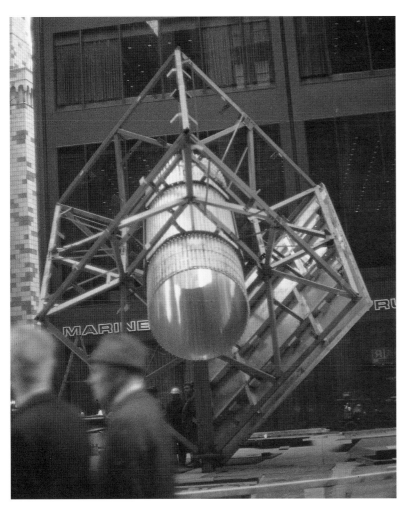
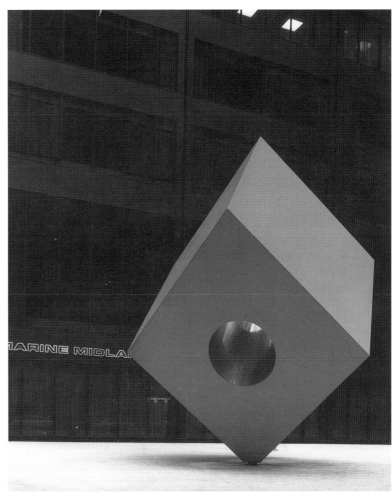

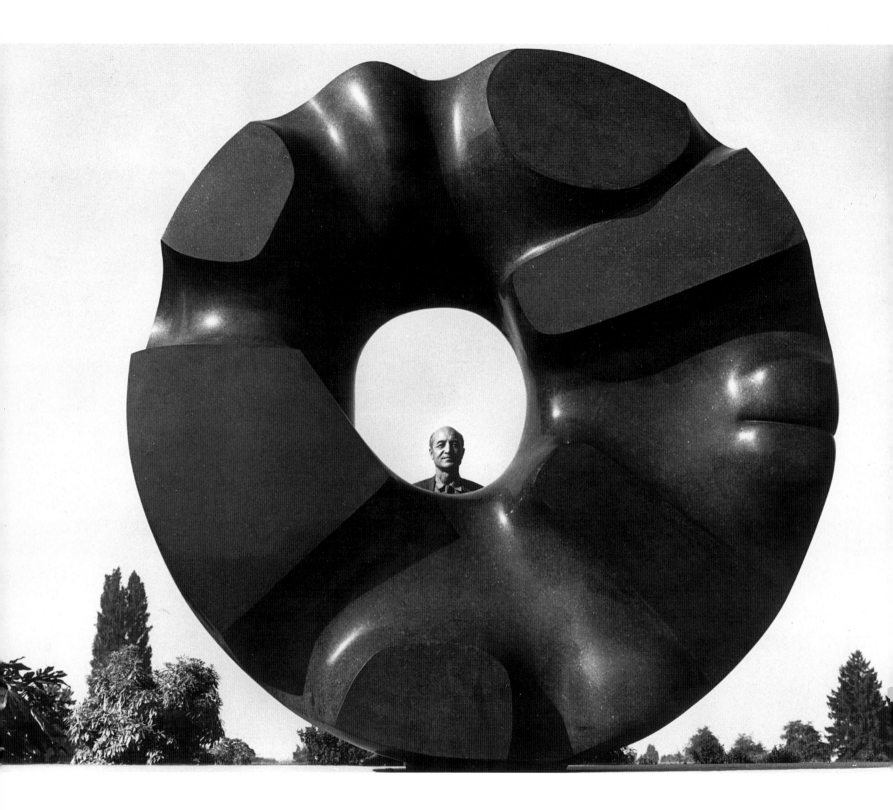

entitled *News*, was cast in stainless steel and weighed nine tons. Casting the sculpture as one piece was an adventure, since something so large had never before been done as one piece. Featuring five figures in the upper left corner, the plaque used the symbols of a camera, a telephone, a reporter's notepad, and a teletype machine to represent global communications systems. Through the figures' gestures Noguchi created the sense of urgency and tension characteristic of the news world.

News and *History Mexico* shared similar social and aesthetic characteristics. Both employed a diagonal composition of figures with defined muscular bodies. *History Mexico* represented the political struggle in Mexico, and *News* the political power of the American communications network. Both murals connected past, present, and future.

During these years WPA Fine Arts Project (FPA) policy encouraged artists to create plaques and friezes with iconography characteristic of the government buildings in which they would be located.[8] In 1939 Noguchi won the commission for one such relief—for a post office building in Haddon Heights, New Jersey. Noguchi produced a magnesite relief, *The Letter*, showing a young girl writing a letter. If in *News* the artist evoked a sense of urgency and tension, then in *The Letter* he created an atmosphere of contemplation and quiet time (fig. 254).

For most of the next two decades, Noguchi focused his energy on the development of a social role for sculpture through the design of gardens and plazas. He did not return to individual sculptures until 1956. During this hiatus, he enriched his concept of sculpture, space, and science as well as his formal vocabulary. He traveled around the world, experimented with set designs with Martha Graham, and completed large-scale public spaces, such as the UNESCO gardens (1956–58). It was evident from the post-1956 public sculptures that Noguchi had matured.

In 1956 Noguchi proposed a sculpture group for the Arrivals Building at John F. Kennedy, then Idlewild, International Airport (fig. 255). This unrealized sculptural group, formed by three vertical elements made from different materials—Greek marble, Tamba granite, and bronze—can be regarded as one of Noguchi's "families." His first had been for the Lever Brothers Building in New York in 1952. Later, these groupings were used

BLACK SUN, SEATTLE ART MUSEUM, WASHINGTON, *1969*
Black Brazilian granite,
108 inches in diameter
FIGURE 259
Isamu Noguchi with Black Sun
Like *Red Cube*, *Black Sun* had its precedent in the "white sun" of the sunken garden at the Beinecke Library at Yale University. The artist considered this piece a complement to the other: "The white sun belongs to the East where the sun rises, the black sun to the West where the sun sets."

SKYVIEWING, WESTERN
WASHINGTON STATE COLLEGE,
BELLINGHAM, WASHINGTON,
1969
Black-painted steel, 10 by 10 by 10 feet
FIGURE 260
Noguchi with model of Skyviewing
The vitality of Noguchi's black-painted
tipped steel cube comes from its
tension; it is supported by three posts.
The piece also incorporates
the concept of weight of pieces like
Cubic Pyramid (1969).

in the gardens for the Connecticut General Life Insurance Company Building in Bloomfield Hills (1956–57) and the First National City Bank Building plaza in Fort Worth, Texas (1960–61). In the Arrivals Building "family," the semicircular head of the tallest element represents the father and shares the vocabulary of Noguchi's sculpture *Mu* at Keiō University (1951–52) and his Mississippi Fountain in New Orleans (1961–62).

In 1966 Noguchi collaborated again with Yoshirō Taniguchi, with whom he had completed the memorial at Keiō University. Taniguchi asked Noguchi to create a sculpture for the new National Museum of Modern Art in Tokyo. The resulting black- and yellow-painted sculpture, *Gate*, consists of two vertical elements of different heights (fig. 256). Noguchi used square metal tubing and sliced off the ends of both vertical elements at a diagonal; he connected the two pieces at their bases with a prismatic element. Because funding was not available for this project, Noguchi decided to recycle the steel girders used in highways and overpasses built for the 1964 Olympic Games in Tokyo. As Dore Ashton stated in *Noguchi: East and West*, in the Japanese art world of the 1960s, a radical movement had appeared in which artists and critics were searching for innovation in the rejection of any aesthetic references to their own his-

tory.[9] Noguchi's work was scorned by those following such trends. It was uncomfortable for some Japanese artists to confront Noguchi's work, and to accept that tradition and technology could be engaged in an innovative way. He sensed this attitude toward his work, but it did not cause him to falter in his commitment to it. *Gate* is a clear example of Noguchi's ability to synthesize Western and Eastern traditions and contemporary technology. It also made obvious the artist's skillful understanding of scale within the urban context of the new Japanese metropolis. The sculpture was the prelude to the large-scale sculptures of the 1970s.

After *Gate*, Noguchi began to receive commissions for public sculptures around the world. *Red Cube* (1968), created in collaboration with Gordon Bunshaft of Skidmore, Owings & Merrill, was Noguchi's next public work (figs. 257 and 258). The sculpture was located in New York's Wall Street District in the plaza of Marine Midland Bank, near Noguchi's sunken garden for the Chase Manhattan Bank plaza. The artist created a twenty-four-foot-high red-painted steel cube with a hole at its center. The cube stands on one of its points, transforming the shape into a rhomboid. The hole, the myth, represents an abyss, a question mark, which to Noguchi symbolized humankind's condition and its relationship with nature and technology. The piece was a reinterpretation of

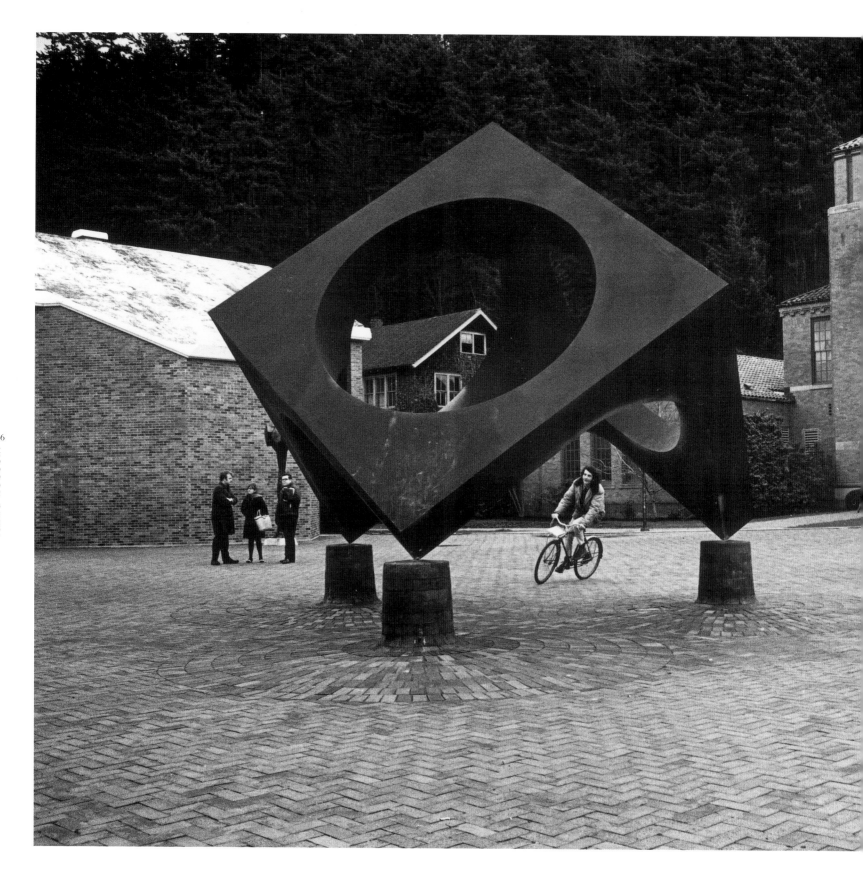

SKYVIEWING, WESTERN
WASHINGTON STATE COLLEGE
FIGURE 261
View
Skyviewing, a metal sculpture in a
brick courtyard, incorporates the
void on a monumental scale. The
sculpture is a symbol of the cosmic
aspirations of humankind.

the cube in the sunken garden at Beinecke Library (1960–64); that cube,
made of solid stone, symbolizes nature and human history. *Red Cube,*
made of steel plates, symbolizes technology and the human-made world.
It became the focus of the plaza and a reference point along Broadway.

Another important connection to elements from Beinecke is
Noguchi's *Black Sun* (1969), a circle, 108 inches in diameter, carved from
black Brazilian granite (fig. 259). *Black Sun* was the first of three commis-
sions that Noguchi received from the National Foundation on the Arts
(later the National Endowment for the Arts). The sculpture was sited in
front of the Seattle Art Museum on the edge of a hill overlooking the city.

In 1966 Noguchi returned to the Japanese island of Shikoku in
search of a place to carve *Black Sun*. There, he had been introduced to
the art of rockfishing by the master garden designer Mirei Shigemori
while he was working on the UNESCO gardens, in 1957. This was not
only a return to that island but also an opportunity to concentrate
more completely on stone and to go back to the spirit of the material.

During this trip, Noguchi was introduced to Masatoshi Izumi, who
later became his assistant. It took more than three years to finish *Black
Sun,* and when it was completed Noguchi decided to establish a studio
in the charming small village of Mure. Izumi helped Noguchi build
his studio and collect and cut stones, which in turn helped Noguchi to
develop his other stone sculptures. He began carving in the hardest
stones, granite and basalt: "It is said that stone is the affection of old
men. That may be so. It is also the most challenging to work. A dia-
logue ensues—of chance no chance, mistakes no mistakes. No erasing or

SCULPTURES FOR BAYERISCHE
VEREINS BANK, MUNICH,
GERMANY, *1972*
Black granite, white granite, and
aluminum, each 8 by 8 by 8 feet
FIGURE 262
View
Using the same vocabulary as
Skyviewing, the two sculptures for the
Bayerische Vereins Bank are raised
slightly above the ground but
nevertheless emerge from it. Noguchi
returned to one of his symbols of past
and future, the tetrahedron.

LANDSCAPE OF TIME, FEDERAL
OFFICE BUILDING, SEATTLE,
WASHINGTON, *1975*
Granite, five elements, 8 feet high
FIGURE 263
View
Noguchi carved *Landscape of Time*, a
sculptural group composed of five
granite boulders, on Shikoku, Japan. It
is characteristic of his final works, in
which the original stones are minimally
transformed.

reproduction is possible, at least not in the way I now work, leaving nature's mark. It is unique and final."[10]

The circle was an important part of Noguchi's formal vocabulary; each of his circular sculptures, including *Variation on a Millstone* (1962), *The Ring* (1945–48), *The Sun at Noon* (1969), and *The Sun at Midnight* (c. 1973), gave the artist an opportunity to refer to different symbolic meanings from the ancient world. With his circles he brought to the modern world the Chinese notion of the cosmos, the bold black circle of Zen calligraphy, and the idea of the circle as an endless line and a symbol of nothingness. *Black Sun* expresses Noguchi's fascination with the concepts of energy and of infinity.

In 1969 Noguchi returned to the symbolism of the cube. He constructing *Skyviewing* in a brick courtyard at Western Washington State College's campus in Bellingham (figs. 260 and 261). *Skyviewing* is a larger version of *Cubic Pyramid* (1969), another variation on the tipped cube. In *Skyviewing* the idea of the void is incorporated into that of the tipped cube. The concept of emptiness, an abstract idea opposing nothingness, is symbolized in the Egyptian hieroglyphic system as the hollow and can be defined as "that place which is created out of the loss of the substance required for the building of heaven."[11] In this case, three corners of the tipped cube touch brick cylinders, resulting in a pyramid that floats above the pavement of the plaza. Noguchi chose to use steel painted black for *Skyviewing* in an effort "to tie sculpture to the awareness of outer space as an extension of its significance, much as one finds in very early observatories."[12] Later, he would demonstrate the same interest in creating a relationship between his sculptural pieces and outer space in the Expo '70 Fountains (1970) and *Intetra, Mist Fountain* (1974–76).

Between 1968 and 1973 Noguchi developed a series of sculptures in his studio based on the notion of forming one large sculpture from several smaller elements. The pieces were based on the structural theory of post-tensioning, with all elements held in tension by steel rods. Using the same vocabulary of other post-tensioned pieces, such as *Ding Dong Bat* (1968), from this period, Noguchi created two sculptures for the Bayerische Vereins Bank in Munich, Germany, in 1972 (fig. 262).

Again, he expressed the duality between nature and technology through his use of materials—in this case, granite and aluminum. The larger sculpture was conceived as another interpretation of *Skyviewing*. It is composed of four granite cubes—a white one at the top and three black ones—that together make up a new cube that stands on its corner point. The smaller piece, made of aluminum, emerges from the ground so that just over half of it is seen.

In 1975, while on Shikoku, Noguchi carved *Landscape of Time*, a stone group now located in front of the Federal Office Building in Seattle, Washington (fig. 263). The piece was commissioned with funding from the General Services Administration. *Landscape of Time* is formed by five granite elements—two vertical and three horizontal pieces. Noguchi always allowed himself the luxury of time to create new abstractions on themes and abstractions of symbols. Following Brancusi's lead in creating precisely polished surfaces, Noguchi indulged himself in a search for perfect form. *Landscape of Time* embodied ideas from Noguchi's studio series of landscape arrangements developed in the 1960s, such as *Lessons of Musokokushi* (1962). The artist often referred to and translated these studio studies into large-scale public sculptures. Many of his earthworks address ideas of nature and gravity in an effort to reconnect humankind with nature.

In October 1974 Noguchi was invited to participate in a competition for a public sculpture to be placed inside the new Municipal Building in Honolulu, Hawaii. After submitting the model, he left the United States for Japan. In 1976 Noguchi received two commissions, the Honolulu sculpture and another one in Cleveland. The Cleveland commission was for a large sculpture at the Cuyahoga Justice Center (figs. 264 and 265). Noguchi proposed a "gateway" to the court building and the jail, "a gateway to hope or despair."[13] He stated that *Portal* was a large-scale translation of the 1970s stone void series *Walking Void*. Noguchi had introduced his concept of the void into an urban scale. This concept was a long-term interest for him: "I have carried the concept of the void like a weight on my shoulders. I could not seem to avoid its humanoid grip."[14] Like *Black Sun*, *Portal* reflects the artist's experiences and recurring references.

PORTAL, CUYAHOGA JUSTICE CENTER, CLEVELAND, OHIO, *1976*
Steel pipe, 35 by 40 feet
FIGURE 264
Portal *during construction at the Paterson-Leitch Factory, Cleveland, Ohio*
Portal was fabricated out of standard hollow steel pipe four feet in diameter. The sculpture's void frames and directs the viewer toward the building entrance.

FIGURE 265
View
In Portal, Noguchi wanted to symbolize both hope and despair. He also used the void as a symbol of the future.

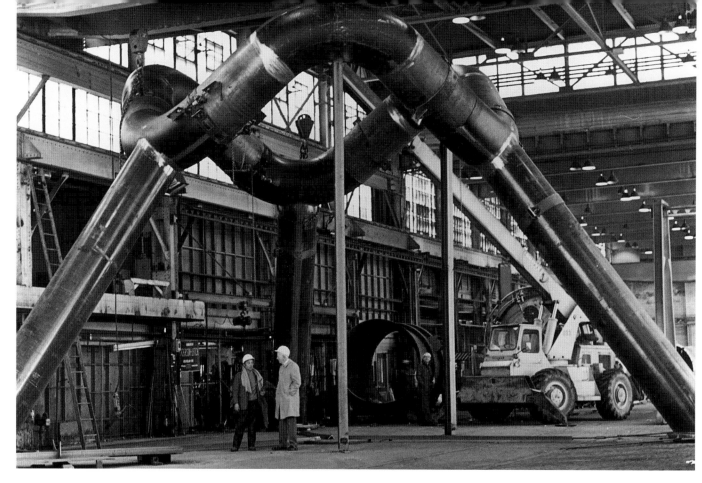

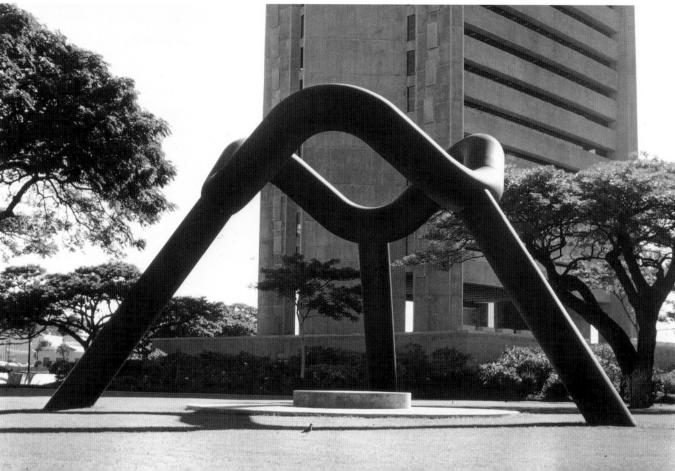

SKY GATE, HONOLULU,
HAWAII, *1976–77*
Painted steel, 24 feet high
FIGURE 266
Noguchi with Sky Gate
during fabrication at Paterson-
Leitch Factory, 1977
Noguchi used the same structural
system to build *Sky Gate* and *Portal*,
but the different sites transform
the works. The void in *Sky Gate*
opens to the sun and evokes
the volcanic landscape of Hawaii.

FIGURE 267
View
Sky Gate, a variation on the
Dodge Fountain at Philip A. Hart
in Detroit, was another way for
Noguchi to address the awareness of
outer space.

MOMO TARO, STORM KING
ART CENTER, MOUNTAINVILLE,
NEW YORK, *1977*
Granite, nine pieces, 9 feet by
35 feet 2 inches by 22 feet 8 inches
FIGURE 268 *(overleaf)*
View
Momo Taro sits on a gentle hill, a
natural gathering place in the
outdoor park. The piece looks different
from each vantage point.

BLACK SLIDE MANTRA, OHDORI
PARK, SAPPORO, JAPAN,
1988–91
Black granite
FIGURE 269 *(overleaf)*
View
Black Slide Mantra is a variation
on *White Slide Mantra*, the sculpture
Noguchi presented at the 1986
Venice Biennale. After Noguchi's death,
it was completed by Shoji Sadao.

The void is not only a symbol for an abyss and the unknown, it is also, in Zen calligraphy, a symbol of the future. As in the 1966 sculpture *Gate*, Noguchi used industrial materials; *Portal* was made of sewage pipe, four feet in diameter.

It was not until *Portal* was underway that Noguchi received approval to build *Sky Gate* in Honolulu (figs. 266 and 267). The twenty-four-foot-high sculpture was made from the same kind of sewage pipe used for *Portal*. Both sculptures share the structural vocabulary of the Dodge Fountain in Detroit (1972–79). Noguchi said of *Sky Gate*, "This sculpture has became an evocation to the skies of Hawaii."[15] It is the only project the artist ever realized of the three he had proposed for Hawaii beginning in 1940. (The first had been the playground equipment for Ala Moana Park, and the second, the large earthwork *Sacred Rocks of Kukaniloko*.) In this sculpture Noguchi created a symbolic gateway to outer space, a gateway to the cosmos. In so doing, he established a free relation between Polynesian tradition and modern technology. He envisioned *Sky Gate* as "a center of attraction, with weekly hula dancing and concerts."[16]

A year later, in 1977, Noguchi was commissioned by the Storm King Art Center in Mountainville, New York, to create a large sculpture, with the explicit agreement—as Peter H. Stern, chairman of Storm King, explained—that the center would accept anything he proposed. Storm King was founded as an open-air museum in the 1960s by Ralph E. Ogden. Located in a valley in upstate New York between two mountain ranges, the two-hundred-acre outdoor site with its rolling hills offered a magnificent setting for Noguchi's work. For this site the artist carved *Momo Taro*, a granite sculpture group, situating it at the top of an artificial hill not far from the center's main building. Noguchi found an oversized stone on Shikoku and split it in half. Of the stone, he exclaimed, "Oh, that is *Momo Taro*"[17] (fig. 268). Momo Taro was a Japanese folk hero who had emerged from a peach to slay a local dragon. Noguchi's *Momo Taro* is formed of nine carved stone elements. He made a circular cavity at the center of one of the halves of the great stone. Metaphor appears in Noguchi's treatment of surfaces: the interior is polished and smooth and the exterior is roughly carved. The cavity represents the

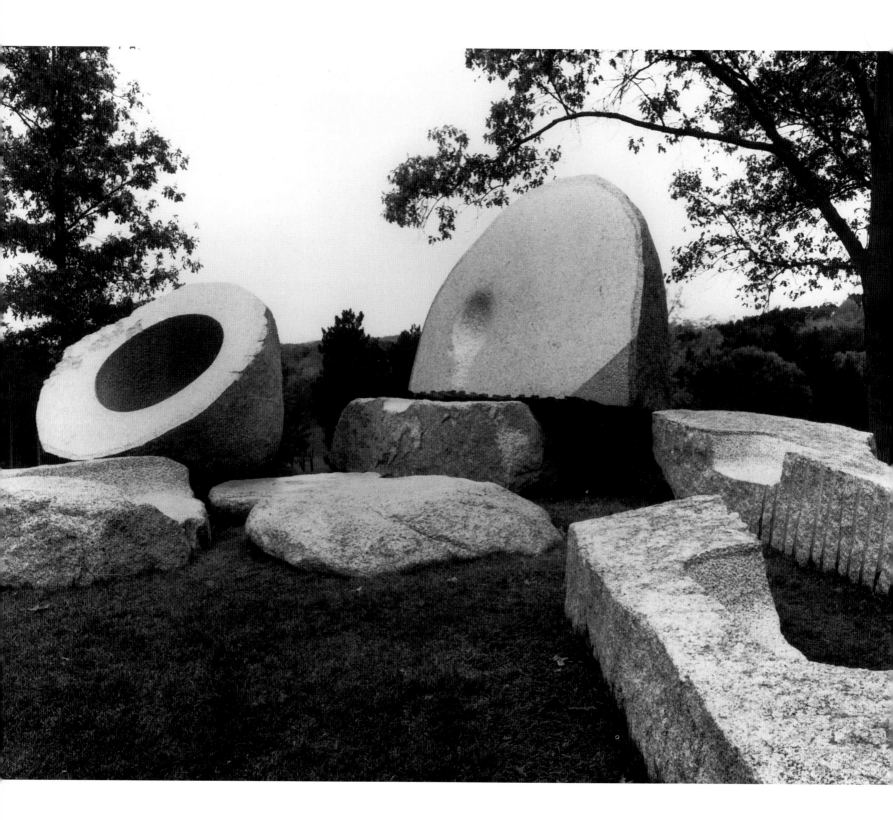

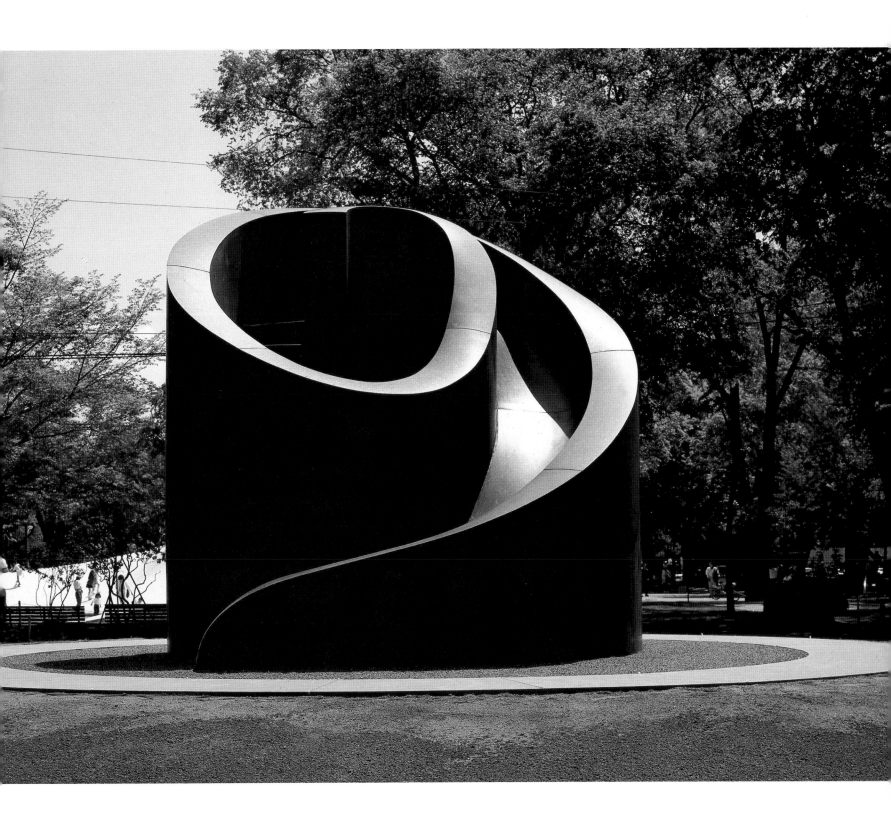

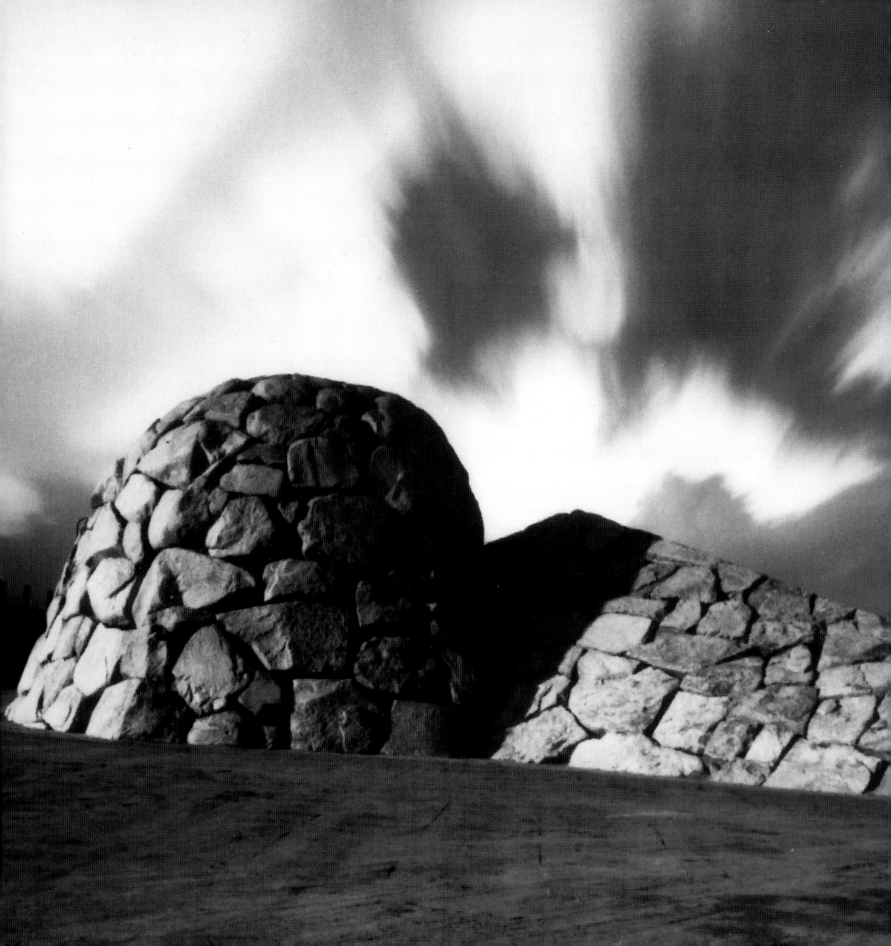

TIME AND SPACE,
TAKAMATSU AIRPORT,
SHIKOKU, JAPAN, 1988–91
Granite
FIGURE 270
View
Time and Space brought forth the artifice with which Noguchi began to experiment in the 1970s. What appears to be a natural pile of rocks is a calculated construct of interlocking parts.

circle, a symbol for infinity. It is also linked with the prehistoric symbol of stone, "mother earth," and childhood. It is a modern interpretation of a megalithic cromlech. The nine elements create their own landscape in which infinite possibilities exist for viewers to sit, climb, or crouch and thus return to the origin and the spirit of the stone.

In 1986 Noguchi was asked to represent the United States at that year's Venice Biennale. He decided to exhibit *White Slide Mantra*[18] (1966–85). His choice of work reflected his interest in the idea "of play as it relates to sculpture."[19] The piece was carved from Carrara marble with the objective of demonstrating his concept: "I am ever mindful of the notion that to discover or rediscover the true meaning of sculpture, the experience of sculpture has to be expanded. Here the tactile quality of sculpture is paramount—a chance for people to slide!"[20]

In 1988 Noguchi sought to place *White Slide Mantra* in Bayfront Park in Miami, Florida. (This did not happen until 1991, after his death.) In 1988 he also received two commissions. One was the sculpture *Black Slide Mantra*, made from black granite and located in Sapporo, Japan (fig. 269). The other was for a large monument for the Takamatsu Airport on Shikoku in Japan, which Noguchi called *Time and Space* (fig. 270). This commission was a variation on both Noguchi's *Illusion of the Fifth Stone* (1970) and *The Spirit of the Lima Bean* (1981; part of *California Scenario*). In each case, he created an artifice—a conglomeration of interlocking stones—that seemed natural. Both projects were completed posthumously in 1991. Isamu Noguchi died in New York on December 30, 1988.

EPILOGUE

STONE WAS NOT CENTRAL TO MY BECOMING A SCULPTOR. CLAY WAS. THINKING WITH CLAY IS HOW I FIRST BEGAN IN THE SUMMER OF 1922 WHEN I WAS SENT TO GUTZON BORGLUM TO TUTOR HIS SON.[1]

A product of two vastly different cultures, Isamu Noguchi's identity was equally split between East and West. As a child he learned, from Eastern culture, to view the materials of daily life as equivalent to and interrelated with art. In this view, the boundaries between the aesthetic and the quotidian are nonexistent, and all things—extraordinary or not—are treated with equal respect. Noguchi understood the fundamental concept that "the beautiful is the vital principle of the cosmos."[2] Yet he also embraced a Western understanding of art as an "elitist" phenomenon to be contemplated disinterestedly, detached from issues of social responsibility and distinct, in use, from mass-manufactured objects.

In *The Isamu Noguchi Garden Museum,* Noguchi stated that he first learned to sculpt by "thinking in materials."[3] It was through materials, form, and symbols that he derived the content of his work: the viewer sees the results of a human mind searching for significance, and the manifestation of found meanings in an extraordinary range of textures, imagery, and cultural references. United by no single aesthetic, Noguchi's work is vastly eclectic in appearance and form but is linked through an intricate system of material, aesthetic, and cultural interconnections.

Throughout his life, Noguchi sought an identity to reconcile his dual Japanese and American heritage. Through concepts of universality, he bridged this cultural chasm. The artist's oeuvre, like his life, was perennially subjected to a process of restless transformation. In part, this may be seen as the manifestation of Noguchi's life-long self-perceived identity as a "loner." His own idiosyncrasies forced him beyond cultural and personal boundaries and enabled him to exhibit what Buckminster Fuller admiringly termed a "global vision." Noguchi embodied the archetypal individual who "habitually sees reality, not in its pure form, but in accordance with his own peculiar model of being which identifies him with the existing space and history."4 Excluded from traditional Japanese and modern American cultures and compelled to formulate an innovative approach to sculpture, he worked toward an art that was centered around the philosophy of a universal approach and created an alternative for himself—a condensation of universal meanings.

Introduced at an early age to poetry and Greek mythology, Noguchi used childhood memories as his touchstones. Memories were employed like tools, with the conviction that memory and myth were equally necessary to daily life. Also compelled by his commitment to social issues, Noguchi coupled these strands with a desire to create public spaces and meaningful gardens.

Noguchi's conception of a "sculpture of space" was essential to his designs for public spaces and was his most significant contribution to modern sculpture. That idea lies at the heart of this book, and is critical to Noguchi's urban design work. He conceived the larger spaces as gardens, as public spaces; as he stated, they were conceived "not as sites with objects but as relationships to a whole."5 Noguchi's gardens, plazas, and public spaces were consistently rooted, in some way, between his two cultures, between historical traditions and the mechanical age, between the past and the future—always embodying a duality. In essence, that duality is emblematic of Noguchi's deepest feelings about humanity and art; it is reflective of his drive and energy, his dreams, his inventiveness, and his intuitive comprehension of site.

Noguchi also refused to remain consistent within any single sculptural style. A seemingly tireless traveler, each time a pause seemed even remotely possible he relocated himself to another country and changed materials and style. His eclecticism and his transitory residence led to widespread differences in opinion among critics and art historians since they were unable to adequately label him or his work.

Ultimately, Noguchi's lifelong aesthetic and cultural peripateticism reflected the social turbulence and restlessness so characteristic of the twentieth century. It is through this lens that his achievements should be viewed.

CHRONOLOGY

1904
Isamu Noguchi is born on November 17 in Los Angeles to American writer Leonie Gilmour and Japanese poet Yonejirō (Yone) Noguchi. Isamu's father had returned to Tokyo earlier that year.

1906–10
Leonie Gilmour takes Isamu with her to Japan to join Yone in Tokyo in 1906. In December 1910 Leonie and Isamu move out of Tokyo to the seaside town of Ōmori.

1912–17
Noguchi and his mother move to Chigasaki. Ailes, his half sister, is born. In November 1913 Leonie builds a new home in Chigasaki and Isamu is informally apprenticed to the carpenter. Isamu leaves Japanese school to attend the Jesuit Saint Joseph's College in Yokohama. Leonie, Isamu, and Ailes move to Yokohama.

1918
Leonie sends Noguchi alone to the Interlaken School in Rolling Prairie, Indiana, which closes in the fall for wartime use. After the school is converted to a military training camp, Noguchi is placed by Dr. Edward Rumely, Interlaken's founder, in the La Porte, Indiana, home of a Swedenborgian minister, Dr. Samuel Mack.

1922–23
Noguchi graduates from La Porte High School. Dr. Rumely raises the funds to send Noguchi to Columbia University for premedical studies and arranges for him to work in Connecticut during the summer for Gutzon Borglum, sculptor of the Mount Rushmore National Monument. Noguchi moves to New York City and enrolls at Columbia. In 1923 Leonie returns to the United States, arriving in California.

1924
Leonie moves to New York City and urges Noguchi to take an evening sculpture class at the Leonardo da Vinci Art School. There, he is introduced to academic sculpture. His teacher, Onorio Ruotolo, gives him his first exhibition after three months. Noguchi leaves Columbia and commits himself to sculpture. He begins using the surname Noguchi instead of Gilmour. He sets up his first studio, at 127 University Place, with assistance from Rumely. He is elected to the National Sculpture Society.

1925–26
Noguchi exhibits figurative sculpture at the National Academy of Design and the Pennsylvania Academy of the Fine Arts. He creates his first work for the theater: masks for Michio Itō's performance of Yeats's *At the Hawk's Well*. He frequents galleries of modern art, such as Alfred Stieglitz's Intimate Gallery and J. B. Neumann's New Art Circle. Impressed with Constantin Brancusi's exhibition at the Brummer Gallery in New York in late 1926, he applies for a Guggenheim Fellowship.

1927–28
Noguchi receives a John Simon Guggenheim Fellowship for travel to Paris and the Far East. He arrives in Paris on March 30, 1927, and is introduced to Brancusi by Robert McAlmon. Noguchi works as Brancusi's assistant for three to six months and spends afternoons drawing at the Académie de la Grande Chaumière and the Académie Colarossi. He socializes within an artists' community that includes Alexander Calder, Morris Kantor, and Stuart Davis. Noguchi creates his first abstract sculpture in his own studio in Montparnasse, at 7 rue Belloni (now rue d'Arsonval). In 1928 he moves his studio to 11 rue Dedouvre, Gentilly.

1929
Noguchi's Guggenheim Fellowship is not renewed for a third year, so he returns to New York. In a studio in Carnegie Hall, he supports himself through portrait sculptures. His first one-person commercial exhibition, which features Paris abstractions, is held in April at the Eugene Schoen Gallery in New York. He meets R. Buckminster Fuller and the modern dancer Martha Graham. He moves his studio to Madison Avenue and Twenty-ninth Street.

1930
Noguchi exhibits portrait sculptures in New York at the Marie Sterner Gallery. He travels on an exhibition lecture tour with Fuller to Cambridge, Massachusetts, and Chicago. Noguchi returns to Paris before traveling via Moscow to Beijing, where he remains for seven months studying ink-brush painting with Ch'i Pai-shih and creating a series of large figurative brush paintings.

1931–32
Despite strained relations with his father, Noguchi returns to Japan, where he is helped by his uncle Totaro Takagi. In Kyoto he sees his first Zen gardens and ancient Haniwa sculpture. He works with master potter Jinmatsu Unō and makes ceramic sculptures that are exhibited in the eighteenth Nikaten Exhibition in Tokyo. He returns to New York in October. In February 1932 he displays Peking brush paintings and Chinese ceramic sculpture in a two-gallery exhibition. When he is evicted from Sherwood Studios at 58 West Fifty-seventh Street, he moves to a storefront at 446 East Seventy-sixth Street. He creates *Miss Expanding Universe*, a sculpture of the dancer Ruth Page, and designs a sack costume for her.

1933–34

Julien Levy publishes the first full-length essay on Noguchi, who moves to better quarters at the Hotel des Artistes, 1 West Sixty-seventh Street. He travels to London for the summer and exhibits his Beijing brush drawings. He designs his first large-scale environmental projects—*Monument to the Plow*, Play Mountain, and *Monument to Ben Franklin*—which are all unrealized. Leonie Gilmour dies in New York City. In 1934 the critic Murdock Pemberton takes Noguchi to present Play Mountain to New York City Parks commissioner Robert Moses, who rejects the proposal. Following this, Noguchi loses the support of the government-sponsored Public Works of Art Project after he submits for review models for nontraditional public projects. He works in Woodstock, New York, to prepare for a winter exhibition, and moves his studio to 239 East Forty-fourth Street.

1935–36

He exhibits public projects and political works, including Play Mountain and *Death (Lynched/Lynch Figure)* at the Marie Harriman Gallery in New York. He initiates a lengthy collaboration with Martha Graham with the set design for *Frontier*. He leaves New York for California where he sculpts busts and designs a swimming pool (unrealized) for Josef von Sternberg. In 1936 he travels to Mexico City, where he works for seven months to create *History Mexico*, a political relief mural at the Abelardo Rodriguez market. He designs his second stage set for Graham, *Chronicle*.

1937–38

Noguchi returns to New York City, where he designs his first manufactured object—the Radio Nurse intercom for Zenith Radio Corporation. In 1938 he designs a magnesite fountain intended for the Ford Motor Company Building at the 1939 New York World's Fair. He wins a competition for his nine-ton stainless-steel relief, *News*, for the Associated Press Building, Rockefeller Center, New York.

1939–40

At the invitation of the Dole Pineapple Company Noguchi travels to Hawaii, where he designs his first playground equipment for Ala Moana Park, Honolulu (unrealized). He also designs his first table, a commission for A. Conger Goodyear, president of the Museum of Modern Art, New York. In 1940 he designs masks and a stage set for Graham's *El Penitente*. *News* is completed and installed over the entrance to the Associated Press Building.

1941–42

He proposes Contoured Playground for Central Park (unrealized) to the New York City Parks Department. He drives to California with Arshile Gorky and friends. Noguchi is living in Hollywood when the Japanese attack Pearl Harbor. In 1942, while there, he organizes the Nisei Writers and Artists Mobilization for Democracy. In Washington, D.C., he discusses with officials the harsh conditions of Japanese-American relocation camps. He voluntarily enters the Colorado Relocation Center in Poston, Arizona, in order to improve the environment of internees. After six months he leaves the internment camp and returns to New York.

1943–44

Noguchi develops his first illuminated "lunar" sculptures and designs a three-legged cylinder lamp, which is produced by the Knoll Manufacturing Company beginning in 1944. He returns to carving stone and wood and makes mixed-media sculptures. In 1944, working with thin stone slabs, Noguchi begins a series of biomorphic sculptures of interlocking elements. He continues to design sets for works by Martha Graham—*Appalachian Spring*, *Herodiade*, and *Imagined Wing*—and a set and costumes for Ruth Page's *The Bells*. He designs a biomorphic coffee table and dinette set, which are manufactured by Herman Miller beginning in 1947.

1945–46

Together with architect Edward Durell Stone, Noguchi submits a proposal for the Jefferson Memorial Park competition, Saint Louis, Missouri (unrealized). He designs the stage set for *John Brown* by the dancer Erick Hawkins. In September 1946 twelve of Noguchi's sculptures are exhibited in "Fourteen Americans" at the Museum of Modern Art, New York. He designs several more stage sets for works by Graham, including *Dark Meadow* and *Cave of the Heart*.

1947–48

Noguchi creates "lunar" ceilings for the American Stove Company Building, Saint Louis, and the Time-Life Building, New York. He makes a maquette of *Memorial to Man*, later called *Sculpture to Be Seen from Mars* (unrealized). He designs stage sets for Graham's *Errand into the Maze* and *Night Journey* and for Hawkins's *Stephen Acrobat*, and the set and costumes for Merce Cunningham's *The Seasons*. Yone dies in Tokyo. Noguchi conceives *Lunar Voyage*, a stairwell for the S.S. *Argentina*. He proposes a park and a memorial for Gandhi's burial place at Rajgat, India (unrealized). He also designs stage sets and costumes for George Balanchine's *Orpheus* and sets for Graham's *Diversion of Angels* and Yuriko Amemiya's *Tale of Seizure*.

1949–50

In March 1949 the first one-person exhibition of Noguchi's work in New York in fourteen years is held at the Charles Egan Gallery. He receives support from the Bollingen Foundation to travel to France, England, Spain, Italy, Greece, Cambodia, Indonesia, and Japan to conduct research for his book *The Environment of Leisure* (never completed). In May 1950 Noguchi returns to Japan for the first time since 1931 and is welcomed by young artists and architects. He receives a commission, with Yoshirō Taniguchi, to design a memorial room and garden for his father at Keiō University, Tokyo (completed in 1952). At the Mitsukoshi Department Store, also in Tokyo, he exhibits ceramics, furniture, sculpture, and models for the garden, as well as a model of a memorial bell tower for Hiroshima. In the fall of 1952 he returns to New York, where he meets his future wife, Japanese actress Yoshiko (Shirley) Yamaguchi. In November he designs a stage set for Graham's *Judith*.

1951–52

Noguchi returns to Japan in early spring. With the support of Kenzo Tange, he receives a commission for railings for two bridges in Peace Park, Hiroshima (completed in 1952). He designs his first Akari lanterns in Gifu, where mass production begins in 1952. He designs a garden for the new Reader's Digest Building in Tokyo. In New York, he prepares plans for a playground (unrealized) at the United Nations. Gordon Bunshaft of Skidmore, Owings & Merrill begins a collaboration with Noguchi on the redesign of the Lever Brothers Building garden (unrealized). In the spring of 1952, at the request of Kenzo Tange and the mayor of Hiroshima, Noguchi designs *Memorial to the Dead*, which is later rejected by a city committee. He marries Shirley Yamaguchi in a Japanese ceremony in May. They establish a house and studio, where Noguchi works in clay, in Kita Kamakura, in a traditional structure belonging to potter Rosanjin Kitaōji. New ceramic works and Akari are displayed at the Museum of Modern Art, Kamakura.

1953–54

Noguchi returns to New York City where he unsuccessfully tries to obtain a visa for his wife. He designs a set for Martha Graham's *Voyage* that is reused for *Circe* in 1963. He lives in Europe and Asia with Yamaguchi during the summer and fall. In 1954 Knoll International manufactures Noguchi's rocking stools and table. He exhibits ceramic work at the Stable Gallery, New York, in November.

1955–56

Noguchi exhibits Akari for the first time in New York and crafts a stage set for Graham's *Seraphic Dialogue*. He also designs stage sets and costumes for the Royal Shakespeare Company's production of *King Lear* in London. He is commissioned in 1956 to design gardens for the UNESCO Headquarters, Paris (completed in 1958), and four courtyards and a garden for the Connecticut General Life Insurance Company (now CIGNA Corporation; completed in 1957), Bloomfield. He begins waterfall wall and ceiling design for the lobby at 666 Fifth Avenue in New York (completed in 1958).

1957–58

Noguchi designs a memorial (unrealized) for a New Delhi competition commemorating the 2,500th birthday of Buddha. He travels to Japan to search for stones for the UNESCO gardens and visits the island of Shikoku for the first time. In 1958, after completing the gardens, he relocates to New York and produces aluminum-sheet sculptures with the assistance of the architect Shoji Sadao at the factory of lighting designer Edison Price. Noguchi designs sets for Graham's *Clytemnestra* and *Embattled Garden* (elements reused for *Night Chant*, 1988).

1959–60

Noguchi carves white marble sculptures when Eleanor Ward refuses to exhibit his aluminum sculptures at his spring Stable Gallery exhibition. He begins a series of circular stone sculptures and a series of balsa-wood sculptures, which are cast in bronze in 1962. In 1960 he commences a sculpture (completed in 1961) for the First National City Bank Building plaza, Fort Worth, Texas; designs the sunken garden at the Beinecke Rare Book and Manuscript Library, Yale University, New Haven, Connecticut (completed in 1964); and designs the Billy Rose Sculpture Garden, Israel Museum, Jerusalem (completed in 1965). He produces sets for Graham's *Acrobats of God* and *Alcestis* (elements reconfigured for *Phaedra's Dream*, 1983).

1961–62

Noguchi moves his studio to a former factory building in Long Island City, New York. He is commissioned for the sunken garden at the Chase Manhattan Bank plaza, New York (completed in 1964). He initiates a long-term collaboration with architect Louis I. Kahn for a playground for New York's Riverside Park. (Five plans were designed through 1966, all unrealized). In 1962, as an artist in residence at the American Academy in Rome, Noguchi completes a series of balsa-wood and clay sculptures to be cast in bronze. He begins a ten-year period of carving at Henraux marble quarries in Querceta, Italy. He designs a set for Graham's *Phaedra*.

1964–65

Noguchi produces gardens for the IBM Headquarters, Armonk, New York, and a tomb (unrealized) for President John F. Kennedy. In 1965 he designs his first realized playground, for Kodomo No Kuni, near Tokyo (completed in 1966).

1966–68

Noguchi ends his work in theater with a stage set for Graham's *Cortege of Eagles*. He carves large works of rough stone at Henraux quarries. In Shikoku, Japan, he begins a collaboration with Masatoshi Izumi for the design of *Black Sun*. In April 1968 he publishes his autobiography, *A Sculptor's World*. The Whitney Museum of American Art, New York, mounts the first major Noguchi retrospective. He submits a proposal for the U.S. Pavilion for Expo '70, Osaka, Japan (unrealized). He creates *Red Cube* for the Marine Midland Bank plaza, New York. He commences a series of stone table/landscape sculptures and a series of marble post-tensioned sculptures in Italy.

1969–70

Noguchi produces *Skyviewing* for Western Washington State College, Bellingham, and installs *Black Sun* at the Seattle Art Museum. In 1970 he realizes nine fountains for Expo '70 in Osaka. He starts a series of open, void-form sculptures.

1972–74

In 1972, with Shoji Sadao, Noguchi begins the design of Dodge Fountain and the Philip A. Hart Plaza, Detroit (completed in 1979). He creates sculptures for Bayerische Vereins Bank, Munich. In 1974 he designs *Intetra, Mist Fountain* for the Society of the Four Arts, Palm Beach, Florida (completed in 1975).

1975–76

In Seattle, Noguchi realizes the General Services Administration's commission *Landscape of Time*. He designs Playscapes for Piedmont Park, Atlanta (completed in 1976). He develops two large works from industrial pipe: *Portal* at the Cuyahoga Justice Center, Cleveland, and *Sky Gate* in Honolulu (completed in 1977). With Shoji Sadao, he plans the 150-foot-high Friendship Fountain (unrealized) for the Missouri River between Nebraska and Iowa.

1977–78

Noguchi commences the design of *Tengoku* for the Sōgetsu Flower Arranging School, Tokyo, Japan (completed in 1978). *Momo Taro* is commissioned for Storm King Art Center, Mountainville, New York (installed in 1978). Noguchi proposes an environmental design for Honolulu, *Sacred Rocks of Kukaniloko* (unrealized). In 1978 the Walker Art Center, Minneapolis, organizes a traveling exhibition, "Noguchi's Imaginary Landscapes." He begins work with Shoji Sadao on the Lillie and Hugh Roy Cullen Sculpture Garden, Museum of Fine Arts, Houston (completed in 1986). Sam Hunter writes the first monograph on Noguchi.

1979–80

Noguchi and Kenzo Tange prepare plans for a piazza in Bologna, Italy; Noguchi begins to design Bayfront Park, Miami, with Shoji Sadao (completed in 1996). In 1980 Noguchi initiates a series of outdoor environments, including *Constellation* (for Louis I. Kahn) at the Kimbell Art Museum, Fort Worth, Texas (completed in 1983); *California Scenario*, South Coast Plaza, Costa Mesa, California, with Shoji Sadao (completed in 1982); and the sculpture *To the Issei* and plaza for the Japanese American Cultural and Community Center, Los Angeles, California, with Shoji Sadao (completed in 1983). He redesigns a 1933 project as *Bolt of Lightning . . . Memorial to Ben Franklin* for Philadelphia. An exhibition of Noguchi's environmental work, "The Sculpture of Space," is held at the Whitney Museum of American Art in 1980.

1981–82

On land across the street from his studio, Noguchi, with Shoji Sadao, starts construction of the Isamu Noguchi Garden Museum, Long Island City, New York (completed in 1983). He also begins a series of galvanized-steel sculptures at Gemini G.E.L. in Los Angeles. In 1982 he receives the McDowell Colony Medal.

1983–84

Noguchi designs and initiates construction of a garden at his studio in Mure, Shikoku, Japan, with Masatoshi Izumi. In 1984 the Sōgetsu Flower Arranging School, Tokyo, hosts an eightieth-birthday celebration for Noguchi. He designs a water garden for the Domon Ken Museum, Sakata, Japan, with Yoshio Taniguchi. Noguchi receives the New York State Governor's Art Award and the Japanese-American Citizens League Biennial Award in 1984.

1985–86

He is awarded the Israel Museum Fellowship in Jerusalem and the President's Medal of Honor from the Municipal Arts Society in New York. The Isamu Noguchi Garden Museum opens to the public. In 1986 Noguchi is designated as the representative of the United States at the Venice Biennale. He installs *Tsukubai*, a fountain for the Metropolitan Museum of Art, New York. He receives the prestigious Kyoto Prize from the Inamori Foundation, Japan.

1987–88

President Ronald Reagan awards Noguchi the National Medal of Arts in 1987. In 1988 he receives the first Award for Distinction in Sculpture from the Sculpture Center, New York. He is also granted the third Order of the Sacred Treasure by the Japanese national government. He designs the master plan of a 454-acre park for Sapporo, Japan (ongoing), and a large sculpture for Takamatsu Airport, Shikoku, Japan (completed in 1991). Isamu Noguchi dies in New York City on December 30, 1988.

Introduction

1. Isamu Noguchi, *A Sculptor's World* (New York: Harper & Row, 1968), 11.
2. Noguchi, *A Sculptor's World*, 18.
3. Marc Treib and Ron Herman, *"Katsurz Rikyu": A Guide to the Gardens of Kyoto* (Japan: Shufunotomo Company, 1980), 110–11.
4. Richard Ellmann, *James Joyce* (Oxford: Oxford University Press, 1982), 3.
5. Noguchi, *A Sculptor's World*, 14.
6. Noguchi, *A Sculptor's World*, 15.
7. Noguchi, *A Sculptor's World*, 15.
8. Noguchi, *A Sculptor's World*, 16.
9. Noguchi, *A Sculptor's World*, 19.
10. Noguchi, *A Sculptor's World*, 39.
11. Noguchi, *A Sculptor's World*, 161.

Chapter One

1. Robert Moses, as quoted in Aline B. Louchheim, "U.N. Rejects Ultra-Fancy Playground for Plain Type," *Des Moines Iowa Register,* Oct. 1951.
2. Some years later, this equipment was eventually used as the set—but without Noguchi's initial agreement—in *Down to Earth*, a film starring Rita Hayworth. A settlement was later reached between Noguchi and Columbia Pictures, the company that produced the film.

Chapter Two

1. Isamu Noguchi, quoted in Martin Friedman, *Noguchi's Imaginary Landscapes* (Minneapolis: Walker Art Center, 1978), 43.
2. For further discussion of Robert Smithson's earthworks, see John Beardsley, *Earthworks and Beyond: Art in the Landscape,* 2nd ed. (New York: Abbeville Press, 1989).
3. Isamu Noguchi, *A Sculptor's World* (New York: Harper & Row, 1968), 22.
4. Dr. Edward A. Rumely, founder of the Interlaken School, took Noguchi to his home in Indiana in 1918 when the school was converted into an army camp. For further discussion, see Noguchi, *A Sculptor's World*, 14.
5. Nancy Grove, *Isamu Noguchi: A Study of the Sculpture* (New York and London: Garland Publishing, 1985), 147.
6. Friedman, *Noguchi's Imaginary Landscapes,* 45.

Chapter Three

1. Isamu Noguchi, *A Sculptor's World* (New York: Harper & Row, 1968), 25.
2. "Orthogonal town planning was not a Roman invention, but the Romans introduced it to new regions and with a particular regularity of their own." J. B. Ward-Perkins, *Roman Imperial Architecture* (New York: Penguin, 1981), 34.
3. Giuseppe Terragni's Danteum is a proposal for a monument based on Dante's *Divine Comedy*. It was planned for Rome but was never realized.
4. Giuseppe Terragni, quoted in Thomas L. Schumacher, *The Danteum: Architecture, Poetics, and Politics under Italian Fascism* (New York: Princeton Architectural Press, 1993), 25. Originally published in Italian as *Il Danteum di Terragni* (Rome: Officina Edizioni, 1980).
5. Noguchi, *A Sculptor's World,* 26.

NOTES

6. Noguchi, *A Sculptor's World,* 160.

7. Harris Armstrong, "Progress in St. Louis," *Architectural Forum,* Oct. 1948, 74.

8. Noguchi's first collaborative efforts were with Wallace K. Harrison, for whom he made a number of garden studies for projected building rooftops. See Noguchi, *A Sculptor's World,* 160.

9. Dore Ashton, "Noguchi's Recent Marbles," in *Out of the Whirlwind: Three Decades of Arts Commentary* (Ann Arbor, Mich.: UMI Press, 1987), 133–37. Review originally published in *Art International,* Oct. 1972, 47–49.

10. George Kubler, *The Art and Architecture of Ancient America* (New York: Penguin, 1962, 1975), 30.

11. "Cuzco" can be translated as "omphalos," or "center," in a cosmological sense. But Sarmiento and Gamboa also define it as "occupying a space (place) in a magical way," as cited by Cesar Paternosto in *Piedra Abstracta: La escultura Inca: Una vision contemporanea* (Buenos Aires: Fondo de Cultura Economica, 1989), 23.

12. Noguchi, *A Sculptor's World,* 29.

13. Albert E. Elsen, *The Partial Figure in Modern Sculpture* (Baltimore: Baltimore Museum of Art, 1969).

14. Isamu Noguchi, "On Sculpture," in *Isamu Noguchi: Essays and Conversations,* ed. Diane Apostolos-Cappadona and Bruce Altshuler (New York: Harry N. Abrams/Isamu Noguchi Foundation, 1994), 16.

15. Noguchi, *A Sculptor's World,* 29.

16. Noguchi writes of leisure that "allows for meditation on the meaning of form in relation to man and space." Noguchi, *A Sculptor's World,* 30.

17. Noguchi, *A Sculptor's World,* 31.

18. Noguchi, *A Sculptor's World,* 12.

19. Aline B. Louchheim, "Noguchi and 'Sculptured' Gardens," *New York Times,* Sept. 30, 1951, Art, X9.

20. Noguchi, *A Sculptor's World,* 32.

21. Noguchi, *A Sculptor's World,* 31.

22. Shoji Yashiro, quoting Yoshirō Taniguchi in "Keiō University and Isamu Noguchi," published in Japanese in *Philosophy* 76 (Apr. 1983).

23. Noguchi, *A Sculptor's World,* 33.

24. "The tallest has a double horned 'head,' the second has rounded, 'feminine' curves and the smallest has outstretched arms that echo the 'father's' horns." Nancy Grove, *Isamu Noguchi: A Study of the Sculpture* (New York and London: Garland Publishing, 1985), 155.

25. Noguchi, *A Sculptor's World,* 165.

26. See Lucy R. Lippard, *Overlay: Contemporary Art and the Art of Prehistory* (New York: Pantheon Books, 1983).

27. Noguchi, *A Sculptor's World,* 165.

28. "Its [*shakkei*'s] implication runs more or less like this: when something is borrowed, it does not matter whether it is living or not, but when something is captured alive, it must invariably remain alive, just as it was before it was captured." Teiji Itoh, *Space and Illusion: In the Japanese Garden,* 6th ed. (New York: John Weatherhill; Tokyo and Kyoto: Tankosha, 1988), 15. Originally published in Japanese as *Shakkei Tsuboniwa: Borrowed Scenery and Courtyard Gardens* (Kyoto: Tankosha, 1965).

29. Alexander Calder, in George W. Staempfli, "Interview with Alexander Calder," *Quadrum* 6 (1959): 10.

30. Located at the intersection of Avenue de Saxi and Avenue de Segur.

31. "*Hanamichi* is one of the distinctive elements of the Kabuki Theater." It is a passageway approximately five feet wide, running from the rear of the auditorium to the stage. It joins the stage at the right and at a right angle, which in Japan is called the "western" side of the auditorium, while the opposite side of the house is called the "east." Earle Ernst, *The Kabuki Theater* (Oxford: Oxford University Press, 1956), 25.

32. Noguchi, *A Sculptor's World,* 166.

33. Brancusi died during the construction of Noguchi's UNESCO gardens.

34. Bruce Altshuler, *Noguchi* (New York: Abbeville Press, 1994).

35. Noguchi, *A Sculptor's World,* 166.

36. Noguchi, *A Sculptor's World,* 167.

37. Harriet F. Senie, "Sculpture and Architecture," in *Contemporary Public Sculpture: Tradition, Transformation, and Controversy* (Oxford: Oxford University Press, 1992), 69–70.

38. Isamu Noguchi, "Towards a Reintegration of the Arts," *College Art Journal,* autumn 1949, 59–60.

39. Noguchi, *A Sculptor's World,* 167.

40. Noguchi, *A Sculptor's World,* 35.

41. Noguchi, *A Sculptor's World,* 35.

42. Noguchi, *A Sculptor's World,* 36.

43. Yve-Alain Bois, Joop Joosten, Angelica Zander Rudenstine, and Hans Janssen, *Piet Mondrian* (exhibition catalog, Verona: Arnoldo Mondadori Editore, 1994), 73.

44. Noguchi, *A Sculptor's World,* 169.

45. Isamu Noguchi, notes for press release, c. 1951, Archives of the Isamu Noguchi Foundation.

46. Isamu Noguchi, "On Gardens and Landscapes," in *Isamu Noguchi: Essays and Conversations,* 64.

47. Carol Herselle Krinsky, *Gordon Bunshaft of Skidmore, Owings & Merrill* (New York: Architectural History Foundation, 1988), 142.

48. Isamu Noguchi, "Area 11," *The Isamu Noguchi Garden Museum* (New York: Harry N. Abrams, 1987), 164.

49. "The program was simple, space was needed for about 800,000 books, exhibition areas, staff offices, and a reading room. The program could have been satisfied by a one-story building." Krinsky, *Gordon Bunshaft,* 142.

50. Umberto Eco, *The Name of the Rose* (New York: Harcourt Brace, 1984), 38. Originally published in Italian as *Il nome della rosa* (Snzogno, Etas: Gruppo Editoriale Fabbri-Bompiani, 1980).

51. Noguchi's photographs documenting the observatory were published in "The Observatories of the Maharajah Sawai Jai Singh II," in *Perspecta: The Yale Architectural Journal* 6 (1960): 68–77.

52. Noguchi created a marble sculpture when Eleanor Ward refused to exhibit his aluminum sculptures at the Stable Gallery. Altshuler, *Noguchi,* 115.

53. Michelangelo had worked on the renovation of the two facades of the existing Senator's Palace and the Conservator's Palace, and on the piazza. Opposite the Conservator's Palace, he had proposed a third structure—a twin of the building. Giulio Carlo Argan and Bruno Contardi, *Michelangelo: Architect* (New York: Harry N. Abrams, 1993), 33. Originally published in Italian as *Michelangelo: architetto* (Milan: Electa, 1990).

54. Argan and Contardi, *Michelangelo: Architect,* 217.

55. Argan and Contardi, *Michelangelo: Architect,* 217.

56. Noguchi, *A Sculptor's World,* 170.

57. Martin Friedman, *Noguchi's Imaginary Landscapes* (Minneapolis: Walker Art Center, 1978), 65.

58. Noguchi, *A Sculptor's World,* 171.

59. Noguchi, *A Sculptor's World,* 171.

NOTES

60. Noguchi, *A Sculptor's World*, 171.
61. Noguchi, *A Sculptor's World*, 171.
62. Noguchi, *A Sculptor's World*, 172.
63. Noguchi, *A Sculptor's World*, 172.
64. Friedman, *Noguchi's Imaginary Landscapes*, 67.
65. Noguchi, *A Sculptor's World*, 161.
66. Noguchi, *A Sculptor's World*, 174.
67. Noguchi, *A Sculptor's World*, 173.
68. Noguchi, *A Sculptor's World*, 173.
69. Friedman, *Noguchi's Imaginary Landscapes*, 67.
70. Noguchi, *A Sculptor's World*, 173.
71. Noguchi, *A Sculptor's World*, 177.
72. David B. Brownlee and David G. De Long, *Louis I. Kahn: In the Realm of Architecture* (exhibition catalog, Los Angeles: Museum of Contemporary Art; New York: Rizzoli, 1991), 115.
73. Louis I. Kahn, "Address by Louis I. Kahn, April 5, 1966," in *Boston Society of Architects Journal* 1 (1967): 5–20; quoted from "Boston Society of Architects," typescript, Box LIK 57, Louis I. Kahn Collection, University of Pennsylvania and Pennsylvania Historical and Museum Commission, Philadelphia.
74. Noguchi, *A Sculptor's World*, 178.
75. Noguchi's other choice of collaborating architect was Philip Johnson, of whom he later said, "should he have accepted I think it would have been built. But I chose Kahn." Heinz Ronner and Sharad Jhaveri, "Levy Memorial Playground, New York, New York," in *Louis I. Kahn: Complete Work 1935–1974*, 2nd ed. (Basel and Boston: Birkhäuser, 1987), 184.
76. Noguchi, *A Sculptor's World*, 171.
77. Krinsky, *Gordon Bunshaft*, 73.
78. Friedman, *Noguchi's Imaginary Landscapes*, 61.
79. Noguchi, *A Sculptor's World*, 37.
80. Noguchi, *A Sculptor's World*, 37.

81. Noguchi, *A Sculptor's World*, 171.
82. Noguchi, *A Sculptor's World*, 171.
83. Noguchi, *A Sculptor's World*, 171.
84. *Isamu Noguchi: The Sculpture of Space* (exhibition catalog, New York: Whitney Museum of American Art, 1980), 24.
85. Jorge Luis Borges, *Fictions* (New York: Grove Press, 1962), 97. Originally published in Spanish as *Ficciones* (Buenos Aires: Emecé Editores, 1956).
86. Noguchi, *A Sculptor's World*, 172.
87. Isamu Noguchi, typescript of presentation to Fountain Selection Committee, Mar. 1973, Archives of the Isamu Noguchi Foundation.
88. Friedman, *Noguchi's Imaginary Landscapes*, 80.
89. *Isamu Noguchi: The Sculpture of Space*, 29.
90. Noguchi, in *Isamu Noguchi: Essays and Conversations*, 36.
91. Friedman, *Noguchi's Imaginary Landscapes*, 48.
92. Isamu Noguchi, typescript notes, Mar. 25, 1977, Archives of the Isamu Noguchi Foundation.
93. Isamu Noguchi, typescript notes, Mar. 25, 1977.
94. Noguchi, "Area 11," *Isamu Noguchi Garden Museum*, 206.
95. Noguchi, "Area 3," *Isamu Noguchi Garden Museum*, 66.
96. Friedman, *Noguchi's Imaginary Landscapes*, 85.
97. Friedman, *Noguchi's Imaginary Landscapes*, 85.
98. Noguchi, "Area 11," *Isamu Noguchi Garden Museum*, 180.
99. Friedman, *Noguchi's Imaginary Landscapes*, 85.
100. Carlo Scarpa lived from 1906 to 1978.
101. James David Andrews, "Haiku (#164, p. 119)," *Full Moon Is Rising: "Lost Haiku" of Matsuo Bash-ō (1644–1694)* (Boston: Branden Press, 1976), 70.
102. Thomas Albright, "Sculptor's Advice to Students: 'A New Nature' Is Needed," c. 1970.
103. Noguchi, "Area 11," *Isamu Noguchi Garden Museum*, 186.
104. The garden contains seventy-five species of tree; all are native to Texas, including crape myrtle, magnolia, pine, sycamore, and oak.
105. Albright, "Sculptor's Advice to Students."
106. Sandra Earley, "Noguchi," *Miami Herald*, Aug. 11, 1985, section K.
107. Noguchi, "Area 11," *Isamu Noguchi Garden Museum*, 190.
108. Noguchi, *A Sculptor's World*, 39.
109. Noguchi, "Area 3," *Isamu Noguchi Garden Museum*, 68.
110. Noguchi, "Area 3," *Isamu Noguchi Garden Museum*, 186.
111. Noguchi, "Area 3," *Isamu Noguchi Garden Museum*, 186.
112. Noguchi, "On Sculpture," in *Isamu Noguchi: Essays and Conversations*, 50.
113. Noguchi, "Area 11," *Isamu Noguchi Garden Museum*, 182.
114. Noguchi, *A Sculptor's World*, 170.
115. Noguchi, "Area 2," *Isamu Noguchi Garden Museum*, 40.
116. See Diana Balmori, "The Case of the Death of Nature: A Mystery," in *The Sex of Architecture*, ed. Diana Agrest, Patricia Conway, and Leslie Kanes Weisman (New York: Harry N. Abrams, 1996), 75.
117. Noguchi, "Towards a Reintegration of the Arts," 59.
118. Noguchi, typescript letter, July 3, 1979, Archives of the Isamu Noguchi Foundation.
119. Noguchi, "Area 11," *Isamu Noguchi Garden Museum*, 184.
120. Michael McClure, introduction to *Isamu Noguchi at Gemini* (exhibition catalog, Los Angeles: Gemini G.E.L., 1982), 53.
121. Noguchi, *A Sculptor's World*, 35.

122. Altshuler, *Noguchi*, 101.

123. McClure, *Isamu Noguchi at Gemini*, 53.

124. Noguchi, "Area 1," *Isamu Noguchi Garden Museum*, 20.

125. Yoshio Taniguchi, quoted in Dore Ashton, "Last Metaphors," in *Noguchi: East and West* (New York: Alfred A. Knopf, 1992), 278.

126. Isamu Noguchi, Yoshio Taniguchi, and Hiroshi Teshigahara, "Garden: Plastic Space with Link Inside and Outside" (interview in Japanese), *Ikebana Sōgetsu* 150 (Oct. 1983): 13.zz.

127. Mirei Shigemori, quoted in Koji Takahashi, "The Poetics of Between: On the Sculpture/Space of Isamu Noguchi," trans. Stanley N. Anderson, introduction to *Isamu Noguchi Retrospective 1992* (Tokyo: National Museum of Modern Art, 1992).

128. For further discussion, see Takahashi, "The Poetics of Between," 185–93.

129. Noguchi, "On Sculpture," in *Isamu Noguchi: Essays and Conversations,* 48.

130. Ashton, *Noguchi: East and West,* 270.

131. Ashton, *Noguchi: East and West,* 270.

132. Jorge Luis Borges, "The Garden of Forking Paths," *Fictions,* 97.

Chapter Four

1. Isamu Noguchi, *A Sculptor's World* (New York: Harper & Row, 1968), 21.

2. Jorge Luis Borges, foreword to *Obra Poética, 1923–1976* (Buenos Aires: Emecé Editores, 1977), 15.

3. Noguchi, *A Sculptor's World,* 21.

4. Noguchi, *A Sculptor's World,* 21.

5. Noguchi, *A Sculptor's World,* 22.

6. Noguchi, *A Sculptor's World,* 22.

7. Noguchi, *A Sculptor's World,* 164.

8. Noguchi, *A Sculptor's World,* 164.

9. Noguchi, *A Sculptor's World,* 168.

10. Noguchi, *A Sculptor's World,* 175.

11. Noguchi, *A Sculptor's World,* 28.

Chapter Five

1. Isamu Noguchi, *A Sculptor's World* (New York: Harper & Row, 1968), 11.

2. Isamu Noguchi, "Area 11," *The Isamu Noguchi Garden Museum* (New York: Harry N. Abrams, 1987), 146.

3. Bruce Altshuler, *Noguchi* (New York: Abbeville Press, 1994), 32.

4. Noguchi, *A Sculptor's World,* 24.

Chapter Six

1. Isamu Noguchi, "Meanings in Modern Sculpture," in *Isamu Noguchi: Essays and Conversations,* ed. Diane Apostolos-Cappadona and Bruce Altshuler (New York: Harry N. Abrams/Isamu Noguchi Foundation, 1994), 35.

2. Isamu Noguchi, *A Sculptor's World* (New York: Harper & Row, 1968), 27.

3. Isamu Noguchi, "Area 11," *The Isamu Noguchi Garden Museum* (New York: Harry N. Abrams, 1987), 196.

4. Noguchi also designed sets for the dancers Ruth Page, Erick Hawkins, Merce Cunningham, George Balanchine, and Yuriko Amemiya, and for the Royal Shakespeare Company's production of *King Lear.*

5. Noguchi, *A Sculptor's World,* 123.

6. Noguchi, "On Sculpture," in *Isamu Noguchi: Essays and Conversations,* 48.

Chapter Seven

1. Isamu Noguchi, "Area 11," *The Isamu Noguchi Garden Museum* (New York: Harry N. Abrams, 1987), 192.

2. Isamu Noguchi, *A Sculptor's World* (New York: Harper & Row, 1968), 21.

3. Noguchi, *A Sculptor's World,* 23.

4. Noguchi, *A Sculptor's World,* 23.

5. Hayden Herrera, *Frida: A Biography of Frida Kahlo* (New York: Harper & Row, 1983), 201.

6. Isamu Noguchi, "On Sculpture," in *Isamu Noguchi: Essays and Conversations,* ed. Diane Apostolos-Cappadona and Bruce Altshuler (New York: Harry N. Abrams/Isamu Noguchi Foundation, 1994), 18.

7. Noguchi, "On Sculpture," in *Isamu Noguchi: Essays and Conversations,* 19.

8. Nancy Grove, *Isamu Noguchi: A Study of the Sculpture* (New York and London: Garland Publishing, 1985), 51.

9. Dore Ashton, *Noguchi: East and West* (New York: Alfred A. Knopf, 1992), 206.

10. Noguchi, "Area 11," *Isamu Noguchi Garden Museum,* 19.

11. J. E. Cirlot, *A Dictionary of Symbols,* 2nd ed. (London: Routledge & Kegan Paul, 1962), 97.

12. Noguchi, "Area 11," *Isamu Noguchi Garden Museum,* 194.

13. Noguchi, "Area 11," *Isamu Noguchi Garden Museum,* 200.

14. Noguchi, "Area 11," *Isamu Noguchi Garden Museum,* 64.

15. Noguchi, "Area 11," *Isamu Noguchi Garden Museum,* 200.

16. Noguchi, "Area 11," *Isamu Noguchi Garden Museum,* 200.

17. Noguchi, "Area 11," *Isamu Noguchi Garden Museum,* 204.

18. Noguchi realized his first studio models of *White Slide Mantra* in 1966.

19. Noguchi, "Area 8," *Isamu Noguchi Garden Museum,* 106.

20. Noguchi, "Area 11," *Isamu Noguchi Garden Museum,* 107.

Epilogue

1. Isamu Noguchi, *The Isamu Noguchi Garden Museum* (New York: Harry N. Abrams, 1987), 9.

2. Toshimitsu Hasumi, *Zen in Japanese Art,* trans. John Petrie (New York: Philosophical Library, 1962), 63.

3. Noguchi, *Isamu Noguchi Garden Museum,* 11.

4. Hasumi, *Zen in Japanese Art,* 64.

5. Noguchi, *Isamu Noguchi Garden Museum,* 11.

Typescript, letter, July 3, 1979. Archives of the Isamu Noguchi Foundation, Inc.

Noguchi, Isamu, Yoshio Taniguchi, and Hiroshi Teshigahara. "Garden: Plastic Space with Link Inside and Outside." Interview in Japanese. *Ikebana Sōgetsu* 150 (Oct. 1983): 13.zz.

The Isamu Noguchi Garden Museum. New York: Harry N. Abrams, 1987.

Isamu Noguchi: Essays and Conversations. Edited by Diane Apostolos-Cappadona and Bruce Altshuler. New York: Harry Abrams/Isamu Noguchi Foundation, 1994.

Books

Altshuler, Bruce. *Noguchi.* New York: Abbeville Press, 1994.

Ashton, Dore. *The New York School.* West Hanover, Mass.: Penguin, 1985.

———. *Noguchi: East and West.* New York: Alfred A. Knopf, 1992.

———. *Out of the Whirlwind: Three Decades of Arts Commentary.* Ann Arbor, Mich.: UMI Press, 1987, 133–37.

Beardsley, John. *Earthworks and Beyond: Art in the Landscape.* New York: Abbeville Press, 1989, 80–87, 130–33.

Beardsley, John, and David Finn. *A Landscape for Modern Sculpture: Storm King Art Center.* New York: Abbeville Press, 1985, 68–72.

Chave, Anna C. *Constantin Brancusi: Shifting the Bases of Art.* New Haven, Conn.: Yale University Press, 1993.

De Mille, Agnes. *Martha: The Life and Work of Martha Graham.* New York: Vintage Books, 1992.

Graham, Martha. *Martha Graham: An Autobiography: Blood Memory.* New York: Washington Square Press, 1991.

Greenberg, Clement. "Review of 'Isamu Noguchi and American Paintings from the Collection of the Museum of Modern Art.'" In *Arrogant Purpose, 1945–1949,* vol. 2. Edited by John O'Brian. Chicago: University of Chicago Press, 1986.

Grove, Nancy. *Isamu Noguchi: A Study of the Sculpture.* New York and London: Garland Publishing, 1985.

Grove, Nancy, and Diane Botnick. *The Sculpture of Isamu Noguchi 1924–1979: A Catalogue.* New York and London: Garland Publishing, 1980.

Herrera, Hayden. *Frida: A Biography of Frida Kahlo.* New York and Mexico City: Harper & Row, 1983.

Hunter, Sam. *Isamu Noguchi.* New York: Abbeville Press, 1978.

Krauss, Rosalind E. *Passages in Modern Sculpture.* Cambridge, Mass.: MIT Press, 1977, 1981, 1988.

Krinsky, Carol Herselle. *Gordon Bunshaft of Skidmore, Owings & Merrill.* New York: Architectural History Foundation, 1988.

Lippard, Lucy. *Overlay: Contemporary Art and the Art of Prehistory.* New York: Pantheon, 1983.

Paternosto, Cesar. *Piedra Abstracta: La escultura Inca: Una vision contemporanea.* Buenos Aires: Fondo de Cultura Economica, 1989.

Ronner, Heinz, and Sharad Jhaveri. *Louis I. Kahn: Complete Work 1935–1974.* Basel and Boston: Birkhäuser, 1987.

Senie, Harriet. *Contemporary Public Sculpture: Tradition, Transformation and Controversy.* Oxford: Oxford University Press, 1992.

Seuphor, Michel. *The Sculpture of This Century.* New York: George Braziller, 1961.

Tobias, Tobi. *Isamu Noguchi: The Life of a Sculptor.* New York: Thomas Y. Crowell Company, 1974.

Treib, Marc. *Modern Landscape Architecture: A Critical Review.* Cambridge, Mass.: MIT Press, 1993.

SELECTED BIBLIOGRAPHY

Writings by Isamu Noguchi

"Shelters of the Orient." *Shelter* 2 (Nov. 1932): 96.

"What's the Matter with Sculpture?" *Art Front* 16 (Sept.–Oct. 1936): 13–14.

"Trouble among Japanese-Americans." *New Republic*, Feb. 1, 1943, 142.

"Meanings in Modern Sculpture." *Artnews* 48 (Mar. 1949): 12–15, 55–56.

"Towards a Reintegration of the Arts." *College Art Journal* 9 (autumn 1949): 59–60.

"Art and the People." *Mainichi*, June 16, 1950.

"The 'Arts' Called 'Primitive.'" *Artnews* 56 (Mar. 1957): 24–27, 64.

"Garden of Peace." *UNESCO Courier* 2 (Nov. 1958): 32–33.

"UNESCO Gardens." *Arts and Architecture* 76 (Jan. 1959): 12–13.

"The Observatories of the Maharajah Sawai Jai Singh II." Photographs. *Perspecta: The Yale Architectural Journal* 6 (1960): 68–77.

"Sculpture Garden of the New National Museum of Jerusalem." *Arts and Architecture* 77 (Oct. 1960): 20–21.

Notes for press release, c. 1961. Archives of the Isamu Noguchi Foundation, Inc.

"Collaboration: Artist and Architect." *Arts and Architecture* 79 (Sept. 1962): 23.

"New Stone Gardens." *Art in America* 52 (June 1964): 84–89.

"Sculpture Garden." *Arts and Architecture* 82 (Sept. 1965): 27–29.

"The Sculptor and the Architect." *Studio* 176 (1968): 18–20.

A Sculptor's World. New York: Harper & Row, 1968.

"A Reminiscence of Four Decades." *Architectural Forum* 136, no. 1 (Jan.–Feb. 1972): 59.

Typescript, letter, Mar. 1973. Archives of the Isamu Noguchi Foundation, Inc.

"Noguchi on Brancusi." *Craft Horizons* 35, no. 4.2 (Aug. 1976): 26–29.

Typescript, letter, Mar. 25, 1977. Archives of the Isamu Noguchi Foundation, Inc.

Walker, Peter, and Melanie Walter. *Invisible Gardens: The Search for Modernism in the American Landscape.* Cambridge, Mass.: MIT Press, 1994.

Articles

Albright, Thomas. "Sculptor's Advice to Students: 'A New Nature' Is Needed," c. 1970.

Apostolos-Cappadona, Diane. "Stone as Centering: The Spiritual Sculptures of Isamu Noguchi." *Art International* 24 (Mar.–Apr. 1981): 79–97.

Dean, Andrea O. "Bunshaft and Noguchi: An Uneasy but Highly Productive Architect-Artist Collaboration." *AIA Journal* 65 (Oct. 1976): 52–55.

Donohue, Marlena. "Isamu Noguchi: A Separate Peace." *Sculpture* 8, no. 3 (May–June 1989): 32–35.

Earley, Sandra. "Noguchi." *Miami Herald,* Aug. 11, 1985, sec. K.

Esterow, Milton, and Sylvia Hochfield. "Isamu Noguchi: The Courage to Desecrate Emptiness." *Artnews* 85, no. 3 (Mar. 1986): 102–9.

Fuller, Buckminster. "Colloidals in Time: Isamu Noguchi, F. S. Lincoln." *Shelter* 2, no. 5 (Nov. 1932): 111.

———. "Noguchi." *Palette* (Connecticut Arts Association), winter 1960.

Greenberg, Clement. "Art." *The Nation* 168 (Mar. 19, 1940): 341–42.

Grove, Nancy. "The Visible and Invisible Noguchi." *Artforum* 17 (Mar. 1979): 56–60.

Gruen, John. "The Artist Speaks: Isamu Noguchi." *Art in America* 56 (Mar. 1968): 28–31.

Ha-Van, Ha-Hong-Van. "Les Monuments d'Isamu Noguchi pendant la période du New Deal." *Histoire de l'Art* 27 (Oct. 1994): 71–79.

Itoi, Kay. "Isamu Noguchi's Moere Numa Park: A Work in Progress." *Sculpture,* May–June 1997, 14–15.

Johnson, Jory. "The Masques of Noguchi." *Landscape Architecture* 75, no. 1 (Jan.–Feb. 1985): 58–64.

Kuh, Katherine. "An Interview with Isamu Noguchi." *Horizon* 11, no. 4 (Mar. 1960): 104–12.

La Farge, Henry. "Ruisdael to Pissarro to Noguchi." *Artnews* 1 (Mar. 1950): 32.

"The Landscapes of Noguchi." *Landscape Architecture* 80 (special issue, Apr. 1990).

Lelyveld, Joseph. "Model Play Area for Park Shown." *New York Times,* Feb. 5, 1964.

Louchheim, Aline B. "Noguchi and 'Sculptured' Gardens." *New York Times,* Sept. 30, 1951, arts section, X9.

———. "U.N. Rejects Ultra-Fancy Playground for Plain Type." *Des Moines Iowa Register,* Oct. 1951.

Maeda, Robert J. "Isamu Noguchi: 5-7-A, Poston, Arizona." *Amerasia Journal* 20, no. 2 (1994): 61–76.

"Noguchi Bridges." *Interiors* 3 (Oct. 1952): 10.

Norton, Bob. "Art Imitates Politics: The Story of the Noguchi-That-Will-Never-Be." *Hawaii Observer,* May 19, 1997.

O'Doherty, Brian. "Public Art and the Government: A Progress Report." *Art in America* 62, no. 3 (May–June 1974): 44–48.

Scheffield, Margaret. "Perfecting the Imperfect: Noguchi's Personal Style." *Artforum* 18 (Apr. 1980): 68–73.

Schonberg, Harold C. "Isamu Noguchi, Kind of Throwback." *New York Times Magazine,* Apr. 2, 1968, 24, 27, 28–30, 32, 34.

Spencer, Charles S. "Martha Graham and Noguchi." *Studio International* 173, no. 889 (May 1967): 250–51.

Staempfli, George W. "Interview with Alexander Calder." *Quadrum* 6 (1959): 10.

Tracy, Robert. "Artist's Dialogue: Isamu Noguchi." *Architectural Digest* 44 (Oct. 1987): 72.

Wolfe, Ruth. "Noguchi: Past, and Present." *Art in America* 56, no. 2 (Mar.–Apr. 1968): 32–35.

Zevi, Bruno. "S. Otani e I. Noguchi: Playground a Kodomo No Kuni." *L'architettura* 7 (Nov. 1967).

Exhibition Catalogs

Anzai, Sigeo. *Homage to Isamu Noguchi.* Tokyo: Galerie Tokoro, 1992.

Ashton, Dore. Introduction. In *Isamu Noguchi: Bronze and Iron Sculpture.* New York: Pace Gallery Publications, 1988.

———. Introduction. In *Noguchi.* New York: Pace Gallery Publications, 1983.

Brownlee, David B., and David G. De Long. *Différentes Natures: Visions de l'art contemporain.* L'Opere, Paris: Lindau, 1983.

———. *Louis I. Kahn: In the Realm of Architecture.* Los Angeles: Museum of Contemporary Art, 1991.

Friedman, Martin. *Noguchi's Imaginary Landscapes.* Minneapolis: Walker Art Center, 1978.

Gordon, John. *Isamu Noguchi.* New York: Whitney Museum of American Art, 1968.

Isamu Noguchi: Seventy-Fifth Birthday Exhibition. New York: André Emmerich Gallery and Pace Gallery, 1980.

Isamu Noguchi: The Sculpture of Space. New York: Whitney Museum of American Art, 1980.

Isamu Noguchi at Gemini. Los Angeles: Gemini G.E.L., 1982, 53.

Kassker, Elizabeth B. *Modern Gardens and the Landscape.* New York: Museum of Modern Art, 1964.

Michelson, Annette. *Isamu Noguchi.* Paris: Gallery Claude Bernard, 1964.

Okada, Takahiko. Introduction. In *Isamu Noguchi: Space of Akari and Stone.* San Francisco: Chronicle Books, 1986. Includes essays by Arata Isozaki and Isamu Noguchi.

Oriental Space: Gardens, Isamu Noguchi Retrospective 1992. Trans. Stanley N. Anderson. Tokyo: National Museum of Modern Art, 1992.

Play Mountain: Isamu Noguchi + Louis I. Kahn. In Japanese and English. Tokyo: Watari Museum of Contemporary Art, 1986.

Shigemori, Mirei. *Karesansui.* In Japanese. Kyoto: Kawara Shobo, 1965.

Takahashi, Koji. *Isamu Noguchi: Retrospective 1992.* In Japanese and English. Tokyo: National Museum of Modern Art, with Asahi Shimbun, 1992.

Yashiro, Shoji. "Keiō University and Isamu Noguchi." In Japanese. *Philosophy* 76 (Apr. 1983).

Films

Isamu Noguchi. Produced by Michael Blackwood, Blackwood Productions, New York. 16 mm., color, 28 min., 1971.

Portrait of an Artist: Isamu Noguchi. Directed by Bruce W. Bassett for Whitegate Productions, New York. 16 mm., color, 55 min., 1980.

A Sculptor's World. Film by Arnold Eagle, New York. 16 mm., color, 27 1/2 min., 1972.

ILLUSTRATION CREDITS